BERNHARD HEISIG AND THE FIGHT FOR MODERN ART IN EAST GERMANY

Studies in German Literature, Linguistics, and Culture

A P R I L A . E I S M A N

BERNHARD HEISIG AND THE FIGHT FOR MODERN ART IN EAST GERMANY

CAMDEN HOUSE

Rochester, New York

First published 2018
by Camden House

Camden House is an imprint of Boydell & Brewer Inc.
668 Mt. Hope Avenue, Rochester, NY 14620, USA
www.camden-house.com
and of Boydell & Brewer Limited
PO Box 9, Woodbridge, Suffolk IP12 3DF, UK
www.boydellandbrewer.com

ISBN-13: 978-1-64014-031-8
ISBN-10: 1-64014-031-X

Library of Congress Cataloging-in-Publication Data

Names: Eisman, April A., 1972– author.
Title: Bernhard Heisig and the fight for modern art in East Germany / April A.
 Eisman.
Description: Rochester, New York : Camden House, 2018. | Series: Studies in
 German literature, linguistics, and culture | Outgrowth of the author's thesis
 (Ph. D.—University of Pittsburgh, 2007) under the title: Bernhard Heisig and
 the cultural politics of East German art. | Includes bibliographical references
 and index.
Identifiers: LCCN 2018029914| ISBN 9781640140318 (hardcover : alk. paper) |
 ISBN 164014031X (hardcover : alk. paper)
Subjects: LCSH: Heisig, Bernhard, 1925–2011—Criticism and interpretation. |
 Modernism (Art)—Germany (East) | Art and society—Germany (East)
Classification: LCC ND588.H476 E39 2018 | DDC 759.3—dc23 LC record
 available at https://lccn.loc.gov/2018029914

This publication is printed on acid-free paper.
Printed in the United States of America.

CONTENTS

ILLUSTRATIONS

ACKNOWLEDGMENTS

I t is humbling to think of all the people who have helped me with this project and to whom I am now indebted. I am grateful to the many artists who have met with me, most especially Bernhard Heisig (1925–2011) and his family, Gudrun Brüne, Johannes Heisig, and Walter Eisler (1953–2015). They opened their homes and studios to me on numerous occasions, and I am thankful for their support and insight into art and life in the GDR. I am also grateful to the former East German artists Hartwig Ebersbach, Sonja Eschefeld, Steffen Fischer, Hubertus Giebe, Angela Hampel, Heidrun Hegewald, Hans-Hendrik Grimmling, Gerhard Kurt Müller, Ursula Mattheuer-Neustadt, Roland Nicolaus, Nuria Quevedo, Cornelie Schleime, Willi Sitte (1921–2013), Gudrun Trendafilov, Walter Womacka (1925–2010), and Doris Ziegler for sharing their stories and studios with me; many of them also provided me with catalogs of their work. Thanks also to Sighard Gille, Karl-Georg Hirsch, Margret Hoppe, Siegfried Krepp, and Volker Stelzmann.

The art historians Günter Meißner (1936–2015) and Rita Jorek were excellent conversation partners over the years who shared their considerable knowledge and experience of the art scene in Leipzig in the 1960s with me as well as important documents. Anneliese Hübscher also provided tremendous insight into life at the Leipzig Academy in the 1960s. I am grateful to all of them as well as to Eduard Beaucamp, Ina Gille, Ulrike Goeschen, Sabine Heinke, Sigrid Hofer, Annika Michalski, Jürgen Pappies, Claus Pese, Carolin Quermann, Dietulf Sander, Kathleen Schröter, Karl-Siegbert Rehberg, Beatrice Vierneisel, Silke Wagler, Karin Weber, Angelika Weißbach, and Frank Zöllner for their perspectives on East German art and its reception in Germany today.

Heisig's dealers, Dieter Brusberg (1935–2015) and Rüdiger Küttner, provided me with helpful information and catalogs, for which I am

grateful. Jutta Penndorf at the Lindenau Museum; Annette Ciré, Anja Gebauer, Wilfried Meyer, and Ruth Neitemeier at the Brusberg Galerie Berlin; and Rainer Ebert at the Galerie Berlin were similarly very helpful. Eckhart Gillen offered me the opportunity to work on the 2005 *Bernhard Heisig: Die Wut der Bilder* exhibition.

I would like to give special thanks to Roland März, who not only introduced me to East German art in 2000 but also took me on as an intern in 2003 for the *Kunst in der DDR* exhibition; the latter was an invaluable opportunity to learn more about this art as well as the politics at play behind the scenes. My thanks as well to Bettina Schaschke, Gabriele Bösel, Manfred Tschirner, and Fritz Jacobi at the Neue Nationalgalerie Berlin.

I had the good fortune to work with outstanding archivists and librarians, including Vincent Klotzsche at the archive of the Hochschule für Grafik und Buchkunst, Anka-Roberta Lazarus at the library of the Museum der bildenden Künste Leipzig, and Ursel Wolff at the archive of the Akademie der Künste Berlin. I am grateful to them for their knowledge, expertise, and support. I am also thankful to Karen Goihl at the Berlin Program at the Freie Universität, Christine Enderlein and the staff of the Sächsische Landesarchiv, Uta Wanderer at the City Library of Leipzig, Renate Kranz at the BStU Leipzig, Elke Pfeil at the Brecht Archive, Iris Türke at the archive of the Gewandhaus, Beate Rebner at the archive of Leipzig University, and the staff at the Bundesarchiv Berlin, the Deutsche Dienststelle, the Archive of the Berlin Ensemble, and the library of the Leipzig Academy.

For their help in getting image permissions and/or high-quality reproductions for the vast majority of artwork in this book I would like to extend special thanks to J'Aimee Cronin at Artists Rights Society, Bettina Erlenkamp at the Deutsche Fotothek, Meghan Brown at Art Resource, and Sabine Schmidt at the Museum der bildenden Künste Leipzig. Special thanks also to the Heisig estate and the Galerie Brusberg. Every effort was made to find and secure permission for the images reproduced in this book, but in a few cases, the rights holders could not be determined or located; if you hold the rights to one of these latter works, please contact the author.

In the United States, a number of people have read and commented upon this manuscript at various points in its development. Most important among them is Barbara McCloskey, who has offered insightful criticism and immeasurable support of my work for nearly two decades. Stephen Brockmann has also been invaluable for his constructive criticism and encouragement since the beginning. The two of them have made me the scholar I am today, and I could not have wished for better role models. My thanks to Sabine Hake, Kathy Linduff, Kirk Savage, Terry Smith, and Anne

Weiss at (or formerly at) the University of Pittsburgh, where I began work on this project. I am also indebted to Kevin Amidon, Savanna Falter, Seth Howes, Debbie Lewer, Chris Nelson, Gisela Schirmer, and an anonymous reader for their insightful comments on the full manuscript. Special thanks to my editor, Jim Walker, who not only read and offered great feedback on the manuscript, he has also patiently answered my many questions. Thanks as well to Tracey Engel and Julia Cook at Camden House; to Carrie Watterson and David Prout; and to those who have commented upon parts of the manuscript, including Carlton Basmajian, Jelena Bogdanovic, Marion Deshmukh, Candice Hamelin, Tom Leslie, Emily Morgan, Chrisy Moutsatsos, Cullen Padgett-Walsh, and, with regard to German translations, Ulrike Passe.

Additionally, I would like to thank a number of English-speaking scholars for thought-provoking conversations about East Germany: Seán Allan, Katrin Bahr, Sara Blaylock, Benita Blessing, Sky Arndt-Briggs, Barton Byg, Joy Calico, Heather Gumbert, Donna Harsch, Sebastian Heiduschke, June Hwang, Justinian Jampol, Sonja Klocke, Debbie Lewer, Heather Mathews, Thomas Maulucci, Kristine Nielsen, Bill Niven, Jon Berndt Olsen, Jonathan Osmond (1953–2014), Jan Palmowski, Eli Rubin, Katrin Schreiter, Hiltrud Schulz, Christine Schwenkel, Joes Segal, Marc Silberman, and Briana Smith. Thanks also to Deborah Ascher Barnstone, James van Dyke, Randall Halle, Paul Jaskot, Libby Otto, Mark Rectanus, and Gregory Williams for interesting conversations about Germany more generally.

Parts of chapter 3 appeared in somewhat different form in "In the Crucible: Bernhard Heisig and the Hotel Deutschland Murals," in *Art Outside the Lines: New Perspectives on GDR Art Culture*, ed. Amy Wlodarski and Elaine Kelly (Amsterdam: Rodopi, 2011), 21–39. Parts of the conclusion appeared in somewhat different form in "Denying Difference in the Post-Socialist Other: Bernhard Heisig and the Changing Reception of an East German Artist," in *Contemporaneity: Historical Presence in Visual Culture* 2 (2012): 45–47; "Whose East German Art Is This? The Politics of Reception after 1989," *Imaginations: Journal of Cross-Cultural Visual Studies* 8, no. 1 (2017), http://imaginations.csj.ualberta.ca/?p=9487; and "Re-examining the *Staatskünstler* Myth: B. Heisig and the Post-Wall Reception of East German Painting," in *Virtual Walls? Balancing Political Unity & Cultural Difference in Contemporary Germany*, ed. F. Lys and M. Dreyer (Rochester, NY: Camden House: 2017): 117–30. I thank the editors and reviewers of those publications for their helpful comments.

I have received generous financial support from several institutions for which I am grateful. A Publication Subvention Grant from Iowa State

University generously supported the publication costs for this book and its many images; thanks in particular to Sandra Norvell for her help. Research in Germany was funded by the Berlin Program of Advanced German and European Studies at the Freie Universität, the German Academic Exchange Service (DAAD), the US Department of Education, the Andrew W. Mellon Foundation, and the University of Pittsburgh, including the Center for West European Studies, the Faculty of Arts and Sciences, the Friends of Frick, the Stanley Prostrednik Nationality Room, and the International Studies Fund. Without their generous financial support, this project would not have been possible.

I also wish to thank some of my friends in Germany, including Roland Fuhrmann, Ulrike Grittner, Ulrich and Ulrike Kirchberg, Constanze Korb, Daniela Krohn and family, Anka Lazarus, Gisela Lohr, Annika Michalski and family, Karin Müller-Kelwing, Karolina Pajdak, Uwe Schumacher, Gisela and Ortwin Schirmer, Frank and Petra Sitzlach, Kathrin Wagner, and Silke Wagler and family for their support, friendship, and insight into life in Germany. In the United States, I thank Dean and Denise Biechler, Arthur and Janet Croyle, Scott Hendrix, Laura Jarboe, Gladys Jones, Sheri Lullo, Dave and Stacey Ross, Kymm Stokke, and Mike Todsen.

Next to last, I would like to thank my parents, Skip and Rosemary Kask, for their love and support. Without them I would not be where I am today. And, last but not least, I thank Grant Arndt, a model scholar and human being who has not only read and commented upon this manuscript countless times, he has been the source of invigorating discussions and of unconditional support, making life's journey much more quirky and enjoyable.

ABBREVIATIONS

AdK Akademie der Künste / the Academy of Arts

BKA-L Bezirkskunstausstellung Leipzig / the District Art Exhibition in Leipzig

DDR Deutsche Demokratische Republik / German Democratic Republic, or East Germany

DKA Deutsche Kunstausstellung (after 1972, Kunstausstellung der DDR) / the German Art Exhibition (after 1972, the Art Exhibition of the GDR)

FRG Federal Republic of Germany (West Germany from 1949 to 1990, unified Germany after October 1990)

GDR German Democratic Republic, or East Germany

HGB Hochschule für Grafik und Buchkunst Kunst / the Leipzig Academy

LVZ *Leipziger Volkszeitung* / The Peoples' Newspaper, Leipzig

ND *Neues Deutschland* / New Germany, the SED's main newspaper

RdB-L Rat des Bezirkes Leipzig / District Council of Leipzig

RdS-L Rat der Stadt Leipzig / City Council of Leipzig

SED Sozialistische Einheitspartei Deutschland / the Socialist Unity Party

SED-L The Leipzig branch of the SED

Stasi Ministerium für Staatssicherheit / East Germany's secret police

VBK Verband Bildende Künstler / the Union of Visual Artists (also referred to as the VBKD before 1970, VBK-DDR afterward)

VBK-L The Leipzig branch of the VBK

ZV Zentral Vorstand / Central Committee of the SED

WHY HEISIG MATTERS

They paint more German in the GDR.
—Günter Grass, 1982

I n 1997, Bernhard Heisig (1925–2011) was commissioned to create a painting for the Reichstag building in Berlin. One of East Germany's most successful artists, Heisig had seemed a natural choice for inclusion in what is now the Bundestag's permanent art collection, a veritable who's who of contemporary German artists, including Joseph Beuys, Anselm Kiefer, and Gerhard Richter.[1] In the 1980s, Heisig had been highly praised on both sides of the Berlin Wall for his artistic commitment to the German tradition and especially to Adolph Menzel, Lovis Corinth, Max Beckmann, and Otto Dix. He regularly exhibited prints and paintings in major international art exhibitions such as *documenta* and the Venice Biennale as well as in numerous exhibitions in West Germany. He also painted the official portrait of the West German chancellor Helmut Schmidt for the German Chancellery in 1986. Three years later, when the Berlin Wall fell, much of Heisig's work was already in the West in a large retrospective exhibition that had opened to praise at the Martin-Gropius-Bau in West Berlin on September 30. It was the first—and ultimately only—major solo exhibition of a contemporary East German artist to be organized in a joint effort by curators from both Germanys.

But the choice to include a work by Heisig in the Reichstag building just a few years after the Berlin Wall fell was heavily contested in the press. In February 1998, the eastern German art critic Christoph Tannert (b. 1955) published a letter in several newspapers arguing that to give Heisig the commission was "not only an art historical mistake, but also a political

lack of instinct."[2] The problem, he stated, was Heisig's "cooperation with
the GDR regime," which Tannert saw as standing "in crass opposition to
a democratic horizon of values."[3] Fifty-eight cultural and political figures
signed the letter, including a number of eastern German artists from the
alternative scene.[4] In response, one of Heisig's earliest students, the painter
and performance artist Hartwig Ebersbach (b. 1940), defended Heisig
in the press, stating that the controversy had nothing to do with a "fac-
tual engagement with [his] work and life, but rather only serves a cliché:
Heisig is the GDR."[5] Ebersbach dismissed the debate as "mudslinging"
against the East and a "campaign" of "self-positioning." Like Tannert's let-
ter, Ebersbach's also had signatories: they included Günter Grass, Helmut
Schmidt, and Armin Zweite as well as leading cultural figures from eastern
Germany such as Hubertus Giebe, Wolfgang Mattheuer, Harald Metzkes,
Werner Tübke, and Christa Wolf.[6]

The debate over Heisig's inclusion in the Reichstag building was one
of several high points in what has become known as the German-German
Bilderstreit, or "image battle." This dispute, which was waged in the unified
German press throughout the long 1990s, took place each time a major
exhibition or commission included a well-known eastern German artist
such as Heisig. At its core, the *Bilderstreit* was over what role, if any, East
German art and artists should be allowed to play in the new Germany.
Despite the heated exchange in the press, however, the commission stood:
Heisig delivered *Zeit und Leben* (Time and Life, 1999) to the Reichstag the
following year, where it has been on view ever since.[7]

In the new millennium, the *Bilderstreit* began to quiet, and in 2005, a
major exhibition of Heisig's work opened for his eightieth birthday with-
out sparking a debate in the press. Then-chancellor Gerhard Schröder
attended the opening in Leipzig and stated in a much-publicized speech
that "Bernhard Heisig [is] one of the most important German artists" of
the twentieth century.[8] What might at first have appeared as the begin-
ning of a return to Heisig's former status, however, revealed itself upon
closer examination as a new phase in the *Bilderstreit*, one that in Heisig's
case elided any positive connections he had to East Germany and offered
a significantly different portrayal of the artist and his life than that found
in most previous scholarship.[9] Rather than a politically active artist com-
mitted to Socialism, Heisig was presented as a victim: "His artistic achieve-
ment lies in the constant artistic examination of the trauma of a biography
that passed from war and dictatorship to a further dictatorship and the
Cold War."[10] This portrayal of Heisig fit well within the western view of East
Germany common in the 1990s, when the German Democratic Republic

(GDR, East Germany) was dismissed as a totalitarian dictatorship with no redeeming value, but it overlooked both the realities of Heisig's life and artwork as well as the shift to a more nuanced understanding of East Germany evident in both second- and third-wave scholarship on the topic.[11]

This book challenges current understandings of Heisig, showing that he was in fact an intellectual artist who was deeply committed to the East German project. As Heisig himself stated in 1972, "We [artists in East Germany] have the chance to take part in a worldview!"[12] Rather than a victim, Heisig was an active participant who stood up for his beliefs about what art in East Germany should be. In the 1960s, he played a key—if now overlooked—role in the development of a modern style of painting in East Germany that landed him at the center of several battles with politicians and cultural functionaries. It is this role, and the change in both his work and in East German painting more broadly—from "socialist realism" to a modern artistic style—that stands at the center of this study of Heisig's career in the Ulbricht era (1949–71). Rather than seeing Heisig as a dissident artist, however, I argue that his involvement in these artistic debates show his commitment to Socialism and his desire to improve it from within.

In its broad outlines, the story told here echoes those found in a number of recent scholarly works about the GDR: it emphasizes the complexity of life in East Germany and the self-determination possible for those who lived there.[13] As Eli Rubin wrote in his pioneering study of plastics in the GDR, state power was "affected by the demands of ordinary East Germans so that the result became a confluence, a sharing of values that created a unique culture, something purely East German, a combination of state and society but representing the power of neither over the other."[14] Dolores Augustine made a similar point with regard to scientists in East Germany—who, like artists, were part of the intellectual elite—stating that creation was "a process of constantly renegotiated power relations."[15]

As this book shows, the East German art world was not a top-down system of uniform repression but rather a "field of friction" (as Heisig called it) in which artists actively engaged in debate with cultural functionaries and politicians.[16] Far from monolithic, cultural policy in East Germany changed over time and by location. Leipzig (where Heisig lived), for example, was more conservative in its art scene than were Berlin or Halle in the early years of the Cold War because of the personalities and history involved.[17] But through Heisig's efforts, and those of other artists, Leipzig came to be the center of a new, modern East German painting style in the mid-1960s. Heisig's struggles thus offer a deeper understanding

of East German artistic policy at the national, local, and personal levels. They also reveal the crucial importance of debate in defining art in East Germany, showing how Heisig and many of his fellow artists fought for and eventually achieved a modern style of art. Before looking more closely at Heisig and the East German art world in which he lived and worked, however, we first need to understand the reception of East German art in the Anglo-American West.

The Cold War Lacuna

Surprisingly little information about East German art exists in English, an absence that stands in sharp contrast to the sizeable bodies of scholarship available about East German literature, film, and material culture.[18] Much of what has been published about the visual arts has been dominated by stereotypes that emerged in the early Cold War period. In 1954, Hellmut Lehmann-Haupt published *Art under a Dictatorship*, which included a chapter titled "German Art behind the Iron Curtain."[19] Although an accurate portrayal of the East German art scene up to 1953—from openness to modern art in the early postwar years to increasing limitations imposed upon artists under Stalinism—the chapter ended at what would turn out to be the high point of repressive cultural practice in East Germany.[20] Three years later, in 1956, *Burlington Magazine* published an article titled, "The Artistic Situation in East Germany," in which the nameless author declared that "no art is being produced under the East German Republic to compare with the best in Western Europe."[21] That which was being produced, the author concluded, would more likely appeal to an historian than an artist.

Whereas Lehmann-Haupt's text reflected the repressive nature of East German cultural politics at the time he wrote it—a repression that peaked in 1953—the article in *Burlington Magazine* reflected the politicization of the visual arts more broadly during these years. It was in the 1950s when—from the Western perspective—modern art came to represent the "freedom" of Western liberal democracy, and realism, the repressive nature of dictatorial regimes. As Serge Guilbaut and Frances Stonor Saunders have documented with regard to the West, the Central Intelligence Agency played an active role in this cultural division, funding international exhibitions of abstract expressionism, which came to be associated with the "freedom" of the United States and stood in opposition to the Nazis'—and by extension, Soviets'—repression of such work.[22] As such, art came to play an important role in the ideological battle between capitalism and

communism. "Socialist realism" became a euphemism in the West for kitsch and political propaganda, which was the only type of art deemed possible in the East.[23]

The tendency to see socialist realism and modern art as binary opposites continues to the present day. In East Germany, however, "modern" was a term used by artists like Heisig to refer to art that rejected a simple illusionism in favor of formal innovation. In some contexts, it was used as a synonym for modernism and, in others, for art created in the West. It was not, however, seen as something separate from or opposed to socialist realism—at least, not after the artistic debates of the 1960s; in fact, it was this shift in definition that artists like Heisig were arguing for at the time. Although frequently viewed in the West today as a style—one marked by a simple realism, optimism, monumentality, and a commitment to figuration—socialist realism in East Germany was, in fact, a position (*Haltung*); it was a commitment on the part of the artist to create art for Socialist society and its people. Socialist realism was thus not the binary opposite of modern art but rather of the Western idea of "art for art's sake." It is this broader use of the term "modern" that I use throughout this book.[24]

In the wake of the politicization of the arts in the 1950s, discussion of East German art essentially disappeared from English-language scholarship. It did not return until 1984, when the British curator David Elliott published a small catalog, *Tradition and Renewal: Contemporary Art in the German Democratic Republic*, to accompany an exhibition he had organized for the Museum of Modern Art in Oxford, England. It was the first exhibition of contemporary East German art held in the Anglo-American West and was the result, in part, of diplomatic efforts by the East German government: the cultural attaché of the GDR embassy in London asked Elliott whether he would be interested in "selecting and showing" such an exhibition.[25] After visiting several artists' studios in East Germany, Elliott agreed and selected fifteen artists whose paintings and graphics drew from the expressionist and Neue Sachlichkeit (New Sobriety) traditions. In the introduction to the catalog, he addressed the assumption that East Germany did not have art, asserting that although these artists, in their responsibility "to mirror and inspire the development of society and the needs of the people," needed to create work that was "broadly intelligible," it did "not result in a facile popularism."[26] This, he later pointed out, was because early on artists like Heisig, Willi Sitte, and Werner Tübke had been able to "revalidate [socialist realism] not as a style with recognizable physical attributes and finite duration but as an attitude which gave conviction to art."[27]

Five years later, in 1989, Peter Nisbet of the Busch Reisinger Museum at Harvard University opened the first American exhibition on the topic, *Twelve Artists from the German Democratic Republic.*[28] As a museum dedicated to art from German-speaking countries, the Busch Reisinger was a natural home for such an exhibition. It was accompanied by a relatively substantial catalog, the introduction to which highlights the absence of East German art from American consciousness:

> Art from the German Democratic Republic? Art from *East* Germany? We must surely look forward to a time when it will seem quite natural and expected for a museum to present the work of living artists from the German Democratic Republic. . . . For the time being, however, we have become used to the fact that our project has evoked some surprise, some skepticism, and above all much curiosity among our American colleagues.[29]

The Berlin Wall fell less than a week after this exhibition closed in Boston. The works then traveled to Los Angeles and Michigan.

Since unification, there has been increasing interest in East German art in the United States, although the number of publications remains low.[30] One of the most substantial is the 1997 conference proceedings, *Cultures in Conflict: Visual Arts in Eastern Germany since 1990*, edited by Marion Deshmukh. Of the five articles, however, only two were written by native English speakers, reflecting the fact that "there are very few scholars or critics [in the United States] who are involved in an ongoing way with current East German art. Nor are there those who even have much knowledge about east German art historically."[31] Instead, the majority of articles were by scholars socialized in West Germany, a problem I will return to later in this chapter. The continuing lack of scholarly engagement with East German art by American academics can also be seen in the most substantial English-language contribution to the subject to date: the catalog for the 2009 blockbuster exhibition at the Los Angeles County Museum of Art (LACMA), *Art of the Two Germanys, Cold War Cultures*. Whereas five articles in the catalog focus exclusively on West Germany, only two focus exclusively on East Germany; and of the two, one was written by a German academic and reflects the totalitarian view evident in the *Bilderstreit* in Germany.[32]

A striking feature of Anglo-American reception of East German art is not simply the fact that there is so little of it, but rather that it is absent in places where one might expect to find it. In 1985, for example, the Royal Academy of Art in London opened a major exhibition titled *German Art*

in the 20th Century: Painting and Sculpture, 1905–1985. Despite its inclusive title, the exhibition did not contain art from East Germany. In the introduction, one of the curators—Christos Joachimides, a Greek scholar who moved to West Germany in 1952—stated simply that East German art had followed "a quite different course" from art in the West, which was apparently enough reason to exclude it from the show.[33] According to David Elliott, curator of the Oxford exhibition held the previous year, however, Joachimides gave quite a different reason for its exclusion when he spoke at a forum held at the time: there he stated that East German art was not "good" enough to be included in the exhibition, that it represented the efforts of essentially "provincial schools."[34]

Four Approaches to East German Art

Joachimides's comment that East German art was not good enough to be included in the exhibition at the Royal Academy represents the first of what I see as four levels of understanding evident in Western texts about East German art. The first three are dominated by the conviction, often implicit, that Art and Communism are mutually exclusive. The fourth moves beyond this stereotype to consider the individual artists and artworks on their own merits.

The first level of understanding, the belief that East Germany did not have art—or at least no art on par with that of the West—originally appeared in the 1950s in articles like the one in *Burlington Magazine* mentioned above; it continues to the present day. In his review of the 2009 LACMA exhibition, the prominent art historian Benjamin Buchloh—a professor at Harvard who was socialized in West Germany—dismissed East German art as "artistic abominations" made by "provincial party hacks" and "opportunists."[35] To make such sweeping statements, he had to ignore the East German art on view in the exhibition such as Heisig's prints from *Der faschistische Alptraum* (The Fascist Nightmare, 1965–66, see fig. 4.10) and Werner Tübke's painting, *Lebenserinnerungen des Dr. jur. Schulze III* (Reminiscences of Judge Schulze III, 1965, see fig. 4.7), both of which display a modernist aesthetic in their examination of the Nazi past. These works resist not only the idea that East German artists were hacks but also the idea that they were provincial: both artists had significant contact with the West during the Cold War, having traveled and exhibited there on many occasions, including at *documenta* and the Venice Biennale.[36]

The second level acknowledges that art was created in the GDR but assumes that it was created by dissident artists who were expressing opposition to the state with their work. This view can be seen in the German press of the 1990s, as well as in German sociologist Paul Kaiser's article in the 2009 LACMA catalog, "Symbolic Revolts in the 'Workers' and Peasants' State': Countercultural Art Programs in the GDR and the Return of Modern Art."[37] Kaiser begins his article by dismissing the East German government for having "created a backward-looking system of art whose conceptual guiding feature was an antimodernist, uncritical, apologetic socialist realism," before focusing on a supposed "nonconformist, 'unofficial' art scene" that stood in opposition to official culture.[38] The suggestion was that the only "good" art created in East Germany was by artists who opposed the state, a view that ignores the many "modern" artists—like Heisig, Tübke, and Mattheuer—who, with state support, represented East Germany in major exhibitions in both the East and West.

The third level recognizes that there were official artists in East Germany who created Art but assumes that they must have had subversive messages in their work that were simply not caught by the censors. Again, this view is driven in part by the belief that a committed Communist cannot create art that could be valued in the West. We find such assumptions in the introduction to the LACMA catalog, where one of the curators incorrectly concluded that canonical East German paintings like Tübke's *Reminiscences of Judge Schulze III* must have been "unofficial works" that had "passed undetected through the censors."[39] The subversive message the curator sees in the painting, however, was not identified, nor was the painting's prominence in East German art history books explained.

The fourth and final approach, and the one that defines this book, recognizes that East Germany had important artists and that those artists could in fact genuinely believe that Socialism, despite its flaws, was a better system than capitalism. As Heisig once stated, "I never wanted to emigrate. I always had the possibility, but I always had the feeling that I was needed. . . . Art in the West . . . did not offer what I wanted, therefore the West was not my world. I wanted this world here to be different."[40] Heisig created paintings that were, at times, critical of East Germany, but they were not an attempt to undermine or overthrow it. Rather, they raised criticisms in the hopes of improving the system, of making it different than it was. Such utopian views were shared by many East Germans, especially visual artists and other intellectuals.[41] As David Bathrick has observed of prominent East German writers, "Many were convinced Marxists who were or had been members of the Communist Party. Most saw themselves working

for a more democratic, humane Socialism. None sought to overthrow the existing system as a whole or to replace it with capitalism."[42] English-language scholarship about these writers—who include Heiner Müller, Christa Wolf, Volker Braun, and Christoph Hein—has been plentiful since the 1970s and offers a more complex understanding of their relationship to East Germany and Socialism. It is my intention in this book to develop a similar approach to East German art.

(Western) Ideology at Work

In the United States, East German art tends to be perceived, albeit often unknowingly, through a western German lens.[43] This viewpoint is encouraged by the strong postwar ties between the United States and the Federal Republic of Germany (FRG; West Germany before 1990, unified Germany thereafter) and by the influence of western German scholars—that is, scholars who were socialized in the FRG—in the United States today. Far from neutral, however, the western German perspective was shaped by the Cold War. The antagonism built into it can be seen in the *Bilderstreit* around East German art that took place in the German press of the 1990s. In these struggles, Heisig was praised by some as the quintessential "German" artist and his work was included in major exhibitions and collections, like that of the Bundestag in Berlin. At the same time, others attacked him in the press for having been a teenage soldier for the Nazis and, seemingly worse still, for having been a successful artist in the GDR. According to one critic, "Heisig offers a clear example of creative ingratiation and flexible crawling into the slime trail of power."[44]

The terms of this debate and the intensity of such attacks reveal the strong biases against East German art that persist in the Federal Republic of Germany today, ones forged from nearly forty years of condemnatory Cold War rhetoric against the "Eastern Zone." Indeed, East Germany and the Third Reich were frequently conflated through the use of the term "totalitarianism," which rose to prominence over "fascism" and "Nazism" in the early Cold War years.[45] As British scholar Corey Ross has pointed out, the term was used in both cases "to bracket together fascist and communist states and to emphasize the similarities in their techniques of rule."[46] Although it fell from favor as the Cold War mellowed and West Germany began to confront its own culpability in the Third Reich, the term reemerged in the wake of November 1989. East Germany was again equated with Nazi Germany, thus allowing for repeated and public dismissal of the

GDR and, with it, of the possible contributions East Germans could offer the new, unified Germany.[47]

Many art historians in the United States remain unaware of the deep ideological commitments in the western German perspective and the extent to which they influence Anglo-American views of East Germany. The problems caused by these unconscious commitments are compounded by the assumption that scholarship written after unification is better than that written beforehand.[48] As the conclusion of this book reveals with regard to Heisig, much of the literature since unification has been written by western German scholars, often with little background in the topic, while eastern Germans scholars—and their perspective on and experience with this art and the context in which it was created—have been largely excluded from post-wall discourse.[49]

The fall of the Berlin Wall marked the beginning of the end of East Germany and of European Socialism. Many Westerners saw it as proof that capitalism was the superior political and economic system. Today, the presumption, encouraged in the media, continues to be that when the wall fell, East Germans wanted the GDR to end. In reality, however, the "peaceful revolution" of 1989 was not about bringing the GDR to an end—it was about reform. Hundreds of thousands of protestors gathered in major cities on consecutive Mondays throughout the fall of 1989 to demand freedom of speech, the right to assemble, and the freedom to travel. In short, these protestors wanted the democracy they had been promised but that had been abrogated by the SED (Sozialistische Einheitspartei Deutschland, the Socialist government in East Germany). They carried signs that stated, "WE are the people" and "We are staying here." According to Konrad Jarausch, an overwhelming 86 percent of them wanted Socialist reform in November 1989, versus only 5 percent who wanted capitalist restoration.[50] Further evidence of this appears in Christa Wolf's call during the November 4 demonstration on Alexanderplatz in East Berlin for a "Socialism where nobody runs away" and in the November 26 manifesto for a "socialist alternative to the FRG" that was drafted by thirty-one writers and later signed by two hundred thousand people.[51]

But this vision of a more democratic Socialist society failed to materialize. The reasons for this failure are complex and include the inability of East German leadership to articulate a clear vision for the future. Their failure to respond quickly to the momentous events of the fall stood in sharp contrast to the actions of West German chancellor Helmut Kohl, who unveiled a Ten-Point Plan for German Unity on November 28. By early February, the number of East Germans who wanted capitalism had

multiplied sixfold to 31 percent, while those wanting Socialist reform had fallen to 56 percent.[52] In March, a popular vote cleared the way for unification, and preparations began. Less than a year after the wall fell, on October 3, 1990, East Germany ceased to exist.

The initial joy surrounding these events, however, turned to disappointment with the West in the years following unification as unrealistic expectations fueled by the media met lived reality. As anthropologist Daphne Berdahl documented in her detailed study of the East German town of Kella between 1990 and 1992: "The welcoming, emotional embraces of the early days were replaced with animosity, resentment, and in many cases aggression."[53] East Germany had been absorbed into the Federal Republic of Germany, which did not change its name with the merger. Although the West did undergo changes as a result of unification, its world nonetheless remained largely intact. East Germans, in comparison, had to adapt to a completely new way of life, from relearning menial tasks like shopping and paying taxes to understanding how their new world worked; in the West, money rather than social relations was the key to surviving, and hoarding was no longer necessary or even desirable.[54] East Germans also had to face the loss of their way of life: the organizations they had belonged to and the products they had bought disappeared almost overnight, while their access to the arts and childcare became prohibitively expensive. They also had to stand by and watch as western Germans took their jobs and bought up their land for bargain-basement prices through organizations like the Treuhand.[55] As the former mayor of Kella stated in the wake of the massive changes that took place after unification, "Everything we did [under Socialism] was wrong. The streets we built were wrong, the trees we planted were wrong, even the roses . . . were wrong."[56]

In 2010, a German politician who grew up in East Germany became embroiled in controversy for referring to unification as an annexation by the West.[57] While this terminology may be too strong for some, the East German experience nonetheless bears striking similarities to those of postcolonial states.[58] Even the portrayal of East Germans in the media is dominated by a western German perspective, as evidenced by the hugely popular *The Lives of Others*, the Oscar-winning movie about East Germans by the western German writer and director Florian Henckel von Donnersmarck and, more recently, by the popular television series *Weissensee* and *Deutschland 83*.[59] East Germans voices have been silenced. Indeed, the *Bilderstreit* was about silencing—or at least muting—those East German artists who had been highly praised on both sides of the wall before it fell.

Bernhard Heisig, an East German Artist

Heisig's life and career reflect the complexities of having been born a German in 1925. Eight years old when the Nazis came to power, he signed up for the military at the age of sixteen and fought for the Nazis on both the eastern and western fronts. When the war ended, he was twenty and a prisoner of the Soviets. Later released, he moved to Leipzig, where he enrolled as a graphic arts student at the age of twenty-four. In that same year, the German Democratic Republic was founded. By the time he was thirty-six, he had risen through the ranks to become director of the Leipzig Academy (Hochschule für Grafik und Buchkunst Leipzig, HGB), a prestigious cultural institution in East Germany where he was also a professor. It was at this time, the early 1960s, that he turned increasingly to painting as his primary medium. He also began to experiment with modern artistic styles. Before the decade was over, he was at the center of four separate controversies about art. At stake was what East German art should look like and who should get to decide; Heisig argued in favor of an openness toward modern art and for artists to be the ones to make such decisions.

In 1971, when Erich Honecker became head of the East German state, cultural policy in East Germany relaxed significantly, and Heisig quickly rose to national—and later international—prominence as an artist. He had major exhibitions, held important cultural offices, and received numerous prizes such as the National Prize (First Class).[60] He also exhibited work in the West, including in England and the United States. Once the wall fell, however, Heisig's reception—like that of many of East Germany's most prominent artists—changed from praise to condemnation as the visual arts, like literature, became contested ground for establishing the national identity of the new Germany.[61] Heisig and his wife, Gudrun Brüne, withdrew to a village on the outskirts of Berlin, where they lived and worked together in relative isolation from 1992 until his death in 2011 at the age of eighty-six.[62] Despite a number of exhibitions and publications in recent years, his work and life in the GDR remain largely misunderstood.[63]

Bernhard Heisig and the Fight for Modern Art in East Germany examines the relationship between Heisig's work and the East German context in which it was created. It is based on extensive archival research, interviews, and above all a close visual analysis of his art, especially his paintings, which led my research in terms of the questions asked and the conclusions made. This approach borrows from Michael Baxandall's theory of inferential criticism, which holds that objects and context mutually reinforce each other: an understanding of the context in which a work was created

informs its interpretation, while the work of art keeps the interpretations of the context grounded in an actual object.[64]

To understand Heisig's work, I first needed to create an informal catalogue raisonné of his paintings, a daunting task due to the artist's tendency to create multiple variations on a topic and to do so across many years. It was further complicated by his practice of overpainting: Heisig frequently made changes to his paintings that could range anywhere from the alteration of minor details to the total obliteration of the original composition. In fact, almost no Heisig painting was safe from his corrective brush, and he was even known to make changes to a work while it was hanging in an exhibition. Reportedly he even had others distract museum guards on occasion so he could make alterations.[65]

To establish a chronology of his paintings, I collated images from Heisig catalogs, books, and articles since the 1950s, as well as from major exhibitions—East and West—of East German art. I also paged through more than twenty years of the *Leipziger Volkszeitung* and *Bildende Kunst*, the GDR's main art magazine, among others. This research allowed me to date more accurately many of Heisig's early paintings, to trace the evolution of various myths in his biography, and to see how Heisig and his art were discussed in the GDR. It also gave me insight into the major issues of the day from the East German perspective. The chronological focus on Heisig's paintings led me to reclassify his life and work during the Cold War era into three distinct phases.[66] The early years, 1948–62, were marked by an illusionistic style and East German subject matter. The period between 1963 and 1976 continued with an East German subject matter, but the style became modern. From 1977 to 1989, Heisig's style remained modern, but he changed to a pan-German rather than East German content.[67]

Much scholarship today takes a thematic rather than chronological approach to Heisig's work and is based, albeit unknowingly, on this third phase.[68] During these years, Heisig created many more paintings dealing directly with the Nazi past than he ever had before. This new emphasis must be seen, in part, as a response to the interest in this topic expressed by a Western audience and presumably encouraged by his West German dealer, Dieter Brusberg. Creating such works not only contributed to a common German culture that transcended the Iron Curtain, it also helped Heisig gain more security in the GDR, since the more valued an East German artist became in the West, the less political functionaries were able to take action against him; East German politicians were very mindful of the West German press.[69] Another factor, however, in Heisig's increasing turn to the Nazi past in his paintings

in these years was presumably his age. Wartime traumas suppressed in one's youth often emerge decades later. The fortieth anniversary of the beginning of World War II in 1979—together with the recent death of his mother and his youngest son's conscription in the National People's Army—may well have triggered a personal examination of his past at the same time.

In addition to the paintings themselves and their public reception, the interpretations in this book are based on extensive archival research. This research included numerous files at the Bundesarchiv in Berlin and the Sächsisches Statssarchiv in Leipzig as well as Heisig's Stasi files (those for the Ministerium für Staatssicherheit, or secret police). New to this book are the archival files at the Leipzig Academy, where Heisig was a student, professor, and director for thirty years, as well as those files requiring Heisig's signature for access, which he gave me early on in my research.[70] The latter include his military files during the Third Reich and, more substantially, his personal files from the GDR, including records of his commissions and sales. Among other things, archival research led to the discovery of photographs of two key works—destroyed through overpainting— that are reproduced for the first time in this book: *Weihnachtsabend des Militaristen* (The Christmas Evening of the Militarist, c. 1962, see fig. 2.7) and *Die Brigade* (The Brigade, 1969, see fig. 5.1). I also looked at numerous smaller archives and the private papers of important people with whom he had contact, including Max Schwimmer and Alfred Kurella.[71]

This book also draws on a large number of interviews I conducted over the course of several years. I met with Heisig on numerous occasions, from exhibition openings and dinners to five day-long interviews in his home. I talked with his family on several occasions, including his wife, Gudrun Brüne, and his sons, Walter Eisler and especially Johannes Heisig.[72] I also met with key figures in Heisig scholarship today as well as colleagues and friends of his from the Ulbricht era; the latter include many artists and art historians who were important in Leipzig at the time but who have largely disappeared from view after unification.[73] Careful of the pitfalls of first-person narrative—from the vagaries of memory to the desire for personal gain—I obtained significant insight into both Heisig and East Germany from these interviews. On several occasions, contemporaries produced primary documents that were in their possession, ranging from meeting minutes to personal letters, photos, and works of art.

By looking at Heisig's life and work chronologically and in context, we can better understand the artist and the art world in which he lived and worked, an art system that had the same (art) history as West Germany up

until 1945 but that differed significantly afterward. As Piotr Piotrowski has argued about Eastern Europe more broadly, art in East Germany was "created in a different semiotic and ideological space than Western Europe."[74] It is only in exploring these differences—in looking at this art through its own frame—that their meaning and significance emerges. When understood on its own terms, East German art is not backward or provincial, as some contend. Such dismissal stems from an outmoded view of art based on the hierarchal approach of modernism rather than one based on the multiplicities of the contemporary world in which we live, what Terry Smith terms "contemporaneity."[75] In this new, transnational world, the study of East German art can contribute to what Dipesh Chakrabarty calls "provincializing Europe," in other words, decentering the "universal" narrative to give equal footing to those traditionally confined to the periphery. As a "close Other," the term Piotrowski uses for Eastern Europe, East Germany offers a particularly interesting new perspective to the newly emerging horizontal—or nonhierarchical—history of the world: once part of the West, it became an Other under Communism, then ceased to exist in 1990.[76] This study thus not only opens up another approach to art, it also allows us to see better how Cold War ideology affected art in both blocs, East *and* West.

Chapter 1 focuses on the first thirty-six years of Heisig's life, with an emphasis on those years spent in East(ern) Germany before the Berlin Wall was built. In the sixteen years following the end of World War II, Heisig went from being a teenage prisoner of war under the Soviets to being director of the Leipzig Academy, a prestigious position within the East German art world. By looking closely at Heisig's life and art within the broader contexts of Leipzig and East Germany in these years, this chapter shows the artist's active engagement with the cultural politics of the day as well as the dynamic nature of those politics, which changed over time and according to place.

Chapter 2 begins in 1961, the year the wall was built and that Heisig became director of the Leipzig Academy. It ends in 1964, the year he resigned from this position. These years mark his emergence as a painter on the East German art scene and the beginnings of a change in his artistic style toward the complex, modern style for which he is best remembered in Germany today. It was also during these years that he began having significant conflicts with politicians and cultural functionaries. This chapter looks at the first of these controversies, the one surrounding his speech at the Fifth Congress of the national Artists Union (VBK, Verband Bildende Künstler, or Union of Visual Artists) in 1964.[77]

Chapters 3 and 4 continue with the discussion about art taking place in East Germany in the mid-1960s—about the role that modern art should play and who should get to decide, artists or politicians—but shift emphasis from the national to the local, focusing on two controversies that took place in Leipzig around Heisig's art in 1965. Chapter 3 focuses on a series of murals he created for the Hotel Deutschland, especially on one titled *Schwedt*. Chapter 4 focuses on one of the first paintings in his oeuvre to demonstrate a modern style, *The Paris Commune*. Taken together, these controversies show that Heisig was deeply engaged in the question of what art in East Germany should be and that East Germany was more open to debate than is often believed. They also reveal the important role that art played in society, and that Heisig's commitment to social engagement and his audience were far more than empty slogans or attempts to curry favor with a repressive regime.

Chapter 5 focuses on a handful of portraits Heisig created between 1968 and 1971 that are undeniably East German in content. Two of the paintings focus on workers; two on Vladimir Lenin. But they were not all praised. *The Brigade*, for example, elicited sharp condemnation when first exhibited in 1969, the fourth and final major controversy in which Heisig was directly involved in East Germany. When considered in context, these paintings emphasize Heisig's deep personal engagement with the art of his time and his commitment to creating challenging works of art that responded to the needs and interests of his intended audience, be it the people or the party. In short, he was interested in creating art that was dialogic rather than didactic and adapted his works accordingly. These works thus also show the importance of discussion and debate for Heisig's artistic process.

By the early 1970s, with the onset of the Honecker era (1971–89), the controversies over art had ended, at least for artists like Heisig who were clearly committed to East Germany and working in traditional media. It is at this point that he began to receive increasing recognition at the national and international levels: first in the GDR, where he had a major solo exhibition in 1973 and received the National Prize (First Class) in 1978, and later in West Germany, beginning with *documenta 6* in the late 1970s. This fame, coupled with Heisig's power within the GDR—as director of the Leipzig Academy (1976–87), vice president of the Union of Visual Artists at the national level (1978–83), and member of the SED—led to his complicated reception in the wake of 1989. The conclusion of this book focuses on Heisig's reception in the Federal Republic of Germany before and after 1989 as well as the paintings for which he is best known in the

West, offering insight into the "hidden" meaning in many of his images of war and trauma as well as into the identity politics at play in his Western reception.

This study offers a new perspective on Heisig and the art world in which he lived and worked for nearly forty years. By focusing on the early years, it corrects a number of misconceptions about Heisig that have strongly affected his reception in the new Germany. It also sheds light on how he, an East German artist, understood his work and role as an artist and how he fought for his beliefs within the East German system. It is a story that finds echoes in scholarship on East German literature and film, but with medium-specific differences. Ultimately, this book is about fundamentally rethinking what we think we know about East German art and about the neutrality or superiority of the West and its art. It offers details of a system that "failed" but that nonetheless has lessons to offer—about art as a site of community, responsibility, and resistance.

FROM THE NAZI PAST TO THE COLD WAR PRESENT

B ernhard Heisig enrolled at the Leipzig Academy in October 1949, the same month that the German Democratic Republic was founded. At twenty-four, he was starting over after having been a soldier for the Nazis, a prisoner of war under the Soviets, and a refugee in eastern Europe. Over the course of the next twelve years, he would become increasingly engaged with the cultural politics of his new country, ultimately becoming director of the Leipzig Academy, a prestigious position within the East German art world. These years also saw a number of important political events—the failed Workers' Uprising in 1953, the New Course of the mid-1950s, and de-Stalinization—all of which deeply affected the visual arts.

This chapter focuses on the first thirty-six years of Bernhard Heisig's life, with an emphasis on those spent in East(ern) Germany until just after the Berlin Wall was built. By looking closely at Heisig's life and art within the broader contexts of Leipzig and East Germany in these years, this chapter shows the artist's active engagement with the cultural politics of the day, first as a student, then as a teacher, writer, cultural administrator, graphic artist, and, finally, director of the Leipzig Academy. This chapter also shows that the GDR was not a monolithically repressive system but rather one that changed over time and according to place. Indeed, and as will become increasingly evident in subsequent chapters, artistic policy in East Germany changed in large part because of artistic interventions by actively engaged artists like Heisig, albeit often after significant and vehement

debate. Additionally, this chapter shows that Heisig was not always a modern artist but, rather, in the 1950s, created realist works that were inspired by nineteenth-century artists like Adolph Menzel (1815–1905).

From Breslau to Leipzig, 1925–48

Bernhard Heisig was born on March 31, 1925, in Breslau, Germany (now Wrocław, Poland). An only child, he grew up with art as part of his everyday life because his father, Walter Heisig, was a painter.[1] In speaking about his childhood, Heisig recalled that, although he knew how to draw before he could read or write, "I didn't make what people call children's drawings. I drew with a certain perfection."[2] His father, however, did not encourage him to create art: "He didn't teach me technique. He never corrected my work."[3] Indeed, his father did not want him to become an artist. It was only after his father died—from injuries sustained from falling off a ladder—that the young Heisig, aged sixteen, enrolled at the Meisterschule des Deutschen Handwerks (Master School of German Handcraft) in Breslau to study commercial art. That same year, he enlisted as a soldier, having to break off his studies the following year when he was called to duty in September 1942.

In the war, Heisig fought on the western front in both Normandy and the Battle of the Bulge as part of the Twelfth SS Tank Division of the Hitler Youth. At the end of the war, he was more than eight hundred miles away, on the eastern front, in his hometown of Breslau, which had been a center of fierce fighting between the Nazis and the Soviets in the spring of 1945. For six months after the war ended, the twenty-year-old Heisig was a prisoner of the Soviets in Breslau.[4] They released him in October 1945, presumably because of a leg injury suffered in the war. As he explained it in 2000, he had inadvertently reinjured the leg a couple days before the Soviet Commission inspected the German prisoners. Severe swelling, which he intentionally exacerbated by not elevating his leg and then rubbing blue ink on it to make it look even worse, led the commission to think he was too injured to be sent to a hard labor camp in the Soviet Union, and he was later released.[5]

By the end of 1945, Heisig was working as a graphic artist for the Polish Propaganda Ministry in Breslau, which had been given to Poland in the wake of the war. He later credited this experience of working with Polish artists as his first exposure to modern art, which the Nazis had largely eliminated from Germany by the late 1930s in their campaign against "degenerate"

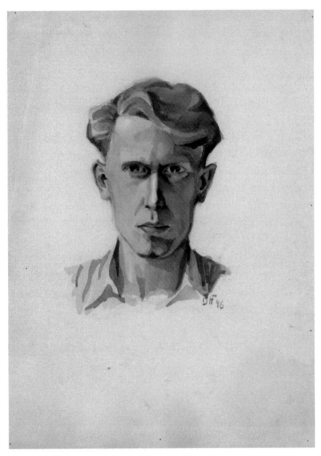

Figure 1.1. Bernhard Heisig, *Selbstbildnis* (Self Portrait), 1946. Watercolor, c. 21 x 29.7 cm. © 2018 Artists Rights Society (ARS), New York / VG Bild-Kunst, Bonn. Private Collection Leipzig. Photo: Galerie Irrweg Leipzig.

art.[6] He also credits it as the beginning of his change in thinking about the Nazis, later remarking that the Polish artists "all spoke German so that I could understand them. That really impressed me. I thought about what would have happened to them had German occupation continued."[7]

In early 1946, Heisig and his fifty-year-old mother were forced to leave Wrocław as the city expelled Germans to make room for a new, Polish population. They became two of thousands of people in transit across the European continent in those years as geographical borders were redrawn, and refugees, prisoners, and soldiers made their way home. They settled nearly 250 miles away in Zeitz, Germany, where Heisig joined what would become East Germany's Freie Deutsche Gewerkschaftsbund (Free German Trade Union) and resumed work as a graphic artist. A self-portrait from these years (fig. 1.1) shows the determined gaze of the young artist depicted with a confident hand. Two years later, in April 1948, he applied to study graphic arts at the Leipzig Academy of Art.[8] His application included a letter in which he identified himself as an evacuee and stated that "alles abhängt" (everything depends) on his being able to continue his studies, which had been interrupted by the war.[9]

Postwar Germany

The Germany to which Heisig returned was in the process of rebuilding. Rubble and decay had to be removed from the streets, buildings repaired and rebuilt, and running water and electricity reestablished. Within this context of massive destruction, the art scene recovered with surprising speed. Just weeks after capitulation, galleries and exhibitions opened throughout the country, displaying new works and old in the bombed-out ruins of major cities like Berlin and Dresden. Modern art, which had been pilloried in the Third Reich, reemerged in these early years to stand alongside more realistic works in an atmosphere of artistic freedom that extended to all four occupation zones.[10]

In the Soviet Zone of Occupation where Heisig later settled, the newly founded Kammer der Kunstschaffenden (Chamber of Artists) exhibited works by modern German artists like Karl Hofer, Ernst Ludwig Kirchner, and Oscar Nerlinger in July 1945.[11] Memorial exhibitions were held in October for Käthe Kollwitz in Berlin and Leipzig and for Ernst Barlach in Rostock, and independent groups of artists banded together—such as Der Ruf (the Call) in Dresden—to hold exhibitions of recent work.[12] The first major postwar exhibition took place a year later: in August 1946, the

Allgemeine Deutsche Kunstausstellung (General German Art Exhibition) opened in Dresden with approximately six hundred works by 250 artists, including the modern masters Oskar Kokoschka, George Grosz, Max Beckmann, Kollwitz, and Barlach.[13] Located in the Soviet sector, this exhibition included work by artists from all four occupation zones. Although many were modern in style, few of the works engaged with the challenges of the present or the problems of the past. Rather, they tended to be portraits or landscapes painted in a decorative and harmonious fashion: after so many years of war and repression, painting was "for many artists an experience of freedom, the simple ability to paint without pressure, to create beauty and harmony."[14]

By the time Heisig applied to the Leipzig Academy, all the art schools in the eastern zone had reopened—Weimar and Halle in September 1946, Dresden and Leipzig in April 1947, and Berlin-Weißensee in June 1947.[15] These institutions tended to be under the direction of Communist artists active in the Weimar era such as Hans Grundig (1901–58) in Dresden and Kurt Massloff (1892–1973) in Leipzig. This generation of artists—many of whom, like Grundig, were indebted to expressionism—dominated the East German art scene of the 1950s and was extremely influential on Heisig's generation, most of whom first studied art in the GDR.

Yet the modern artistic style that many of them promoted would soon become the focus of debate as the Cold War set in and art became politicized. With the Second World War withdrawing ever further into the past, the ideological differences between the eastern and western occupying forces in Germany became increasingly insurmountable. A major breaking point came in June 1948 when the western zones announced a currency reform that effectively separated their economy from that of the eastern zone. Days later, the Soviet Union exacerbated the situation by blocking all land routes to West Berlin, which was deep within the Soviet zone. In response, the Western powers supplied the city with food and other necessities by dropping packages from airplanes—the famous Berlin Airlift—until the Soviet Union relented eleven months later. Less than two weeks after that, on May 23, 1949, the western zones founded the Federal Republic of Germany; the eastern zone followed suit five months later with the German Democratic Republic, on October 7. These political events had a visible impact on the development of art in postwar Germany—in the East, most notably in what have become known as the Formalism Debates.

The Formalism Debates began in October 1948 when two articles appeared in *bildende kunst*, the main art journal of the Soviet Zone of Occupation.[16] Written by the joint editors of the journal, Karl Hofer and

Oskar Nerlinger, respectively, these articles took opposite stances on the role that art should play in society.[17] In "Art and Politics," Hofer called for artistic freedom, arguing that it is up to the artist to decide on style and content, including whether or not it is political. In "Politics and Art," by comparison, Nerlinger argued that no art could be free from politics, even that which claimed to be, and therefore all art, as a public medium, should be made accessible to the people.[18] The Soviet Union shared Nerlinger's view with its emphasis on a straightforward realism: in November 1948 Alexander Dymschitz, the cultural officer of the Soviet Military Administration, published an article in the Soviet newspaper in Germany, the *Tägliche Rundschau*, titled "About the Formalist Direction in German Art." In it, he criticized Hofer's view of art for art's sake and argued instead that "the highest criteria" for the evaluation of art is whether it meets the call of "the people [*das Volk*] and their progress."[19]

In Leipzig, this emphasis on art as a political tool was encouraged by Kurt Massloff, whom the Soviets had made director of the Leipzig Academy in February 1946.[20] A committed Communist and founding member of the Association of Revolutionary German Artists, or Asso, which had been founded during the Weimar era and was based on a similar organization in the Soviet Union, Massloff had the kind of background the Soviets wanted for those who would lead the new Germany. Not only a committed Communist, he had a proven anti-fascist pedigree: the Nazis had arrested him in 1933 and again in 1942, at which point he was given a life sentence for his anti-Nazi provocations. When the war ended, the Soviets freed him from a prison in Waldheim and gave him the commission to rebuild the Leipzig Academy. In April 1947, the fifty-five-year-old Massloff reopened the school. His clear political orientation enabled him to mold students into politically conscious artists, while his commitment to the theory and practice of socialist realism laid the foundation for the mastery of handcraft for which Leipzig would later become known.[21]

Heisig's initial application to the Leipzig Academy in spring 1948 was rejected. As he explained it decades later, "I was rejected because I wasn't modern enough. The crazy stuff, I couldn't make it, no imagination."[22] It was not until the following year—in the wake of the articles in *bildende kunst* and *Tägliche Rundschau*—that he began his studies at the Leipzig Academy, the result of an intervention by Max Schwimmer (1895–1960), an art professor there, after he saw some of Heisig's work.[23] In the interim, Heisig attended the Leipziger Kunstgewerbeschule (Leipzig School of Applied Arts), where he took a class in decorative painting and graphics with Walter Münze (1895–1978), a committed Communist who, like

Massloff, had been a founding member of Asso in Leipzig.[24] Like Heisig, the fifty-three-year-old Münze had fought in the war and been taken prisoner. Presumably this similarity in experience contributed to their subsequent friendship, despite the age difference. Heisig credits Münze with introducing him to important Communist figures from history like Rosa Luxemburg, Karl Liebknecht, and Ernst Thälmann and with his decision to join the SED in the late 1940s.

After working with Münze for a year, Heisig was accepted at the Leipzig Academy and enrolled for the winter semester, beginning classes in October 1949.[25] He studied under Schwimmer, a fifty-four-year-old graphic artist and book illustrator who had joined the Communist Party shortly after the war ended and began teaching at the Leipzig Academy as soon as it reopened. According to Heisig, Schwimmer had exposed him to the great illustrators of the past and gave him space to develop his own skills.

Heisig's artistic debt to Schwimmer appears in several of the black-and-white lithographs he created in these years. Like Schwimmer's work, they display a similar use of delicate, agitated lines. One illustrates a poem by Hans Lorbeer, a Socialist East German author. It shows two blacksmiths at an anvil: one holds a small object with metalworking tongs while the other holds a sledgehammer above his head, at the beginning of a downward swing. Another print from these years, *Zu Richard Wright: Ich habe schwarze Hände gesehen* (To Richard Wright: I Have Seen Black Hands, 1950, fig. 1.2), is loosely based on the African American author's poem of the same name.[26] It depicts a police officer—with a dollar sign on his hat and a "US" on his lapel—nonchalantly smoking a cigarette while two others beat a cowering man against a backdrop of skyscrapers and the Statue of Liberty. Although Heisig may not have chosen the texts—it is likely these prints were created to fulfill class assignments—his interpretation of the poem suggests that he was critical of capitalism, a position shared by both Münze and Schwimmer. Indeed, highlighting racism as intrinsic to capitalism was a standard part of anti-fascist discourse in East Germany.

A well-traveled artist, Schwimmer loved Picasso, Kirchner, and especially Paul Klee, and this, together with his relaxed manner, made him well liked by his students at the Leipzig Academy. But his personality and artistic interests stood in sharp contrast to Massloff's serious nature and commitment to a conservative, Soviet-style socialist realism. These differences would eventually divide the school and lead to Schwimmer's departure, which had a significant impact on Heisig. The minutes of a faculty meeting (*Kollegiums-Sitzung*) in August 1950, for example, note a lively

Figure 1.2. Bernhard Heisig, *Zu Richard Wright: Ich habe schwarze Hände gesehen* (To Richard Wright: I Have Seen Black Hands), 1950. Lithograph (ink on transfer paper), 17.9 x 12.9 cm. © 2018 Artists Rights Society (ARS), New York / VG Bild-Kunst, Bonn. Museum der bildenden Künste Leipzig (Sander Nr. 2). Photo: Museum der bildenden Künste Leipzig.

debate over which students should get fellowships to attend the Leipzig Academy. Schwimmer, together with the sculptor and professor Walter Arnold (1909–79), argued that artistic quality should be the deciding factor for such fellowships, not a student's political activities.[27]

This argument took place just months before the second phase of the Formalism Debates began at the national level. In January 1951, N. Orlow published a two-part article in the *Tägliche Rundschau* titled "Directions and Misdirections of Modern Art."[28] In it, he condemned modern art's emphasis on form to the exclusion of content, dismissing what he called "the cult of the ugly and immoral," which he saw as the "damaging influences of American cultural barbarity" and a sign of the "general crisis of the capitalist system."[29] He also rejected work by socially committed artists like Käthe Kollwitz, whose realism and images of downtrodden workers he found too pessimistic. Although her art was understandable for the period in which it was created, he deemed it unsuitable for the GDR, which was the embodiment of Socialist victory:

> What should one say about people who, years after Käthe Kollwitz,
> and with the great role model of the workers and farmers of the Soviet
> Union and that of . . . the successful building of the German Democratic
> Republic in mind . . . portray the creators of this new life as 'unhappy'
> [*unglücklich*] people! Is it so difficult to understand that such an attitude
> toward the working class . . . is false and cannot serve the moral renewal
> of the German people?[30]

Instead, he encouraged artists to learn from both the classical tradition
and from Soviet art and to create works that help with the "building of a
democratic consciousness" and that "fight against the ideology of war, fas-
cism and genocide."

N. Orlow was probably a pseudonym for Kurt Magritz (1909–92),
Massloff's closest advisor at the Leipzig Academy.[31] Magritz taught art
history and sociology in Leipzig and worked at the *Tägliche Rundschau*
in Berlin. The views he expressed in this article closely resemble those
expressed at the Fifth Conference of the SED's Central Committee in
March, where an official "fight against formalism" had been declared.[32] In
November 1951, Walter Ulbricht, head of the SED, further confirmed the
party's stance on modern art: "We do not want to see any more abstract
pictures in our art schools. . . . Gray-on-gray painting is an expression of
capitalist failure and stands in the sharpest contradiction to the new life
found in the German Democratic Republic."[33]

This second phase in the Formalism Debates was strongly felt at the
Leipzig Academy, which increasingly emphasized Marxist-Leninist ideol-
ogy in the education of its students and discouraged the "decadent" and
"formalist" artistic styles of the West. It also took on personal dimensions.
When Schwimmer exhibited works at the Kunsthandlung Kurt Engewald
in Leipzig in the spring of 1951, a full-page article appeared in the
Leipziger Volkszeitung with the title "Life in the World Is More Beautiful."[34]
Supposedly written by Paul Ruhland, one of Massloff's students, it attacked
Schwimmer's "dilettantish" work, suggesting that such "artistic individual-
ism" was contributing to "the destruction of culture."[35] This stood in sharp
contrast to the praise Schwimmer had received a few weeks earlier in a
review of the same exhibition published in Berlin: "Schwimmer delivers
an essential contribution to the lively continuation of the German drawing
tradition established by Menzel and Slevogt. Schwimmer—one of the most
important German illustrators of the present—is a naïve talent full of . . .
artistic charm."[36]

Schwimmer believed Massloff was behind Ruhland's article, a reflection
of the rivalry between the two professors and, ultimately, their respective

students. They differed not only in their approach to art but also in their productivity. After the war, Massloff created very little art, the result of an eye injury incurred while in captivity. Schwimmer, on the other hand, continued to create and exhibit art until his death in 1960. This difference did not go unnoticed by students, some of whom pointed to it in the increasingly rancorous atmosphere at the Leipzig Academy in these years. As one student stated: "If [Massloff] didn't produce anything, it was not only due to a lack of time."[37]

In the immediate wake of the attack on his art, Schwimmer left the Leipzig Academy, taking up a position at the Dresden Academy. After his departure, his former students continued to feel the repercussions of having had him as their mentor. A report dated June 25, 1951, for example, lists Heisig as one of six students who, supposedly influenced by his former teacher, did not take the study of Marxism-Leninism seriously enough.[38] In a letter to Schwimmer that July, Heisig talked about the difficulty Schwimmer's students were having—in comparison to Massloff's students—getting a diploma and the tense atmosphere at the Leipzig Academy. He called it an "Affentheater" (monkey theater) and stated that he was "now in search of a corner in which to catch my breath."[39] He dropped out of school the following month, having completed only two years of classes.

As a freelance artist, Heisig supported himself by making posters and other promotional materials for the Leipzig trade fairs.[40] He also began work on his first oil painting, *Zirkel junger Naturforscher* (Circle of Young Natural Scientists, 1952, fig. 1.3). In a conservative realist style characteristic of painting in Leipzig at the time, it shows a group of nine well-dressed men and women in a classroom, a chalkboard visible behind them. They are arranged in clusters around and in front of a table covered by a white cloth. A microscope sits on the table to the left of center. Most of the students read from books, seemingly in search of an answer. In the foreground, a pile of open books, face down, creates a still life that further emphasizes the importance of education. The woman at the far left of the painting is Brunhilde Eisler, a fashion student at the Applied Arts School in Leipzig whom Heisig married in November 1951. Together, they would have two sons, Johannes in April 1953 and Walter in September 1954, before divorcing in 1956. Primarily a graphic artist at the time of this painting, Heisig claims he taught himself how to paint with this work and that his wife had sat as a model for it for so long that she never wanted to see it again.[41] Significantly, this first painting—like his earlier prints—shows no signs of a modern style, suggesting that Heisig's departure from the Leipzig Academy the previous year had less to do with the conservative socialist realist style

Figure 1.3. Bernhard Heisig, *Zirkel junger Naturforscher* (Circle of Young Natural Scientists), 1952 Oil painting, 124 x 190 cm. © 2018 Artists Rights Society (ARS), New York / VG Bild-Kunst, Bonn. Museum der bildenden Künste Leipzig (Inv.-Nr. G 3281). Photo: bpk Bildagentur / Museum der bildenden Künste Leipzig / Bertram Kober (Punctum Leipzig) / Art Resource, NY.

Figure 1.4. Klaus Weber and Harald Hellmich, *Die jüngsten Flieger* (The Youngest Fliers), 1953. Oil, 240 x 350 cm. © 2018 Artists Rights Society (ARS), New York / VG Bild-Kunst, Bonn. Photo: SLUB / Deutsche Fotothek.

being emphasized under Massloff's leadership than the acrimonious atmosphere brought on by the Formalism Debates.

While Massloff's policies drove off a number of important artists from the Leipzig Academy, they also led to the emergence of Leipzig as a center for the Soviet-inspired socialist realism desired by the government. At the Third German Art Exhibition, which opened in Dresden in March 1953 with approximately six hundred works by four hundred artists, many of the most highly praised paintings were created by artists from Leipzig, including Harald Hellmich and Klaus Weber's *Die jüngsten Flieger* (The Youngest Fliers, 1953, fig. 1.4). This large painting depicts a group of boys and girls on top of a hill playing with model airplanes and laughing together in the summer sun. Some wear the white shirts and red or blue kerchiefs of the Junge Pioniere, the East German youth organization. The largest boy, standing just to the right of center, looks off into the distance as he is about to release the plane in his hand; several of the others watch him expectantly. The meaning of this work is clear and easy to understand: in the GDR, life is good, children are happy and healthy, and in them resides much promise. These children can also be read metaphorically as the young GDR

itself. Not only easy to understand, this work is also realistic, optimistic, and focuses on people, all essential elements of a Soviet-inspired socialist realism.[42] Together with paintings like Hans Mayer-Foreyt's *Ehrt unsere alten Meister* (Honor Our Old Masters) and Gerhard Kurt Müller's *Bildnis eines Offiziers der kasernierten Volkspolizei* (Portrait of an Officer of the People's Police), *The Youngest Fliers* embodied the conservative cultural politics of the day and contributed to Leipzig's early prominence in the East German art world.[43]

The New Course, 1953–56

The triumph that Leipzig and socialist realism experienced at the Third German Art Exhibition did not last long. On June 17, 1953, half a million workers in East Germany took to the streets to protest increased production demands. This Workers' Uprising, which was ultimately suppressed by Soviet tanks, led the East German government to relax its grip on the arts in what was termed the New Course. In part, this change in policy—which had actually begun a few days before the uprising took place—evolved into an attempt to win back intellectuals after the violence of the summer. As a result, artists were publicly able—although not encouraged—to experiment with modern art for a few years in the mid-1950s. Picasso, in particular, was the focus of a series of articles in East Germany's main art journal, *Bildende Kunst*, in 1955 and 1956 because of his merging of Communist ideology with a modern artistic style.[44] Whereas some authors dismissed his use of modern styles, others defended it: "The 'art consumer' . . . wants paintings with which he can think along; he wants paintings that encourage him to think and also to dream. And without a doubt, the latter is what Picasso's paintings do."[45]

In the more relaxed atmosphere of the mid-1950s, the Leipzig Academy altered its course. Conservative professors hired at the beginning of the 1950s left, and more open-minded artists returned, including the twenty-nine-year-old Heisig, who became an *Assistent* (lecturer) there in January 1954.[46] The lack of qualified teachers in the wake of World War II meant that he could be offered such a position because of the skills he possessed despite not having a college diploma. This year also marked the second time he was on the jury for the District Art Exhibition in Leipzig, a position he would hold until East Germany's collapse in 1989/90.[47]

It is at this time that Heisig created his second painting, *1848 in Leipzig* (1954–58, fig. 1.5), a work that reveals a significant loosening of the artist's

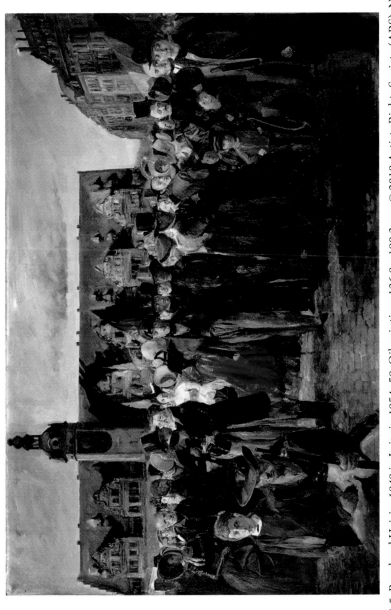

Figure 1.5. Bernhard Heisig, *1848 in Leipzig*, 1954–58. Oil painting, 126.8 x 190.3 cm. © 2018 Artists Rights Society (ARS), New York / VG Bild-Kunst, Bonn. Museum der bildenden Künste Leipzig (Inv.-Nr. G 2712). Photo: Museum der bildenden Künste Leipzig.

brushwork in its depiction of a crowd of more than thirty well-dressed bourgeois men, women, and children. (The red-headed boy at the lower left is based on his elder son, Johannes). The figures gather in the square in front of the old town hall in Leipzig. It is a scene from the revolution of 1848 in Germany, an historical topic that the East German government encouraged artists to illustrate.[48] In the background, the yellow, red, and black flag proposed by the short-lived Frankfurt Parliament of 1848–50 is visible, symbol of the revolutionaries' hopes for a democratic German state.

Despite the title's reference, however, the figures in Heisig's painting do not appear to be on the verge of revolution. Rather, they seem to be waiting, a portrayal that reflects the GDR's official view of these events at the time. A local report by Leipzig's district council in June 1952, for example, states that "it is less about portraying the fight at the barricades than it is about symbolizing the popular uprising, in which the workers, together with some students, played a leading role while the petit bourgeoisie took a wait and see approach."[49] In this painting, Heisig has focused on the latter. Men mill about in long coats complete with fitted vests and ascots, some with top hats; women, fewer in number, appear in corseted dresses and wide-brimmed bonnets. A handful of figures throughout have turned to face the viewer, a few make eye contact, but there is little movement. The emphasis on waiting, however, may have also been a reflection upon the Workers' Uprising in 1953: fighting for change was not possible in the face of Soviet tanks. As Heisig stated years later, the waiting evident in a number of his early paintings "had something to do with our situation in the GDR. One was mentally practically always sitting on a suitcase. We all believed that something would happen, that this could not be everything."[50]

Although Heisig's brushwork loosened in these years, he did not experiment with Picasso-inspired simplifications and the flattening of space in his paintings, preferring instead to emulate the more traditional works of the nineteenth-century artist Adolph Menzel. This stylistic conservatism in the mid-1950s stands in sharp contrast to the modern works being created by many East German artists his age, including that of his neighbor and colleague at the Leipzig Academy, Werner Tübke (1929–2004).[51] Four years younger than Heisig, Tübke was too young to have fought in the war, although he, too, had a traumatic past. Shortly after the war ended, the Soviets incarcerated him on suspicion of having shot a Soviet officer and of being part of the Nazi guerilla organization known as Werwolf.[52] After eight months of detention that included torture, he was released without charge.[53] It was an experience that would affect his views on East Germany as well as his art.

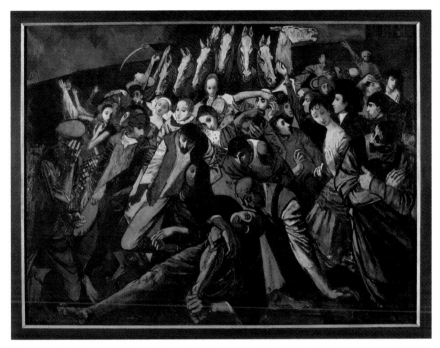

Figure 1.6. Werner Tübke, *Versuch II* (Attempt II), 1956. Oil on canvas, 150.4 x 200.4 cm. © 2018 Artists Rights Society (ARS), New York / VG Bild-Kunst, Bonn. Tübke Stiftung Leipzig (WVZ G 24). Photo: Tübke Stiftung Leipzig / Martin Weicker, Leipzig.

In 1956, Tübke created *Versuch II* (Attempt II, 1956, fig. 1.6). Like Heisig's work, this painting focuses on a group of more than thirty men and women, but, rather than standing around, they crowd together in a writhing triangular mass as white horses come barreling down upon them like the horses of the apocalypse; the sword-wielding arm of one of the riders appears at the left. Most of the people portrayed appear unaware of the impending doom, although their faces are grim. Clear references to figures by modern masters like Beckmann, Hofer, and Picasso—as well as to old masters like Velázquez and Delacroix—appear throughout the canvas.[54] The modernist influence also appears in the flattened picture plane: rather than receding into the image, the people appear to be stacked on top of each other and about to tumble forward into the viewer's space. The title, together with the timing of the work, suggests it was a reflection upon the protests that took place in Hungary in June 1956; like those in East Germany three years earlier, this second

Figure 1.7. Bernhard Heisig, *Zweikampf* (Single Combat), for Ludwig Renn's *Krieg*, 1955/56. Lithograph, 27.1 x 22.1 cm. © 2018 Artists Rights Society (ARS), New York / VG Bild-Kunst, Bonn. Museum der bildenden Künste Leipzig (Inv.-Nr. 1989-387 / Sander Nr. 43). Photo: Museum der bildenden Künste Leipzig.

attempt at reform in the Eastern bloc was suppressed by Soviet military force.[55]

Unlike with Tübke, who created both realist and modernist paintings, there are no references to modernist art in Heisig's paintings from these years, although a few prints show that he was aware of Picasso's work. In 1955/56, he created a series of illustrations for Ludwig Renn's *War*, an autobiographical account of Renn's experiences as an ordinary foot soldier in World War I. In one of these illustrations, *Zweikampf* (Single Combat, fig. 1.7), two figures engage in hand-to-hand combat. Their contorted faces recall that of Dora Maar in paintings by Picasso such as *Head of a Woman* (1938). This print, however, is a rarity in Heisig's oeuvre, suggesting that he—in sharp contrast to many of his colleagues—was not particularly interested in modernist experimentation in these years.[56] In an interview years later, Heisig explained that he was aware of Picasso's work at the time—indeed, he had first encountered it in the early postwar years—but that he did not find it interesting: "I didn't know what to do with it. I couldn't use it for my work, for the things I wanted to do."[57]

In addition to creating art during the more relaxed years of the New Course, Heisig also wrote a number of fairly critical reviews of the art scene in Leipzig. Between 1954 and 1957, he published five articles of varying length in *Bildende Kunst*. All but one were reviews of local exhibitions. Together, they reveal Heisig to be a young artist surprisingly critical of both the East German art scene and his colleagues, several of whom he singled out for praise or criticism, more frequently the latter.[58]

In his first article, published in May/June 1954—just a few months after he began teaching at the Leipzig Academy—Heisig faulted artists in Leipzig for being too fearful, for clinging to "verbrauchte Formulierungen" (tired formulations) and mere craftsmanship rather than finding the "bildgestalterische Moment" (creative moment) in their work.[59] In a subsequent article, he laid the blame for this on the current system with its "starre" (rigid) emphasis on artistic tradition.[60] For Heisig, praiseworthy art united craftsmanship, artistic inspiration, and a socially relevant subject matter. He criticized those artists who emphasized artistic skills or the "mörderlichen Konstatierung naturalistischer Details" (deathly noting of naturalist details) to the detriment of subject matter.[61] He also expressed regret that political themes remained mostly the result of state commissions rather than personal artistic choice and remarked that this situation needed to be overcome.

In his second article, a June 1955 review of the Third District Art Exhibition in Leipzig, Heisig pointed out the abundance of landscapes and still lifes in the exhibition, stating that he believed many artists were using these genres as "neutrale Zonen" (neutral zones) without realizing that even these subjects did not offer an escape from making decisions.[62] Clearly, Heisig agreed here with Nerlinger's argument in the first of the Formalism Debates: all art is political. He then turned to history painting and faulted the dominance of subject matter in these works to the detriment of painterly execution and deeper meaning. As he would explain in more detail in an article from the following year, a work of art is not good just because of its subject matter, nor is art merely the result of craftsmanship: "The historically accurate, well-executed work does not necessarily result in an artistic statement."[63]

For Heisig, *Inhalt* (meaning) was the key to a good work of art, and he made a clear distinction between it and *Stoff* (subject matter). Meaning requires the artist to come to terms with the subject and make a personal connection with it. As such, it is inextricably bound with the artist's identity and is what makes the subject matter relevant for the present day. Moreover, the form of a work of art is directly related to its meaning, thus,

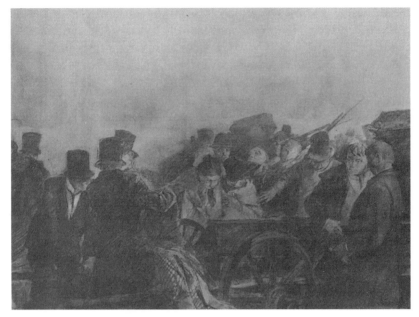

Figure 1.8. Bernhard Heisig, *Aufbahrung der Märzgefallenen I* (Public Viewing of Those Who Fell in March I), 1953. Chalk drawing, 30 x 56 cm. © 2018 Artists Rights Society (ARS), New York / VG Bild-Kunst, Bonn.

as Heisig stated in the third article, "There is no artwork with good content [i.e., meaning] and bad form or vice versa."[64]

What was lacking among many Leipzig artists, according to Heisig, was meaning, the personal coming to terms with the subject matter in relation to one's own historical and social moment, rather than mere historical illustration. As examples of what history painting should be, he pointed to Goya, Delacroix, and Picasso: "Alone, these artists took the concept [of history painting] far beyond its restricted borders [of nineteenth century, historically antiquated 'rightness' combined with academic polish]. They did not relay history, but rather reinterpreted it in the sense of a passionate resistance, and their painting is for their time, like their ideas, revolutionary."[65]

This distinction between subject matter and meaning, and between mere "historical illustration" and "history reinterpreted as passionate resistance," can be seen in a series of lithographs Heisig created just a few years earlier, in 1953. Inspired by Adolph Menzel in both content and style, *Aufbahrung der Märzgefallenen I* (The Public Viewing of Those Who Fell in March I, fig. 1.8) focuses on a woman in a crowd who leans over a

wheeled cart carrying a coffin. The men in top hats and suits pulling the cart have stopped momentarily to allow the woman a moment of grief; others attempt to hold back the writhing crowd, in which umbrellas and rifles can be seen. Ostensibly, this print—and the others in the series—is about mourning those who died in the 1848 revolution. When interpreted within the historical and social moment in which they were created, however, these works become a reflection upon the uprising that took place in East Germany in 1953. Unlike the revolutionaries in 1848, the protesting East German workers who died did not receive a hero's burial. By drawing his content from an event in the past, Heisig was able to address a taboo issue in the present, express sorrow at the loss of life—and of the ideals of Communism—and offer a comparison that raised interesting questions about the present.

In 1956, Heisig published a five-page article in *Bildende Kunst* titled "Junge Künstler in Leipzig" (Young Artists in Leipzig). In it, he explained his understanding of art—the distinction between subject matter and meaning described above—and criticized the ossified and isolated nature of art in the GDR. He pointed out that most young artists then working in Leipzig were trained at the Leipzig Academy but added that "beyond the usual collegial contacts, there is little overlap among artists, and groups with similar artistic views are not to be found."[66] He blamed this condition on the "starre Struktur" (rigid structures) of the Verband Bildender Künstler (Union of Visual Artists), the national organization that coordinated all aspects of artistic life in the GDR.[67] With its headquarters in Berlin, the Union of Visual Artists had local branches in each of East Germany's districts that took care of everything from determining art policy—in consultation with the party—to organizing exhibitions and helping struggling artists by offering them commissions. To be a practicing artist in East Germany, one had to be a member, which usually required having a degree from one of the four main art schools.[68]

In addition to the limitations he saw stemming from the Union of Visual Artists, Heisig also saw the official art exhibitions—such as those he had been writing about—as sending artists down the wrong path because many were starting to paint for the exhibitions rather than from conviction. Due to their large scale and the political importance placed upon them, these official exhibitions, according to Heisig, tended to level the quality of art shown. Heisig had complained about this already in his first article two years earlier, where he pointed out that Heinz Plier's "unlively, schematic, [and] wooden" painting, *Heinrich Heine Visiting Karl Marx*, had been allowed into the exhibition largely because of its subject matter.[69]

As a corrective, he called for "a number of smaller, more objective exhibitions with fewer commitments [that would] encourage youth to be more open and experimental. That might even help to create an artistic atmosphere that would make the adventure of art lively again instead of just an exercising of rules."[70] He then stated that the goals and wishes of most artists were to be left alone for a few years to work without restriction.[71]

In all these articles, Heisig expressed his commitment to raising the level of art in East Germany and portrayed art and society as inseparably linked. He also argued for the freedom to experiment and urged artists to take control and fulfill their responsibility to society. For a man who had dropped out of art school only a few years earlier and had not yet had any works accepted into the German Art Exhibition in Dresden, he demonstrated surprising self-confidence in these articles, which leveled criticism at both his colleagues and the system itself.[72] Moreover, he called upon the younger generation (himself included) to take the lead in artistic matters, depicting the older generation as part of the problem.[73]

Whereas one might expect him to have gotten in trouble for such views, the opposite seems to have been the case: in 1956, Heisig was elected chair of the Leipzig branch of the Union of Visual Artists (VBK-L).[74] This made him—then thirty-one years old—the first of a younger generation of artists to hold this position in Leipzig.[75] It was also in this year that he took part in a small, artist-organized *Atelier-Ausstellung* (Studio Exhibition) in Leipzig, the very type he had been calling for in *Bildende Kunst.*[76] This juryless exhibition included approximately 150 paintings and graphics by fifteen artists between the ages of thirty and forty, three of whom were from West Germany. The works shown ranged from conservative realism to abstraction, with Heisig contributing an expressive black-and-white lithographic self-portrait. According to Heisig, the intention behind the exhibition was to "escape the certain leveling [that takes place] in the official exhibition business," to create a more intimate atmosphere that, according to the catalog, would encourage "tolerance" and a "fruitful interaction" among the artists.[77] Such exhibitions, he stated, would help to "activate our artistic life," and he encouraged others to follow their example.[78]

De-Stalinization, 1956–59

Few documents survive from Heisig's first three years as chair of the VBK-L. Presumably he spent a lot of time in meetings—with artists, political functionaries, and politicians—and fulfilling other bureaucratic duties. He may

also have been responsible for organizing the Fifth District Art Exhibition in Leipzig in 1959, for which he wrote the introduction to the catalog: in it, he emphasized the exhibition as an important step toward "einer neuen Blüte der Künste" (a new flowering of the arts). He was certainly on its jury. He also wrote the introductory text for *Reise Skizzen aus China* (Travel Sketches from China), a small exhibition of his former teacher and friend, Walter Münze, emphasizing the importance of artistic exchange between the two countries and the "imponierende Arbeitsleistung" (impressive artistic achievement) evident in the exhibited work.[79]

In these years, Heisig also continued to teach at the Leipzig Academy, having been promoted to *Dozent* (lecturer) in 1956.[80] The following year, he became one of seventeen members of a new board set up by the Rat des Bezirkes Leipzig (RdB-L, District Council of Leipzig) for the distribution of cultural funds to local artists.[81] Then in 1958, he exhibited *Meine Mutter* (My Mother), a pencil drawing, at the Fourth German Art Exhibition in Dresden; it was the first time he showed work in this prestigious exhibition. Heisig also painted several portraits in 1958, although he did not exhibit any of them at the time. In *Bildnis Gertrude Skacel* (Portrait of Gertrude Skacel, 1958, fig. 1.9), an older woman with white hair leans back against a chair and stares at us with crossed arms and legs. A piano emerges from behind her, suggesting her occupation. This painting, the most experimental of Heisig's portraits from these years, reflects a darker tone and looser style than that evident in his history paintings, and it suggests an engagement with Velazquez and Menzel. In addition to impasto throughout the work, drips of white paint appear on the woman's black skirt, and swathes of unpainted canvas appear in the lower right-hand corner. That same year, Heisig also created a painting of himself (*Selbstbildnis*, 1958, fig. 1.10), which survives as a black-and-white photograph. In a simplified but more finished style, it shows the young artist, tall and thin, standing before his canvas with paintbrush raised. He looks at us from haunted eyes and a clean-shaven face.[82] Behind him, an abstract painting by the West German artist Heinz Prüstel appears on the wall; Prüstel had shown this work in the studio exhibition two years earlier.[83]

Although the specifics of Heisig's work in the VBK-L during these years are not known, it must have been a challenging time to hold such a position. Shortly after he became chair, the cultural relaxation of the New Course ended. This change was largely the result of a series of events set off by Nikita Khrushchev's famous de-Stalinization speech at the Twentieth Congress of the Soviet Union's Communist Party in February 1956. In this speech, Khrushchev, the first secretary of the Communist Party of the

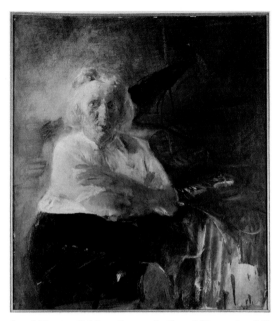

Figure 1.9. Bernhard Heisig, *Bildnis Gertrude Skacel* (Portrait of Gertrude Skacel), 1958. Oil on hard fiber panel, 80 x 71 cm. © 2018 Artists Rights Society (ARS), New York / VG Bild-Kunst, Bonn. Photo: SLUB / Deutsche Fotothek.

USSR, denounced Stalin's crimes, forcing a reassessment of the cult around Stalin that had persisted after his death three years earlier. Initially, this speech led to revisionist discussions throughout the Eastern bloc and the desire for "Socialism with a human face." In the GDR, many Communist intellectuals, especially in the universities, began to criticize more openly the repressive methods of governing employed by the East German state under Ulbricht. They called for academic freedom and for the freedom to have open discussions without fear of punishment. Critical of Stalinist methods, they wanted to reform Socialism and give it a human face; in short, many wanted a "third path" between Stalinist Communism and Western capitalism.[84]

Whereas many East German intellectuals, including within the party itself, welcomed Khrushchev's speech and the new path it suggested, it came as an unwelcome surprise to the hard-liners of the party, including Walter Ulbricht, whose dictatorial power was undermined by it.[85] The topic of de-Stalinization was barely addressed at the SED's Central Committee the following month. Then in June, Ulbricht tentatively began to encourage

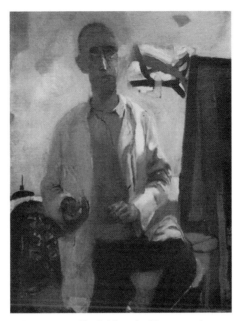

Figure 1.10. Bernhard Heisig, *Selbstbildnis* (Self Portrait), 1958. Oil, 100 x 70 cm. © 2018 Artists Rights Society (ARS), New York / VG Bild-Kunst, Bonn. Photo: Rolf Lotze.

discussions along the lines of the Twentieth Congress. By August, however, he was discouraging such talks, fearing a loss of control.[86]

With the Hungarian Revolution in October/November 1956, Ulbricht was able to reestablish a firm grip on East Germany. Khrushchev, who sent in Soviet tanks to quell the uprising—as the Soviet Union had done for the uprising in East Germany three years earlier—was no longer open to experimentation and was thus willing to support Ulbricht's conservative stance.[87] Ulbricht made his position on the issue of reform clear in December 1956, when he stated in the party's main newspaper, *Neues Deutschland*, "The most important lesson we can learn from the events in Hungary is that there is no third path!"[88] This was followed by a crackdown on revisionism that led to show trials and the imprisonment of committed Communists who had supported a revisionist platform, like Wolfgang Harich (1923–95) and Walter Janka (1914–94).[89] By the beginning of 1958, opposition within the SED had been quelled.

This crackdown in the political realm was accompanied by a new freeze in the visual arts. Perhaps the first significant sign of this change

at the national level was the removal of Herbert Sandberg as editor of *Bildende Kunst* between the May and June issues in 1957; an artist himself, Sandberg had allowed articles about Picasso to be published in the magazine in the mid-1950s. Four months later, in October 1957, the SED held a cultural conference in Berlin titled "Im ideologischen Kampf für eine sozialistische Kultur" (The Ideological Fight for a Socialist Culture). It introduced a new, harder position in the arts in which modern art, including expressionism, was rejected. It also announced Alfred Kurella—an important figure for artists in Leipzig—as head of the Kulturkommission (Cultural Commission) of the Politbüro, thus making him the most influential cultural functionary in the GDR until he left office six years later in 1963.[90] Then in December 1957, the relatively modern art shown at the District Art Exhibition in Halle was attacked by party officials in what some have called the next stage in the Formalism Debates.[91] An article about the exhibition published in *Neues Deutschland* the following month criticized the lack of engagement with current issues and especially the emphasis on "formal experiments" before ending with a statement similar to Ulbricht's a year earlier: "There is no 'third' way. . . . There is only a for or against Socialism!"[92]

Over the course of the next few years, art publications and official proclamations emphasized the importance of the Soviet Union and Socialist life as models for art. The results of this can be seen in the catalog for the Fourth German Art Exhibition, held in Dresden in the fall of 1958. The images are innocuous and illusionistic, albeit showing slight traces of postimpressionist brushwork and a Gauguin-like reduction of details. There are portraits, still lifes, and landscapes, but history paintings are notably lacking. The focus is instead on the everyday, which perhaps explains why this exhibition was deemed a disappointment even by Ulbricht, who was looking for a new Socialist art for East Germany.[93]

The desire for a specifically Socialist type of art and the inability to predict what form it would take was an ongoing problem in the GDR. No one could say what the new Socialist art should look like since it had not yet been created, although politicians and conservative cultural functionaries claimed to know what it was not: anything related to modern art. Instead of giving artists the freedom to experiment with modern styles in their search for something uniquely Socialist, and thus to assume the responsibility to society the government proclaimed they had, officials fell back instead on the Soviet model. And yet the results—as with the Fourth German Art Exhibition—were increasingly unsatisfactory for artists and politicians alike.

The Bitterfeld Way, 1959

In April 1959 a major cultural conference held in Bitterfeld, just north of Leipzig, established the view on art that would dominate official cultural discussions for years to come. The Bitterfeld Way called for artists—as well as writers—to work in factories to better understand the workers they portrayed, and for workers to try their hand at creating art and serving on selection committees for exhibitions. Although implemented from above, many of the ideas behind the Bitterfeld Way originally came from below. In the immediate wake of the Second World War, several Communist artists in Halle, for example, banded together as Die Fähre (the Ferry), a group that combined artistic experimentation with the motto "Maler in den Betrieb!" (painters into factories!).[94] The intent was to bring artists and their public closer together, an approach that stood in sharp contrast to that being taken in the West, where an emphasis on art for art's sake tended to alienate the general public.

In December 1959, Heisig praised the Bitterfeld Way as a positive development in a speech he delivered, as chair of the VBK-L, at the Fourth Congress of the national Artists Union.[95] These congresses, which took place roughly every four to five years and brought together artists and cultural functionaries from around the country to discuss important issues in art, generally lasted three days, each of which was filled with speeches.[96] In his speech at the Fourth Congress, Heisig attacked the dogma of artistic "laws" that had been taken from late bourgeois modern art, explaining that the emphasis on formal issues—such as flatness, color, line, and the relationship of forms to each other—to the exclusion of subject matter (in the traditional sense) had led to the crisis currently being experienced in the Western system. In particular, he noted, it had led to the alienation of the artist from society. According to Heisig, the snobbish art press in the West mystifies artists and their work, setting them up as loners whose art can only truly be understood in the future. From this idea, he continued, the thought developed that the artist is working for the future rather than the present, and, from this, it was not long before one started to believe that any art that is approachable—let alone liked by the masses—is to be mistrusted.[97] Heisig went on to explain that it was clear that

> from this position, the laws of art are sought out only in the ontological realm. From Impressionism came Expressionism; from Cézanne, Cubism, etc. The societal component was, because of the emphasis on intellectual individuality, an abstraction. From here the way led logically and carefully through many exciting shades and interesting varieties to

artistic suicide, where, after the masterful and artistically prescribed de-
molition of appearances, the artist is left horribly alone without a societal
purpose, and forced by the iron logic of his role, is no longer able to por-
tray the human being.[98]

According to Heisig, Socialism had put the brakes on this "artistic
suicide" early enough to prevent it in the East by giving artists a socially
directed mission—reaching the people. It was nonetheless difficult, since
many artists in the GDR had grown up with these so-called laws, which
continued to hold sway over many of them. He pointed out that "we are at a
point where we need to clarify what art is for us, or more precisely, what art
can be based on societal experience."[99] He then stated that "the gratifying
order that shines through in the greatest masterpieces of art [from the past]
and keeps them alive is primarily a result of their ideological relationship
and not . . . [because] of rules and laws in the abstract. The surface . . . is
not an abstraction. It is not there for itself, but rather is a kind of analogy
to reality for the artist."[100]

Heisig explained that he was pointing all of this out in his speech
because he believed that the "Gesetze der Kunst" (laws of art) had become
a kind of fetish for many artists in East Germany and were threatening to
hypnotize them in a dangerous way.[101] He admitted that had been the case
for him as well.[102] But, as he explained it, the rules of flatness so proudly
proclaimed by architects today, those that forbid any sense of "perspektival
Raumwirkung" (perspectival space) because it would damage the flatness
of the wall, are not the same rules to which Raphael, Michelangelo, Tiepolo,
or virtually any other mural painter adhered.[103] According to Heisig, this
"ontological" view of art had led to the tragic situation that artists faced in
the West, and it could be prevented in the GDR "only with a decided turn
away from repeated dogmas and laws."[104]

For the final few minutes of his speech, he turned his attention to
teaching in the art academies, stating that a good teacher is the result
of both artistic skill and ideological commitment. Having only one or
the other is not enough. He then suggested that the hiring policy at the
academies be more transparent and that the Union of Visual Artists play
a role in these choices (rather than leaving it to the politicians), before
ending with the following statement: "We should attempt to solve our
problems objectively and without prejudice, and above all we should
work together in the knowledge that what we, as visual artists in society,
want to portray will be found in proportion to what we have to offer."[105]

This speech reveals that Heisig was committed to the collapsing of
the distance between life and art as proposed by the Bitterfeld Way and to

artists playing an active role in society. In fact, Heisig seems to have played an important role in spreading the Bitterfeld Way's message to the younger generation of artists in Leipzig, as is suggested by official reports from the time and from nomination letters for the awards he received.[106]

Although the Bitterfeld Way has been denigrated in the West, where criticism has focused on the many works of low quality that it produced and the narrowness of cultural politics that resulted, its basic principles were embraced by many East German intellectuals, including Heisig.[107] It also defined East German art in its wake and contributed ultimately to the creation of many of the works that are now praised in the West. It did so in two ways. First, it educated the masses about art, creating a larger and more discerning audience, which enabled painters like Heisig to shift from a simple, easy-to-understand realism to more artistically and intellectually challenging works.[108] Second, its emphasis on collapsing the distance between life and art helped artists to avoid what Heisig termed the "artistic suicide" taking place in the West, where the emphasis on artistic autonomy had isolated artists from society and taken away their purpose.[109] Instead, the Bitterfeld Way charged artists to make their art relevant to the people, a principle that Heisig—among others—adhered to at least until 1989, if not longer.

A Controversial Director, 1961

In May 1959, just a few months before his term as chair of the VBK-L ended, Heisig was given a diploma in graphics from the Leipzig Academy, the result of a new regulation that required university teachers to have a higher degree.[110] The following year, the school leadership recommended he be promoted to the level of professor and become *Prorektor für Studienangelegenheiten* (head of academic affairs).[111] In the formal justification for these requests sent to the Ministry of Culture in Berlin in November 1960, Albert Kapr, as director of the Leipzig Academy, stated that "Heisig's pedagogical work is extremely successful and fruitful. In addition to a course in free graphics, he teaches a foundations course. . . . It is thanks to his untiring work that drawing is a particular strength of the Leipzig Academy."[112] Kapr then pointed to the success of Heisig's students in competitions and exhibitions, and to his active participation in the art scene in Leipzig. Recalling an evaluation made by Alfred Kurella, Kapr stated that he, too, considered Heisig to be "one of the most talented younger artists of the republic."[113]

On January 1, 1961, Heisig became head of academic affairs; he was promoted to professor eight months later.[114] In the time between these two appointments, the leadership of the school discussed who would replace Kapr as director when his two-year contract ended that summer. Archival files suggest that initially the school leadership wanted to nominate Hans Mayer-Foreyt (1916–81), who was a teacher and head of the foundations course, but in a meeting held in April 1961, Mayer-Foreyt essentially declined the nomination.[115] After further discussion, the thirty-six-year-old Heisig, who was nearly ten years younger than Meyer-Foreyt, agreed to be the next director. In May, the party leadership approved this decision, and, in August, Heisig received official confirmation from the Ministry for Culture in Berlin.[116] The suddenness of his appointment is apparent from a letter sent by Kapr to the Ministry of Culture in August urging them to confirm Heisig's appointment as professor before he became director on September 1.[117]

Apparently the party leadership neglected to inform the Leipzig branch of the SED, however, an omission for which it was criticized in a meeting held on October 13, just a few weeks after the wall began to be built in Berlin.[118] Representatives of the SED-L expressed reservations about Heisig and asked for an explanation of why the party leadership at the school had chosen him. Erwin König, head of Gesellschaftswissenschaft (social sciences) and a former director of the Leipzig Academy, acknowledged that "we knew it would not be easy to work with him" but pointed out that there were directors at other art schools who were not even in the party.[119] The reason why Heisig might have been difficult to work with was not mentioned but presumably related to his temperament: Heisig was not someone who simply did what he was told. There may have also been some question about his political reliability. König further defended him by stating that although Heisig still had some weaknesses, he had shown a thoroughly positive development over the past few years. Indeed, according to König, they would probably soon all be "im Schlepptau des gen. Heisig" (riding on comrade Heisig's coattails).

The SED-L's reservations about Heisig may have been caused by a letter he sent to a lawyer in the small town of Bischofswerda, near Dresden, less than three weeks after becoming director. In the letter, dated September 20, Heisig defended an applied arts student from the Leipzig Academy who had gotten into trouble with the law for ripping down an election poster.[120] He described the student as quiet and hardworking and stated that his actions were probably not an attack against the party, as was the charge, but rather those of a student who had simply gotten drunk and—upset by

the "künstlerische Mängel" (artistic shortcomings) of what was "clearly a very bad example of commercial art"—impulsively ripped it down.[121] The student was later acquitted of the charges at the state level, although he and three students who were with him had to face a disciplinary hearing at the Leipzig Academy.[122]

The SED-L saw Heisig's letter as an attempt to trivialize an important matter: student drinking, which they believed reflected poorly on the school and, thereby, on Socialism, which was a particularly sensitive subject at the time because of the recent building of the wall.[123] They warned the party leadership at the school that if Heisig continued in this vein, he would run into trouble: "If Comrade Heisig continues to pursue such a line as in the letter, he will come into conflict with the party, [and] then we will have to initiate proceedings [Parteiverfahren] against him."[124]

Heisig, too, had to explain himself. In a meeting of the Leipzig Academy's party leadership and the SED-L on October 17, Heisig told the committee that he did not know the student personally, but, "assuming he was fully drunk, I tried to help him not completely botch up his life with a dumb matter [Angelegenheit], if it is one."[125] He pointed out that the contents of his letter were based on discussions with both Gerd Thielemann, the new party secretary at the Leipzig Academy, and the senate at the school but that he had formulated it badly. Nonetheless, he continued, he did not understand why this was an issue now, six weeks after the fact, especially since he had shown the letter to Thielemann shortly after it was sent. Thielemann responded that he had only glanced at the letter, an inattention that he regretted in retrospect.

In response to the SED's concerns about the student's actions reflecting poorly on East Germany, Heisig stated that they needed to be careful not to exaggerate the problem. He saw the destruction of the poster as a singular event resulting from student drinking and pointed out that their reputation as a result was no worse than those of the other art academies in Berlin, Dresden, and Halle. Indeed, he saw *Dozenten* (lecturers), not students, as the greater issue to be address, citing one faculty member who had gone on vacation without notice and others who focused on art alone rather than including the party's perspective in their teaching. "One can't expect discipline from students when one is not prepared to do the same."[126]

This conflict so early in his tenure as director of the Leipzig Academy reveals Heisig's willingness to take on political functionaries when he disagreed with them—in this case, in the defense of a student—and his ability to navigate politically heated situations. It also illustrates an important aspect of his position: as director, Heisig regularly had to deal with

student issues like this one and the various organizations and personalities involved. He also dealt with the daily operations of the school. These included writing official reports and letters, as well as promoting, disciplining, and paying teaching staff. Archival files reveal mundane letters—like requests for a replacement car for the school and a thank-you letter to a nearby institute for allowing faculty to eat there—next to substantial reports about the school's ideological situation.[127] Heisig also had to give speeches at national meetings and entertain foreign artists visiting the city. He did all of this while also teaching and creating his own art.

In recognition of his hard work, Heisig was awarded a Medal for Outstanding Achievement on May 1, 1963; it was the fourth time he had received this award since 1955.[128] A few months earlier, in October 1962, the leadership of the Leipzig Academy (*Hochschulleitung*) recommended that he be given tenure (*Einzelvertrag*).[129] In the justification, they stated that he was committed to improving the methods of education and to conveying a comprehensive knowledge and skill set to his students. His class "is one of the strongest in the school."[130] They also pointed out that, since becoming director in September 1961, he had performed with "the greatest readiness for action," striving "to promote true talent and to aim at top achievement for the whole school."[131]

In the course of just sixteen years, Heisig had gone from being a twenty-year-old prisoner of war under the Soviets to being a highly praised teacher at and director of the Leipzig Academy, a prestigious institution within the East German art world. At thirty-six, he was the youngest person to hold this position. He had also been the first of a younger generation to chair the local branch of the Union of Visual Artists a few years earlier. Yet Heisig was not universally liked. He was a vocal figure who was forthright in his criticisms—as evidenced in his articles in *Bildende Kunst*—and stood up for his beliefs. Views of him at the time were divided largely between those of artists on the one side, who tended to see him positively, and those of conservative cultural functionaries and politicians on the other, many of whom did not. This is a division that continued throughout the Ulbricht era: some praised Heisig as a great artist, others criticized him for being a troublemaker. The next chapter looks at the first of four major conflicts Heisig had in the 1960s.

ART FOR AN EDUCATED NATION

O n August 13, 1961, construction began on the Berlin Wall. Although viewed in the West with almost universal horror and disdain as the symbol of a dictatorship gone wrong, one in need—quite literally—of walling in its own people, the wall had a more complicated reception in East Germany, where many intellectuals, including Heisig, saw it as a necessary evil, the only way to save the "better Germany," which had been in danger of collapsing in on itself as a result of the loss of skilled and educated workers across the border.[1] In the year before the Berlin Wall was built, nearly two hundred thousand citizens had left East Germany.[2] The higher ideals of the self-proclaimed anti-fascist East were no match for the lure of the materially prosperous West.[3]

The building of the Berlin Wall marked a new phase in the history of East Germany, one in which the SED turned away from the idea of reunification and attempted to establish the country's identity as a Socialist nation. It also marked a shift in the East German art scene to a younger generation of artists and, ultimately, to a more modern style. Many artists, even some from the older generation, believed that the wall, by eliminating the immediate threat of the West, would enable them to take more chances with their work. And some began advocating for an art based on German rather than Soviet precedents.

Just two weeks after construction on the wall began, Heisig became director of the Leipzig Academy, a position he held until 1964. It was during these years as director that Heisig began showing paintings in major exhibitions in East Germany and that his style started to change toward

the complex, modernist aesthetic for which he is now known. It was also at this time that he began to clash with politicians and cultural functionaries in a number of high-profile conflicts. Before the 1960s were over, he would be at the center of at least four major controversies, the first of which took place in the spring of 1964, just shortly after he resigned as the director of the Leipzig Academy.[4]

Focusing on the years 1961–64, this chapter begins by situating Leipzig within the larger art world of East Germany before turning to the Sixth District Art Exhibition in Leipzig. "The Sixth," which opened in November 1961, marks Heisig's emergence as a history painter onto the East German art scene. It was also an important moment in the development of painting in Leipzig. Organized by Heinrich Witz (1924–97), a friend and colleague of Heisig's, the exhibition was praised by cultural functionaries and politicians alike for its conservative realist style, which they held up as a model for artists throughout East Germany. Many artists, on the other hand, disagreed with the politicians' assessment and, in particular, with the inordinate praise that Witz's paintings received, finding that, whatever their political value, these works lacked artistic merit. In the wake of this exhibition, many of the younger artists in Leipzig, including Heisig, turned away from the conservative realism displayed there and began to develop a modern style that would first become visible at the Seventh District Art Exhibition four years later.

Witz's meteoric rise and sudden fall reveals some of the political and aesthetic challenges that artists faced in East Germany in the early 1960s. His career also offers an illuminating contrast to Heisig's. The second half of this chapter shows how Heisig successfully negotiated the fluctuating cultural politics of the era as the debates that had marked cultural policy in the late 1940s and 1950s intensified in the wake of the building of the wall, dividing artists and art historians on the one side from politicians and conservative cultural functionaries on the other in the struggle to define and create a uniquely East German art.[5] The chapter ends by looking at the impact of one such debate—the one around Heisig's speech at the Fifth Congress—on his painting style.

Leipzig Art in Context

In 1952, the SED divided East Germany into fourteen *Bezirke* (districts) plus Berlin. Four of the districts—Berlin, Dresden, Leipzig, and Halle— had art academies, making them the most important centers for art in

the GDR. The SED assigned each of these academies a pedagogical focus based on the historical strength of the area. Berlin and Dresden became centers for painting. Leipzig, known for publishing and its annual book fair, emphasized graphics and book arts. Halle, as a former home to the Bauhaus (in Dessau), focused on the applied arts and industrial design.

Although not intended as a center for painting, Leipzig nonetheless emerged early on as the unofficial center of socialist realism at the Third German Art Exhibition in Dresden in 1953, where paintings like Klaus Weber and Harald Hellmich's *The Youngest Fliers* (see fig. 1.4) were highly praised in the press. According to an article in *Neues Deutschland*, "The young artists have learned from the masters of Soviet painting and created a work full of optimism that embodies the passionate striving of our youth."[6] Without a well-established tradition of painting, and especially of modern painting, to stand in the way, Leipzig was particularly well suited for the implementation of a political style of art based on the Soviet model. Kurt Massloff at the Leipzig Academy and the conservative politician Paul Fröhlich—a friend of Walter Ulbricht's—in the local branch of the SED contributed significantly to the emphasis on politics and illusionism in Leipzig in the 1950s. Similarly, Alfred Kurella, who had worked in Leipzig for several years before becoming head of the Cultural Commission in the Politburo, was personally invested in its art and in a realism based on Soviet models. The result was that even in the cultural thaw of the mid-1950s, there was relatively little artistic experimentation among artists in Leipzig: illusionism continued to dominate the paintings produced there.[7]

When placed in context, we can see why politicians were so pleased with Leipzig in these years. In sharp contrast to Leipzig, Halle was a center for modern art throughout the 1950s as exemplified in paintings like Willi Sitte's *Raub der Sabinerinnen* (The Abduction of the Sabine Women, 1953, fig. 2.1). The flatness and fractured forms of this painting clearly draw upon the work of Picasso, Fernand Léger, and Renato Guttoso to tell the story of the first Romans who, lacking women, held a festival and then forcibly took the women who attended as their brides. Sitte (1921–2013), a teacher at the Hochschule für industrielle Formgestaltung Halle, Burg Giebichenstein (Halle Academy), since 1949, had been experimenting with modern art since the late 1940s. In the more relaxed atmosphere of the mid-1950s, he received the Art Prize of the City of Halle twice, although for more traditional works, and published an article in *Bildende Kunst* in 1957 in which he declared that "the field of painting, in particular, must become a battleground for passionate arguments about artistic problems that will enable us to rediscover our courage for artistic experimentation."[8]

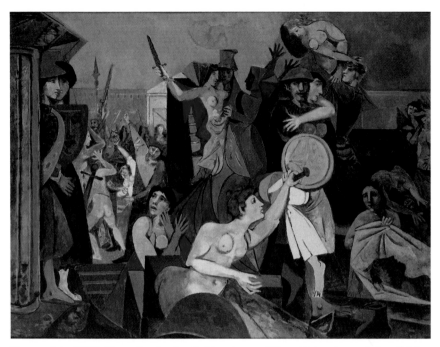

Figure 2.1. Willi Sitte, *Raub der Sabinerinnen* (The Abduction of the Sabine Women), 1953. Oil on fiberboard, 126.5 x 165 cm. © 2018 Artists Rights Society (ARS), New York / VG Bild-Kunst, Bonn. Nationalgalerie, Staatliche Museen, Berlin, Germany (Inv. A IV 333). Photo: bpk Bildagentur / Nationalgalerie, Staatliche Museen, Berlin / Jörg P. Anders / Art Resource, NY.

He also suggested the Italian realists as a model for East German artists and emphasized the importance of contemporary themes. With the freeze in cultural policy that set in after Khrushchev's de-Stalinization speech, however, Sitte found himself again at the center of criticism. In 1957, he and others in Halle were castigated for the modernist works they exhibited at the District Art Exhibition in Halle and Magdeburg that December.[9]

In 1960, Berlin joined Halle as a "trouble spot" for modern art when the Galerie Konkret, an artist-organized exhibition and sales space, opened in Berlin with a small exhibition of fourteen young artists, including Harald Metzkes, an artist who, like Sitte, had experimented openly with Picasso's style in the mid-1950s.[10] Organized and partially funded by the highly celebrated sculptor and committed Communist Fritz Cremer (1906–93), the gallery was closed down a few months later, viewed by the Stasi as a "hotbed [*Keimzelle*] of a protest against the cultural politics of the SED."[11]

Undeterred by the closure, Cremer began work on a similar exhibition for the following year, this time at the Academy of Arts in Berlin. *Junge Künstler—Malerei* (Young Artists—Painting), which opened in September 1961, brought together work by a new, younger generation of artists—the average age was thirty-three—from across East Germany, including several of those from the Galerie Konkret exhibition the previous year.[12] Like the earlier exhibition, this one was heavily criticized and ultimately closed early.[13] In a report to the Politburo in November 1961, Siegfried Wagner, head of the Culture Department of the SED at the national level, stated, "Most of the images in this exhibition demonstrate . . . a rejection of Socialist art politics and with it, the Bitterfeld Way. . . . [T]heir creators deny the leading role of the Party in the realm of art. . . . They do not honestly engage with realistic art of the past and present . . . [but rather] orient themselves to Western art. . . . [M]ost of these artists have not recognized their responsibility to society."[14]

In contrast to the exhibition in Berlin, Wagner held up the Sixth District Art Exhibition in Leipzig as a positive counterexample, praising it for its "decided encounter with life." The Sixth in Leipzig was more than just an exhibition of conservative realist art, however; it was also an exhibition that explicitly aligned itself with the cultural politics of East Germany. In the two-page introduction to the catalog, Heinrich Witz, the organizer, cited important precedents, including the Fifth Party Congress of the SED and the Bitterfeld Way. Like them, he wrote, the Leipzig exhibition emphasized the importance of a close relationship between artists and workers, and the need to overcome the distance between art and life—and between artist and viewer—that had developed in capitalist society. He also emphasized the important role artists should play in the development of East German society—in clarifying important questions about Socialist life and socialist realism, helping to create the new Socialist people, and securing peace: art "can testify to the victoriousness of Socialism . . . and to the triumph of all true humanistic thought in the image of the new Socialist person."[15]

But Witz did not limit his comments to the cultural realm: halfway through the introduction, he explicitly confirmed Leipzig artists' commitment to East Germany, Communism, and the Soviet Union, stating that "if no blood flows in Germany in these autumn days, if there is peace, then it is the result of the resolute politics of the peace-securing Soviet Union, the other Socialist countries, and the decided actions of our government on August 13, 1961," the day that construction started on the Berlin Wall.[16] He ended with the hope that Leipzig's workers would view the exhibition and know that "the visual artists in Leipzig want to contribute actively . . . to the

completion of the building of Socialism in our Republic."[17] In the two-page introduction, Witz thus explicitly confirmed Leipzig artists' support of the East German government at a moment—just weeks after the Berlin Wall began to be built—when it was vulnerable to attack, and at a time when artists in other regions of the country were challenging the party's cultural views.

Witz was not working alone when he wrote this introduction. Rather, he was speaking for a group of young artists, including Heisig, who had been meeting informally at the Ringcafé in Leipzig for years to discuss the artistic situation in East Germany and their plans.[18] Several had shown work together at the studio exhibition in 1956, which they had initially organized without the VBK-L's permission.[19] The core members of this informal group can be seen in a painting shown at the Sixth, Harry Blume's *Gruppenporträt Leipziger Künstler* (Group Portrait of Leipzig Artists, 1960/61, fig. 2.2).[20] The five young artists appear in front of a large canvas—its back toward us—and confidently meet our gaze as if we have just entered the room. Heisig, in a yellow jacket and dark shirt, crosses his arms just to the left of center. To his left sits Werner Tübke in front of the canvas. The bespectacled Hans Meyer-Foreyt, the oldest of the group—he was born in 1916; everyone else in the 1920s—leans on the back of Tübke's chair, cigarette in hand. Witz, with his left hand in his pocket, looks over his shoulder at us, while Blume stands in the background, holding a cigarette up to his mouth. A table with fruit and a vase of flowers separates these men from us, while the canvas separates them from the only other figure in the room, a nude woman.[21] She leans on her right hand, a white cloth draped across her legs at the far left of the image. Through the window behind her, the large tower of Leipzig's New City Hall appears beneath a cloudy sky.

According to Anneliese Hübscher, Heisig's assistant at the Leipzig Academy in the early 1960s and an art historian there for many years before that, "Witz was the first who actually said, 'we can't leave the union's politics, the politics of art, . . . to the functionaries. . . . We must take cultural policies into our own hands.' In other words, I will now paint works that are interesting for the party, but I will determine the party policies of the union [the Union of Visual Artists]."[22] Witz proved his point when, in 1959, he earned national attention for his painting *Der neue Anfang* (The New Beginning, 1959, fig. 2.3). Finished in a conservative socialist realist style, the work depicts two brigade leaders in suits shaking hands over a table at a festive social gathering.[23] Well-dressed men and women look on from their seats, while champagne bottles and glasses wait for the toast to come. It is an image that stresses the fruits of collaboration and collegiality,

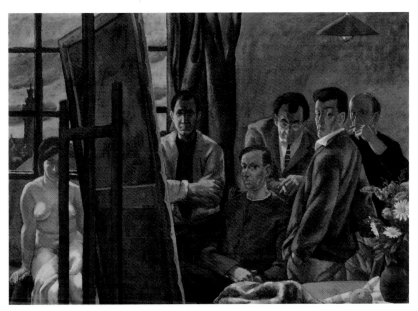

Figure 2.2. Harry Blume, *Gruppenporträt Leipziger Künstler* (Group Portrait of Leipzig Artists), 1960/61. Oil painting, 90 x 125.5 cm. Reprinted with permission of Julia Blume. Photo: bpk Bildagentur / Museum der Bildenden Künste Leipzig / Michael Ehritt / Art Resource, NY.

Figure 2.3. Heinrich Witz, *Der neue Anfang* (The New Beginning), 1959. Oil, 95 x 120 cm. © Heinrich Witz. Photo: SLUB / Deutsche Fotothek.

which were promoted in East Germany as a positive alternative to the individualism pursued in the West. Highly praised by politicians, Witz received several prizes in 1960 for this work, including the Kunstpreis der Stadt Leipzig (Art Prize of the City of Leipzig). He also replaced Heisig as chair of the VBK-L, which made him responsible for organizing the Sixth District Art Exhibition in 1961.[24]

Heisig Emerges as a Painter

The Sixth District Art Exhibition in Leipzig opened just two months after Heisig became director of the Leipzig Academy and marked his emergence onto the East German art scene as a history painter. Before this, he had been primarily a graphic artist, having exhibited only two paintings at the district exhibitions—a color study (*Farbstudie*) in 1955 and a portrait of a female model (*Modellpause*) in 1959—and none at the prestigious German Art Exhibitions in Dresden. At the Sixth, by contrast, he exhibited three oil paintings in addition to an assortment of prints and drawings. All three of the paintings depict an important moment in Communist history and employ a realistic style to depict a group of well-dressed men, women, and children gathered together in an urban environment. The paintings can also be seen as illustrations of Witz's philosophy of art—in particular, in contributing to the development of East German society by clarifying important questions about Socialist life and socialist realism—as declared in the exhibition catalog.

In *Die Geraer Arbeiter am 15. März 1920* (Gera Workers on March 15, 1920, 1960, fig. 2.4), Heisig depicted a crowd of people gathered in the city's center. They stand and watch as a group of approximately ten figures, most wearing helmets, are carted off to jail. The prisoners were part of the Kapp Putsch, which took place in cities throughout Germany in 1920, an attempt by right-wing militants to overthrow the fledgling democracy of the Weimar Republic. With hands raised, the captured revolutionaries step down from a military vehicle at the right side of the painting and walk toward the left through the crowd of which we, the viewer, are a part. Some of the figures sneer or heckle; one turns to look at us as if we have just arrived on the scene. And yet the downward perspective of our gaze suggests that we ourselves might be stepping out of a vehicle. This perspective complicates our relationship to the scene depicted, since we cannot be certain of our own moral position within it: Are we among the militant or the figures who push them forward?

Figure 2.4. Bernhard Heisig, *Die Geraer Arbeiter am 15. März 1920* (Gera Workers on March 15, 1920), 1960. Oil, 100 x 200 cm. © 2018 Artists Rights Society (ARS), New York / VG Bild-Kunst, Bonn. Subsequently destroyed through overpainting. Photo: SLUB / Deutsche Fotothek / Kramer.

According to Hübscher, Heisig was fascinated by the question of what makes ordinary people take up arms for a cause.[25] As she explained it in 2005, "Back then [in the mid-1950s] we had Massloff, who was a [Communist] revolutionary [as the director of the Leipzig Academy], and we had a respectable superintendent [*Hausmeister*] who had been in the Nazi Party. That led him [Heisig] to the question: Why do people become revolutionaries? Why was the superintendent a true servant, and why had Massloff tried to overthrow the system? This psychological problem interested him."[26]

Many of Heisig's canvases from these years show an interest in the question of what makes ordinary people fight. In *Gera Workers*, the theme also appears through the inclusion of the middle-aged, balding man in the bottom center of the painting who, as Heisig explained it, recognizes his son—the youth in front of him with his hands raised—amid those advocating for the putsch. Heisig had heard this story when, in preparation for the painting, he visited nearby Gera to interview people who had been there in 1920.[27] By including this eyewitness account in the composition,

Heisig posed the question of why the son had chosen to support the putsch while the father had not. He also encouraged viewers—through the downward perspective on the scene—to contemplate which side they would have been on had they been there. Through these simple devices, Heisig animated a moment from history, making it interesting and relevant for a contemporary audience and an example of the "passionate resistance" he had written about in 1956.

The "Leipzig Problem" Begins

Despite the official praise the Sixth received, some artists were disappointed with the exhibition and, in particular, with the poor quality of some of the works. This disappointment contributed to a significant change in Heisig's artistic style as well as that of a number of painters in Leipzig—away from the conservative realism lauded by Witz and various politicians to a complex, modern style—in the years leading up to the next district art exhibition in 1965. The Sixth thus marked not only a high point in Leipzig's artistic reception among politicians that had begun with the Third German Art Exhibition in 1953, but also the end of Leipzig as a center for conservative realist painting. Just a few years later, it would join Berlin and Halle as a center for modern art and even supersede them as a focal point for politicians' anti-modernist ire.

The beginnings of this change can be seen in a meeting that took place on January 18, 1962, just five weeks after the Sixth closed.[28] Heisig, Witz, Meyer-Foreyt, Mattheuer, Kapr, and Thielemann, among others, gathered at the Leipzig Academy to analyze the exhibition. The main topic of conversation was the high praise received by Klaus Weber's painting *Chemiezirkel* (Chemistry Circle, 1961, fig. 2.5), which had been purchased by Ulbricht after he visited the exhibition.[29] The painting shows a group of six men and one woman gathered around a table watching as one of the men holds up a Büchner flask, seeming to show the results of an experiment. An article in the *Neues Deutschland* praised the painting, stating that "many workers wanted to take it home with them."[30] Most of the artists in the meeting, in comparison, rejected the work for its illusionist style and lack of a deeper meaning or theme. Heisig stated that content alone should not be the criteria used for evaluating art and argued in favor of getting experts involved. Kapr pointed out that Weber's painting fulfilled a need the masses had at the moment and thus was in agreement with the Bitterfeld Way, but that, in a few years, it would not be enough. There was a general consensus

Figure 2.5. Klaus Weber, *Chemiezirkel* (Chemistry Circle), 1961. Oil, 135 x 98 cm. © 2018 Artists Rights Society (ARS), New York / VG Bild-Kunst, Bonn. Photo: Rolf Lotze / Horst Clauß.

among the artists present about the need to raise the aesthetic level of art in Leipzig.

The questioning of artistic quality that took place in this meeting was presumably encouraged by the sharp criticism that had been leveled at Heinrich Witz by artists and art critics in multiple national publications a few months earlier.[31] The focus of these attacks was his painting *Besuch bei Martin Andersen Nexö* (Visit with Martin Andersen Nexö, 1960, fig. 2.6), which depicts the Danish socialist realist poet in a straightforward realist style. Nexö appears as an older man seated at a table outdoors with a dog at his feet and an umbrella over his head. He reads to the group of adoring, well-dressed, and youthful fans seated around him. Some sit at the table, absorbed in his words; others recline on the stairs nearby. The painting conveys the value of learning encouraged by the Communist government as well as respect for one's elders, but the artistic quality is poor: according to a jury of professional artists who rejected the painting at the time, it was "too big, too romantic, badly painted, and badly drawn."[32] This criticism was echoed in the press. As Hübscher stated it in *Das Blatt* in June 1961, "Almost all of the articles that have looked at Witz's paintings have had the same conclusion: in principle, a good

Figure 2.6. Heinrich Witz, *Besuch bei Martin Andersen Nexö* (Visit with Martin Anderson Nexö), 1960. Oil, 385 x 180 cm. © Heinrich Witz. Photo: Rolf Lotze / Horst Clauß.

approach [and] an honest interaction with the chosen theme—but what bad painting!"[33]

Although initially a catalyst for artists in Leipzig to, in essence, beat the politicians at their own game, Witz became increasingly problematic because of his lack of ability as a painter.[34] The disconnect between politicians' high praise of his work and the criticisms by artists and art critics made some artists in Leipzig, including those in the meeting mentioned above, begin to question the wisdom of following the politicians' aesthetic preferences. Exacerbating the problem was Witz himself, who had apparently allowed the politicians' praise to go to his head. Heinz Mäde, a friend of his at the time, noted years later that "the recognition didn't suit him. I noticed how everything he thought and did became increasingly superficial."[35]

On July 11, 1962, Tübke, Mayer-Foreyt, Blume, and Heisig met with Witz at the Leipzig Academy to ask him to withdraw his painting *Labutin* (1962) from consideration for the national Fifth German Art Exhibition in Dresden that would open a few months later. Like *Visit with Nexö*, this painting exhibited a simple realism and contrived, theatrical composition that his peers rejected on aesthetic grounds. According to notes taken by Witz after the meeting, Tübke—who had replaced Witz as chair of the VBK-L two months earlier—asked him if he was sure he wanted to show the painting, to which Witz replied that it was a dumb question: "Of course I want to show it, otherwise I wouldn't have given the *Leipziger Volkszeitung* permission to publish it."[36] Witz refused to withdraw the work, perhaps

thinking he knew better than his colleagues. He had, after all, received the Art Prize of the City of Leipzig the previous year and was highly praised by Ulbricht and Kurella. In the end, the jury of the exhibition in Dresden had the final say: it rejected the painting.

Just as Witz alienated his colleagues with his increasingly imperious attitude, he also began to make enemies in high places. Keeping exacting records of party policies and conversations, he used these records to point out other people's contradictions and failures.[37] In essence, he angered politicians by holding them accountable. Presumably this is what led one local party official, allegedly, to say to the other artists, "Sacrifice Witz. We can work with the rest of you."[38] A few months later, Witz sent a letter to the SED-L that reveals just how much his position in Leipzig had deteriorated in the preceding year: "I am turning to you about an issue that is causing me grave sorrow and that is extending to my private life."[39] Not learning from his mistakes, however, he then pointed out various artistic policies of recent years that he had adhered to but that the party had not: "I view the lack of implementation of Politburo decisions as the cause [of my current isolation]."[40] A week later, on October 10, 1962, he sent a short and formal resignation letter to Heisig at the Leipzig Academy; it contained no indication that he knew Heisig on a personal level. He then moved to Bernau, near Berlin. After a commission to paint Ulbricht the following year ended in heavy criticism from the Ministry for Culture, he largely disappeared from East German cultural life.[41] Years later, Willi Sitte called Witz a "tragic figure" whose "zeal to conform" was so "dermaßen überzogen" (heavy handed) that in the end the functionaries "let him fall."[42]

Witz's downfall in the wake of the Sixth contrasts with Heisig's rise as a painter at the national level in the same years. In 1962, the jury for the Fifth German Art Exhibition in Dresden selected three of Heisig's paintings for display; this was the same jury that had rejected Witz's work. Before this, Heisig had exhibited only once at this prestigious exhibition, a drawing of his mother at the Fourth German Art Exhibition in Dresden in 1958. In addition to *Gera Workers on March 15, 1920* (see fig. 2.4), and a new painting about the Paris Commune, Heisig exhibited *Weihnachtsabend des Militaristen* (The Christmas Evening of the Militarist, c. 1962, fig. 2.7) at the Fifth in 1962.[43] The latter depicts a bespectacled man in black pants and a light-colored short-sleeve shirt reclining on a sofa or, possibly, a broad armchair. With hands behind his head, he looks at a toy tank sitting on his stomach, the iron cross clearly visible on its side. In the background dance the candles from a Christmas tree, recalling the title of the work. This painting, which demonstrates a significantly looser brushwork than

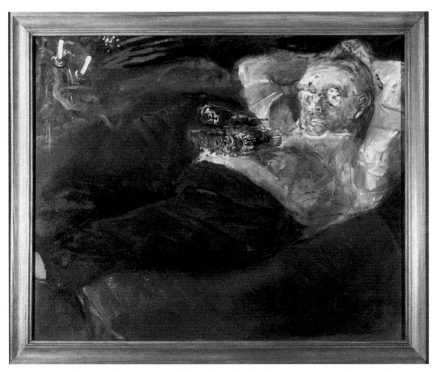

Figure 2.7. Bernhard Heisig, *Weihnachtsabend des Militaristen* (The Christmas Evening of the Militarist), c. 1962. Oil, 60 x 80 cm. © 2018 Artists Rights Society (ARS), New York / VG Bild-Kunst, Bonn. Subsequently destroyed through overpainting. Photo: SLUB / Deutsche Fotothek / Kramer.

his earlier works, marks the very beginnings of Heisig's change to a more modern style.

Even though this was Heisig's first appearance as a painter at the German Art Exhibition in Dresden, he was singled out for praise in two articles in *Bildende Kunst*. In the October 1962 issue, the art historian Joachim Uhlitzsch, who would become director of the Galerie Neue Meister in Dresden the following year, included a half-page illustration of *The Paris Commune* as one of six illustrations for his article, "From the Right Way and the Big Goal, on the Opening of the Fifth German Art Exhibition in Dresden."[44] Then in April 1964, a reprint of a Polish review of the exhibition praised Heisig's work, especially *Gera Workers* and *The Paris Commune*, for their "economical, nearly monochrome spectrum of warm and cold asphalt. . . . [N]o one can walk by with indifference. . . . [T]he carefully chosen, individualized . . . accents of the human faces emphasize

the horrendousness of the situation. I did not find any solutions in the exhibition akin to Heisig's."[45] The Polish reviewer considered them the best paintings in the show.

Controversial Speeches at the Fifth Congress

Less than a year after the Fifth German Art Exhibition in Dresden closed, Heisig resigned as director of the Leipzig Academy. In his resignation letter, dated February 19, 1964, he cited the desire to dedicate himself more intensely to his art as well as health issues.[46] He continued on as a professor, however, and remained active in the Union of Visual Artists. In fact, he was invited a few days later to give a lecture titled "Views of Realism" at the Fifth Congress of the Union of Visual Artists in March 1964.[47] This lecture would end up placing Heisig in the middle of a heated debate about art that resulted in a multi-week investigation into his loyalty to the state and ultimately an official self-criticism, revealing just how easy it was for artists to misjudge the changing cultural situation in East Germany in these years. Indeed, the congress as a whole was considered so controversial that only some of its speeches were published afterward. Those that were left out, together with the investigations that took place after the congress, offer insight into the struggle between artists and politicians over what Socialist art in East Germany should look like.

The Fifth Congress took place in Berlin from March 24 through 26, 1964. It opened with a keynote address by Lea Grundig, who became the new president of the Union of Visual Artists at this conference. Of Jewish heritage, Grundig had spent the final years of World War II in exile in Palestine, returning to Germany in 1949. Active in the Communist scene in Dresden in the 1920s with her husband, the artist Hans Grundig, she played an important role in the cultural politics of the GDR in its early decades and especially after her husband's death in 1958. In her speech at the congress, which had been approved ahead of time by the party, Grundig examined what the expressionist tradition had to offer East German artists. She also argued that artists each needed to develop a "künstlerische Handschrift" (artistic signature) as an expression of their individuality.[48] The speech marked a significant liberalization in the cultural policies of the GDR.

Hermann Raum (1924–2010), a young art historian from Rostock, spoke directly after Grundig and was the first of the conference's speakers to generate controversy. In a rousing speech, he called for stylistic freedom in the visual arts, arguing that it is the meaning of a work, not its form, that

should determine whether it is good.[49] In particular, he argued against the Cold War division of the arts into one of "zwei Schubkästen" (two drawers), either realistic or modern. The exact contents of each "drawer," he pointed out, had changed several times in recent years. He also emphasized the fact that form does not equal ideology and noted the difficulties that Nazi art raised for such a formula, since they, like the Soviets, had used nineteenth-century realism as a model. To adopt a style, therefore, is not to adopt the ideology behind it, he argued.

Raum then turned his attention to the twenty years since the end of the war, stating that these years had been an artistically fruitful time but that the potential of the "neue gestalterische Möglichkeiten" (new formal possibilities) had not been realized in the West. He argued that in the East, by contrast, such forms could be changed from "art for art's sake" to "art for us."[50] He pointed out that the East German people could be educated to understand complex art like that created by Picasso. To assume they could not, he stated, was arrogant. Indeed, he believed that it was the artist's duty to educate people about art. The West, in comparison, was not educating its people about art, and this would lead to its artistic downfall. Moreover, in contrast to the West, the East's focus was on rebuilding and on optimism. *It is therefore the intent—the humanism—that makes something socialist realist*, he insisted, rather than its style. Polemically Raum asked whether East German artists were "too weak to engage productively with so-called modernism," an engagement that he wanted to see take place in the open.[51] He then concluded by pointing out that the Soviet Union's rocket program had begun with the adoption of Western technology, which they then perfected and took to the stars. The suggestion was clear: East German artists should be allowed to experiment with modern art in their attempts to develop a uniquely German Socialist art.

Fritz Cremer, the highly praised sculptor involved with the Galerie Konkret and the controversial *Young Artists—Painting* exhibition a few years earlier, spoke next. He began by praising Raum, whom he called a "brilliant art theoretician," and wondered how he had never heard of him before.[52] "What I have to say," he stated to laughter, "is not much different, just a bit more primitive."[53] He then launched into a passionate fifteen-minute critique of the current artistic situation in East Germany in a tone that was both commanding and self-deprecating. Making reference to the recent summons from the Ministry for Culture for an "open discussion about art," Cremer stated brazenly that "we need a *true* discussion, not an artificial one."[54] He then called for a "reexamination of the consequences of the era of the cult of personality on the visual arts."[55] In his opinion, the

Stalinist era had led to a way of thinking about art that was unrealistic, in particular the focus on illusionism and optimism to the exclusion—and denigration—of everything else. Cremer argued instead for a critical realism for Socialism, something "that could very well serve the further development of our Socialist society."[56] Similarly, he argued for a nuanced view of modern art and the elimination of condemnatory labels like abstraction, formalism, and decadence.

"We need to understand that our art is for civilized people, for the literate, not the illiterate," he stated to applause.[57] "We need an art that provokes the civilized and literate people of our century with the question, 'Capitalism or Socialism?' and that gives [them] the right and the responsibility to decide for themselves between these two societal systems. . . . We need an art that gets people to think, not an art that takes the thinking from them."[58] He argued further that "we do not need an art for 'ordinary people.' The people are not 'ordinary'"—indeed, such an art was what the "Thousand Year Reich" had propagated.[59] Cremer continued, "We need an art that gives every single artist the freedom to decide the substance and form of his art. We need the search for truth in art, and we need the unconditional personal responsibility of the artist."[60] Cremer also brought up the idea of "Realismus ohne Ufer" (realism without boundaries) a term that originated from Robert Garaudy's book of that name published the previous year.[61] The book had promoted a broader view of realism that was then dismissed by the government as revisionism. Cremer stated that he was uncertain about a realism without boundaries, but that he did not see why it was viewed as a danger to Socialism. What was needed, he argued in the final analysis, was an art that sought truth in its entirety, not just on the surface. He argued for the end of division and dogmatism. We do not need art "to be a poster for Socialism. We need an art that radiates [Socialism's] new feeling for life" in whatever outward form that takes.[62] It was an impassioned speech that clearly resonated with the audience, who interrupted him numerous times with applause and calls of "sehr richtig!" (very true!).

A scheduled lunch break followed Cremer's speech. According to people who were in attendance, there was a palpable excitement in the air. The three speeches that morning had all signaled a new, more liberal direction in East German art, each more progressive than the previous—from Grundig's state-approved reassessment of expressionism to Raum's measured critique of the polarization of art in the Cold War era to Cremer's brazen attack on the current state of art in East Germany. These speeches set the tone for the day, and Cremer's, especially, would color each of those delivered in its wake. His position within the program as one of the first

speakers of the conference suggested to some that what he said, while per-
haps surprising, had nonetheless been approved. Moreover, there was no
public rebuke until the following day.

Heisig gave his speech in the afternoon of the first day, the twelfth of
fourteen speakers. He began by stating that he wanted to make a couple of
comments about some terms that he believed needed readdressing because
they were threatening to become dogma, but he confessed—in what can
be interpreted as either rhetorical modesty or actual uncertainty—that he
felt uncomfortable following the "excellent speeches" that morning, since
he would not be able to present his with the same emotional force.[63] He
would nonetheless try to help shed light on the issue by approaching it
from another angle.

In the speech that followed, Heisig, like Raum and Cremer before him,
criticized the artistic situation in East Germany. Specifically, he argued
against dogmatic extremes, the ossification of artistic policy, and treat-
ing artists and the public like "children." He began by placing the current
artistic situation within its historical context, pointing out that the current
emphasis on realism "had first been characterized by the attempt to orient
artists to the new Socialist present, and the effort to shield them from all
manifestations of Western ideology" as well as a desire to "lead the artist
out of his isolation" and "away from the extreme of autonomous art" and
back toward societal relevance.[64] The focus on tradition and the human
figure, in other words, had been intended to help artists find inspiration
for the new, Socialist present. This good intention had resulted, however,
in another kind of isolation: artists had been cut off from a large part of
contemporary art. The modern art of Western Europe had been denigrated
as "rotting fruit on the dying tree of imperialism."[65]

The rejection of Western styles, Heisig pointed out, was not uni-
versal in the East. Architecture, book illustration, and the commercial
arts—those branches of art where economics play a role—had developed
a "class-indifferent character."[66] Skyscrapers in Moscow were hardly to be
distinguished from those built in New York, he stated, before expressing
the desire for such liberalizations in the realms of painting and sculpture.
Instead of opening up discussion, cultural policies such as the Bitterfeld
Way, however, had increasingly become ossified rules that led to artistic
stagnation. "In the effort to protect him from dangerous influences, the
artist is sometimes treated like a child not allowed onto the street so that
the heavy traffic won't endanger him."[67] Such fear and limitation, Heisig
pointed out, was having unintended effects: it was leading to provinciality
and an uncritical overvaluation of Western art as forbidden fruit. Heisig

then argued that ignorance, repression, and isolation were not the ways to overcome the current artistic impasse but, rather, engagement with modern art. As he put it, "This is not about ingesting poison, this is about an intellectual engagement with the art of the 20th century."[68] Furthermore, it was up to the artist alone—not a committee—to decide what from this tradition is valuable; that was part of the artist's responsibility to society.

Heisig then pointed out that art should not be limited to only portraying the positive side of life. Such a limitation, he stated, was unnatural. Nothing should be repressed. Fear, imperfection, and pain—in short, life and death—were all valid topics to explore in art. That such explorations were not allowed, however, Heisig saw as stemming from a narrow interpretation of the term "realism." It was the result, he said, of trying to create a new art based on rules rather than stemming from a naturally unfolding artistic process. Rather than thinking about these questions, art historians and critics "reach for the cure-all stamp" of socialist realism.

Heisig argued instead for an art "that thrills and delights or annoys and provokes . . . [but] in any case must be interesting."[69] Moreover, he argued that people should be allowed to interact with the works on their own rather than always having someone tell them what to think. He then returned to the role of the artist in East German society, stating that "the artist is also the critic of his time" and thus it was artists who needed to address these issues.[70] He insisted that artists must have better arguments and called for more room to experiment with ideas rather than condemnation of such experiments.

Toward the end of his speech, Heisig expressed regret that representatives of the district leadership of the party in Leipzig and other important organizations were not in attendance, stating that their support would have been appreciated. He then commented on Grundig's opening speech, praising her attempt to fight the current paralysis in art. But he also warned her against going from one artistic extreme to another before ending with a statement about how the discussion about art in East Germany needed to be left open to a wide range of possibilities; only in that way could a true discussion take place.

The Initial Rebuke

While Heisig's speech—like Raum's and Cremer's—was met with repeated applause from an audience of mostly artists and art historians, not everyone approved. That night cultural functionaries and high-ranking members of

the Union of Visual Artists gathered to figure out how they could win back the conference.[71] Speeches for the following day were changed: some were canceled, others rewritten, and still others added. Only the most politically reliable were allowed to speak.

The Berlin artist Walter Womacka, vice president of the Union of Visual Artists—and creator of *Am Strand* (On the Beach), one of the East German public's favorite paintings at the Fifth German Art exhibition in 1962—opened the second day with an address that criticized the speeches by Raum and Cremer from the previous day. At the very end, however, he turned to Heisig, calling his talk an example of "Intellektuelle Unredlichkeit" (intellectual dishonesty).[72] He pointed out that Heisig had given a brilliant performance, but that he was angered because, as he saw it, Heisig had given a similarly brilliant performance at the Fourth Congress in 1959, "but there he said exactly the opposite!"[73] After quoting a long passage from Heisig's earlier speech that he interpreted as being against modern art, Womacka again accused him of dishonesty, this time in the earlier speech, erroneously claiming that Heisig had just become "a public official and professor" at the time.[74] "Such behavior," Womacka concluded, "is called, quite simply, demagoguery!"[75]

Womacka was not the only one who saw Heisig's speech the previous day as a significant change in his views on art. The Dresden artist Gerhard Bondzin similarly accused Heisig of abandoning the conception he had forwarded in 1959, stating at the Congress that he was "in Erstaunen gesetzt" (amazed) by the abrupt change in Heisig's position in his most recent speech: "as Colleague Womacka already said earlier today, [Heisig] stood by a concept of art at the Fourth Congress and tried, through his art, to realize this conception, but then yesterday took a stance that has nothing more to do with that conception."[76] In response, Heisig called out from the audience, "I never gave up the conception."[77]

A comparison of the speeches Heisig gave 1959 and 1964 reveals how Womacka and Bondzin could think he had changed his position while Heisig saw himself as being consistent. In his earlier speech, Heisig had criticized the West, especially its emphasis on autonomy, which he saw leading to artistic suicide due to the separation of the artist from society. In 1964, in comparison, he criticized the East, and in particular, the narrow-mindedness of recent art policy. Although superficially the speeches might seem to contradict each other—a criticism of the West versus a criticism of the East—read together, they reveal a similar interest in criticizing dogmatism. Ultimately, in both, Heisig argued for the responsibility of the artist to society and the freedom to use whatever artistic style he or she deemed

appropriate to reach this goal, a stance that can also be seen in his articles in *Bildende Kunst* and the *Leipziger Volkszeitung* in the mid-1950s.

That Heisig had not intended to set himself against the party's cultural policies with his speech at the Fifth is suggested by the fact that he had requested feedback on his talk before giving it. At a meeting of the leadership of the Union of Visual Artists to discuss the contents of the 1964 congress a day before it began, Heisig had told the group that he planned to discuss the issue of "no more taboos" and would be grateful for any information as to whether this was an acceptable topic for the congress.[78] While the file contains no mention of his having received a response, in one of the investigative meetings held after the congress, Heisig claimed that Siegfried Wagner, head of the SED's Culture Department, had answered him by saying that he had not understood the question: the concern was not about whether something is acceptable to say, Wagner replied, but rather that everything is said.[79] According to Heisig, Wagner later told him that he had brought up some important problems in his speech but that the form the speech had taken was problematic.[80] Indeed, another report suggests that for many it was *how* Heisig delivered his speech that was the real problem: "The tone of his lecture was said to be very cynical and ironic."[81]

A comparison with his speech from 1959, however, suggests that sarcasm was simply part of Heisig's rhetorical style. Indeed, it helps explain the antipathy some people—usually those who did not know him well—had toward him, both then and in the controversies that took place after unification. Both speeches reveal a similar use of irony and an approving audience that laughed at his remarks on repeated occasions. Certainly, the switch from criticizing dogmatism as found in the West to criticizing dogmatism as found in the East played a role in the difference in reception. And yet Heisig also leveled criticism at the East in the 1959 speech. One has to question, then, the extent to which Cremer's impassioned and brazen critique affected the reception of Heisig's—and Raum's—speech. To what extent was the furor Heisig and Raum experienced the result of displaced anger and feelings of betrayal that could not be taken out on Cremer directly because of his near-legendary status in the GDR?[82]

In a letter sent to Kurt Hager at the Politburo informing him about what had unfolded at the conference, Siegfried Wagner focused on Cremer with only a passing reference to Heisig.[83] Similarly, in the letter Lea Grundig sent to Hager two days later, Heisig played a subordinate role. Her criticism focused instead on "the politically hostile ideology [promoted] by Fritz Cremer and Raum."[84] She did, however, recommend that "[Heisig's]

particularly unpleasant speech be reviewed" because of its "cynicism and nasty innuendo," which she found to be "particularly poisonous."[85] That Heisig had singled her out for criticism at the end of his speech, warning her against going from one artistic extreme to another, presumably played a role in this request.[86]

But Heisig was not universally criticized. In fact, two artists from Leipzig defended some of what he said in speeches they gave at the congress on the second day. Harry Blume, for example, who had painted the studio portrait of important Leipzig artists several years earlier (see fig. 2.2), agreed that there was a certain narrowness in the art scene in Leipzig: "There is a certain tendency to vulgarize the term socialist realism among artists—I'm not an exception—[as well as by those] in the state apparatus and also by comrades of the party [in Leipzig]."[87] Nonetheless, he criticized Heisig's cynicism: "Don't be right against the party, be right with the party."[88] Gerhard Kurt Müller—who would succeed Heisig as director of the Leipzig Academy a few weeks later—declared that while he was often personally at odds with Heisig, he nonetheless valued him: "The congress is a congress of open debate and open discussion, the presentation of all the problems and questions that move us. . . . I have to say that there are valuable qualities in the person of Comrade Heisig in that he is often the catalyst for bringing important problems to discussion."[89]

In the Wake of the Fifth Congress

In the weeks that followed, Heisig was the focus of several reports and at least one meeting, all of which were at the local level, albeit prompted by the Politburo and the Ministry for Culture in Berlin.[90] On April 2, an extended meeting of the Leipzig branch of the Union of Visual Artists took place to discuss the congress and, in particular, the attitude of the Leipzig delegation, including Heisig. The tone of the meeting was set by the recent assessment of the Ideological Commission of the Politburo, which viewed the congress as a Havemann-like attack against the cultural politics of the party begun by Comrade Fritz Cremer.[91] Robert Havemann (1910–82) had been a chemistry professor at Humboldt University who had lost his job and position in the party the previous year for a series of lectures, later published as *Dialectic without Dogmatism*, in which he had called for reforms of the Communist system.[92] The results of the meeting in Leipzig were summarized in a six-page document, *Report on the Confrontation in the Enlarged Party Leadership Meeting of Visual Artists*

on the Performance of Bernhard Heisig at the Congress.[93] As its title sug-
gests, much of the report focused on Heisig, who was seen as "having used
the platform of the congress to cast doubt on the cultural politics of the
party and to coarsely distort the party's relationship to artists."[94] Not only
had he pursued the goal of negating and discrediting the party's leader-
ship, the report stated, he had also promoted the leadership claims of the
artistic intelligentsia as well as the "hypocritical catchphrase" of "artistic
freedom."[95]

The report then shifted to criticisms by the VBK-L party secretary
Gerd Thielemann in the meeting, the same man who had criticized Heisig
for defending a drunken student shortly after becoming director of the
Leipzig Academy in 1961: "Apparently incited by Comrade Raum's pre-
sentation and Comrade Cremer's against-the-party-line political-aesthetic
program, Comrade Heisig began a polemic against the handling of artists
by the party."[96] In fact, Thielemann continued, Heisig thought that "artists
are being treated like small children who are not allowed onto the street
so that they won't be run over. At the same time . . . [he] promoted an
'expanded realism.'"[97] In the discussion that followed, "Heisig's own com-
ments . . . confirmed that the trend is toward the smuggling in of modern-
ism under the disguise of revolutionary phrases."[98]

According to the report, the Ideological Commission in Leipzig
together with the VBK-L had dealt with Heisig in this regard several times
in recent months. "The heart of the criticism was that Comrade Heisig had
expressed doubts about the party's politics on fundamental questions and
in so doing essentially challenged the results of the Politburo's consulta-
tion with artists in March."[99] Of particular importance in this regard, the
report noted, was Heisig's introduction for a Festschrift written for the two
hundredth anniversary of the Leipzig Academy in 1964, where, appar-
ently, he "consciously deviated from the party's cultural politics with the
argument: The anniversary of the Leipzig Academy is of importance not
only to the GDR, but also at a national and international level, and dem-
onstrates peaceful coexistence in the realm of ideology and culture."[100] If
this quotation is accurate—and one needs to be careful with this type of
report, which was written by the SED in Leipzig—then Heisig referred
directly to Khrushchev's de-Stalinization speech with the term "peaceful
coexistence" and thus signaled a revisionist mind-set similar to that of
Garaudy, Havemann, and Cremer, which would have been alarming to
the party.[101]

Regardless of whether Heisig mentioned peaceful coexistence in his
text, some people clearly thought he had. Nor was it the only problem

they had with him. Heisig had apparently also been in trouble recently for "subjective distortions of party decisions" in his leadership of the Leipzig Academy and for "similarly unprincipled behavior in a number of . . . discussions related to his artistic activities and teaching."[102] The report states that as a result of all the criticism mounting against him, Heisig "apparently gave up his position."[103] The report's next sentence hit upon the real problem: "And then he used the congress to renew his old position against the party in a dogmatic way and showed that his self-criticism was basically disingenuous and double tongued."[104] As with Cremer, the party felt betrayed by Heisig's speech at the Fifth Congress.

The report continued with Heisig's response to these allegations—in which he stated that "he had not spoken out against the party's cultural politics, but rather against the narrowly dogmatic interpretation of them"— before broadening its focus to other comrades of the Leipzig delegation who had not taken the party's position.[105] Werner Tübke and Wolfgang Mattheuer, the report continued, had expressed a sentiment similar to Heisig's in that "they had seen nothing dangerous in Cremer's speech."[106] And while they were critical of the congress as a whole, they "did not distance themselves openly from Heisig's and Cremer's position" the way that others like Thielemann had.[107] The report then went on to explain that one of the reasons for the wavering position of a number of Leipzig artists was the fact that in recent years their "false views," although sharply criticized in Leipzig, had been tolerated in Berlin.[108] When Cremer took the stage, according to the report, these artists "smelled fresh air" and believed they could denounce the narrow view of art that dominated Leipzig: "The main attack was on images by the painter Klaus Weber, whose *Chemistry Circle* was bought by Comrade Ulbricht, and paintings by Comrade Heinrich Witz."[109]

Interestingly, the "Leipzig problem" also appears in the SED-L's report about the congress. Although it began with Heisig, the report then focused on two other artists from Leipzig who had spoken at the congress. Harry Blume, it related, had warned that modernism needed to be taken as seriously as naturalism, clearly weighing in against the "vulgarization" of the term "socialist realism" as represented by Leipzig artists like Weber and Witz.[110] Similarly, Gerhard Kurt Müller stated that every *Bezirk* (region) had a certain "Stallgeruch" (barnyard smell), emphasizing the differences between the various districts in the GDR.

Significantly, this second report expressed an interest among politicians and cultural functionaries in coming to terms with the issues raised rather than merely blaming artists for them. In the final page, it became

self-reflective: "Leipzig has undergone a defeat at this Congress. Why? . . . there is a certain narrowness in artistic views [in Leipzig] and especially in the interpretation of the term 'socialist realism.' . . . We need to investigate whether a false attitude by cultural functionaries or maybe in the positioning of the artists themselves has led to an 'artistic narrowness,' and whether the accusation of narrowness even fits."[111]

The unnamed author of the SED-L report then pointed out that according to the views of socialist realism expressed by Grundig, Raum, Sitte, and others, which were more differentiated in their understanding of modern art, Comrades Heisig, Blume, and Müller were right in their assertion that the view of art taken in Leipzig was too "narrow." "We should . . . act more loyally towards artistic attempts to portray the themes of our times. We should consistently promote quality works. We must also, more than we have to this point, conduct open conversations in artists' studios."[112]

In Halle and Dresden, the report pointed out, there was a much better relationship between artists and the party, the result of the building of studios in both cities, of regular personal discussions with artists, and of the artists there receiving recognition. The report concludes, "In these questions there are a few things that need to be corrected in the city and district of Leipzig."[113]

This report conceded that Heisig's views were supported by many of his colleagues in Leipzig. In fact, both reports indicated a broader problem in Leipzig that needed to be addressed, a problem that I return to and discuss in more depth in the next chapter. Nonetheless, Heisig was held accountable. On Wednesday, June 10, 1964, just under three months after his speech at the Fifth Congress of the Union of Visual Artists, he gave an official self-criticism at a *Parteiaktivtagung* (party session) held in the Berlin artists' club known as the Möwe (Seagull). The surviving transcript is a testament to Heisig's rhetorical skills that helps to explain how he was able to survive the vagaries of artistic policy in the Ulbricht era despite being at the center of several controversies. It also reflects Heisig's statement years later that "I didn't say anything I didn't believe. I never lied. I looked for things to say that I believed."[114]

Heisig's Official Self-Criticism

The general tone of Heisig's self-criticism was apologetic and began with an acknowledgment of wrongdoing. "Although it [my speech at the Fifth

Congress] was planned and given with the intention to help push things in the realm of art forward, the implementation was incorrect on important points."[115] He then went on to refute the inadvertent distortions of party views that had appeared in his speech, distortions he explained as stemming largely from his ignorance of the party's more recent resolutions on art. He took back, for example, the accusation he had made at the Fifth Congress that the party considered all late bourgeois art to be rotting fruit, stating that "the party has corrected this oversimplification . . . itself."[116]

He also clarified his position on modern art. "I did not mean the wholesale adoption of the apparatus and forms of Western art, and I certainly did not mean artistic play separate from societal engagement. It is about . . . the legitimate keeping open of possibilities to get to know new methods of expression that can be used for socialist realism."[117] As he explained it, "the form of art is not decisive for its [art's] capacity for stimulation."[118] He also clarified his view on the artist's role in society, explaining that he had not been calling for "a maximum of artistic freedom in the sense of an artist being responsible to only himself," but rather for "a higher measure of responsibility."[119]

The second major "mistake" he admitted to having made in the speech was viewing individual occurrences of artistic dogmatism as indicative of East German artistic policy as a whole. Distancing himself through the use of the third person, he clarified that "because the author was not well enough aware of the party's view, he didn't realize that he needed to localize appearances [Erscheinungen] of dogmatism, but instead generalized them."[120] It was an error he did not repeat in the self-criticism. Instead, he gave specific examples: he explained his continuing fear of artistic dogmatism by pointing to recent remarks by a worker at the Ministry for Culture that in the future Hemingway and other Western authors would no longer be published. He then pointed out the "differentiated view" of the party and the fact that this person—like he himself in his speech at the congress—must not have been aware of recent changes in party policy.

Rather than disavow the core statements of his original speech as one might expect from an official self-criticism, Heisig subtly argued them anew.[121] This can perhaps best be seen in the example of the worker at the ministry just mentioned, as well as in his acknowledgment that "the party has long since formulated a differentiated judgment of the art of the late bourgeoisie."[122] To illustrate the latter, he pointed to the positive influence of various Western artists on socialist realism, such as Picasso on Guttoso, Hemingway on Soviet authors, and the importance of futurism to the

creation of various masterpieces of socialist realism. In doing so, Heisig subtly showed that he was in agreement with the party (or they with him!); he had simply not realized it when he was giving his speech at the congress. His error was thus not in the way he viewed art but rather in his misunderstanding and misrepresentation of the party's views, together with the polemical tone he had used in the speech, a tone that had inadvertently set him in opposition to the party. As he admitted, even if his observations had been correct, the tone of his criticisms prevented their discussion. As such, Heisig's self-criticism seemed to take Blume's call to "work with the party" to heart.[123]

A comparison with Raum's self-criticism shows how careful Heisig was in his, and how contradictory art policies were at this time. Rather than emphasize what he did wrong at the congress, Raum defended himself—not unlike Witz years earlier—calmly arguing his point in a self-criticism that was approximately three times the length of Heisig's.[124] He pointed out that people were well aware of his views on art before he was asked to prepare the congress speech and that he had been given neither feedback on his ideas nor guidance on how to present them at the congress despite having asked for them. Moreover, he pointed out that he had received applause during his speech, and the ideas he had expressed were, by and large, those now being officially promoted, as proven by recent issues of *Bildende Kunst*. He then pointed out his commitment to the GDR and its art and the importance of discussing these issues in the open. In terms of things done wrong, he admitted to having formulated some statements incorrectly. He also acknowledged that he should have discussed other problems that were more important than the ones he chose to focus on, and, most importantly, that he should have distanced himself from Fritz Cremer when the latter praised his speech but went on to say things with which Raum did not agree.[125] Throughout the self-criticism, Raum posed two rhetorical questions: How does one, as a member of the party, handle oneself during a difference of opinions? And where do artists go from here?

Interrupted several times by a disapproving committee, Raum's self-criticism was later summarized as follows: Raum "does not yet understand the essence of the criticism against him. He acknowledged that he must have done something wrong since he is now being criticized for it by everyone but went on to explain at great length what he had meant and how it had been misunderstood."[126] In the end, it was decided that Raum needed to be dealt with further, but that it could be handled at the local level in Rostock, where he lived.

In contrast, Heisig's self-criticism was viewed positively as "a first step towards serious reflection."[127] It is unclear, however, whether he received a lesser penalty as a result. At the end of his self-criticism, he stated that he considered the "strenge Rüge" (strong reprimand) decided upon during the investigation to be appropriate. With the exception of one report in his Stasi file in which it is mentioned in passing, however, there is no archival evidence to indicate that he actually received this punishment.[128] Was it literally erased from the party books when it expired five years later? And would such an erasure have extended to his personal file at the Leipzig Academy, which bears no mention of it? Or might his skillful self-criticism have allowed him to escape formal censure? The latter seems more likely.

The Beginnings of a Change

Whether Heisig received a "strong reprimand" for his speech at the Fifth Congress or not, it nonetheless marks a serious break with the party, at least from the party's perspective, one that could have resulted in his being thrown out of the SED or worse.[129] While he had spoken for the betterment of the GDR, such sentiments had not helped Robert Havemann and other committed Communists, who had lost their jobs, or worse, for expressing constructive criticism. The threat was therefore real, as were the attacks on his character that took place during the five-week investigation that followed.

The events also seem to have had an impact on Heisig's painting style as evidenced in *Weihnachtstraum des unbelehrbaren Soldaten* (The Christmas Dream of the Unteachable Soldier, 1964, fig. 2.8), which he exhibited just a few months later at an exhibition celebrating the Leipzig Academy's two hundredth anniversary in October.[130] Like its predecessor from 1962, this painting depicts a man in black pants and a light short-sleeved shirt with a toy tank on his chest, but now the man reclines on an oriental carpet and seems to be haunted by memories of the war: images of an atom bomb exploding, an imperial eagle, soldiers, and war planes, along with other objects, including part of a swastika flag, swirl around him in a simultaneous narrative composition that refers directly to the Second World War. Significantly, this is the first painting in Heisig's oeuvre to employ simultaneity—the incorporation of multiple moments or events in one image—which would become a standard part of the style for which he later became famous. Considering the timing of the work, which was exhibited just a

Figure 2.8. Bernhard Heisig, *Weihnachtstraum des unbelehrbaren Soldaten* (The Christmas Dream of the Unteachable Soldier), 1964. Oil, size unknown. © 2018 Artists Rights Society (ARS), New York / VG Bild-Kunst, Bonn. Subsequently destroyed through overpainting. Photo from *Zweihundert Jahre Hochschule für Grafik und Buchkunst Leipzig, 1764–1964* (Leipzig Hochschule für Grafik und Baukunst, 1964).

few months after his controversial speech and self-criticism, it seems likely that he created this painting with his critics' comments in mind, especially their criticism that his artwork did not match his words. This painting—in sharp comparison to all those he had exhibited before it—is unabashedly modern in both its composition and brushwork. It clearly reflects, as he stated it in his speech, "an intellectual engagement with art of the 20th century."

This painting is also the first in Heisig's oeuvre to focus explicitly on the Nazi past. As such, it not only challenged official notions of what styles were suitable for East German artists, it also touched upon issues that, as he argued at the conference, are just as valid to explore in art as the positive side of life, namely fear, imperfection, and pain: here is a man clearly suffering from his memories of the war as they swirl around him. The emergence of the Nazi past in Heisig's work at this particular moment is a response, in part, to the Auschwitz trials then taking place in West Germany; as such, it also reflects Heisig's statement that an artist is "the critic of his time."[131] Beginning in December 1963 and lasting until August 1965, the Auschwitz trials brought more than 350 witnesses to Frankfurt am Main to testify to the atrocities that had taken place in the concentration camps in Auschwitz. Focusing on the terror system of the camps and on the brutal, sadistic actions of the perpetrators, it changed the perception of the camps from being the unfortunate result of war to a place where the crime of genocide had occurred. This event marked the beginning of West Germany's coming to terms with the Nazi past and was publicized heavily in East Germany as proof of the West's failure to come to terms with this past earlier. In this context, the shocked expression on the reclining man's face can be read not only in terms of trauma from the war but also in terms of the new fear that former high-ranking Nazis living in West Germany had of being found out and held accountable. That the man is West German—and not Heisig himself—is suggested by his unrepentant attitude as indicated both in the title of the work and the Iron Cross he clutches in his right hand.

The Christmas Dream of the Unteachable Soldier from 1964 marks the beginning of what I see as a new phase in Heisig's art, one in which he combined modernist techniques and brushwork with a Socialist subject matter. Its emergence in his oeuvre at this time is clearly the result of the context in which he found himself, one in which he argued publicly that East German artists be allowed to engage with modern art in their attempt to create a new, Socialist art and in which he suffered consequences for doing so.

Conclusion

By the fall of 1964, Heisig had begun to create paintings in the modern style for which he is now known. This shift can be seen in part as a response to the controversy around his speech at the Fifth Congress of the Union of Visual Artists. It can also be seen, like the speech itself, as the result of a process that had started in the 1950s among a younger generation of artists in Leipzig that included Blume, Heisig, Meyer-Foreyt, Tübke, and Witz, artists who wanted to make a name for themselves in the East German art world. For Heisig, who was originally a printmaker, this ambition meant not only taking on cultural positions such as chair of the VBK-L and director of the Leipzig Academy, but also expanding his oeuvre to include painting, the GDR's most prestigious visual arts medium.

Although Witz had initially been a leading figure of this group, his limited artistic abilities and confrontational nature ultimately made him a liability, especially in the wake of the building of the wall. Physically cut off from the West, a number of artists and art historians, including in Leipzig, believed that the time had come to move away from the conservative, Soviet-style of socialist realism the politicians liked in favor of a more complex, modern art that they considered better suited for an educated, industrial nation like East Germany. The criticisms that Heisig and others leveled at the Fifth Congress of the Union of Visual Artists in 1964 were an attempt to open up East German art to a greater breadth of artistic styles and subject matter as well as to make artists—rather than politicians—the primary decision makers about art. These calls, however, were too much, too soon and thus resulted in numerous meetings and discussions and, ultimately, a self-criticism.

What becomes clear when looking more closely at the East German art world in these years is that art policy was not universally repressive but, rather, changed over time, with political events often affecting how open artistic policy was. People's personalities also played an important role, with how one responded—whether one defended oneself, as did Witz and Raum, or accepted the situation and did one's best to engage with it, as Heisig did—having an impact on the outcome. Heisig's self-criticism, for example, reveals a politically savvy artist who was able to give cultural functionaries what they wanted to hear while at the same time remaining true to the original speech.

Although Heisig was at the center of a multi-week investigation into his loyalty to the party in the wake of the Fifth Congress, he continued on as a professor at the Leipzig Academy and became head of the Painting

and Graphics Department shortly thereafter. He was also considered and ultimately chosen for a prestigious—and lucrative—series of murals for the Hotel Deutschland, a new international hotel then being built in Leipzig.[132] The murals he created for it that fall landed him at the center of another controversy that began in January 1965, the second in less than a year.

AGAINST THE WALL: MURALS, MODERN ART, AND CONTROVERSY

Heisig turned in sketches for three murals for the Hotel Deutschland in July 1964, just a few weeks after his self-criticism. Although overlooked in current scholarship, murals formed an important part of Heisig's oeuvre in the Ulbricht era (1949–71), a time when the East German government promoted the creation of large-scale public works as a particularly Socialist medium.[1] Embraced by politicians and artists alike, murals were seen as a socially engaged art form that was well suited for reaching the people.[2] In the 1950s and especially 1960s, Heisig created more than ten murals, many of which—such as those for the Hotel Deutschland—can still be found in their original locations. The number and type of works he created, which included plaster and sgraffito, suggest he was interested in exploring new media. Indeed, it was his experiences making murals—a medium that denies the illusionism possible in oil painting—that I believe contributed, ultimately, to his development of a modern painting style.

In addition to encouraging the shift in Heisig's painting style, the Hotel Deutschland murals—which demonstrated a playful use of form and color that was new to Heisig's oeuvre—also sparked a vehement controversy, Heisig's second in less than a year. In February 1965, shortly after the murals were finished, Alfred Kurella, a powerful figure in East German cultural politics, wrote a five-page report titled "Thoughts about the Murals in the 'Hotel Deutschland' (Leipzig)."[3] In it, he criticized all of the murals created for the new building, including those by Wolfgang and Ursula Mattheuer

and Hans Engels, but it was Heisig's murals that elicited his sharpest criticisms: "[These murals show] the most serious demonstration against our view of art. . . . Here is the principle of intentional *deformation, mutilation and uglification of reality* and the use and frequent mixing together of single *deformed fragments* of pieces of reality carried too far."[4]

Kurella's report sparked a flurry of activity. In less than a week, all the organizations associated with the commission filed their own reports explaining their role in the creation of the murals and their evaluation of them. Some agreed with Kurella; others did not. The Union of Visual Artists in Leipzig, for example, argued that Heisig's mural captured "the beauty, strength and optimism of our life [in East Germany]."[5]

The split in opinion over Heisig's murals suggest that they embodied the very essence of the debates about art taking place at the time. These debates tended to pit artists and art historians on one side against politicians and conservative cultural functionaries on the other. At stake was what East German art should look like and who should get to decide. The controversy over the Hotel Deutschland murals thus continued the heated debate that had taken place the previous year at the Fifth Congress, but this time at the local level. The change to a complex, modern style in Heisig's murals suggests he was responding, at least in part, to criticisms raised about his controversial speech and, more specifically, the fact that his stated support of modern art seemed to contradict the realist style of his artwork.

The Hotel Deutschland murals and the debate around them reveal an important and overlooked stage in the development of Heisig's artistic style and emphasize the role he played in promoting a complex, modern art for East Germany. They also illustrate the complexity of cultural politics in the GDR where cultural policy varied significantly at the local level, and the many organizations responsible for art were often in competition with one another. Before turning to the murals and the controversy around them, it is necessary to place them first into the larger context in which they were created in order to understand better their significance and the vehemence of the debate they inspired.

Leipzig and Karl-Marx-Platz

The Hotel Deutschland was built on the prestigious Karl-Marx-Platz in Leipzig in 1965 as part of the city's eight hundredth anniversary celebrations. Founded in 1165, Leipzig was the second-largest city in East Germany as well as its most international city—even more so than East

Berlin—because of its annual *Messe*, or "trade fairs," which attracted a large number of visitors from both the Eastern bloc and the capitalist West.[6] A center for publishing and art, Leipzig also had a vibrant music scene and boasted an impressive list of former inhabitants, including Johann Sebastian Bach, Johann Wolfgang von Goethe, Vladimir Lenin, Felix Mendelssohn, Friedrich Schiller, Robert and Klara Schumann, and Richard Wagner.[7] It was also the birthplace of Walter Ulbricht.

The city's eight hundredth anniversary was celebrated with a number of cultural events throughout the year, including performances, exhibitions, and the completion of major building projects. Local party officials planned these events with subsidies and guidance from Berlin, including discussions with Ulbricht himself.[8] The festivities were intended to pay tribute to Leipzig's importance both historically and in the present, and to showcase the GDR's recent successes to a national and especially international audience.

Visual artists played an active role in these anniversary celebrations, creating posters and brochures, decorating new buildings with murals and sculptures, and putting together the Seventh District Art Exhibition. Heisig, for example, created a series of nine colorful lithographs for the Festival Day program and exhibited work at the District Art Exhibition (see fig. 3.6). It was also in this context that he received the commission in 1964 to create three murals for the Hotel Deutschland on Karl-Marx-Platz, which was under construction at that time.

Known before and after the GDR as Augustusplatz, Karl-Marx-Platz was almost completely destroyed by Allied bombing in December 1943. By the end of the war, only two buildings, both located on the western side of the square, remained standing.[9] Originally the plan was to rebuild the square according to its prewar appearance. The decision to create an entirely new space—albeit sharing the same basic size and shape of the old—came in the early 1950s, by which point Leipzig had been designated one of the GDR's most important cities for rebuilding. Karl-Marx-Platz, at its center, was earmarked to become a major square for Socialist demonstrations.

The first new building in the square was the Opera House, the first and only new opera house built in the GDR.[10] Located on the northern edge of the square, it replaced the New Theater, which had been destroyed in the war. Although the decision to build it had been made by 1950, postwar financial difficulties delayed its construction until the latter half of the decade. The final work, designed by the architects Kunz Nierade and Kurt Hemmerling, demonstrates a reduced classicism clad in sandstone typical for the late 1950s. It opened its doors on October 8, 1960.

Like all new buildings in East Germany, the Opera House was supposed to reflect a close collaboration between artists and the architect. The local *Rat der Stadt* (city council) responsible for commissioning the artwork, however, waited until late in the construction process before putting together a planning committee to decide on the building's artistic decoration. On January 1, 1958, it selected six artists, including Heisig, to work together with Nierade to come up with a theme.[11] After several inquiries from the VBK-L, it finally assigned the commissions at the end of May 1959, signing contracts with several local artists, including Heisig, Harry Blume, and Willi Sitte from nearby Halle. Heisig was to create a triptych titled *Geschichte des Arbeitertheaters* (History of the Workers' Theater) for the ground-floor foyer; later that summer, he received approval and a down payment for sketches made.[12] In the end, however, none of the paintings commissioned was included in the Opera House.[13] Apparently, the final building did not have room for them, a decision that angered local artists, who filed complaints with functionaries in Berlin.[14] Recurrent difficulties like this one between artists and local politicians became known behind the scenes as the "Leipzig problem," an ongoing struggle between the two sides over what East German art should look like and who should get to decide.

The opening of the Opera House was followed shortly thereafter by the rebuilding and significant enlargement of the Post Office that had been located on the northeast corner of the square. Built between 1961 and 1964, this new building displayed an entirely different aesthetic from the modern classicism of the Opera House across the street. Instead of being clad in sandstone, it was constructed from steel and glass, making it one of the first buildings in East Germany to have an aluminum curtain façade; these features became characteristic of East German architecture in the 1960s, especially in Berlin.

Construction on the Hotel Deutschland, the third new building on Karl-Marx-Platz, began before the Post Office was completed. Located across the street from it on the eastern edge of the square, it was built in just seventeen months between 1963 and 1965. "The largest project in the hotel-building program" for the eight-hundred-year anniversary of the *Messemetropole* Leipzig, it was intended, as a "travel hotel of the first order," to impress visitors, especially those from abroad.[15] Designed to complement the Post Office, it had eight floors and a modern construction, including an aluminum curtain façade, the glass from which was intended to reflect the clouds and thus lend the building a sense of movement. Inside, a large reception area on the ground floor contained a front desk and elevators to

the hotel rooms located upstairs; there were 280 rooms with a total capacity of 430 beds. These rooms were equipped with the latest comforts, including a radio, an electric alarm clock, and a telephone, which was a luxury item in East Germany that most households did not have.[16] A variety of premium services was also available, including a full-service beauty salon, restaurants and bars, a dance floor, and both childcare and dog sitting.

The Hotel Deutschland Murals

A crucial element of the Hotel Deutschland was its artistic decoration, which included both sculpture and numerous murals throughout the building. All the artists, except Fritz Kühn, a sculptor from Berlin, were from Leipzig. Among the many works were seven large-scale murals (20′ x 8.2′) located in the *Bettenhaus* (building with beds), the part of the hotel containing the guest rooms. The murals were on the wall just to the right of—and perpendicular to—the elevator on each floor and were created by four young artists who had recently emerged onto the East German art scene: Hans Engels, Bernhard Heisig, and Wolfgang and Ursula Mattheuer. In keeping with the national theme of the hotel, each work showed an important East German city: Eisenach, Halle, Leipzig, Rostock, Schwedt, Trier (later replaced by Berlin), and Weimar.[17]

Discussions about which artists should be commissioned to create works for the Hotel Deutschland took place over the course of several months in the spring of 1964. In an early report dated April 18, "Suggestions for the Building of the City Center of Leipzig," the Ständige Kommission Kultur (Standing Commission for Culture) recommended Heisig as one of ten possible artists to create the murals for the *Bettenhaus*.[18] Just over a month later, on May 22, it narrowed the list to three, including Heisig and Engels, and invited them to submit sketches for consideration.[19] The standing commission also offered a list of possible cities to be depicted and suggestions for how they should be portrayed: the seven murals in the *Bettenhaus* "should artistically represent the theme of the national landscape together with the progressive traditions of the national history of the past and present in a simple, allegorical readability."[20] It recommended that the murals be created in a linear graphic style and that they convey a sense of emotion. The standing commission also encouraged artistic experimentation, at least on a limited basis, and recommended that the three artists submit sketches "so that a visual image of the new manner of artistic design [*Gestaltung*] can be brought into the discussion."[21] Little did

Figure 3.1. Hans Engels, *Weimar*, 1965. Sgraffito, 300 x 900 cm. © Hans Engels.
Photo: author, 2005.

the commission realize at the time that the modern style of some of the
murals, most notably Heisig's *Schwedt*, would result in an artistic contro-
versy that would last well into the summer of 1965.

In comparison to Heisig's murals, those created by the other artists
on the Hotel Deutschland project were straightforward, largely black-and-
white compositions with color used only as an accent. Engels's *Weimar*
(fig. 3.1) was the most linear of the works, with the majority of the com-
position made from simple black lines. Images included Fritz Cremer's
Buchenwald Monument, the German National Theater, and a sculpture of
Goethe and Schiller. Several large, abstracted blocks of yellow help break
up the image and move the eye through the work; a red triangle—symbol-
izing Communism—appears just to the right of center, emphasizing the
Communist background of those at Buchenwald. There is also a reference
to Picasso's dove of peace on the right-hand side of the work. Overall, the
image is light in tone and easy to read by anyone visiting the hotel.

Presumably Engels's second mural for the project, *Trier*, had a simi-
lar style. Although this work played a more prominent role in the debate,
an image has not survived: it was the only one of the seven murals to be
destroyed in the wake of the controversy. Coincidentally, it was also the
only West German city depicted, presumably chosen because it is the
birthplace of Karl Marx. Its inclusion may have been intended to suggest
that one day Germany would be united under Socialism.[22]

The Mattheuers created two murals, both of which, like Engels's are
largely black and white, although much darker in tone as a result of their
greater emphasis on black. In *Eisenach* (fig. 3.2), for example, artistic inspi-
ration was clearly taken from woodcuts: the faces of most of the figures are

Figure 3.2. Wolfgang Mattheuer and Ursula Mattheuer-Neustädt, *Eisenach*, 1965. Carved plaster, 300 x 900 cm. © 2018 Artists Rights Society (ARS), New York / VG Bild-Kunst, Bonn. Photo: author, 2005.

black with the details excised in white. Color is limited to the center of the image, where dark shades of red and yellow appear in two German flags and a fire. In the debate that followed, this mural received the most praise from political functionaries.

Heisig's murals, in comparison, are colorful abstractions. Like the others, they emphasize the importance of each city to the GDR. *Rostock* (fig. 3.3), located on the fourth floor, depicts one of East Germany's primary ports and therefore contains numerous images of boats and fish. A red building with a gabled roof and gothic arches, presumably referring to a building in the New Market in the town's center, stands in the middle of the composition. Below it, a gray stone, limbless tree, and the name of the city appear. These images divide the composition roughly in half. The left side focuses on historic Rostock: it shows a fisherman in a yellow slicker and black hat standing next to a swordfish and small sailing boat. Next to him on the left-most edge of the painting, a galleon sails toward a harbor in the distance. The right side of the image refers to Rostock's role in East Germany as a center for industry. Birds soar above modern freighters, behind which iron towers appear. In the foreground a figure in a welder's mask bends down in front of a pile of pipes, working on the construction of a ship.

Schwedt (fig. 3.4), which became a focal point in the subsequent debate, appeared on the sixth floor. Although not considered an important city today, Schwedt received much attention in East Germany, where it was viewed as a "symbol of the new, the forward-pushing in our Republic" because of its large factories for petroleum processing and nitrogenous fertilizer.[23] Heisig referred to the city's importance as an industrial center in his mural by incorporating numerous chimneys and factory buildings into

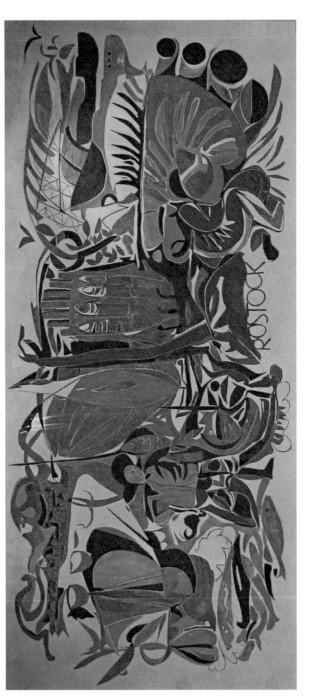

Figure 3.3. Bernhard Heisig, *Rostock*, 1965. Sgraffito, 300 x 900 cm. © 2018 Artists Rights Society (ARS), New York / VG Bild-Kunst, Bonn. Photo: author, 2005.

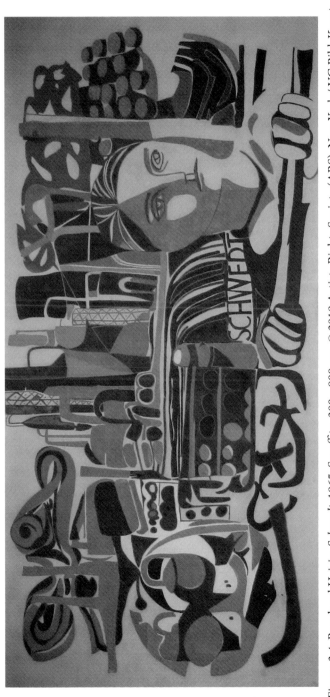

Figure 3.4. Bernhard Heisig, *Schwedt*, 1965. Sgraffito, 300 x 900 cm. © 2018 Artists Rights Society (ARS), New York / VG Bild-Kunst, Bonn. Photo: author, 2005.

the composition. The importance of the worker, however, is not lost in this industrial landscape but rather is emphasized by the large head of a woman that dominates the right half of the picture. She holds a tool in her hand and looks to the right, her goal seemingly in sight. That the worker is a woman connects the image to recent attempts by the East German government to encourage women to enter the skilled workforce.[24] The placement of the mural next to a window suggests that she is looking through it, thus emphasizing the close relationship between art and architecture desired by the party at this time. The worker appears earnest, strong, and proud—a person with an important mission. The vibrant red, blue, and yellow tones and the artistic play of the abstracted forms convey a sense of optimism.

Halle (fig. 3.5), located on the seventh floor, was the third mural Heisig created for the Hotel Deutschland. Unlike the other murals, he divided this one into three sections like a triptych. The central image focuses on the city marketplace with the Market Church of St. Marien and a sculpture of the eighteenth-century Baroque composer, Georg Friedrich Händel; to the lower right, the word "Halle" is clearly visible. The image on the left focuses on a worker standing next to a large metal beam in front of a cityscape, a reference to the construction taking place in Halle-Neustadt in the mid-1960s. The image on the right shows three figures stacked on top of each other. The two at the bottom clearly have rifles in hand, while the one at the top blows into a trumpet. This is a scene from "The Little Trumpeter," a popular song among children in the GDR and the topic of an East German film the previous year.[25]

When compared to the oil paintings Heisig had created to this point, these murals mark a significant shift in artistic style. Not only clearly East German in subject matter, the colorful, organic abstractions display an optimism seldom seen in his oeuvre. Indeed, they seem to illustrate the "optimism of Socialist life" so often championed by politicians. This shift in tone may have been a response, in part, to the criticisms leveled against him for his controversial speech at the Fifth Congress. Nor were the bright colors and optimistic tone limited to these murals: they also appear in a number of lithographs he created that year, including for the brochure commemorating the festival days for the eight hundredth anniversary of Leipzig (fig. 3.6) and for a publication of Bertolt Brecht's play *Mother Courage* (fig. 3.7). That such imagery appears in both in Heisig's murals and in his prints from 1965 and suggest he was working through ideas in a variety of media. In the case of the Hotel Deutschland murals, he was working in sgraffito, a technique that requires carving into a wall created by building up layers of different colors; to produce the

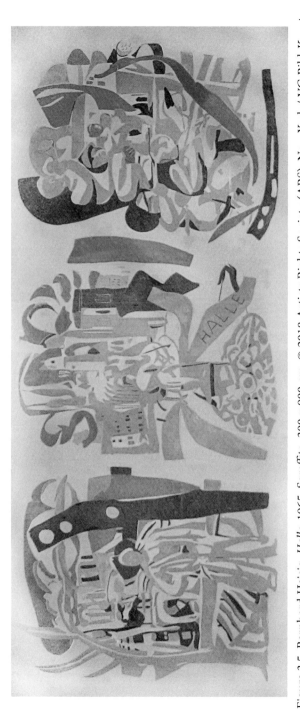

Figure 3.5. Bernhard Heisig, *Halle*, 1965. Sgraffito, 300 x 900 cm. © 2018 Artists Rights Society (ARS), New York / VG Bild-Kunst, Bonn. Photo: author, 2005.

800 Jahre Stadt Leipzig

*Festtage vom 25. September
bis 7. Oktober 1965*

Figure 3.6. Bernhard Heisig, cover design for *Festival Days in Leipzig*, 1965. Lithograph, c. 15 x 25 cm. © 2018 Artists Rights Society (ARS), New York / VG Bild-Kunst, Bonn. Photo: author.

Figure 3.7. Bernhard Heisig, illustration for Bertolt Brecht's *Mutter Courage*, 1964. Lithograph, size unknown. © 2018 Artists Rights Society (ARS), New York / VG Bild-Kunst, Bonn.

image, the artist had to cut down to the appropriate color level. Unlike oil painting, it is an unforgiving medium, and one that resists naturalistic representations.

While each of the murals created for the *Bettenhaus* heeded the dictate of the commission to create a linear-graphic work, not all of them are simple and easy to understand.[26] Of the six, Heisig's are the most difficult to read because of his playful use of form. This stylistic complexity is balanced by the optimistic tone created through the bright colors and swirling, organic shapes, an optimism lacking in the other artists' murals.[27] These two aspects of Heisig's work—their semi-abstract style and their optimistic tone—polarized opinion in 1965, placing them, and especially *Schwedt*, at the center of a heated debate about what was appropriate for *Kunst am Bau* (architectural art).

Kurella's Attack

On February 11, 1965, less than two weeks after all but one of the murals in the *Bettenhaus* were finished, they were lambasted as a whole in a five-page report written by Alfred Kurella. Personally invested in the art scene in Leipzig, Kurella had played instrumental role in bringing national attention to some of its younger artists in the late 1950s and early 1960s.[28] Indeed, it was Kurella, as head of the Cultural Commission of the Politburo until 1963 and vice president of the Academy of Arts in Berlin, to whom these artists had turned for help in the wake of the problems with the Opera House commission.[29] Presumably this investment—and, more specifically, a sense of betrayal of his support—informs the animosity in his report about the Hotel Deutschland murals.

In "Thoughts about the Murals in the 'Hotel Deutschland' (Leipzig)," Kurella denounced the murals, arguing that they "depict a true invasion of modernism and the theory of 'realism without boundaries' into our artistic life. . . . How could the creation of these images take place without the commission-giver and the governmental agencies that are responsible noticing and preventing [their] unbearable deviation from the party and government's views on art and politics?"[30]

Kurella's reference to "realism without boundaries" recalls Cremer's statement from the Fifth Congress the previous year and alludes to a book by Roger Garaudy that promoted a broader view of realism that many politicians rejected as revisionist. Unable to understand how such "revisionist" works could have been created for a major hotel built to celebrate Leipzig's

eight hundredth anniversary, Kurella demanded written explanations from those responsible for overseeing the commissions. He also called for meetings with the artists involved as well as with the Union of Visual Artists at both the local and national levels.

As Kurella saw it, murals throughout history had been created in the same style as the easel paintings of the day. The murals in the Hotel Deutschland were thus an attempt, in his opinion, "to smuggle in the whole nonsense of formalist, anti-realist, abstract, symbolic 'art' under the watchword of 'architectural art.'"[31] The comment recalls Heisig's controversial speech the previous year in which he had called for greater flexibility in the fine arts and pointed to architecture and applied arts as a place where this relaxation had already occurred.

Clearly, Kurella wanted a realistic style for the murals, one better suited to fresco rather than the sgraffito and carved plaster (*Gipsintarsie*) that had been chosen for the project, although he did not mention the choice of media in his criticisms. Nor did he see a contradiction in using a realist style for a modernist building. In terms of the murals themselves, he found the two by the Mattheuers to be "relatively acceptable," although "unnecessary formalist simplification" had led them to be ultimately "unsatisfactory."[32] Engels's work, in comparison, he found "fully unqualified."[33] The "primitive means" of the work was, in his opinion, "below the level of children's drawings."[34] A particular source of ire was the image of Marx and Engels in *Trier*, which he saw as a display of "impudent cheek."[35] He recommended it be covered up for the duration of the international trade fair that spring, after which its fate would be decided.

Kurella's strongest criticisms, however, were aimed at Heisig's work and take up an entire page of his report. As quoted earlier in the chapter, he found Heisig's murals "the most serious demonstration against our view of art. . . . Here is the principle of intentional *deformation, mutilation and uglification of reality* [as well as] the use and frequent mixing together of single *deformed fragments* . . . carried too far." He continued, "Only with effort can one recognize, in principle, the arrangement of these fragments of purely *formal effects* or *decorative* impressions ('rhythmically' distributed flecks of formless color detached from objects). In the painting 'Schwedt,' this anti-realism expresses (perhaps unbeknownst to the artist) a *hostility toward technology*. The *rhythmic* and *harmonious image* of the system of pipes, capacitors, [and] towers that portray to every viewer a modern petro-chemical factory is turned into an intentional chaos of unharmonious, broken, squashed, unrhythmic fragments of technical details!"[36]

For Kurella, these works expressed a life-view foreign to East Germany, a "time consciousness" nearer to pessimistic Western worldviews like existentialism.[37] *Schwedt*, in particular, he saw as expressing "a foreign view of art . . . Here a kind of art is propagated (and practiced) that refuses to illustrate reality and demands that the artist fundamentally juxtapose to reality an antireality."[38]

One factor in the venomous quality of Kurella's criticism is presumably a significant sense of disappointment and perhaps even betrayal: he had placed great hope for the future of East German art in the realism of artists like Heisig and Tübke. In a letter about the Opera House from October 1960, for example, he had called these artists "not only the most talented younger artists in Leipzig, but in the republic."[39] With regard to the sudden change to a modernist style demonstrated by Heisig's Hotel Deutschland murals, he stated, "The misfortune is that Heisig's talent and gift is as a *realist*. . . . He must therefore *force himself* to make anti-realism . . . to grasp at *Picasso and Léger*. It is embarrassing to see how dilettantishly he acquires the formal elements of these artists."[40]

Clearly, Kurella considered Heisig a linchpin for the future of East German art, and thus the change to a modernist style had implications that extended beyond the hotel and Leipzig. As he put it in the final sentence about Heisig in the report, "the ideological and art-theoretical discussion with Heisig on the basis of these paintings is of *fundamental meaning for our entire art* and must be thoroughly prepared and led."[41]

Scrambling to Respond

Within a few days of this report, which was forwarded to Kurt Hager at the Politburo in Berlin, the various organizations and individuals responsible for overseeing the Hotel Deutschland murals had filed written explanations of their view of and part in the project.[42] Together, these documents provide a fascinating glimpse into the complicated inner workings of East German cultural bureaucracy. They also suggest, like Kurella's report, that Heisig was a key figure in the discussions taking place about art at the time, especially in Leipzig.

On February 15, in a one-page letter addressed to the local branch of the party (SED-L), Heinz Mäde, head of the painting and graphics section of the VBK-L, defended the murals. He stated that the Leipzig branch of the Union of Visual Artists "fundamentally welcome[s] the solutions to the assignment" demonstrated by the works.[43] He also pointed out that murals

are not oil paintings with precisely readable details but rather decorative, ornamental creations that try to create a unity with the building. Of all the murals in the *Bettenhaus*, the VBK-L leadership found *Schwedt* and the Mattheuers' *Eisenach* to be the best because they capture "the beauty, strength, and optimism of our life."[44]

On the same day that the VBK-L wrote its letter, Gerhard Winkler, consultant for the hotel project and curator of the Museum der bildende Künste Leipzig (Museum of Visual Arts Leipzig), wrote a four-page letter to Paul Fröhlich, head of the SED-L. Recalling their meeting in front of the murals two days earlier, Winkler said that he would focus primarily on Heisig's work since that was where the two of them had differed the most in their opinions. He then went on to describe each of Heisig's murals, praising them as a whole: "The particular difficulty [of the works]—but in my opinion, what is innovative [about them]—consists in the fact that here an attempt was made to develop ornament on the basis of a political theme. To my knowledge, there has been no example of this in art and architecture until now."[45]

While Winkler acknowledged that the works were not perfect, he argued that they nonetheless indicated "a possible and promising way [forward]."[46] He concluded by saying that Heisig's murals were "a step forward" on the path of East German art and worthy of a "fruitful discussion" about the synthesis of art and architecture.[47]

The city council, which, as the commissioning body, was ultimately responsible for the murals, wrote a ten-page report—also dated February 15—plainly detailing the process as it had unfolded. It then turned to an evaluation of the murals that agreed with Kurella in most respects: it viewed both of the Mattheuers' murals as "successful" and dismissed Engels's *Trier* as "artistically immature and politically insufficient."[48] It also criticized Heisig's *Halle*, although mildly, for its lack of clarity. But the city council did not agree with Kurella on all points: unlike him, it viewed *Rostock* as "successful" and *Schwedt* as a "win" for its portrayal both of the city as a new industrial center of the GDR and of the decisive role of the new man: "This synthesis is successful because of the foreground portrayal of an optimistic human face and the conception of the dynamic process of labor."[49] It closed with a series of suggestions for improvement of the art process, including the need for artists to have more time for their work and an acknowledgement that too much time had been wasted in the earliest phases of the planning process before the artists were involved.

The Rat des Bezirkes (RdB, district council) of Leipzig followed with a fifteen-page report the next day that gave a similar listing of the murals'

development, although it emphasized what went wrong in the process and blamed the city council for much of it.[50] According to the district council, artists complained early on that they did not know who at the city council was responsible for making decisions about the murals. The district council also faulted the city council for focusing on content rather than on style and ideological concerns when discussing early sketches with the artists: the final works were essentially identical to the sketches they had approved.

In its evaluation of the murals, the district council agreed with Kurella on all points and with equal fervor. It dismissed Engels's work as having "ideological weaknesses" and praised the Mattheuers' work, which the council saw as "a starting point, a realistic way with artistic means, for future decorative murals."[51] It also condemned Heisig's work, denouncing *Halle* and *Schwedt* in particular for the "blurring of contents and the overemphasis on the formal."[52] As the district council saw it, *Schwedt*'s "overemphasis on the formal-decorative leads to an extensive disintegration of form and content—the violation of one of the most essential demands of a realistic artwork."[53] Significantly, it then pointed to Heisig's controversial speech at the Fifth Congress the previous year, which it saw as related: "[From that speech emerged] a formalist view that . . . can hardly be distinguished from [that of] many Western works of art and . . . cannot represent a method for the realistic artistic design of modern building projects in the future."[54]

The district council's report then turned to Kurella's question about how these murals could have come into being. It blamed the original commission, which had encouraged artistic experimentation, as well as the architect, who had apparently expressed interest in a "so-called bold modern [art]" rather than a "socialist realist" portrayal.[55] It cited the need for a discussion with artists about the basic ideological-aesthetic questions at stake in "our cultural politics" and ended by calling for such a discussion to take place, stating it was desperately needed, especially with regard to architecture and the visual arts.[56]

Of all the murals, *Schwedt* was the most contentious, revealing the biggest divide in opinion between artists and politicians. The VBK-L and the curator of the Museum of Visual Arts Leipzig singled it out for its beauty, strength, and optimism, while Kurella and the district council dismissed it for its distorted forms and arbitrary coloring. The city council, which was ultimately responsible for the works and thus had more at stake in defending them, expressed restrained praise, stating that Heisig's mural had found general approval.

In retrospect, the polarization of opinion around *Schwedt* suggests that it had hit a nerve in the debates taking place about art at the time. In this

work, Heisig had explored the possibilities of the sgraffito medium at a time when artists and politicians throughout East Germany were struggling to determine what Socialist art should be. Artists wanted the freedom to make that decision themselves and to create complex works of art suitable for Ulbricht's "educated nation." They also wanted the same freedom accorded to architects, who were allowed to explore the modernist tradition for inspiration. In Heisig's murals, and especially *Schwedt*, several local artists and art historians saw an attempt to create a new artistic style suitable for Socialism and thus emphasized the East German content and optimism of the works in their praise. Many cultural functionaries and politicians, on the contrary, simply wanted an easy-to-understand realism regardless of the medium and architectural space. Kurella's ire and the many reports written testify to *Schwedt*'s importance to the discussions about art then taking place in Leipzig as well as in East Germany more broadly. The debate over *Schwedt* showed that cultural policy in the GDR was far from monolithic. Multiple organizations were involved in the decisions being made about art, especially when it came to architectural art, and they did not always agree with each other. In fact, they often blamed each other when topics became heated.

Going Public

The debates over art that took place in these years were not limited to the administrative sphere. Indeed, a discussion about the Hotel Deutschland murals took place in several issues of the *Leipziger Volkszeitung* that summer, where it was intended to lead into reviews of the Seventh District Art Exhibition later that fall.[57] The hope was to interest the general public in art and to begin educating them about it. As Heisig had stated in a meeting that June: "We need an educated audience [*Fachpublikum*] for the visual arts."[58] It was a desire encouraged by the government itself through the Bitterfeld Conference and the Sixth Party Conference's call for an "educated nation." Increasing conversations about art in the press was one step toward these goals and reflected new efforts by the government to utilize newspapers more effectively to reach the public.[59] The articles published in the *Leipziger Volkszeitung* also coincided with the formation within the Union of Visual Artists of a new department for *Kunstwissenschaftler* (art historians). This department offered art historians and critics an officially recognized position from which to enter the artistic debates taking place at the time and related to Heisig's call in 1962 to "get experts involved."[60] In

comparison to the internal reports written about the murals in mid-February, however, the articles in the press were less vehement in their criticisms. They also focused on the appropriateness of the artistic forms chosen for the task at hand rather than viewing style as an indicator of political persuasion and thus as a threat to East Germany.

Just as in the behind-the-scenes reports about the Hotel Deutschland murals, *Schwedt* was a focal point in the discussion that took place later that summer. In fact, the first of the five articles in the series, published on July 10, 1965, was titled "A First Conversation with Professor Bernhard Heisig."[61] Written by Rita Jorek, the *Leipziger Volkszeitung*'s visual arts editor, it delivered a positive view of the murals in the hotel and was illustrated with a photo of *Schwedt*. The article began with the story of an "ordinary" cleaning woman who was so enthusiastic about Heisig's work that she offered "to explain the mural to us so that we might recognize its particular beauty."[62] But, as the author pointed out, "Heisig did not make it easy for her."[63] With these words, Jorek subtly challenged her readers to take the time needed to see the image and to understand "the artist's interpretation of reality."[64] She then went on to praise the cooperation of artist and architect demonstrated by the project as well as the artistic fantasy of the mural that was, according to Heisig, "not to be understood as an illustration of thoughts and ideas, but rather as an independent artistic creation."[65] Indeed, Heisig praised the commission's freedom from requiring a literal interpretation: "All too frequently it is forgotten that the happy attitude towards life that a work of art can produce also has an ideological function."[66] At the end of the article, Jorek invited "artists, art historians, and architects [as well as interested readers] to write to us so that the experiences that are won by this work can be harnessed for other occasions."[67]

Whereas Jorek's piece was wholly positive, the tone of the article published the following week was slightly defensive, suggesting that further discussions were taking place behind the scenes. Written by Günter Meißner, an important art historian in Leipzig, the second article in the series argued against the idea that the murals were too abstract: "From the beginning a photorealistic panorama of these cities was prohibited, since the murals in these passageways should convey their essence concisely and quickly and decorate the space."[68] He believed the "energy and personal passion . . . must be able to be experienced, the artistic form itself must be rich in content and not simply the means to an end of an ideal statement with the help of certain motifs."[69]

Of all the murals, Meißner liked *Schwedt* the best and dedicated almost a fourth of his article to it, three times as much space as to any other artist.

Despite the praise, however, it is clear he was also defending the work against the type of criticism found in Kurella's report: "This artist [Heisig], whose inclination toward the fantastic sometimes changes into bizarre deformation, does not want to offer pleasant drama [*wohlgefällige Pathetik*], but rather to pack sense and imagination with reassuring [*sic*] intensity. He scales back the diversity of symbols in favor of the overall effect, forces everything to a characteristically moving language of form that can at first appear shocking, the sense of which however comes from the content of the task. As such, much is 'made foreign' and what the eye perceives at first as a beautiful play of forms and colors—a completely legitimate function of architectural art—the imagination deciphers with observation."[70]

Two weeks later the tone of the discussion changed. In his article from July 31, 1965, Herbert Letsch, head of the cultural department of the *Leipziger Volkszeitung*, singled out Heisig's work on the murals as "an interesting attempt" that was "not sufficiently resolved."[71] He noted that the sgraffito technique did not seem suitable for the closeness of an inner room: "In my opinion, the viewer finds a discordant note between the intimacy of the room and the hard, one could say cyclopic symbolism of the image."[72] He also found the complexity of the image unsuitable for the quick view of the hotel guest: "[The image requires] more time and repeated viewing."[73] Letsch's article seems a compromise between the two sides expressed earlier in the reports: the artists were praised for their efforts, but the murals themselves remained unsuitable. His was the last substantive article on the murals published in the *Leipziger Volkszeitung*. A week later, a short and relatively neutral article by one of the architects of the building marked the premature and unexplained end to the series.[74]

The public discussion of the murals continued at the national level, however, in two professional journals, *Deutsche Architektur* and *Bildende Kunst*. In August, *Deutsche Architektur* published an article about the working relationship between artists and architects.[75] Largely a dialogue between representatives of these two groups, the article was illustrated with a photograph of *Schwedt* and included comments by Heisig, who expressed a desire for architects to have a clearer vision for the artistic decoration of their buildings and to share this vision with artists earlier in the process, "else a synthesis between art and architecture is not possible." Then, in October, Meißner published an article about the Hotel Deutschland murals in *Bildende Kunst*, the GDR's most important art journal.[76] *Schwedt* was the cover image for the issue. The article included several preliminary sketches for *Schwedt* in addition to photographs of all the finished murals. It singled out Heisig's work for particular praise, calling his efforts in all

Figure 3.8. Bernhard Heisig, *Berlin*, c. 1965–67. Carved plaster, 300 x 900 cm. © 2018 Artists Rights Society (ARS), New York / VG Bild-Kunst, Bonn. Photo: Foto-Brueggemann, Leipzig.

three murals courageous: "He didn't let the symbolism take over, but rather reduced and merged [the images] into a large decorative unity of moving, organic lines, surfaces, and colors. . . . Here the artist documents his own attitude toward life, not with a simple complacent contentment, but rather [by combining a] disconcerting intensity of the senses and fantasy . . . with a thoroughly optimistic foundation."[77]

Although Heisig had been at the center of controversy when he received the Hotel Deutschland commission and then again as a result of the murals themselves, he was selected to create the mural that ultimately replaced Engels's *Trier*. Sometime before 1967, when Winkler published an illustrated booklet about the Hotel Deutschland that discussed the building and its decoration, Heisig created *Berlin* (c. 1965–67, fig. 3.8), a work made from carved plaster that was located on the second floor of the *Bettenhaus*.[78] The work has a similar style to the others he created but is easier to read and more clearly propagandistic, suggesting a partial response to the earlier criticisms. The objects depicted unfold chronologically across the space, beginning with "1945" on the left and "1965" just to the right of center. In the middle, a giant fist holds up a hammer, next to which floats the head of a stalk of wheat. Together they mark the Socialist present. An unseen figure's right hand appears on the left side of the work, crushing a snake-headed swastika in its mighty grip. Behind it, flames shoot out above the Brandenburg Gate in reference to the city's destruction in the Second World War. According to the logic of the mural, this is the past that the Communists vanquished and from which East

Germany emerged. Between the two fists, the recognizable landmark of Berlin's *rotes Rathaus* (city hall) appears; on the right, images of the new Berlin, including the *Fernsehturm* (television tower) then under construction in Alexanderplatz. At the far right, three Picassoesque doves of peace fly toward the future.[79] While it was easier to read than his earlier murals at the Hotel Deutschland, *Berlin* continued with the swirling composition and abstracted forms criticized by Kurella but ultimately deemed a success by his colleagues in Leipzig.

Conclusion

The Hotel Deutschland murals illustrate an important if overlooked part of Heisig's oeuvre and a significant moment in his career. In the space of a decade, he created more than ten murals. Although these works have been largely overlooked in current scholarship, Heisig considered them important at the time, including them in his CV in 1972, together with his most important paintings and graphic works.[80] In fact, a desire to spend more time working on murals may well have played a role in his decision to resign from his position as director of the Leipzig Academy in February 1964. According to Willi Sitte, a good friend at the time, Heisig had left his position because he "wanted to dedicate himself to . . . large murals, which were easier to manage [as a] freelance [artist]. Not only were [murals] more lucrative, they also introduced him to interesting artistic experiences with carved plaster [*Gipsintarsie*] and sgraffito."[81]

These new artistic experiences likely included the challenge of creating work in a material ill suited for the realism that had dominated his paintings to that point. Indeed, it is in 1965 that Heisig engaged closely with some of Picasso's modernist work, creating a number of paintings he titled *Picassoides*. In the most accomplished of these paintings (1965, fig. 3.9), a female figure with thick red lips and black, above-the-knee boots sits in the center of Heisig's studio, her hands in her lap, a bookshelf visible behind her. Clearly Heisig was engaging here with the cubist interest in translating a three-dimensional object onto a two-dimensional surface without belying the flatness of the painted surface. This engagement marks a shift in his thinking on Picasso, whose cubist work had been of little interest to him up to that point. Indeed, it is these experiments with the flatness of the pictorial surface, together with his experiences at the congress the previous year that I believe contributed to the significant change in his artistic style that occurred at this time as evidenced by *The Christmas Dream of the*

Figure 3.9. Bernhard Heisig, *Picassoides*, 1965. Oil on canvas, 80 x 70 cm. © 2018 Artists Rights Society (ARS), New York / VG Bild-Kunst, Bonn. Photo: copyright Galerie Brusberg Berlin.

Unteachable Soldier, a painting that was first exhibited in October 1964, just a few months *after* Heisig began working on these murals.[82]

Heisig's murals were also considered important by his colleagues. In a letter recommending him for the highly prestigious Kunstpreis der Stadt Leipzig (City Art Prize of Leipzig) in 1966, the VBK-L wrote, "In the GDR, his architectural works for the Interhotel Deutschland have received much attention. With them, as with all his work, he brings formal problems to light that activate the conversation about the further development of our national art in interesting and positive ways."[83]

This recommendation further illustrates the complexity of cultural politics in East Germany in these years. Policies were not simply handed down from on high but rather were discussed and debated at the local level without agreements necessarily being reached. Moreover, Heisig could be under investigation for his controversial speech at the Fifth Congress and yet still be recommended for a prestigious award, receive important commissions, exhibit work in major exhibitions, and continue to mold impressionable minds as a professor at the Leipzig Academy.

Ten months after Kurella's report, the debate over the murals was finally over, but another was about to begin. In October 1965, the same month that Meißner's article on the Hotel Deutschland murals appeared in *Bildende Kunst*, the legendary Seventh District Art Exhibition in Leipzig opened. Within weeks, Heisig would be at the center of yet another debate, this time over his painting *The Paris Commune*.

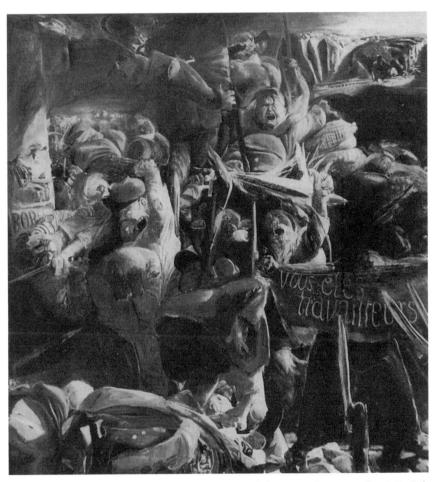

Figure 4.1. Bernhard Heisig, *Pariser Kommune* (The Paris Commune), 1965. Oil, 150 x 140 cm. © 2018 Artists Rights Society (ARS), New York / VG Bild-Kunst, Bonn. Subsequently destroyed through overpainting. Photo: Horst Clauß / Rolf Lotze.

THE CONTENTIOUS EMERGENCE OF THE "LEIPZIG SCHOOL"

As the debate over the Hotel Deutschland murals unfolded in the *Leipziger Volkszeitung* in the summer of 1965, preparations were being made for the Seventh District Art Exhibition in Leipzig.[1] Organized by the local chapter of the Union of Visual Artists, this exhibition was, along with the opening of the hotel, one of the major cultural events in the year-long celebrations for the city's eight hundredth anniversary. Held at the Messehaus am Markt, a new building located across the square from the historic city hall in downtown Leipzig and just up the street from the Hotel Deutschland, "the Seventh" contained 759 works by 175 artists, including three paintings and a number of prints and drawings by Heisig.[2] One of these, a large oil titled *Pariser Kommune* (The Paris Commune, 1965, fig. 4.1), became embroiled in controversy before the exhibition closed, Heisig's third such entanglement in less than two years.[3]

The controversy around *The Paris Commune* centered on the seeming pessimism of the work, which marked a significant change in his portrayal of the subject. The first Socialist government on European soil, the short-lived Paris Commune was considered an important precursor to the GDR by many in East Germany and was a topic that Heisig had been making prints and paintings about for several years. But whereas his paintings from 1960 and 1962 focused on the beginnings of the commune, the hopeful early days after it was first established in March 1871, the 1965 painting focused on its bloody end two months later when, in

May 1871, Parisians vainly defended their newly created Socialist govern-
ment against heavily armed French troops. In addition to the temporal
shift to the end of the commune, the 1965 painting also marked the cul-
mination of a stylistic change in Heisig's work that began in the wake of
his controversial speech at the Fifth Congress with the *Christmas Dream
of the Unteachable Soldier* (1964) and the Hotel Deutschland murals—
away from the straightforward realism that had previously dominated his
easel paintings to one that combined multiple moments and events into
one complex image.

Initially, *The Paris Commune*—like the exhibition as a whole—received
positive reviews in the press. Describing the work as "energetic" and "explo-
sive," critics from Leipzig viewed it as a "symphony of dramatic tones" that
made "the unstoppable strength of the Communards noticeable."[4] As time
went on, however, critics from beyond Leipzig began to attack the paint-
ing on both stylistic and thematic grounds. These attacks culminated the
following spring with an article in *Bildende Kunst* in which Harald Olbrich
stated that Heisig's "superficial interests in problems of form . . . and writh-
ing amorphously doughy masses decidedly limit the partisan value of the
commune."[5]

This chapter looks at how Heisig's treatment of the Paris
Commune—the longest-running series in his oeuvre—developed from
its first emergence in a series of prints in the mid-1950s to the contro-
versial painting shown at the Seventh District Art Exhibition in 1965.[6]
By looking at how these works changed over time and at their recep-
tion in the press, this chapter shows the strong relationship between
these works and the changing East German context in which they
were created. Indeed, it reveals how artistic discussion created a field
of friction in which artists like Heisig honed their ideas. This chapter
also reveals the connection between the changes evident in the 1965
version of the painting and both Heisig's 1964 speech and the Hotel
Deutschland murals.[7]

Before turning to these paintings, however, it is necessary first to
look at the Seventh District Art Exhibition in Leipzig, which marked
another concerted effort among a younger generation of artists, includ-
ing Heisig, to make Leipzig a center for painting. In sharp contrast to
the Sixth, however, where they emphasized a conservative realism that
appealed to politicians, they now championed a complex, modern style
of art. Working together with local art historians, who wrote positive
reviews of the exhibition when it first opened, artists used the Seventh to
push for an art more suitable for the "educated nation" of East Germany.

The Seventh District Art Exhibition in Leipzig, 1965

The VBK-L began planning for the Seventh District Art Exhibition in July 1963.[8] At this time artists throughout East Germany were discussing what art and their role as artists should be because of the Sixth Party Conference of the SED. Held in January 1963, the conference announced a new phase in East German society, one that ushered in sweeping changes under the name of the New Economic System (NES). The NES focused on the comprehensive building of Socialism in which artists and writers alike were encouraged to play an active role, which led, in part, to the controversial speeches given at the Fifth Congress of the Union of Visual Artists the following year. In Leipzig, artists like Heisig who had become dissatisfied with the conservative realism found in paintings by Klaus Weber and Heinrich Witz used the NES to advocate for a more complicated art, one appropriate for Ulbricht's "educated nation." Indeed, before the VBK-L released a call for submissions for the Seventh, it scheduled studio visits for those "colleagues whose naturalist tendencies have brought discredit to Leipzig in past years."[9]

When planning for the exhibition began in 1963, Heisig was no longer on the board of the VBK-L, having resigned his position in 1962. He was nonetheless still actively engaged in the Leipzig art scene as an artist, professor, and director of the Leipzig Academy. As a professor, he regularly taught a course in graphic arts as well as a painting class he had established shortly after becoming director of the school in 1961. Two of his earliest students in this class, Hartwig Ebersbach (b. 1940) and Heinz Zander (b. 1939), submitted works for graduation in 1964 that had many of the hallmarks of the "new" Leipzig School that would emerge the following year at the Seventh District Art Exhibition in Leipzig: they were complex, ambiguous works done in a modernist style.

Although the planning for the Seventh began in mid-1963, the call for submissions first appeared much later, on March 25, 1965, a little more than two months after the controversy over the Hotel Deutschland murals began and seven months before the exhibition itself opened. In a two-page document titled *Call to All Visual Artists in Leipzig*, the VBK-L announced its hope that the exhibition would contribute "to making Leipzig a modern Socialist metropolis" and described the current cultural situation: "Once again . . . artists, art critics, and cultural politicians are busying themselves with questions about artistic means—which artistic formulations are an adequate expression of our times; to what extent can individual talents and leanings be integrated into a larger, objective message about the problems

of our times; how can artistic development be pushed forward [*vorange-trieben*] by a true Socialist and artistic difference of opinions."[10]

In this pursuit, the call for submissions pointed out, artists must make their own decisions as to which themes they are able to portray with the means at their disposal. The call also emphasized that the further development of Socialist art depended on the full unfolding of a variety of talent. The document ended with a call to artists to submit their best work "to help make this exhibition varied, interesting, and engaging . . . [and thereby] to contribute to a true artistic difference of opinions [*Meinungsstreit*] and to the further development of artistic production in Leipzig."[11]

More than one hundred artists heeded the call to submit work. From Heisig, the jury accepted three paintings, three drawings, and six lithographs. The drawings and prints were untitled works, only one of which— a black-and-white lithograph—was illustrated in the catalog: it depicts a nude woman reclining on a sofa behind a small table of food and drink. Of the paintings exhibited, two were portraits of women: his future wife, Gudrun Brüne, and the National Prize–winning singer, Eva Fleischer. *The Paris Commune* was the only history painting he showed and was the only one of his paintings reproduced in the catalog. Today, a black-and-white photograph is all that remains of the work, the original having been over-painted at a later date, a frequent occurrence in Heisig's oeuvre.

In *The Paris Commune* (see fig. 4.1), Heisig depicted the final, tragic moments of the commune in a simultaneous narrative composition that combined multiple moments and perspectives: Communards and soldiers merge in the chaos of hand-to-hand combat. Only with effort can the individuals—let alone the two sides—be distinguished from each other. Just to the right of the center, a figure with his mouth open holds up his left hand as if pronouncing the words on the banner before him; it reads, in French, "vous êtes travailleurs" (you are workers).[12] A woman with her head bowed holds the banner up between her outstretched arms like a shield against the approaching bayonets. Along the bottom left-hand corner, a man with a bandaged head lies supine on the ground, apparently dead. Another figure—curled into himself, perhaps wounded in the stomach—falls forward onto him. To the right of the falling figure, an old man buries his head in his hands in despair. Behind him, two figures struggle, one turning back to face us, his fist raised in the air in defiance. Near the advertising column at the far left, the face of a blond woman disappears amidst the fighting. Above her a figure in a military uniform arches backward, apparently lifted from the ground by the force of a blow. To his right, just above the center of the painting, another face with an open mouth—screaming in defiance

or fear—is clearly visible. While the complex style was new, Heisig had created several paintings about the Paris Commune before this one; it was a topic he had been engaging with for more than a decade.

The Paris Commune in Heisig's Oeuvre, 1956–64

Heisig first began working on the Paris Commune in the mid-1950s. Primarily a graphic artist at the time, he created a series of more than fifteen black-and-white lithographs on the topic between 1956 and 1958. These works fall into six main compositional groupings, all of which focus on a handful of Communards.[13] In some, they gather together and seem to be posing for the image; in others the battle has begun. In most of these early works, the emphasis is on waiting rather than on the battle itself, and the style reflects a straightforward realism.

In *Kommunardengruppe mit Kanone* (Group of Communards with a Cannon, 1956, fig. 4.2) more than twenty men, women, and children gather, some sitting, most standing. A cannon appears at the far left of the composition, a reminder of the origins of the commune both in the Franco-Prussian War (1870–71) and in the new French government's attempt to confiscate the Communards' weapons shortly thereafter; this was one of the events that catalyzed Parisians into creating the Paris Commune in the spring of 1871. A man in a business suit and goatee leans against the cannon on one side; an older woman in a long, light-colored dress rests both hands against its barrel on the other. Behind her, a National Guardsman—identifiable by his uniform and cap—stands in the back row and raises his hand in a fist. Some figures laugh; others appear serious. A faceless man stands above the rest with his hand on his hip, the vague outlines of city buildings visible behind him. Altogether, the image captures the diverse range of people who came together in Paris under the auspices of the commune, reflecting Heisig's interest in the question of what motivates ordinary people to take up arms in the defense of a cause.

In *Barrikaden II* (Barricades II, 1956, fig. 4.3), we look over the backs of a row of Parisians standing behind a shoulder-height barricade. They watch intently as a mass of battling figures spills across a bridge only a few yards away. The figure closest to us waves a banner at the approaching mob. Next to him, a fallen chair on one side and several hats on the other suggest the speed with which this group has jumped to attention. In this image, the battle is nearly upon them and the figures appear tense in anticipation of what is to come.

Figure 4.2. Bernhard Heisig, *Kommunardengruppe mit Kanone* (Group of Communards with Cannon), 1956. Lithograph, 33 x 45 cm. © 2018 Artists Rights Society (ARS), New York / VG Bild-Kunst, Bonn. Museum der bildenden Künste Leipzig (Inv.-Nr 1989-353). Photo: Museum der bildenden Künste Leipzig.

Like the paintings Heisig would make on this topic in the later 1950s, these prints reflect a knowledge of the historical event gained from studying surviving photographs and reading books, including Prosper Olivier Lissagaray's eyewitness account *History of the Paris Commune of 1871* (1876). In his research into the topic, Heisig paid particular attention to the clothes worn and weapons used and eventually became so familiar with the different sites of confrontation that he was later able to find them himself when he visited France in 1977.[14]

It seems significant that Heisig first began working on the Paris Commune in 1956, the same year that the reforms unleashed by Nikita Khrushchev's de-Stalinization speech reached their climax with the Hungarian Revolution. Like with the uprising in East Germany in 1953, Soviet tanks violently suppressed the popular protest. Thousands lost their lives, thousands more were imprisoned, and many more lost faith in the Socialist project. This event marked a major break between the ideals of

Figure 4.3. Bernhard Heisig, *Barrikaden II* (Barricades II), 1956. Lithograph, 33.5 x 44.5 cm. © 2018 Artists Rights Society (ARS), New York / VG Bild-Kunst, Bonn. Museum der bildenden Künste Leipzig (Inv.-Nr 1989-359). Photo: Museum der bildenden Künste Leipzig.

Communism and its reality, and, in its wake, the number of East Germans emigrating to the West steadily rose, leading ultimately to the SED's decision to build the Berlin Wall in August 1961.

In the same year that Heisig began working on the Paris Commune thematic, Bertolt Brecht's play *The Days of the Commune* (1948) was performed for the first time in East Germany. It premiered in November in Karl-Marx-Stadt, a city not far from Leipzig, and focused on fourteen moments in the history of the Paris Commune. Although Heisig later denied any connection between his interest in the topic and Brecht's play, the timing suggests that he was not alone in seeing the Paris Commune as a topic relevant for addressing issues important to East Germany in these years.

Although archival evidence suggests Heisig created his first painting on the Paris Commune in the latter half of the 1950s, the first paintings

Figure 4.4. Bernhard Heisig, *Pariser Märztage I* (March Days in Paris I), 1960. Oil, 123 x 153 cm. © 2018 Artists Rights Society (ARS), New York / VG Bild-Kunst, Bonn. Subsequently destroyed through overpainting. Photo: Rolf Lotze / Horst Clauß.

with definitive dates are *Pariser Märztage I* (March Days in Paris I, 1960) and *Pariser Märztage II* (March Days in Paris II, 1961), both of which appeared in the Sixth District Art Exhibition in 1961 and its catalog.[15] Together with *Gera Workers*, these paintings mark Heisig's emergence onto the East German art scene as a history painter. They also display the conservative realist style typical of Heisig's painted work before 1964. The first painting (fig. 4.4) shows more than twenty Communards—some standing, some sitting—in a stiff frontal pose. They look at us and seem to be waiting as if we are a nineteenth-century photographer about to take their picture. Indeed, one man, just left of center, seems to be posing: left hand on his abdomen, head held high, he holds a rifle with bayonet to his right side.

The second painting (fig. 4.5) depicts a large number of Communards milling about in what is presumably a city square. Some have their backs turned to us and appear to be in the midst of conversation. Others turn

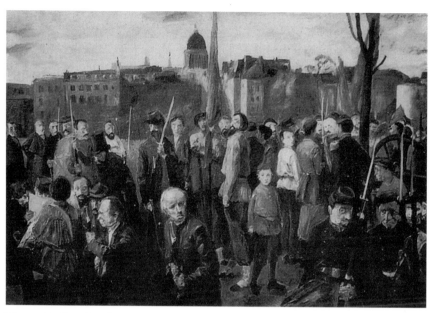

Figure 4.5. Bernhard Heisig, *Pariser Märztage II* (March Days in Paris II), 1960/61. Oil, 127 x 189 cm. © 2018 Artists Rights Society (ARS), New York / VG Bild-Kunst, Bonn. Subsequently destroyed through overpainting. Photo: Rolf Lotze.

from their companions to catch our gaze; they appear wary. One of these figures, a bearded man just to the right of center, recalls Gustav Courbet, a painter who was an active participant in the Paris Commune but never created a work of art about it. In comparison to the first painting, this one shows more movement, and the figures are interacting with each other as if conspiring. The perspective is also closer, suggesting that the person recording the image is actually mingling among the people.

Both of these paintings elicited much discussion in the local press when shown at the Sixth District Art Exhibition in late 1961. Indeed, even Walter Ulbricht is said to have commented upon them when he visited the exhibition: "The communards didn't sleep, they stormed!"[16] This quote appears in most of the reviews of the exhibition that mentioned Heisig's work, although many also praised the artist for having chosen a subject from the revolutionary history of the working class. Those that criticized him focused, like Ulbricht, on the work's seemingly pessimistic tone:

Heisig chooses the situation in March 1871 when the Paris Communards took power into their hands. But the knowledge of the terrible end that

the reaction delivered to the Communards hangs over the whole picture. One cannot get rid of the impression that the people shown stand at lost posts, determined to put their lives into the fight, but already knowing that they will succumb to the enemy's superiority . . . the strength of the revolutionary vigor of the proletariat of those days is not to be sensed.[17]

Reviews suggest that the jury had leveled a similar criticism when deciding whether to accept these two works into the exhibition. Indeed, the changes in the second painting appear to be the direct result of these conversations: "Bernhard Heisig decided to repaint the second version of this theme between the jury [meeting] and the exhibition opening and thereby tried to make use of the jury's suggestions [which had criticized the pictures' lack of revolutionary vigor]. The second version is somewhat more active, although he has still not overcome the general tendency of his [original] approach to the topic."[18]

The criticisms of Heisig's paintings were intended as suggestions to the artist for improvement. As one reviewer put it, "We are convinced that with further party-oriented encounters with such important themes, the artist will come to a portrayal of self-consciously functioning people."[19] Other reviews suggested that Heisig was similarly dissatisfied with the paintings, which he considered to be "important preparatory works for the next attempt at a solution" rather than finished paintings in themselves.[20] Indeed, he destroyed both of them through overpainting in the wake of the exhibition's closing in December 1961. *March Days in Paris I* became *Pariser Märztage III* (March Days in Paris III), better known today as *Kommunarden* (Communards, fig. 4.6). This third painting was exhibited nine months later at the prestigious Fifth German Art Exhibition in Dresden in September 1962. It is the first painting on the topic to survive and the first for which we have a color reproduction.

Like the earlier works, *Communards* depicts a group of men and women, young and old, gathering on a street corner for a photograph. Some wear military uniforms and decorative swords, others carry bayonets, and some wear civilian clothes. A woman whose face is in shadow stands to the left of center, light reflecting off her long red skirt. In future paintings, she would become Lady Liberty charging forth with a Communist red banner in hand. In this painting, she stands as one in the crowd, albeit subtly separated from them. In front of her, a man in a white undershirt and hat leans forward to straighten out the center of a red banner. Like the banner in the *Paris Commune*, it states in French, "you are also workers." Next to him, another man pulls up cobblestones

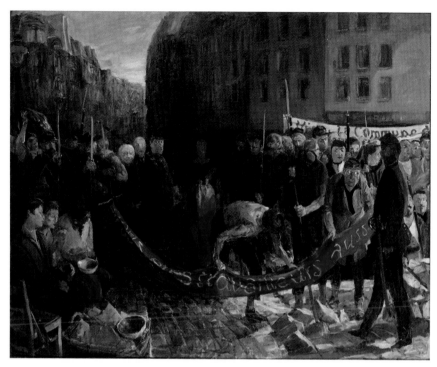

Figure 4.6. Bernhard Heisig, *Pariser Märztage III / Kommunarden* (March Days in Paris III / Communards), 1962. Oil painting, 123.5 x 152.5 cm. © 2018 Artists Rights Society (ARS), New York / VG Bild-Kunst, Bonn. Museum der bildenden Künste Leipzig (Inv.-Nr. G 2178). Photo: bpk Bildagentur / Museum der bildenden Künste Leipzig / Bertram Kober (Punctum Leipzig) / Art Resource, NY.

with a spade, while a third holds up part of the red banner and looks at us through thick spectacles. Behind them a group of more than fifteen figures looks at something taking place beyond the right-hand side of the image. A white banner emblazoned "Vive la Commune" appears behind them. To the left of "Lady Liberty," an old woman, a soldier, and a man in a suit stare at us. Next to them a man disappears into the crowd with one end of the red banner, his muscled arm visible. In the bottom left corner, three figures sit on wooden chairs in front of a large basket; they seem to be eating and talking with each other as they wait. At the bottom right, a man in uniform turns to face us, the viewers, suggesting that we are part of—or just joining—the group portrayed. In comparison to the earlier paintings, *Communards* shows movement: the figures gather for the photograph that has yet to be taken.

The response of the press to this painting was mostly positive. In a review of the Fifth German Art Exhibition—illustrated with a black-and-white copy of Heisig's painting—the Leipzig art historian Henry Schumann observed that "the new version of the *Paris Commune* . . . [shows] particular advances in content over earlier versions; the street ballad quality and passiveness of his forms is retreating ever more."[21] Similarly, Joachim Uhlitzsch, who had been ambivalent about Heisig's Paris Commune prints in 1959 and critical of his paintings in 1961, praised the work:

> In the new version, Heisig has given the theme a different content. The Communards stand as a uniform front and await the enemy. The hints of depression that were characteristic of the painting in the district exhibition have given way here to an expression of decided preparedness for the battle. "Vous êtes travailleurs aussi" [You too are workers] stands on the banner that will be held up in the path of the enemy soldiers who are expected to attack. The image, painted in deep, broken colors, the red tones of which are the most important accent, holds a high painterly appeal. The painting could also be titled "Before the First Attack." "Before the Final Defeat" would have been the title one could have written under the earlier version.[22]

Two years later, in the fall of 1964, Heisig exhibited another painting on the Paris Commune, a triptych, at an exhibition celebrating the Leipzig Academy's two hundredth anniversary.[23] This was the same exhibition where, in the wake of his controversial speech at the Fifth Congress, he showed *The Christmas Dream of the Unteachable Soldier*, the first painting in his oeuvre to evidence a complex, simultaneous narrative composition. Whereas this painting, together with its pendant, *Jewish Ghetto Fighters*, were illustrated in the catalog, the Paris Commune triptych was not, leaving no record of what it looked like. The only clues come from an article by Rita Jorek published in the *Leipziger Volkszeitung* at the time:

> One can also admire the three parts of *Paris Commune* by Bernhard Heisig, although the theme is not properly dealt with in this most recent version. In a color composition he created an exciting uprising, fight, and end of the commune. Had he succeeded in portraying the mass of people as really upright people—it is hinted at in the third part—then a brilliant work would have come into being. Now the first two parts recall something of Dix and the senseless murder of war.[24]

With this work, it would appear that Heisig had begun to change his approach to the theme from an emphasis on waiting evident in his early

prints and paintings to a depiction of the final battle that would prove so controversial in the work he exhibited at the Seventh District Art Exhibition the following year.

The Leipzig School

At the Seventh, Heisig was not alone in presenting controversial work: several of his colleagues also exhibited modern paintings that focused on pessimistic subject matter. These works marked a departure for painting in Leipzig and the emergence of the Leipzig School of modern painters. Werner Tübke's *Lebenserinnerungen des Dr. jur. Schulze III* (Reminiscences of Judge Schulze III, 1965, fig. 4.7) was one such work. A large tempera painting, it focuses on the fictional judge, Schulze, who sits in the center of the composition wearing a pink-and-white judicial robe and hat. A closer look reveals him to be a metallic mannequin anchored down by several ropes as memories of his past swirl around him: images from his bourgeois upbringing appear to his left, scenes of execution and torture resulting from his judgments in the Nazi period to his right. He gazes at these latter events with a toothy smile that—together with the rest of his features, including a thin mustache, red circles for cheeks, and long-lashed eyes, one of which wears a monocle—has been coarsely painted onto his football-shaped head. According to Tübke, this painting was made in response to "neofascist tendencies" in West Germany, including the Auschwitz trials then taking place.[25] The harsh colors and depiction of Schulze as a mannequin were intended to distance the viewer from the figure, making it easier to pass judgment on him for his crimes.

Wolfgang Mattheuer, another of Heisig's contemporaries and one who also worked on the Hotel Deutschland murals, exhibited *Kain* (Cain, 1965, fig. 4.8), a surrealistic blue monochromatic painting depicting the biblical story of the first murder. It shows a bald, broad-shouldered man with a knife in his hand lumbering away from his brother, Abel, a thin man who grabs at his throat. In the background, a mother and child look on at the left, while a modern city at the right indicates that this is a contemporary retelling of the tale. Although Mattheuer himself did not explain his intentions with the work, critics saw it as a response to the "deluded savagery of genocide," be it in Algeria in the late 1950s or, more recently, in Vietnam.[26] Indeed the conflict in Vietnam was a topic much discussed in the East German news in the months leading up to this exhibition. Referred to as

Figure 4.7. Werner Tübke, *Lebenserinnerungen des Dr. jur. Schulze III* (Reminiscences of Judge Schulze III), 1965. Tempera on canvas on wood, 188 x 121 cm. © 2018 Artists Rights Society (ARS), New York / VG Bild-Kunst, Bonn. Nationalgalerie, Staatliche Museen, Berlin, Germany (A IV 581). Photo: bpk Bildagentur / Nationalgalerie, Staatliche Museen, Berlin / Jorg P. Anders / Art Resource, NY.

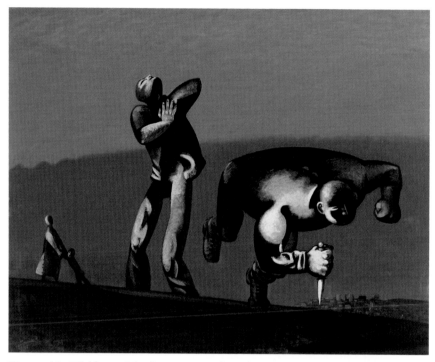

Figure 4.8. Wolfgang Mattheuer, *Kain* (Cain), 1965. Oil on hard fiber, 95.5 x 118 cm. © 2018 Artists Rights Society (ARS), New York / VG Bild-Kunst, Bonn. Kulturstiftung Sachsen-Anhalt—Kunstmuseum Moritzburg (MOI01718). Photo: Klaus E. Göltz.

"the dirty US war in Vietnam" in SED documents of the day, headlines in the *Leipziger Volkszeitung* in 1965 included "USA Terror in Vietnam" (May 1), "South Vietnamese Patriots Deal the USA New Blows" (May 28), and "300 Air Pirates Shot Down" (May 28).[27]

Heinz Zander, a recent graduate from the Leipzig Academy and former Heisig student, responded explicitly to the increasing American military presence in Vietnam in a lithographic print titled *Helden der Freiheit* (Heroes of Freedom, fig. 4.9), which appeared prominently on the cover of the exhibition's catalog. It depicts seven grotesque figures holding machine guns and crossing a river.[28] The physical distortions of the figures reflect the immorality of their task. The one in the center—the insignia of a US corporal visible on his left arm—wears a gas mask.

Each of these works, and Heisig's, was reproduced in the exhibition catalog, which praised the breadth of "artistic individualities" shown in

Figure 4.9. Heinz Zander, *Helden der Freiheit* (Heroes of Freedom), 1965. Lithograph, 30 c 45 cm. © 2018 Artists Rights Society (ARS), New York / VG Bild-Kunst, Bonn. Photo: Rolf Lotze / Horst Clauß.

the exhibition and the fact that "a number of . . . Leipzig artists have found their personal style, which has made it possible for them to portray the important societal and political themes [in an individual and interesting way]."[29] The introduction to the catalog makes clear that the VBK-L had conceived of the exhibition as an opportunity to discuss the artistic development that had taken place in Leipzig since the previous district art exhibition four years earlier. It also suggests that the VBK-L was proud of the new works:

> The artists of Leipzig are convinced that they have achieved a further contribution to the development of socialist realism. We express the wish that the works presented in this exhibition might elicit a lively intellectual discussion and enrich [*befruchten*] the conversation about the important tasks and possibilities of art in our time.[30]

The paintings by Heisig, Mattheuer, and Tübke, among others, showed a significant shift away from the realism that had brought Leipzig to artistic prominence in 1953 and again in 1961.

Just as the catalog praised the new works, so too did the press early on. Even before the exhibition opened, there was an article in the *Leipziger Volkszeitung* that applauded the "variety of artistic expression" in the art submitted and expressed the feeling that Leipzig "artists have found themselves."[31] This sentiment was repeated in the full-page, illustrated review that appeared one week after the exhibition opened: the Seventh "is one of the most interesting" district exhibitions that has taken place in Leipzig.[32] The unnamed author singled out the variety of expression and artistic styles for praise, connecting them to the revolutionary—but acceptable—changes that had taken place in architectural and applied arts in recent years. The author also pointed to the importance of drawing for these works and thus emphasized their connection to Leipzig's artistic tradition. This opening review was followed each week by a substantial article on a single work from the exhibition. These were written by important art historians working in Leipzig and focused on what would become the exhibition's most controversial paintings.

On October 16, Henry Schumann published an article about Tübke's painting. In "Allegory of Injustice," he explained the painting in terms of the "Nazi blood judges" still working in West Germany.[33] Schumann pointed to the recent case of Hans Globke, who had been West German chancellor Konrad Adenauer's right-hand man until his past role as one of the writers of the 1935 Nuremberg Laws became the focus of public outcry. Schumann concluded the article by stating that Tübke's work was both an accusation and a warning.

On October 23, Dieter Gleisberg, director of the Museum of Visual Arts Leipzig, published an article about Mattheuer's painting titled "Das Gleichnis des Kain" (The Parable of Cain). In it, he called the painting one of Mattheuer's most important to date. He praised it for its removal of unnecessary detail and saw the monochrome color palette as lending it a monumental quality. Like Schumann's view of Tübke's painting, Gleisberg saw this work as a warning against the barbarity of war and the inhumanity of genocide.

The final article in the series focused on Heisig's *Paris Commune* and was written by Günter Meißner, the art historian who had defended Heisig's murals that summer. In "A Picture of the Commune," Meißner began by talking about the historical event itself and its link to the present before turning to Heisig's painting:

> For eight days an embittered street fight raged before the Prussian-supported reactionary forces suffocated the Paris Commune . . . in a sea of blood. The greatness and tragedy of this first proletarian revolution

remains alive . . . as legacy and lesson . . . in the German working classes. But slight was its echo in the visual arts. . . . Today, almost one hundred years later, with the dreams of the Paris Communards a reality in many lands, visitors to the Seventh District Art Exhibition stand before an image by Bernhard Heisig that is dedicated to this event.[34]

Meißner admitted that Heisig did not make it easy for the viewer, and then looked at how the work functioned as a commentary on the present: "Heisig paints historical events not for remembrance alone, but rather as a rousing warning to contemporaries. His own experiences and visions flow into this appeal against the strengths of death and repression that still threaten today. That is why the main attention is to the tragic side of the commune."[35]

After praising the style of the painting, which he compared to music in its subordination of details to the overall effect of the work, Meißner went on to point out that the image in the catalog and the article no longer existed; it had been reworked. This, he explained, was the result of "Heisig's always searching, never content attitude."[36] He then concluded that "out of innermost conviction, [Heisig] dedicated a picture, upsetting to some, to the main question of our being: the fight against death and oppression."[37] This last comment almost certainly would have echoed within the context of the escalating war in Vietnam.

Significantly, each of the three paintings singled out for coverage in the *Leipziger Volkszeitung* displayed a modernist aesthetic—simultaneous narrative in the case of Tübke and Heisig; surrealism in the case of Mattheuer. All three also engaged critically with pressing political issues of the day and, in particular, with what they saw as fascist aggression. As such, they exhibited an East German perspective on the world, albeit not the optimism or simplicity expected from art. In fact, these paintings stood in sharp contrast to the straightforward realism and cheerful subject matter praised by politicians just four years earlier at the Sixth District Art Exhibition, where Heinrich Witz and Klaus Weber were the most important names. The change to a modern artistic style was one the artists and art historians in Leipzig wanted, as evidenced by their praise of the works in the press. This desire for change is also evident in the meeting minutes.

The early praise of the Seventh was not limited, however, to the catalog and articles by art historians. On the second day of the exhibition, Paul Fröhlich of the local branch of the party noted that the Seventh was "a remarkable step forward for Leipzig artists," a statement not unlike that found in the catalog.[38] He added the caveat, however, that this statement was not a final judgment. His caution proved prescient.

The Controversy around *The Paris Commune*, 1965

On November 6, just one week after Meißner's article on *The Paris Commune* appeared in the *Leipziger Volkszeitung*, the first negative review of Heisig's painting was published. Written by Werner Krecek, head of the newspaper's cultural department, "Letter about a Painting" appeared under the pseudonym Klaus-Dieter Walter and was presented as a letter sent in by a reader. It begins by praising the exhibition as a whole before concentrating on Heisig's painting. Acknowledging that such a topic must be difficult for an artist to portray, Krecek nonetheless had "objections."[39] He stated that Heisig's painting "doesn't breathe the spirit" of the Communards.[40] These were people who worked day and night, he pointed out, to create a society that would become the model for the Socialist state. "Perhaps it is not even possible to show that in an image when one only portrays the end."[41] Perhaps if the painting were called "The Last Days of the Commune," it would be okay, he admitted. Ultimately, however, it was Heisig's focus on the end of the commune in this work—his picking the wrong moment in the story—to which Krecek objected, "[The Paris Commune] was a great beginning: the first proletarian state in the world."[42]

Commissioned by the Leipzig branch of the SED, Krecek's letter may have been prompted by a report sent to Kurt Hager, head of the Politburo's Ideological Commission, three weeks earlier, although the report itself does not mention Heisig's work specifically.[43] Dated October 20, this two-page document began by praising the "variety of artistic styles" apparent in the district exhibitions taking place in Berlin, Leipzig, and Halle but then goes on to criticize Leipzig.[44] "In Leipzig other tendencies are noticeable. . . . Basically an entire group of the exhibited works, especially paintings, testify to an abandonment of our worldview."[45] It then called for a "thorough appraisal" of the exhibition.

Significantly, the negative review of Heisig's painting published by Krecek in the *Leipziger Volkszeitung* was supposed to have been written by Rita Jorek, but she submitted a positive review instead, one that was never published.[46] Like her article on Heisig's murals four months earlier, Jorek began the unpublished text by pointing out that "*The Paris Commune . . .* often reveals itself fully to the viewer only after prolonged looking."[47] She went on to state that "the more one knows about the heroic fight of the Communards, the better one understands [the painting]."[48] She then set herself the task of explaining why the work was important. After briefly describing the image, she argued that it illustrated the words Brecht gave

to the Communard Delescluze in his play, *Die Tage der Kommune* (The Days of the Commune): "Even if our enemies succeed in turning Paris into a grave, it will in any case never become a grave of our ideas."[49] She pointed to the figures sacrificing their lives to hold up the banner that says, "you too are workers," and to the figure holding up his fist "like a prophet . . . in warning and admonition, as if he wanted to keep the murderers from a mistake."[50] She went on to say that "the hope that the good idea must convince, that it could do this better, perhaps, than weapons, characterizes the greatness of these fighters of the proletarian revolution; it is also, however, the reason for its defeat, [since] some of its leaders thought until the end that the justness [of the cause] did not require violence."[51]

This latter idea can be seen as subtly connecting Heisig's painting to the East German present, where service in the National People's Army had been made mandatory just three years earlier, in 1962.[52] This militarization of Socialism was the result, in part, of a lesson learned from the downfall of the Paris Commune: Socialism needed to be defended, even if that meant taking up arms to do so.[53]

In contrast to the pessimism others found in the work, Jorek saw optimism: "The optimism that this image radiates lies not only in the individual figures of the Communards . . . but also in the composition. This becomes particularly clear in a comparison with the middle panel of Otto Dix's war triptych . . . [which] emphasizes the senselessness of war. . . . In *The Paris Commune*, by contrast, the people strive to the top . . . they are themselves signs that point to the future."[54]

At the end of the unpublished article, Jorek became critical. Significantly, however, her criticism focused primarily on the image reproduced in the catalog, which presented a painting, she pointed out, that had been reworked in the meantime. The earlier work, she stated, had been oriented less toward the future and had expressed a greater sense of doubt than the work on view in the exhibition. Turning to the current work, she pointed out that the foreground was not as strong as the middle ground with its "rich possibilities for association."[55]

Even though the exhibition closed in mid-November, the debate about Heisig's painting continued at the national level. In February 1966, Meißner published a six-page article praising the Seventh District Art Exhibition in *Bildende Kunst* as "a decided advance" on the path to a true Socialist art. Accompanied by eight illustrations, including Heisig's *The Paris Commune* and Mattheuer's *Cain*, Meißner's article "About the Deepening of the Realistic Message," discussed several works from the

exhibition. Meißner stated that *The Paris Commune* was the "object of criticism and of a comprehensive discussion. In this [discussion] arose the principal question of historical truth and the legitimacy of seeing—under a subjective viewpoint—unsettling connections between this event and the present."[56]

Meißner stated that the work was of "burning actuality," although he admitted that "one must agree with critics . . . that the shift in accent [from waiting] to the destruction [of the Commune] grasps only a part of the historical truth. But this part is very expressively and provocatively portrayed and does not concentrate only on the pessimistic realization of the physical defeat."[57] Not unlike Jorek before him, Meißner opined, "To me it appears that the moments of heroism—such as the balled fists of the last Communards, the dynamic beacon of the red banner, or the blast-of-trumpets-like yellow of the background—point to the future victory of the ideas of the proletarian fight for independence. Here the expressive power of the artist is ecstatic and visionary at the same time."[58]

Three months later, in the May 1966 issue of *Bildende Kunst*, the art historian Harald Olbrich responded to Meißner with a long article about *The Paris Commune* titled "Aesthetic Subjectivity or Subjectivism?" In a passage quoted in part at the beginning of this chapter, he began by praising Heisig before turning a critical eye to the work:

> I value Professor Bernhard Heisig's efforts toward a gripping, emotionally deep [*tieflotende*] and intellectually complex art. I am impressed by his murals for the "Interhotel Deutschland" in Leipzig. In the dynamic conception of the images and, to a great extent, their generalization, I see the artist's wholly personal reflection of the human atmosphere of the free Socialist society. But it is only with difficulty that I can agree with his most recent attempts with *The Paris Commune*, since there, superficial interests in problems of form [and] the artist's attraction to . . . writhing, amorphously doughy masses decidedly limit the partisan value of the commune. The tragedy of the final fight, the uncompromising position of the revolutionary Communards becomes a bestial-compulsive convulsion. The image limits itself to an ethical rejection of the counterrevolutionary troops, thus persisting with accusation and negation.[59]

Like Krecek, Olbrich believed Heisig had not found the "fruitful" moment in this work. "The theme of the commune can only be immortality despite defeat."[60] It was, above all, the work's pessimism that he found so objectionable: "Doesn't the chaos of the scene emerge primarily from a

momentary disbelief in the victory of humanity and Socialist progress?"[61] The work suffered, he believed, from an ideologically unclear position and did not fulfill art's task, which was to be a moral and true expression of reality.

Significantly, Olbrich did not have the same objections to Heisig's lithograph *Der faschistische Alptraum* (The Fascist Nightmare, 1965, fig. 4.10), a surreal print that won a gold medal at the International Book Exhibition in Leipzig the previous summer. This black-and-white print, one of approximately thirty-six in the series, depicts a wounded figure— bandaged and missing an arm and part of a leg—sitting propped up against a slatted wooden fence in the foreground, a Nazi swastika visible to the left of his screaming mouth. In the background, a tank, echoed by the shape of a giant, vulture-like creature, rolls over a mass of fleeing people. Olbrich interpreted this work as an "artistic criticism of neofascism and imperial-ism in West Germany."[62] In comparison to *The Paris Commune*, "the ten-dency toward negation [and] the invocation of the fantastic [functions in this work] as a cathartic shock effect."[63]

In light of Olbrich's comments, it becomes clear that the problem with *The Paris Commune* was ultimately not one of style or tone in and of itself, but rather in combination with the subject matter, an almost-sacred moment in Socialist history. As Olbrich stated it, "the historical experi-ences of Marxism have not been fully mastered" in this work and thus "are not effective."[64] For him, *The Paris Commune* should form the "Gegenpol" (opposite pole) to *The Fascist Nightmare*. He thus ended the article with a call for balance between the negative and positive in art: "Only in the interplay of both sides, and in the dominating role of the latter [the posi-tive], will Socialist partisanship [*Parteilichkeit*] reveal itself in its entirety."[65]

Conclusion

The Seventh District Art Exhibition in Leipzig closed on November 10, 1965. It marked a significant change in the work of both Heisig and his colleagues from those shown at the Sixth four years earlier. No longer indebted to nineteenth-century models of realism, the paintings of the "new" Leipzig School were modern, allegorical works that engaged with complex, contemporary themes that encouraged viewers to think about and engage with the material presented.

The controversy around *The Paris Commune* shows that Heisig had done exactly what artists and art historians set out to do in the Call to Artists

Figure 4.10. Bernhard Heisig, *Der faschistische Alptraum* (The Fascist Nightmare), 1965. Lithograph, 47 x 33 cm. © 2018 Artists Rights Society (ARS), New York / VG Bild-Kunst, Bonn. Photo: SLUB / Deutsche Fotothek / Kramer 1965.

put out for the Seventh District Art Exhibition: he had created an "interesting" work that contributed to "a true artistic difference of opinions and to the development of art in Leipzig." Together with paintings by Tübke and Mattheuer among others, it marked the emergence of the Leipzig School of modern painters onto the East German art scene, although it would be several years before such works would come to represent East Germany in the Western art market.[66]

When viewed in the context of Heisig's oeuvre, *The Paris Commune* reflects Heisig's larger interest in the theme of conflict and, in particular, the question of what makes someone take up arms in defense of an idea. This theme can be seen in countless works across his oeuvre, including the German revolution of 1848, the Kapp Putsch in 1920, and World War II. The sheer number of works he produced on the Paris Commune suggests it had a special importance for him, a chance to deliberate upon real existing Socialism. In Heisig's earliest paintings, an emphasis on waiting can be interpreted as reflecting the waiting East Germans experienced in the late 1950s and early 1960s, unsure of events to come—as Heisig put it, "We were sitting on our suitcases." The 1962 painting shows the beginnings of movement, which can be seen as a reflection on the changes starting to take place in the wake of the building of the wall in 1961. Questions about whether to leave or stay had been largely foreclosed, and the emphasis was on a new beginning. Heisig's shift from focusing on the early days of the Paris Commune to focusing on the final days of conflict appears in the wake of his controversial speech at the Fifth Congress and the Hotel Deutschland murals, two controversies stemming from his attempts at reform. Even if not directly linked to these events, the furor and chaos of the paintings reflects the turbulent nature of cultural policy in the mid-1960s.

The Paris Commune also marks the culmination of a process of stylistic change that began with the *Christmas Dream of the Unteachable Soldier* the previous year, in 1964. More complex than the earlier painting, *The Paris Commune* combined numerous bodies and flailing limbs in a composition that appears at first to be a chaotic scene of bloodshed but, on closer examination, reveals a grid-like structure underlying the work. The vertical line begun by the bayonet at the bottom right, for example, stretches up through weapons and raised fists to the top of the canvas, while the dead body on the bottom left, lying horizontally, is echoed in the banner in the lower right and the soldier arching backward in the upper left.

The greater complexity found in *The Paris Commune* may also be related to Heisig's engagement with the Hotel Deutschland murals in the intervening months. In both, a swirling vortex seems to burst forth from

the center of the image. Moreover, a comparison of *The Paris Commune* with the right side of the triptych-like *Halle* (see fig. 3.5), reveals a similar stacking of figures. Indeed, Heisig later referred to the figures in the mural as "barricade fighters," suggesting he was thinking about the Paris Commune while working on this mural.[67] The overlap also suggests that he was engaging with formal questions across multiple media.

In the wake of Seventh District Art Exhibition in Leipzig, Heisig had several years of relative quiet in which he created and exhibited work in a variety of media. In 1966, he had an exhibition of prints and drawings at the Angermuseum Erfurt, where he showed several illustrations for Bertolt Brecht's *Threepenny Opera* and *Mother Courage and Her Children* as well as Ludwig Renn's *Krieg* (War); he also had a joint exhibition of drawings and graphics in this year, including *The Fascist Nightmare*, with his colleague Hans Meyer-Foreyt at the Museum of Visual Arts Leipzig. The brochures for both mention that Heisig was a professor and *Leiter* (head) of a course on painting and graphics at the Leipzig Academy. Then in 1968, he had an important solo exhibition, *Bernhard Heisig, Exhibition of Paintings and Graphics*, at the Dresden gallery Kunst der Zeit (Art of the Times), the first to show not just prints but also a large number of Heisig's paintings. In a review of the exhibition, the Leipzig art historian Henry Schumann mentions the inclusion of the controversial Paris Commune painting from 1965 as well as additional versions that testify to Heisig's continued engagement with the topic after the Seventh.[68] The loose brushwork visible in the black-and-white images in the brochure suggests that he was also continuing to experiment with modern artistic styles and, in particular, that he was looking at the work of Oskar Kokoschka and Lovis Corinth. This loose brushwork would contribute to the fourth and final controversy for Heisig in the 1960s: this one focused on a portrait of a brigade of factory workers that he exhibited at the District Art Exhibition in Leipzig in 1969 and that led to the creation of one of his best-known paintings the following year, *The Brigadier*.

Figure 5.1. Bernhard Heisig, *Die Brigade* (The Brigade), 1968/69. Oil, size unknown. © 2018 Artists Rights Society (ARS), New York / VG Bild-Kunst, Bonn. Subsequently destroyed through overpainting. Photo: Akademie der Künste, Berlin, Kober 14/1, Photographer unknown.

PORTRAYING
WORKERS AND
REVOLUTIONARIES

Less than four years after the controversial Seventh District Art Exhibition in Leipzig, Heisig created another painting that would become a center of debate, *Die Brigade* (The Brigade, 1968/69, fig. 5.1). In loose, expressive brushstrokes, it depicts a group of workers on a construction site; the figure in the middle meets our gaze with a smile and gives us a thumbs-up. Little known in current scholarship, this painting—which is reproduced here for the first time—marks the first of a number of portraits Heisig created between 1968 and 1971 that focused on figures of particular importance in East Germany. Others include *Lenin, Lenin and Doubting Timofej,* and *Brigadier II.* Indeed, these are three of the most highly praised portraits in Heisig's oeuvre and contributed directly to Lothar Lang's statement in 1973 that Heisig was one of East Germany's "best portraitists."[1]

When Heisig created these paintings, he was a freelance artist, having left his teaching position at the Leipzig Academy in August 1968. Like in the early 1950s after he had dropped out of art school in the wake of the Formalism Debates, Heisig relied solely on his artwork to earn money and continued to do so until 1976 when he returned to the Leipzig Academy as director and professor.[2] These years as a freelance artist follow immediately in the wake of his transition—in the first half of the 1960s—from being primarily a graphic artist to being primarily a painter.

Years later, Heisig explained his departure from the Leipzig Academy in 1968 as having been "encouraged by some circumstances that spoiled

the teaching profession for me at the time."[3] This was presumably a reference to the Third University Reform, which went into effect that year and increased the party's influence within universities. It marked a dogmatic turn in East German higher education that led several professors to leave teaching. Long the focus of criticism from individual members of the local party, Heisig's teaching—and, in particular, the pessimism found in many of his students' work—had come under increasing fire in a number of reports leading up to the reform. A report filed with the Leipzig office of the SED in 1966, for example, states that "the diploma classes of Comrade Professor Heisig . . . embody in their basic attitude marked skepticism. . . . [There is] an inclination toward the depiction of the peculiar, strange, or, as it is expressed in the visual arts, an inclination toward "plumbing the depths of the soul."[4] Similarly, Heisig's graphics classes were criticized for encouraging students to illustrate works by existentialist authors like Sartre and Kafka rather than East German authors.[5]

But the dogmatic turn in higher education was not the only reason Heisig believed he "had no choice" but to leave the Leipzig Academy in 1968. As he explained it, "The circumstances at the time did not give me the necessary measure of freedom I needed to realize my goals."[6] Specifically, he needed more time for his art: "[I] voluntarily left my teaching position in 1968 because the time required no longer allowed for a meaningful continuation of my artistic work."[7] Even the Stasi acknowledged the important role that having more time played in Heisig's subsequent success; a report from 1974 stated that "Prof. H. undoubtedly belongs to the most important artists of our republic. He has become known to the greater public, however, only in recent years, that is, since he gave up his teaching position at the Leipzig Academy and could devote himself completely to his artistic work."[8]

At the time Heisig left the Leipzig Academy, he had numerous commissions to fulfill, including at least three paintings, two murals, and a print series, and he was part of the new Beirat für bildende Kunst und Architektur (Advisory Council for Art and Architecture), which was responsible for planning the architectural-artistic design of Leipzig through 1975, including the Karl Marx University building located across the square from the Hotel Deutschland.[9] He was also spending more time on painting than had previously been the case. Indeed, it was in these years that he created the first works from what would later become several of his best-known series, including Festung Breslau (Fortress Breslau), Schwierigkeiten beim Suchen nach Wahrheit (Difficulties in the Search for Truth), and Christus Fährt mit Uns (Christ Travels with Us, see fig. 6.4).[10] In addition to works engaging with fascism and militarism, he also created numerous portraits,

all of which showed a change in style—as first evidenced in his exhibition at the gallery Kunst der Zeit in 1968—to what one reviewer called a "new, very painterly painting [that] is loud, brutal, wild—and very sensitive."[11]

This new, more expressive painting style is largely to blame for Heisig's last major controversy in East Germany, that over *The Brigade*, which was heavily criticized in the press after being exhibited in 1969 at the District Art Exhibition in Leipzig. In the wake of this debate—and in large measure as a result of yet another change in cultural politics at the national level in 1971—Heisig would become one of East Germany's most highly praised artists, fulfilling the predictions that cultural functionaries like Alfred Kurella had made years earlier.

In this chapter, I begin by looking closely at *The Brigade*, the debate that surrounded it, and the artistic context in which it was made. I then turn to the highly praised painting that emerged in its wake, *Brigadier II*, as well as at two portraits of Lenin he created in these years. When placed in context, these four paintings show that Heisig was actively engaged in artistic questions of the day. In each, Heisig attempted to rejuvenate hackneyed subject matter—worker portraits and portraits of Socialist heroes like Lenin—to make it relevant for the intended audience, be it the people or the party. When placed back into the social and artistic contexts in which they were created, these four paintings show an artist who was committed both to the ideals of Socialism and to the creation of artistically challenging work. He was also interested in the dialogical nature of his work, wanting it to engage his audience, which at that time was firmly located in East Germany.

This interest in engaging with his audience, which can also be seen in his history paintings, stands in sharp contrast to much of the art created in the 1950s and 1960s in the West, where, as Heisig observed in 1959, the rules of art had led artists to consider anything the "masses" like as bad.[12] This development of art as an autonomous sphere in the West, one that emphasized the artist over the audience, was encouraged by postwar discourse that saw the West as the defenders of freedom and the East as a continuation of totalitarian practices. In East Germany, by contrast, artists saw it as their duty to use art to intervene in society. One prerequisite of this obligation was to make artwork that was accessible to the audience. But in contrast to the prescriptive art desired by political functionaries, artists like Heisig developed a dialogical art, one that, as Fritz Cremer stated in 1964 in a passage quoted at greater length in chapter 2, "gets people to think, not an art that takes the thinking from them."[13] It was this difference in approach that caused most of the debates over art in East Germany that

this book examines. Ultimately, as David Bathrick has argued in terms of East German literature, artists like Heisig were able to create "alternative spaces for public speech" with their work.[14]

This chapter shows Heisig was able to take even the most banal subject and make it interesting and relevant for his intended audience by emphasizing the dialogical nature of art. His work demonstrates that engaging an audience does not have to result in kitsch, nor do paintings of political subjects need to be prescriptive propaganda. Indeed, and in sharp contrast to the Western belief that Communist ideology and modern art are mutually exclusive, the works Heisig created in this period reveal the complexity and artistry that was possible in East Germany. This chapter also shows that commissions, rather than always resulting in bad art, could in fact encourage artistic experimentation.[15] And, like the previous chapters, it emphasizes the importance of discussion and debate for the development of Heisig's art.

Creating *The Brigade* (1968/69)

Heisig completed *The Brigade* (see fig. 5.1), his first worker portrait, in 1969, the result of a commission he had received more than a year earlier, in June 1968, for an oil painting with the working title *Die Rohrisolierbrigade* (The Pipe Insulating Brigade).[16] Commissioned by the District Council of Leipzig, the work was to be finished by January 31, 1969, in time for the District Art Exhibition in Leipzig that summer.[17] Considered a highlight in Leipzig's cultural program that year, this exhibition was one of several that took place in the GDR in 1969 to celebrate the country's twentieth anniversary.[18] Architectural art, history paintings, and portraits of the working class were the three main foci of these shows, which were to showcase the GDR's achievements in the visual arts. Heisig exhibited work in all three areas.

Looking back on *The Brigade* commission in 1973, Heisig stated that he had not created any worker portraits before, but, since he had spent a lot of time on construction sites for his architectural work, he had felt able to attempt one when the opportunity presented itself. As he explained, he was less interested in the portraits themselves than

> in capturing the atmosphere. For example, one time I saw a pipe insulation brigade working in the freezing cold. I found it optically quite interesting how they carried out their work in the snow with their big red hands. . . . I painted two or three versions of the painting. Shortly before it was due . . . I decided to pull one of the figures—the one giving the thumbs-up—to the front of the image.[19]

This painting was exhibited as *The Brigade* in the district art exhibition for which it was commissioned.

The Brigade depicts six workers against the backdrop of a factory.[20] The main figure, a middle-aged man with thinning white hair, stands second from the left. He rests his left hand on his hip. His right leg, bent and raised, carries his weight. He gives a thumbs-up with his right hand as he looks directly at the viewer and grins. Behind him to the right, three workers in red shirts—at least two of whom wear hard hats—also look toward the viewer, or possibly at the smiling man standing at the right-hand border of the image. The worker closest to us has his left hand raised, presumably pointing to himself in the midst of a conversation. The figure on the right side of the painting is nearly as large as the one giving the thumbs-up. Wearing a hard hat, he catches our gaze with a smile, his arms folded across his chest. He is echoed on the left-hand side of the painting by another figure whose back is to us. This left-most figure subtly challenges the overall optimism of the painting, reminding us of the hard work these men undertake on a daily basis. With left hand raised to the back of his white-haired head, he appears tired, perhaps perplexed.

The Brigade captures these workers at a moment of rest and—with the exception of the figure on the far left—emphasizes their good mood with smiles and the thumbs-up gesture of the central figure. They appear confident, relaxed, and in dialogue with us, the viewers, or with the artist. On one level, the work illustrates the fulfillment of life under Socialism by focusing on the contentedness and joviality of its workers. On another, it suggests that Heisig had a good relationship with these men, who seem to have stopped their work to interact with him and seem to be enjoying themselves in the process. As such, this painting can be seen as visually supporting the Bitterfeld Way, which promoted the better integration of workers and artists in East German society, primarily by sending the latter into factories to observe operations and by encouraging the former to create art and take part on exhibition juries.

At the time Heisig created *The Brigade*, worker portraits had become a topic of particular interest among artists and functionaries in the GDR. Such works had long been a part of East German art, from early 1950s paintings focusing on rebuilding to early 1960s works focusing on the fruits of labor.[21] They became even more important in the late 1960s after Walter Ulbricht gave a speech at the Seventh Party Conference of the SED in April 1967 in which he criticized the visual arts for lagging behind the social-political development of the GDR: "[There is a] certain insecurity among many artists, also the younger ones, toward . . . our Republic."[22] Just a few months

later, *Bildende Kunst* devoted the first three articles of its January 1968 issue to worker portraits. All three take for granted what Gertraude Sumpf stated outright in the second one: "The central task of the visual arts [in East Germany] today is to portray the people who are perfecting Socialism in our country."[23] What exactly these new images should look like was not stated. Rather, it was presented as a puzzle that only artists could solve.[24] The lack of artists taking up this challenge, however, was bemoaned in the journal's lead article, "Das Bild des arbeitenden Menschen" (The Image of the Working Man). The authors of this article, Waltraut Westermann and Jutta Schmidt, then focused on several paintings on display at the Sixth German Art Exhibition in Dresden that they saw as pointing in the right direction.[25]

A closer look at one of these works—Erhard Großmann's *Brigade vom LIW Prenzlau* (Brigade from LIW Prenzlau, 1967, fig. 5.2)—provides a useful comparison for understanding how Heisig engaged with the genre in *The Brigade*.[26] Depicted in a realist style with just a hint of cubist simplification, Großmann's painting shows seven male workers gathered in an indoor setting, presumably the break room at the LIW Prenzlau factory. Loosely grouped into four figures on the left and three on the right, they appear both posed and relaxed, as if knowing their picture is going to be taken but the photographer is still loading the film. In the meantime, they sit or stand and wait. They appear sedentary, perhaps tired, and although they share the same physical space, they do not interact with each other or with us. Instead, each appears lost in thought, an aspect of the work that is both praised and criticized by Westermann and Schmidt, who see the portrayal of "psychologisch vertiefte Züge" (deep psychological traits) in many of the figures as evidence of the artist's closeness to the brigade, on the one hand, but as taking away from the group feeling of the work, on the other: "Missing is that inner cohesion that would bring the individual figures into relationship with each other."[27] Nonetheless, they saw the work as a "genuine step forward."[28]

In contrast to Großmann's painting, whose somber tone and static nature are typical traits of worker portraits at the time, Heisig's painting is full of life, a feeling emphasized by the dynamic brushwork and bright colors. Like Großmann, Heisig has caught the workers during a break, but, far from appearing tired or static, the men are active and happy—one gives the thumbs-up, another brings his hand to his chest, several laugh. Rather than a group of individuals isolated from one another, the men seem to belong together, a fact emphasized by their shared orientation toward the front of the picture plane. In fact, Heisig has made us—the viewers or artist—the unifying factor of the work. The men appear to be responding to us, while two of them clearly return our gaze, something unusual for worker portraits

Figure 5.2. Erhard Großmann, *Brigade vom LIW Prenzlau* (The Brigade from LIW Prenzlau), 1967. Oil on hard fiber, 160 x 240 cm. Reprinted with permission of the artist. Photo: Kunstarchiv Beeskow.

of the day. As such, Heisig has made us active participants in the work, as either fellow brigade workers (many attending the exhibition would have been workers) or as visitors. The smiles and gestures both welcome us into the fold and indicate how great life is as a worker in this brigade.

Not only illustrating the joy of life under Socialism, where workers are proud of their active role in the development of a better society, *The Brigade* also reflects the importance of technology to the GDR at that time. Since the Seventh Party Conference of the SED in 1967, technology had been promoted in official statements as the way for Socialism to overtake capitalism. Perhaps the most famous worker portrait created in response to this new emphasis on technology is Willi Sitte's *Chemiearbeiter am Schaltpult* (Chemical Worker at a Control Panel, 1968, fig. 5.3). It focuses on a man at work before a control panel, buttons and levers visible in front of him. He reaches forward with his right hand, toward the viewer, to push a button on the panel before him. With his left hand, he reaches toward a pair of knobs in the foreground. Behind him, tanks and tubes appear, suggesting a modern factory setting. In *The Brigade*, by comparison, Heisig emphasizes the highly technological nature of East German industry through

Figure 5.3. Willi Sitte, *Chemiearbeiter am Schaltpult* (Chemical Worker at a Control Panel), 1968. Oil on hard fiber, 148 x 102 cm. © 2018 Artists Rights Society (ARS), New York / VG Bild-Kunst, Bonn. Kulturstiftung Sachsen-Anhalt—Kunstmuseum Moritzburg (MOI01920). Photo: © Reinhard Hentze, Halle (Saale).

the prominence of the factory setting behind the workers. Whereas Sitte emphasized the integration of worker and technology by placing his worker literally within the scene—the viewer looks through the control panel to see him—Heisig did so by the inclusion of four smokestacks in the background, which echo the four figures in the center of the work.

The Brigade's Reception

Despite the optimism of the work and its relationship to the ideology of the day, *The Brigade* was not well received in the party press. The harshest criticism came from Herbert Letsch, editor of the *Leipziger Volkszeitung* and longtime critic of Heisig's work.[29] In an article published in the newspaper on May 24, Letsch wrote:

The expressive painting elicits above all the impression of tortured, mistreated human beings. The painting has a strong leaning toward the amorphous, the destructive, the morbid. At the same time the rude and brutal painting style is not to be ignored. . . . Bloody and almost brutal reds have been placed in the faces, with corresponding pale, sick blues and weak greens. The warm orange tones emphasize the amorphous and brutal character of the painting. This use of color does not serve an expressive intensification of a true statement about the intellectual life of the new human being, but rather elicits the impression of tortured and physically mistreated human beings. . . . Similarly, the composition avoids all stability; it is as amorphous and formless as the painting itself. The features of the artist's style apparent here are the painterly expression of a subjective, a false interpretation of the essence of the Socialist human being.[30]

A similar sentiment, although in softer tones, was expressed a month later—allegedly by a reader—in the SED's national newspaper, *Neues Deutschland*: "I know that Professor Heisig is an artist with great talent, but the construction workers that he painted radiate, in my opinion, neither the strength of the working class, their creativity, their self-confidence, nor the true humanity of Socialist personalities. They appear to me to be crude, impersonal, and foreign."[31]

Ostensibly, the problem with *The Brigade* was its style and, in particular, the "almost brutal" way in which it was painted. And yet Heisig's use of a loose, late German impressionist brushstroke was not new to his work at this point. Rather, it had been in evidence publicly for at least a year, since the solo exhibition of his work at the Kunst der Zeit gallery.[32] A review of that exhibition, published in March 1968, was cited at the beginning of this chapter and deserves quoting at greater length:

[Heisig's] new, very painterly painting is loud, brutal, wild—and very sensitive. It is unaccommodating and inelegant yet knows the delicacies of the palette of late German impressionism or perhaps [Max] Schwimmer. What shimmers through the latter . . . winds its way in Heisig's work . . . through an idiosyncratic topography. It seems to threaten us from behind the surface, to explode suddenly from it, to float above it as a fine web of lines. The formal aggression corresponds with the thematic [aggression].[33]

Nor was *The Brigade* the only painting Heisig showed at the District Art Exhibition in Leipzig that year that displayed such brushwork. *Die Söhne Ikarus* (The Sons of Icarus, 1968, fig. 5.4) had a similarly loose brushstroke, but it was not criticized in the press. In fact, it was illustrated in the catalog, albeit in black and white. Moreover, this other painting—a

Figure 5.4. Bernhard Heisig, *Die Söhne Ikarus* (The Sons of Icarus), 1968. Oil, 125 x 188 cm. © 2018 Artists Rights Society (ARS), New York / VG Bild-Kunst, Bonn. Subsequently destroyed through overpainting. Photo: Gerhard Reinhold.

comparison of two worldviews, one based on science, the other on religion—was relatively pessimistic in tone. The left half of the painting is dominated by the Russian scientist and father of human space flight, Konstantin Ziolkowski. He is seated on a plinth and looks to the stars much like he does in the sculpture of him outside the Memorial Museum of Cosmonautics in Moscow. Above him soar planes and rockets. In the right half of the painting, however, a bishop holds his hands to his face while a heretic, tied to a stake, burns beside him. Behind them the Tower of Babel looms large. In the bottom right-hand corner of the painting, Leonardo da Vinci works on a flying machine while looking up toward Ziolkowski, making a connection between the artist and scientist that Heisig himself may have felt. Between them a small figure of Icarus—his wings drawing a diagonal line between da Vinci and Ziolkowski—bends forward as if to jump into the sky. Behind him another image of Icarus plummets to the ground.

In light of the lack of controversy around *The Sons of Icarus*, it seems clear that it was not Heisig's brushstroke per se that was shocking about *The Brigade* but rather its use in the worker portrait genre. Worker portraits

were always political, but in the wake of the criticisms issued at the Seventh
Party Conference, they had become of even greater interest to both politi-
cians and artists alike. Artists were expected to define the genre, yet their
attempts frequently clashed with the limited artistic understanding of
many political functionaries who simply wanted traditional pictures done
in a conservative realist style.

A report written by the Leipzig branch of the SED on May 28, 1969,
suggests another reason why Heisig's painting drew criticism. This report
lists all three of Heisig's paintings from the District Exhibition as showing
no socialist realist position, but it singles out *The Brigade* for particular
censure, accusing him of neglecting "the dialectical unity of content and
form. He breaks free from the form and dissolves it. The workers are inten-
tionally portrayed as hideous. The brigade image stands in sharp contrast
to the Socialist human image. Through this portrayal, Professor Bernhard
Heisig expresses skepticism in his relationship to the working class as the
leading force for our social development."[34]

According to this report, the problem with Heisig's "hideous" por-
trayal of the figures in his painting seems to be less the style itself than
the fear that the painting may have been criticizing the GDR or perhaps
even real existing Socialism as a whole. Indeed, there were things to criti-
cize. In 1968, the Soviet Union had put an end to the revisionism taking
place in Czechoslovakia, where Alexander Dubček had been trying to give
Socialism "a human face." The changes he advocated—such as ending cen-
sorship—had given many intellectuals throughout the Eastern bloc hope
for a more democratic Socialism. In August, these hopes were crushed—as
they had been in East Germany in 1953 and Hungary in 1956—when the
Soviets sent in tanks to forcibly suppress dissent. It was also in this year
that the University Church St. Pauli in Leipzig was demolished to make
room for another building despite significant protest from local citizens.
This event marks a particularly low moment in Leipzig's history as political
functionaries won out against the will of the people.[35] In this context, one
might view the overt optimism of Heisig's work as ironic or, when com-
bined with the extremely loose brushwork, as an illustration of the dissolu-
tion of Socialism's "human face" before our very eyes.

Whereas the party criticized *The Brigade*, the Leipzig branch of the
Union of Visual Artists defended it. In June, shortly after the SED's critical
report, it released its own evaluation of the exhibition: "Professor Heisig's
composition shocked some observers through its very expressive applica-
tion of color. . . . If one succeeds in looking past this first and—for some—
alienating impression, however, the work reveals outstanding value. To be

emphasized in particular are the optimism that radiates from the entire painting, the complete lack of convention, as well as the convincing inner power and strength of the people."[36]

The VBK-L's report did concede that Heisig's painting overemphasized formal elements but pointed out that this was a commissioned work and laid the blame on a lack of communication between Heisig and the commissioning body, the district council. It also discussed the difficulty of creating images of brigades, calling for more time and money to develop this genre, and praising the attempt: "The exhibition shows that Leipzig artists have no fear of tackling great tasks. . . . That is also the case with regard to format. This courage to master important themes intellectually and practically should be praised and recognized."[37]

In another report, Joachim Uhlitzsch seems to straddle the line between these two perspectives. On the one side, he admits that "the three most problematic artists of our time are (1) Werner Tübke, (2) Bernhard Heisig, and (3) Wolfgang Mattheuer."[38] And yet, he goes on to say, "I don't consider any of these three artists to have strayed so far from the demands of the party that he cannot be won over in regard to future works with patient inclusion in the collective . . . and, in particular, with concrete tasks."[39] With regard to *The Brigade*, Uhlitzsch takes a cautiously positive view: "In contrast to Comrade Letsch, who . . . strongly criticized Heisig's Brigade painting . . . I believe that here lies the beginnings of a [new] consciousness on the part of the artist regarding [his] societal commitment."[40] More importantly, he states that, "after talking to Heisig extensively about this Brigade painting, I will give him a new commission with the concrete advice to emphasize the optimistic tenor [of the painting] and to undertake a formal clarification of the figure and space in light of this."[41] Whether Uhlitzsch gave him a new commission remains unclear, although Heisig did create at least two more worker portraits over the course of the next year, destroying *The Brigade* in the process.[42] One of these, *Brigadier I* (fig. 5.5), portrays two figures not unlike those in the earlier painting. A heavyset man in a hard hat, blue jacket, and red shirt stands in the middle of the canvas and gives a thumbs-up. Another man stands next to him, partly cropped out of the image; he rests a hand on his belt and smiles. Both men appear relaxed and to be looking at something outside the right-hand side of the picture frame. For the second portrait, *Brigadier II*, Heisig eliminated one of the men to focus solely on the one giving the thumbs-up; like with *The Brigade*, he meets our gaze. This painting would quickly become one of Heisig's best-known and most highly praised paintings in East Germany.

Figure 5.5. Bernhard Heisig, *Brigadier I*, c. 1969. Oil, 110 x 100 cm. © 2018 Artists Rights Society (ARS), New York / VG Bild-Kunst, Bonn. Subsequently destroyed through overpainting. Photo: SLUB / Deutsche Fotothek / Godenschweg.

Forging Success from Controversy

According to Heisig, he created *Brigadier II* (1970, fig. 5.6) in response to a magazine's request to include the controversial painting—*The Brigade*—in an upcoming issue:

> The brigade painting was so ripped apart that I took it back. I wanted to change it, but it got worse and worse, and then I threw it in the corner. [Then] through word of mouth, *FF Dabei*, the only newspaper to do art reproductions, came to me. . . . [It] wanted to give *The Brigade* a whole page, but the painting didn't exist anymore. Not wanting to lose the opportunity . . . I took out the main figure . . . and painted him in front of a ballet mirror.[43]

Confirming his account, *Brigadier II* appears as a nearly full-page color illustration in the December 4, 1970, issue of *FF Dabei*: a stocky middle-aged brigade commander with a slight beer belly and graying hair stands in front of the factory where he works. He wears a red V-neck shirt, blue

Figure 5.6. Bernhard Heisig, *Brigadier II*, 1970. Oil, 120 x 125 cm. © 2018 Artists Rights Society (ARS), New York / VG Bild-Kunst, Bonn. Photo: SLUB / Deutsche Fotothek / Rabich 1972.

jacket, and a hard hat with goggles typical for construction workers and takes up more than half of the nearly square composition. He appears to be a content, possibly even smug man in control. Meeting our upturned gaze with a slight smile, he gives us the thumbs-up.

Gerhard Winkler, director of the Museum of Visual Arts Leipzig, which owned the work, wrote a brief text to accompany the illustration. In it, he discussed the genesis of the painting: "[*The Brigade*] gave rise to much approval, but also to sharp disapproval. Some of these discussions were the occasion for [*Brigadier II*]."[44] He explained that in the wake of these discussions "images developed in quick succession in which the foundational theme of . . . [*Brigadier II*] began to crystallize."[45] Winkler then offered insight into how the latter painting was viewed in East Germany:

> [*Brigadier II* shows] an experienced builder between thirty and forty years old, who is no longer so quickly brought to action, but whom one nonetheless trusts can be hard in the suitable moment. His class consciousness presents itself not through external attributes but rather through his inner bearing. He is not the worker who, in a constant dispute over wages as a so-called "employee," must assert his rights with respect to the capitalist employer, but rather the worker who, as owner of the societal means of production, is the type of human being who characterizes our Socialist present.[46]

Four months later, the *Leipziger Volkszeitung* featured *Brigadier II* as the Museum of Visual Arts Leipzig's work of the month with another laudatory text by Winkler: "The individual riches of the man, his vitality, are . . . presented as a coloristic experience."[47] So began the painting's rise to fame.

Over the course of the next few years, *Brigadier II* was exhibited in numerous exhibitions, including *The Face of the Working Class in the Visual Arts of the GDR*, the Eighth District Art Exhibition in Leipzig, and the Seventh Art Exhibition of the GDR in Dresden. Like earlier worker portraits such as the Berlin artist Otto Nagel's highly praised *Junger Maurer von der Stalinallee* (Young Bricklayer on the Stalinallee, fig. 5.7) from 1953, Heisig emphasizes the self-confidence of the worker. In both paintings, the worker stands in the center of the composition, his place of work visible behind him, and makes eye contact with the viewer. Both wear a hat and jacket and have their right arm at their side. In Heisig's composition, however, the worker's dress is more relaxed, the jacket open, and he raises his left hand with a raised thumb, which can be read as an indication that

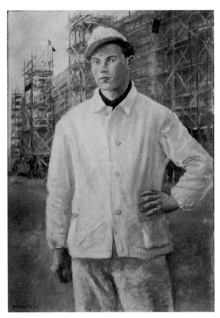

Figure 5.7. Otto Nagel, *Junger Maurer von der Stalinallee* (Young Bricklayer at the Stalinallee), 1953. Oil, 115 x 80 cm. © 2018 Artists Rights Society (ARS), New York / VG Bild-Kunst, Bonn. Photo: SLUB / Deutsche Fotothek.

someone—perhaps a crane operator—needs to lift something; it also signals that all is well. The expressions on their faces are also different: whereas Nagel's worker is serious, Heisig's is ambiguous, with a hint of amusement and personality.

Heisig was not the only artist creating worker portraits at this time. The Berlin artist Barbara Müller's *Bauarbeiterlehrling Irene* (Construction Worker Apprentice Irene, fig. 5.8) and the Leipzig artist Volker Stelzmann's *Schweißer* (The Welder, fig. 5.9) were also popular works created in 1971. Like Heisig's, each focuses on one worker who stands confidently in the center of the composition. Müller's focuses on a young woman with shoulder-length blond hair who confronts our gaze as she adjusts her hard hat, a reflection of recent changes in policy that had been made to encourage women to aspire to more skilled positions within the East German workforce.[48] The brushwork is loose and emphasizes a sense of movement and vitality. Stelzmann's painting, in comparison, shows an indebtedness to the hard lines and flat surfaces of Neue Sachlichkeit in its depiction of a welder. The man with goggles on his head and thick gloves stares down at us during a break. He is a commanding and unapproachable figure.

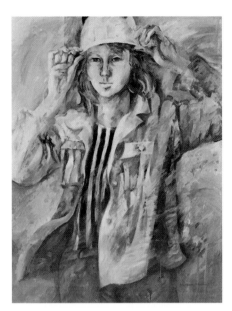

Figure 5.8. Barbara Müller, *Bauarbeiterlehrling Irene* (Construction Worker Apprentice Irene), 1971. Oil, 80 x 60 cm. Kunstfonds, Staatliche Kunstsammlungen, Dresden, Germany. Photo: SLUB / Deutsche Fotothek.

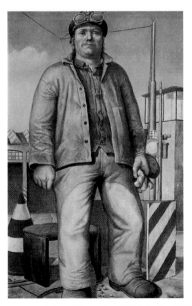

Figure 5.9. Volker Stelzmann, *Schweißer* (The Welder), 1971. Mixed medium, 120 x 75 cm. © 2018 Artists Rights Society (ARS), New York / VG Bild-Kunst, Bonn. Photo: SLUB / Deutsche Fotothek.

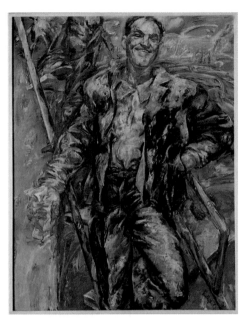

Figure 5.10. Frank Ruddigkeit, *Meister Heyne*, 1971. Oil, 130 x 100 cm. © 2018 Artists Rights Society (ARS), New York / VG Bild-Kunst, Bonn. Photo: SLUB / Deutsche Fotothek / Rabich 1972.

Heisig's worker, like Müller's, is more approachable: presented at an angle, he stands only slightly above the viewer and with a bemused look on his face.

Not only popular with the public and politicians alike, Heisig's painting also affected how other artists portrayed workers. The most notable example of this is Leipzig artist Frank Ruddigkeit's *Meister Heyne* (1971, fig. 5.10), which, like Heisig's, is a close-up of a confident and happy worker. Instead of giving a thumbs-up, Ruddigkeit's worker, who stands on a ladder and makes eye contact with the viewer, laughs wholeheartedly. Like Heisig's, the brushwork is loose and the colors warm.

By the end of the 1970s, *Brigadier II* had been reproduced countless times in newspaper articles and textbooks. Heisig even painted a self-portrait, *Selbst mit erhobener Hand* (Self with Raised Hand), that included it in the background. Then, in 1981, a slightly reworked version of *Brigadier II*—one in which some of the background details were painted out to place greater emphasis on the figure—became the image on the twenty-pfennig stamp made to honor the Tenth Party Conference of the SED.[49]

What had begun as a controversial work in 1969 had developed into one of Heisig's best-known and most lauded paintings in the GDR.[50] Not simply a reflection of what politicians wanted, the painting found significant social approval. Heisig had created an image that embodied the professed ideals of the "workers' paradise."

Lenin, a Man for the People

In 1968, the same year Heisig received the commission to create *The Brigade*, he was invited to submit a sketch of Vladimir Lenin to a competition in Leipzig.[51] Although there is currently no archival evidence to confirm whether he actually entered work for this competition, he created several prints and at least two paintings on the subject in these years. The first and best-known of the paintings was *Lenin und der ungläubige Timofej* (Lenin and Doubting Timofej, 1970, fig. 5.11), which depicts Lenin sitting next to an older, bearded man—often interpreted by East German scholars as a farmer—in Moscow's Red Square.[52] A well-known painting in his oeuvre, this work—or, more accurately, two subsequent versions of it—is praised today for its seemingly irreverent portrayal of the Soviet leader. Indeed, the image is filled with humor, which, when placed in context, can be seen as another attempt—as with *The Brigade* and *Brigadier II*—to rejuvenate a subject matter that had been painted countless times before.

As Heisig's description of the painting's development suggests, it was not a topic he simply came to on his own:

> As I began to work with the Lenin theme, I had no connection to it; that is to say, no more and no less than anyone else did. It is a figure that, as a subject, is so hackneyed and so often made that one could really be driven to despair. It didn't seem to make any sense at all to work with the figure. Where on earth would one go with it? Everything had already been done. I watched all possible films and studied other materials until the conversation with [the cultural functionary Alfred] Kurella [about how the success of the book *Naked among Wolves* stemmed from its use of a story from the Bible] came back to me. I took up the old biblical subject of Christ and doubting Thomas, and from Thomas, I made Timofej; I didn't know that Timofej was not the [Russian] translation of Thomas.—It was simply about showing the relationship of two people to each other. . . . [I] simply sought a fable to make the Lenin figure somehow current. That was for me a very significant point.[53]

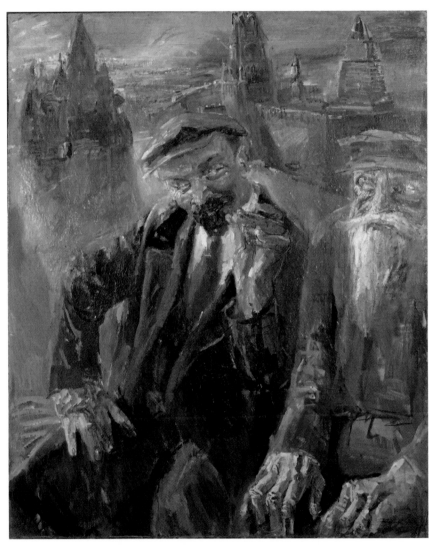

Figure 5.11. Bernhard Heisig, *Lenin und der ungläubige Timofej* (Lenin and Doubting Timofej), 1970. Oil on fiberboard, 272 x 150 cm. © 2018 Artists Rights Society (ARS), New York / VG Bild-Kunst, Bonn. Museum der Bildenden Künste Leipzig (Inv. 2220). Photo: bpk Bildagentur / Museum der Bildenden Künste Leipzig / Ursula Gerstenberger / Art Resource, NY.

The painting shows Lenin seated in the center of the composition, the buildings of Moscow's Red Square behind him. Wearing a suit and tie, he rests his right hand jauntily on his leg and turns his body toward the figure seated to his left. His eyes are mere slits, as if he is trying to size up the man beside him, and he holds his left hand in the air—a small cigar between his index and middle fingers—as if taking a moment to think of how best to continue with his argument or, perhaps, emphasizing a point in the making. The bearded older man next to him, in comparison, takes up less than one third of the canvas, as if being crowded out, or perhaps he is trying to inch away from Lenin. He rests both hands in his lap and looks at the man speaking to him out of the corners of his eyes.[54] He does not seem to recognize that the figure seated next to him is a renowned political leader nor to believe what he is saying.

At first glance, this portrayal of Lenin—who, to Western eyes, seems to have the aura of a used car salesman—may appear to be a negative one. Indeed, the seeming ambiguity of the two figures and their relationship to each other has allowed Western viewers to interpret the farmer's skepticism as aptly placed and, thus, to see the work as a subtle criticism of Communism. The title of the painting, however, suggests this was not Heisig's intention. Recalling the biblical story of Christ and doubting Thomas, this painting places Lenin in the role of Christ and thus as the figure in the right. Timofej, on the other hand, is doubting Thomas, the apostle who would not believe Christ was truly resurrected until he touched his wounds. In this case, the simple farmer Timofej does not believe Lenin's vision of a Communist utopia since he cannot actually touch it. The humor for East Germans would have stemmed from the unusual visual portrayal of the two figures, illustrating the Socialist belief that Lenin had tried to help the people even if they could not see it themselves.

The use of humor to portray Lenin was highly unusual, both then and now. A comparison with other works shown alongside Heisig's in the 1970 exhibition *Im Geiste Lenins—Mit der Sowjetunion in Freundschaft unlösbar verbunden* (In the Spirit of Lenin, Indivisibly Bound with the Soviet Union in Friendship) emphasize the uniqueness of Heisig's approach.[55] Kurt Klamann's *Lenin* (fig. 5.12), for example, shows the political leader as a studious figure. He sits behind a desk in an office filled with books. Holding one open before him, he catches our gaze. Similarly, Frank Glaser's *Bildnis W. I. Lenin* (Portrait of V. I. Lenin, fig. 5.13) shows him leaning on a podium, a red curtain behind him. He catches our gaze and seems to be in mid-conversation. In both works, there is an attempt to show Lenin as a real person, yet the tone is serious and honorific.

Figure 5.12. Kurt Klamann, *Lenin*, 1970. Oil, 80 x 100 cm. © Kurt Klamann. Photo: Heinz Nixdorf.

Figure 5.13. Frank Glaser, *Bildnis W. I. Lenin* (Portrait of V. I. Lenin), 1970. Oil, 150 x 110 cm. © Frank Glaser. Photo: Egon Beyer.

But seriousness was not the only way to make a point, a fact of which Heisig was well aware and with which he was experimenting in this painting:

> One can convince another human in many different ways, also with a joke. But [in this painting] the other remains hardheaded; he is already too old. And that is what I tried to paint, in that I gave Lenin two-thirds [of the image] and squeezed Timofej into the corner so that one has the impression that Lenin is slowly pushing him into the corner and saying: So now you must start to believe! But the other doesn't think about it. Apparently, that is why so many people felt so spoken to, because it is perhaps similar for them and because it appeals to them that someone can convince another slowly and quietly and with a joke or humor.[56]

In sharp contrast to the countless honorific portraits of Lenin that people would have encountered every day and thus passed by without noticing, Heisig's painting, through its unusual and humorous portrayal, encourages viewer engagement by making Lenin interesting again. He becomes a real person with a personality rather than a towering myth to be venerated without question. Indeed, one of the reasons Karl Max Kober lauded the painting in the catalog for Heisig's first retrospective exhibition in 1973 was that it made Lenin current: "It was not about portraying Lenin for the many hundredth time per se, but rather about creating new views or even new nuances of the view of him . . . to make from the person, things and appearances 'in themselves,' people, things and appearances 'for us.'"[57]

In this context, Heisig's painting can also be seen as a commentary on Socialist society: Timofej, on the one hand, represents the people, who are bombarded on a daily basis with official proclamations and teachings. Lenin, on the other hand, is the state apparatus intent on understanding the people and convincing them that it—the state—is working in their best interest.[58]

A Leader among Leaders

Heisig also created more conventional images of Lenin. In fact, at the same exhibition that he showed *Lenin and Doubting Timofej*, he showed two lithographic prints that are much more serious in tone than the painting: *Lenin an die Bayrische Räterepublik* (Lenin to the Bavarian Council Republic, 1970, fig. 5.14) and *W. I. Lenin* (1970, fig. 5.15). These prints were

Figure 5.14. Bernhard Heisig, *Lenin an die Bayrische Räterepublik* (Lenin to the Bavarian Council Republic), 1970. Lithograph, 65 x 50 cm. © 2018 Artists Rights Society (ARS), New York / VG Bild-Kunst, Bonn. Photo: SLUB / Deutsche Fotothek / Bolitzki 1972.

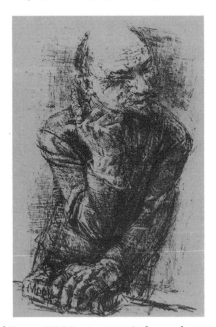

Figure 5.15. Bernhard Heisig, *W. I. Lenin*, 1970. Lithograph, 80 x 50 cm. © 2018 Artists Rights Society (ARS), New York / VG Bild-Kunst, Bonn. Photo: Christian Kraushaar.

presumably created as part of a graphic project by Leipzig artists focusing on a series of telegrams Lenin wrote between 1917 and 1920.[59] The first print shows Lenin in his characteristic suit and tie seated with pen in hand before a piece of paper. Behind him the faces of the martyred German Socialists Karl Liebknecht and Rosa Luxemburg rise above a city scene of fighting that recalls the second phase of Heisig's Paris Commune paintings. On the building behind them are the words, in German, "remember Karl and Rosa." These background images seem to convey Lenin's thoughts as he pauses in his writing to meet our gaze. In the second print, Lenin raises his right hand, pointing to the sky.[60] He seems to be in the midst of a heated discussion with someone outside of the picture frame to our right. In his other hand, he holds a thick book, on the binding of which the name Marx is visible. It is an image that prefigures the serious painting of Lenin that Heisig would make the following year.

In January 1972, Heisig exhibited *Lenin* (1971, fig. 5.16), the second and more serious painting on the theme, at the Eighth District Art Exhibition in Leipzig. Current scholarship suggests that this work was created to fulfill a commission from the Leipzig branch of the SED, in whose offices it hung until 1989.[61] This would explain the significant shift in tone from the earlier painting, since the work would have been created for state officials rather than for the general public.[62]

Heisig described the challenge he faced in creating this work as follows:

> For me the problem was how to paint such an unattractive man, a man who ran around with such a crumpled suit and an almost-slashed shirt . . . who seems anything but heroic, but nonetheless radiates such a fascination. I made many attempts and thought the best solution was to set it in a square, him as a post [*Pfahl*], like an exclamation point. I changed the arms many times. It took a long time before I had the movement so that he comes out of the image somewhat.[63]

In the painting, Lenin does indeed stand like an exclamation point in the center of a large square canvas. He meets our gaze and points his left index finger at us like a schoolteacher making a point. In his right hand, he holds a book that, albeit closed, has a particular page marked with his finger as if that passage inspires his current words. The background of the work is a textured brownish-red color with no ornamentation. It contrasts with the bluish black of his suit and tie to push him forward into our space. The perspective, however, is unusual. We look down on Lenin, and yet, because of the size of the painting itself, which is just over five feet tall, he looms over us, larger than life. As such, our relationship to him is in constant flux,

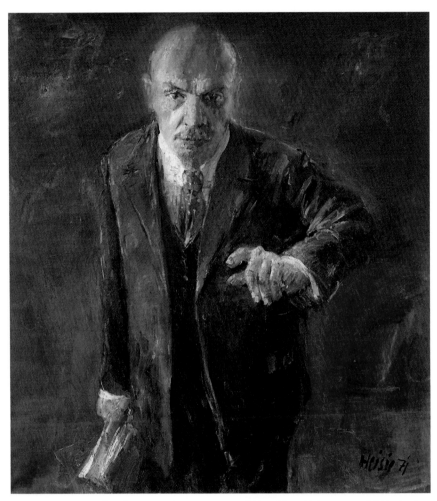

Figure 5.16. Bernhard Heisig, *Lenin*, 1971. Oil, 160 x 150 cm. © 2018 Artists Rights Society (ARS), New York / VG Bild-Kunst, Bonn. Photo: copyright Galerie Brusberg Berlin.

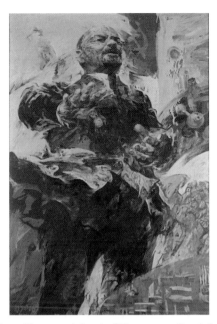

Figure 5.17. Willi Sitte, *Homage à Lenin* (Homage to Lenin), 1969. Oil and tempera on fiberboard, 181 x 123 cm. © 2018 Artists Rights Society (ARS), New York / VG Bild-Kunst, Bonn. Nationalgalerie, Staatliche Museen, Berlin, Germany (Inv. A IV 239). Photo: bpk Bildagentur / Nationalgalerie, Staatliche Museen, Berlin / Art Resource, NY.

not unlike the relationship between two people engaged in a debate. One moment he appears to be below us, the next, to tower over us. Significantly, this tension draws the viewer into the work to literally engage with the figure portrayed.

Like *Lenin and Doubting Timofej*, this painting demonstrates a very different portrayal of Lenin than those by other artists. This difference becomes clear in a comparison with Willi Sitte's painting *Homage à Lenin* (Homage to Lenin, fig. 5.17) from two years earlier. In Sitte's work, Lenin is depicted from the worm's perspective. He towers over us as he speaks to what is presumably a mass of people outside the confines of the canvas. He does not meet our gaze, nor is he approachable. In sharp contrast to Sitte's portrayal of a mythic leader, Heisig's painting captures a sense of Lenin the person and his presence. He not only meets our gaze, he is leaning toward us. Indeed, we seem to be in the middle of a heated conversation with him.

Alfred Kurella, who had met Lenin decades earlier, wrote a letter to Heisig in 1972 that praised him for capturing a sense of Lenin the person

and his presence: "You will remember that during my last visit with you I expressed delight over some of the pictures you had recently exhibited in Leipzig, especially the Lenin portrait. You told me at the time about your difficult considerations regarding the portrayal of Lenin. I told you then that you . . . had captured Lenin's personality with exceptional exactness, as I remember it from my contact with him in 1919."[64]

With this painting, Heisig encouraged the viewer to think about Lenin the man. Rather than a myth to be blindly worshipped, here is an engaging figure willing to enter into debate with us. In comparison to *Lenin and Doubting Timofej*, however, whose audience was primarily a general public grown weary of being lectured to from above, here was a painting for party officials, a work that hung in the offices of the Leipzig branch of the SED. As such, it can be seen as a reminder to the party to remain true to the foundations and ideals of Communism. One of these ideals was remaining open to debate and change for the greater good rather than settling into an ossified bureaucratic state. Such a reading is encouraged by the shifting perspective within the painting, which prevents one from establishing a permanent relationship to the figure portrayed.

Conclusion

As with *Brigadier II*, Heisig's paintings of Lenin offered significantly new interpretations of the subject matter at hand, ones that were closely linked to the intended audiences. While commissions presumably inspired the works initially, Heisig made them his own. Not satisfied with creating just another portrait of a worker or political leader, he offered fresh depictions of both that made the subjects of interest again to an audience made weary by countless other versions. As he stated it in 1973, "I like it when people like [my art], when they get something out of it. . . . I am always like a lynx on the trail to find out what people say about a picture."[65] It is this interest in reaching his intended audience—together with his ability to capture the essence of the personality he was portraying—that made him the accomplished portrait artist that he was and for which he was praised for being in East Germany.[66] It also contributed to the change in his artistic style just a few years later when, in the latter half of the 1970s, he shifted from a specifically East German audience to creating works that would appeal to Germans on both sides of the Berlin Wall.

THE QUINTESSENTIAL
GERMAN ARTIST

*It will take us longer to tear down the Wall
in our heads than any wrecking company
will need for the Wall we can see.*
—Peter Schneider, 1982

Between 1964 and 1969, Heisig was at the center of four controversies about art. These centered on his speech at the Fifth Congress, his murals for the Hotel Deutschland, and his Paris Commune and Brigade paintings. In each controversy, he argued—in words or pigment—that artists, not politicians, should be the ones deciding what art in Socialism should be and that there needed to be a greater openness to modern artistic styles and to the breadth of life's experiences. Pushing the boundaries of what was officially acceptable at the time—in both content and style—Heisig ultimately helped to change painting in East Germany from the realistic, heroic, and optimistic socialist realism of the early 1950s to the dialogical, modern art of the 1970s. It is these latter works, by Heisig and others, that came to represent East Germany internationally beginning in the late 1970s.

The shift to a modern artistic style in official East German art was facilitated by the rise of Erich Honecker to power. Shortly after replacing Ulbricht as head of the East German state in 1971, Honecker gave a speech at the Fourth Congress of the SED's Central Committee, reproduced in *Neues Deutschland*, in which he stated that, "when one starts from a committed Socialist position, there can be . . . no taboos in art and literature,

neither in content nor in style."[1] In the wake of this speech, the openness to modern art that Heisig and others had fought for throughout the 1960s became official and the debates around art ended, at least with regard to the expressionist tradition and for those committed to Socialism.

This shift in cultural policy marked the beginning of Heisig's rise to national, later international, recognition. In 1972, he received the National Prize of the GDR (Second Class) and became chair of the VBK-L for the second time.[2] The following year, he was given his first major retrospective exhibition at the Gemäldegalerie Neue Meister Dresden; it then traveled to the Museum of Visual Arts Leipzig. At forty-eight, he was the youngest East German artist to be given such an honor. The retrospective was accompanied by a lavishly illustrated color catalog that included a thirty-four-page text by Karl Max Kober, who would go on to publish a monograph on Heisig's work nearly a decade later.[3] In 1974, he was elected vice president of the Union of Visual Artists at the national level. Then in 1976, he resumed his post as director of the Leipzig Academy, a position he then held for more than a decade. Despite these successes, however, a change in his art was on the horizon, one that can be seen by comparing two paintings he created of the mythological figure Icarus between 1975 and 1978/79.

Icarus

In 1975, Heisig completed *Ikarus* (1975, fig. 6.1), a large painting—approximately 15′ x 9′—created for the atrium of the Palast der Republik (Palace of the Republic), a prestigious new building then under construction in Berlin.[4] Located in the square where Karl Liebknecht had announced a Socialist Germany in November 1918, the Palast became an important political and cultural center in Berlin, housing the East German parliament as well as a high-tech theater, several restaurants, and a large gallery containing sixteen large paintings commissioned from some of East Germany's most important painters, including Heisig.[5] Heisig's contribution focused on the young mythological figure rising unsteadily above the island of Crete, where he and his father Daedalus had been held captive by King Minos. Daedalus, who had fashioned the wings for their escape, appears as a tiny figure on a cliff in the bottom right-hand corner of the composition. The painting shows the early moments of Icarus's flight, before he flew too close to the sun and plummeted to his death in the ocean below. Indeed, the sun is but a small dot just breaking the horizon far behind him. A more immediate threat is the eagle headed toward him with its talons extended.

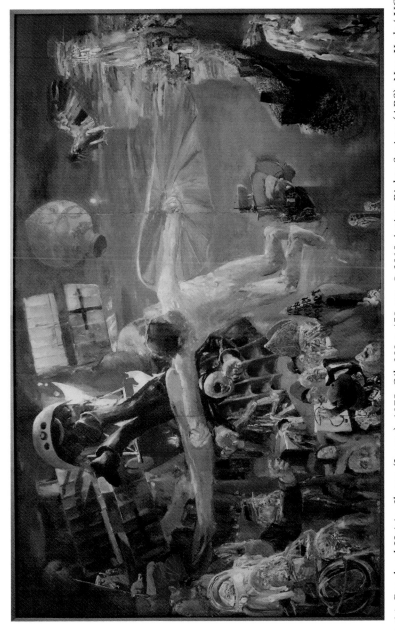

Figure 6.1. Bernhard Heisig, *Ikarus* (Icarus), 1975. Oil, 280 x 450 cm. © 2018 Artists Rights Society (ARS), New York / VG Bild-Kunst, Bonn. Stiftung Deutsches Historisches Museum, Berlin. Photo: author.

Presumably, it has come from the island below. The mushroom cloud of a nuclear explosion is visible on one end of the island, and countless tiny soldiers—recalling Albrecht Altdorfer's 1529 painting, *The Battle of Alexander at Issus*—are falling into the ocean in droves on the other. It is the eagle that draws Icarus's attention as he struggles to gain altitude. The left side of the painting is filled with images that appear in various combinations in many of Heisig's other paintings: a man falling from an exploding biplane, the mythical Tower of Babel, a bishop covering his eyes before a red-hooded heretic at a stake, Salvador Dalí in a red-and-black cap looking at a reclining nude model and drawing a question mark, a skeletal soldier with cards looking over at a screaming man, a Communard in blue reaching forward with his right hand, and a figure carrying a candle in one hand, a book in the other. Other images are unique to this painting: an astronaut and a man with his face resting in his left hand while looking at a globe.

The theme of the Palast der Republik commissions was "Do Communists Dare to Dream?" Heisig's Icarus can thus be seen as the personification of the Communist dream itself and, more specifically, the hope that was East Germany in the minds of many intellectuals. It was the hope for an alternative Germany, one that would stand in opposition to the fascism of the Nazi past and its perceived continuation in the present. In the painting for the Palast, Icarus is shown during his ascent, which suggests the possibility of a different, happier ending. It is a hope wrapped in pessimism: the naked figure appears uncertain as he glances over his shoulder.

Three years later Heisig created a second painting of Icarus that shows a very different scene. Rather than focus on the early moments of Icarus's flight, *Der Tod des Ikarus* (The Death of Icarus, 1978/79, fig. 6.2) focuses on a moment just before the end, a point after his fate has been sealed. Screaming, the protagonist dominates the canvas as he falls, belly-up, toward the ocean below.[6] The yellow sun that had been just a dot on the horizon in the earlier work now looms large as it emerges from behind the Tower of Babel. The passage of time is also suggested by the ship, which is disappearing across the horizon; in *Icarus*, it had not yet reached the island.

Whereas the earlier painting showed a moment of promise, *The Death of Icarus* focuses on the anguish of a certain death. It is an image that can be interpreted as a reflection on the loss of hope many intellectuals experienced in the wake of the East German government's decision to deny the singer-songwriter Wolf Biermann (b. 1936) reentry into the GDR after giving a concert in Cologne, West Germany, in November 1976.[7] A committed Communist with a large following among East German intellectuals, especially of the younger generations, Biermann had had difficulties

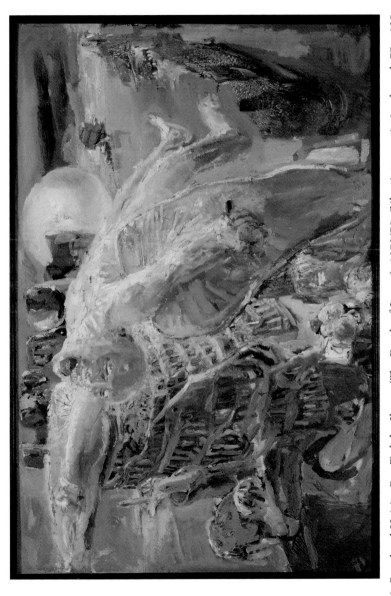

Figure 6.2. Bernhard Heisig, *Der Tod des Ikarus* (The Death of Icarus), 1978/79. Oil paint on painting board, 77 x 125 cm. © 2018 Artists Rights Society (ARS), New York / VG Bild-Kunst, Bonn. Museum am Dom Würzburg (Inv.-Nr. E/2001-36.B.St). Photo: Thomas Obermeier, provided by courtesy of Kunstsammlungen der Diözese Würzburg.

with the SED since the 1960s because of his critical lyrics. In 1965, he was forbidden to publish in the GDR or to perform there in public, a condition that continued into the 1970s. His forced expatriation in 1976 led to protests in East Germany and a public letter requesting the SED reconsider its decision that was signed by some of the country's most valued cultural figures, including writers like Christa Wolf and Stefan Heym; Wolf lost her position in the executive council of the Berlin Writers Union as a result, while lesser-known signatories lost their party membership.[8] Denying Biermann reentry to the GDR was, according to some scholars, one of East Germany's worst political blunders and a defining moment because it gave those who previously supported the regime a reason to reconsider.[9] After this point, the number of writers and intellectuals who left the country increased dramatically.[10]

At the time of Biermann's forced expatriation, Heisig was director of the Leipzig Academy and vice president of the national Union of Visual Artists. According to an interview with him in 1996, members of the *Parteibezirksleitung* (district party leadership) visited him shortly after Biermann was refused reentry and spent an entire day trying to convince him to sign a document approving the measures taken.[11] He refused. But he also did not sign a letter opposing those measures. Indeed, few painters did.[12] It was primarily writers who led the protest.

Even though Heisig did not sign anything with regard to Biermann's expatriation, his perspective on the event can be deduced from the very different portrayal of the protagonist in *The Death of Icarus*. It is an image that, on one level, can be seen to represent Heisig's disappointment with the East German regime as well as his loss of hope in the possibility it could be changed for the better. Whereas earlier moments of disappointment— the uprisings in 1953 and 1956, the building of the wall in 1961, the Prague Spring in 1968—were followed by signs of hope, the Biermann Affair was the last straw for many intellectuals in East Germany. Icarus can also be seen as a reference to Biermann himself, who not only identified with the figure, he was inspired to write one of the songs he premiered at his concert in Cologne—the "Ballad of the Prussian Icarus"—by a photograph of himself in front of a winged sculpture of Icarus. In this song, Biermann sang about the GDR and his relationship to it:

> And if you want out, you must go.
> I've seen a lot of people take off
> and leave our half country.
> I'll hang on till this hated bird

sinks its claws deep into me
and yanks me over the edge.[13]

As it turned out, when he sang this song in Cologne, those claws were just hours away.

It was at this time that Heisig's work as a whole changed, marking the beginning of a new phase in his artistic production that would last through the end of the Cold War. This third phase was characterized by paintings that were still modern in style but less obviously Socialist in subject matter. This shift in subject matter to a much greater emphasis on modern warfare and ideological manipulation, together with the change in the Icarus paintings, suggest that Heisig had turned his focus from the hope for a unified Germany under Socialism to a unified Germany through culture, a revival of Friedrich Meinecke's idea of *Kulturnation* (cultural nation) that was prevalent in both Germanys beginning in the late 1970s.[14] His new paintings—although based on a Socialist perspective critical of war and committed to uncovering the mechanisms of oppression—were well suited for transcending the Iron Curtain and came at a time when West Germany was beginning to show interest in East German art.

An example of this new kind of *Gesamtdeutsch* (pan-German) painting is *Beharrlichkeit des Vergessens* (The Persistence of Forgetting, fig. 6.3). Completed in 1977, it depicts the unteachable soldier who first emerged in Heisig's oeuvre in 1964, a figure suffering from his memories of combat in World War II. Wearing black pants, a white shirt, and suspenders—but this time without a tank on his chest—the man holds up an iron cross in his right hand and screams. Three of his limbs are prosthetics, perhaps metaphorically reflecting the losses experienced by Germany in three world wars—a banner with the words "we are all brothers and sisters" suggests the Cold War; a swastika flag, the Second World War; and a reference to Otto Dix's famous triptych, *War*, the First World War. Behind the reclining man's head, a grandfather clock reads five after twelve, suggesting that global catastrophe has already happened even if nuclear war has not yet broken out. The title of the work, *The Persistence of Forgetting*—a play on the title of Dalí's famous painting, *The Persistence of Memory*—points to mankind's inability to learn from its mistakes and thus the continuation of warfare to the present day. In the foreground, a clown blows a horn with all his might, suggesting—together with the row of eyes and mouths topped by speakers in the background on the far left—the media's constant emphasis on conflict. Between these two levels, several figures struggle with each other.

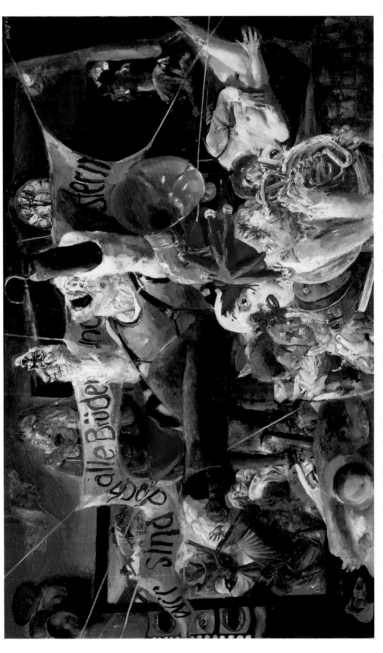

Figure 6.3. Bernhard Heisig, *Beharrlichkeit des Vergessens* (The Persistence of Forgetting), 1977. Oil on canvas, 151 x 242 cm. © 2018 Artists Rights Society (ARS), New York / VG Bild-Kunst, Bonn. Nationalgalerie, Staatliche Museen, Berlin, Germany (Inv. A IV 367). Photo: bpk Bildagentur / Nationalgalerie, Staatliche Museen, Berlin / Bernd Kuhnert / Art Resource, NY.

Behind the clown, a man in a nineteenth-century spiked helmet fights a man with a thin mustache and sword. In the top right corner, a couple embraces; below them, a man leans over another, perhaps strangling him; and, below them, a man embraces a nude woman who appears repulsed by his advances.[15] Similarly, the clown in the foreground is echoed by a white face; the reclining man by another holding his face in his hands; and the solder lying dead in the left corner by a screaming face sinking into the mud. The emphasis on pairs throughout the painting suggests the sibling nature of the two Germanys, at once belonging together and causing each other anguish.

In addition to a new focus on pan-German topics in his work after 1977, Heisig also began creating works that encouraged a biographical reading. Although *The Persistence of Forgetting* does not make explicit reference to the artist's wartime experiences, many others do. *Festung Breslau* (Fortress Breslau, 1972/78) and *Ardennenschlacht* (The Battle of the Ardennes [The Battle of the Bulge], 1978/81), for example, make reference—through their titles—to places where Heisig had fought during the war. Others include tanks, thus invoking Heisig's own experiences as a tank driver. *Christus Fährt mit Uns* (Christ Travels with Us, 1978/88, fig. 6.4), for example, is one in a series of paintings that focuses on tanks from which a crucified Christ emerges. The title refers to the ease with which either side of a war can call on religion for justification and, more concretely, to the words inscribed on belt buckles that many Nazi soldiers wore: "Gott mit uns" (God with us). By switching the text from God to Christ, Heisig suggested the suffering undergone by soldiers in war, a reading of victimhood emphasized by the similar body language of a soldier in the foreground. Scenes from Pieter Brueghel the Elder's sixteenth-century painting, *The Triumph of Death*, in the background emphasize the long tradition of warfare in Western civilization.[16] Tanks also appear in a number of other paintings Heisig created in these years, including *Neues vom Turmbau* (What's New from the Tower, 1977, fig. 6.5) and *Seeräuberjenny* (Pirate Jenny, 1979/80), both of which include a singing woman sitting atop a tank, recalling the use of movie stars to entertain the troops as well as the connection between sex and violence: Heisig once explained that part of his interest in becoming a soldier was because girls liked the uniforms.[17] It is works like these that are best known in the West, where Heisig's reception has been strongly shaped by politics. Significantly, most were done after his trip to West Germany for the *documenta* exhibition in 1977, which must also be seen as an important catalyst for the shift in his work to a third phase.

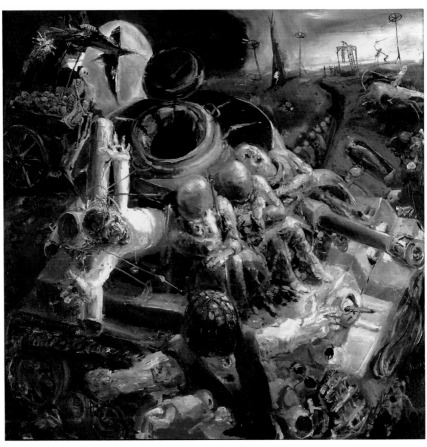

Figure 6.4. Bernhard Heisig, *Christus fährt mit uns* (Christ Travels with Us), 1978/88. Oil, 140 x 120 cm. © 2018 Artists Rights Society (ARS), New York / VG Bild-Kunst, Bonn. Subsequently destroyed through overpainting. Photo: copyright Galerie Brusberg Berlin.

Figure 6.5. Bernhard Heisig, *Neues vom Turmbau* (What's New from the Tower), 1977. Oil on canvas, 148 x 118 cm. © 2018 Artists Rights Society (ARS), New York / VG Bild-Kunst, Bonn. Kulturstiftung Sachsen-Anhalt—Kunstmuseum Moritzburg (MOI02026). Photo: Klaus E. Göltz.

West German Reception

West German journalists and scholars first began writing articles about Heisig in the 1970s, although it was not until 1980 that these were anything more than occasional.[18] In that year, Heisig had solo exhibitions in Bremen and Frankfurt am Main, which prompted a number of articles in the local press.[19] These exhibitions were followed by another at the Brusberg Gallery in Hanover in 1981. Together, these exhibitions mark the beginnings of what would become a veritable flood of exhibitions of Heisig's work as well as articles about him in the FRG that continues to the present day.[20] In contrast to critics in the East, those in West Germany tended to downplay Heisig's many portraits, landscapes, and still lifes in favor of his paintings of war and conflict.[21] Similarly, their interpretations of these images were different from those in the East. Rather than seeing these paintings as critical of fascism, Western authors tended to see them as evidence that Heisig was a victim of history. One Western author, for example, described Heisig as a "deeply frightened admonisher"; another, as a man "traumatically

touched" by his wartime experiences; a third wrote that these experiences "churn his innards" and "afflict him to the present day."[22] These paintings were thus frequently viewed in the West as Heisig's "attempt to free himself from [the] angst" produced by his "traumatic experience of the destruction of his hometown of Breslau."[23] Only a few West Germans focused on the critical potential of such paintings in terms of the Nazi past, an approach that was common in the East. Georg Bussmann, for example, stated in an article in the Frankfurt am Main exhibition brochure that Heisig's art asks "questions that are posed too seldomly, too inexactly, and not persistently enough in the present society of the FRG."[24] Similarly, Rudolph Lange stated that the GDR was much further along in coming to terms with this past than was the FRG; it had not "stopped denouncing the violent crimes of the National Socialists and the fascists."[25]

The West German interest in Heisig's paintings on war and trauma, and their tendency to view them in terms of the artist's wartime experiences more generally, coincided with renewed discussions of the Nazi past that took place in West Germany in the 1980s. This renewed interest was due, in part, to a number of fiftieth anniversaries, including that of Hitler's rise to power in 1933 and that of the infamous *Kristallnacht* (night of broken glass) pogrom in 1938. In the mid-1980s there was also the heated *Historikerstreit*, or "historians' debate," about whether the Holocaust had been a unique event in history or part of a larger continuum that includes Stalinist death camps. The latter viewpoint was criticized as trying to relativize the Holocaust. This debate followed in the footsteps of Ronald Reagan's visit with Chancellor Helmut Kohl to the Bitburg military cemetery in 1985, which had caused a similar scandal because the cemetery includes graves of Waffen-SS soldiers.[26] In this context, Heisig's paintings of suffering soldiers—and, especially, Nazi soldiers—found a ready audience and market in West Germany.

Another reason for West German interest in Heisig's work at this time was the emergence of neo-expressionism—and especially the art movement known as the Neue Wilde (New Wild)—onto the (Western) international art scene. Young artists like Rainer Fetting, Helmut Middendorf, and Elvira Bach created large paintings focusing on everyday subjects—especially nightclubs and their clientele—with bright colors and loose, even aggressive brushwork. Although these artists were successful, some critics dismissed them as a superficial market phenomenon. Benjamin Buchloh, for example, criticized them for not dealing with important issues of the day such as the escalating military tensions between the Eastern and Western blocs.[27] Instead, he saw the Neue Wilde as selling out by choosing

a fashionable style for the market, one filtered through abstract expressionism and thus supporting American hegemony. In this context, Heisig's work could be seen as more authentic: not only was the subject matter more significant, his neo-expressionist style emerged from within a dictatorship and was the result of his having fought for the privilege rather than simply appropriating something fashionable.[28] His artwork was thus seen by many West Germans as an authentic alternative to an art world where, as his West German art dealer Dieter Brusberg once stated, "the market had won."[29]

Another element evident in most of the articles written by West Germans was an emphasis on the "Germanness" of Heisig's work. Unlike the Neue Wilde artists, Heisig's style had not been filtered through abstract expressionism but rather grew out of a deep engagement with German masters. Brusberg, for example, stated he was completely convinced that Heisig was "one of the great German painters of the present" because of his commitment to a "specific German tradition—Corinth, Kokoschka, Beckmann, and Dix."[30] Nor was it just West German critics and dealers who saw Heisig as the rightful heir to these artists: Max Beckmann's son Peter gave Heisig his father's unused canvases shortly before the end of the Cold War.[31]

Heisig's praise in West Germany reached a high point just a few weeks before the wall fell. On September 30, 1989, a major retrospective of his work opened at the Martin-Gropius-Bau in West Berlin. With 120 paintings and more than 300 prints and drawings, *Bernhard Heisig, Retrospektive* was the largest and most comprehensive exhibition of an East German artist ever held in West Germany.[32] It included portraits such as *Brigadier II* and *Lenin* as well as still lifes, landscapes, and *Komplexbilder* (complex paintings, i.e., simultaneous narrative compositions that engage with history, mythology, or the present). The earliest works included dated back to the 1950s. It was also the first major exhibition to be co-organized by curators from both East and West Germany.

In the introduction to the catalog, the exhibition's curators—Peter Pachnicke from the East and Jörn Merkert from the West—pointed out that unlike music and literature, which were able to cross political borders with relative ease, the lack of access to original works in the visual arts had led to deep-seated stereotypes on both sides of the wall. In the West, East German art was often thought to be "beautified party-conforming realism without artistic individuality," while in the East, West Germany was often thought to be an "art market-controlled dictatorship of abstract artists without any content from the real world."[33] Although these stereotypes

had begun to be redressed in the 1970s and 1980s, Pachnicke and Merkert argued that a deeper look at individual artists was needed: both sides wanted a comprehensive exhibition of Heisig's work.

The catalog combined Eastern and Western perspectives on Heisig's work in a total of nine articles. Of the three by East Germans, co-curator Pachnicke's is by far the longest and follows directly after the introduction. In it he attempted to correct some of the misunderstandings he perceived as surrounding Heisig's work in the West. First, he explained that the often-vehement artistic debates that took place in the GDR, especially those in the 1960s, were not merely clashes with "dogmatic narrow-mindedness" but rather "disputes of opinions" over the definition of realism in the GDR.[34] They were an attempt—ultimately successful—to "push through a new understanding of realism against a historically outmoded one [i.e., illusionism]."[35] Also at stake in these clashes, he stated, was the role of the artist in society: "Artists [like Heisig] wanted . . . a dialogical relationship to the public" rather than a didactic one.[36] These debates, Pachnicke pointed out, were the crucible in which Heisig forged his views on art; they were a "method of recognizing—and being able to formulate—his own truth."[37] A second idea that Pachnicke argued was that Heisig's *Thema* (theme) was not war, as was often contended in the West but rather conflict; war was simply the *Stoff* (subject matter) through which he could address it. Pachnicke also emphasized the importance of structure in Heisig's work before ending the article with his third main point: Heisig's images are "not just about oppression and angst. An insatiable hunger for beauty, harmony, and continuity fill . . . many of Heisig's landscapes, nudes, and portraits."[38]

In the article following Pachnicke's, Western co-curator Merkert focused much of his text on Heisig's views on art, which were often at odds with the Western perspective. He pointed out that Heisig did not believe in the West's emphasis on the unique individuality of the artist and quoted him as follows: "Having to hold onto oneself is very stressful, especially for artists. Always requiring him to be original and new, to push his ego to the forefront. A dreadful thought."[39] As Heisig stated it, the problem with freedom and art as understood in the West is that it means "'make whatever you want,' and that is a haunting indifference that suggests to artists that they are superfluous. . . . To be needed, to play an indispensable role in society's intellectual debates, that needs the cooperation [*Entgegenkommen*] of the artist with society. Not in that [the artist] gives in [*anpasst*], but rather in that he reaches out [to society] with his own concerns, gets mixed up in it, and takes a position."[40]

Bernhard Heisig: Retrospective marks the high point in Heisig's reception in the two Germanys, offering an overview of his life and work that balanced Eastern and Western perspectives. At the age of sixty-four, Heisig had established himself as a "German" artist—highly praised in both East and West—at a time when a unified Germany still seemed a distant prospect at best. In actuality, the collapse of the GDR would take place less than six weeks after the exhibition opened.

The German-German *Bilderstreit*

The fall of the Berlin Wall had a huge impact on Heisig's reception in the Federal Republic of Germany, as it did on that of many of East Germany's most successful artists. Almost immediately, the western German press began to attack Heisig on the basis of his biography and, in particular, his connection to the German Democratic Republic, giving new prominence to dissenting voices who had been speaking out against Heisig and other East German artists since these artists first appeared in West Germany.[41] Already in 1977, when Heisig, Tübke, Mattheuer, and Sitte exhibited paintings at *documenta* 6 in Kassel, West Germany, protestors delivered leaflets and conducted a sit-in, and two artists, Georg Baselitz and Markus Lüpertz, pulled their work from the show.[42] That these voices did not command the attention of the press the way they had in the wake of November 1989 was due in large part to the leftist leanings of West German intellectuals in the 1970s and 1980s. With the sudden collapse of the GDR, however, the authority that leftist intellectuals had enjoyed since Willy Brandt's *Ostpolitik* (politics toward the East) was undermined, and conservative voices—as well as those with axes to grind—came to the fore.[43]

In Heisig's case, one such voice was that of Creszentia Troike-Loewig, the wife of Roger Loewig (1930–97), an artist who had been arrested in East Germany in 1963 for exhibiting works that were critical of the government; he spent a year in jail and later moved to West Berlin, where Troike-Loewig "petitioned and fought for his recognition" as an artist.[44] Between November 1989 and March 1990, she wrote a number of multipage letters to curators at museums in West Germany trying to stir up a negative reaction to Heisig and the traveling exhibition of his work.[45] Notably, all the letters date to after the fall of the Berlin Wall. Wanting to know who was paying for this exhibition with its posters, invitations, and catalog, Troike-Loewig was upset that Heisig was receiving such attention both in terms of the money spent and the number of important guests attending the

opening. Her letters hit upon most of the major tropes of anti-Heisig sentiment that would be used in the coming years. She saw Heisig as opportunistic, slippery, and shrewd, and pointed out his having joined the SS and then later the Communist Party upon arriving in the Eastern Zone as proof. She asserted that he was part of the GDR elite, which had the same privileges as the political elite, and thus that he represented the GDR with its "denial of human rights" and continuation of Nazi ways.[46] And yet, she also admitted that Heisig was perhaps "the best" of the East German artists and that she could not see past her own emotions.

Troike-Loewig's attacks on Heisig's character were a precursor to the larger debate around what role East German art and artists should play in the new Germany that became known as the German-German *Bilderstreit*, or "image battle." Like Troike-Loewig's letters, the attacks on East German artists were based more on emotion than on facts and focused more on biography than on the artwork produced. The *Bilderstreit* began in earnest in 1993 when eighteen prominent West Germans—including the GDR emigrants Georg Baselitz and Gerhard Richter—left the visual arts department of the West Berlin Academy in protest against the en-bloc acceptance of colleagues from its eastern counterpart, the East German Academy.[47] Then, the following year, the Neue Nationalgalerie in Berlin became the focus of debate when it placed masterpieces from the two Germanys side by side in an exhibition of postwar German art from its permanent collection. A meeting of the Berlin CDU in the Abgeordnetenhaus (House of Representatives) in April 1994 ignited the debate, when a politician there likened the museum to a *Parteischule* ([Communist] Party school) because of its inclusion of East Germany's so-called *Staatskünstler* (state artists): Heisig, Sitte, Tübke, and Mattheuer.[48]

A third major flare-up in the *Bilderstreit* took place in 1998 when Heisig was invited—as one of only two East German artists—to contribute work to the Reichstag building in Berlin. That discussion peaked in mid-February with a letter from the eastern German curator Christoph Tannert that was signed by fifty-eight cultural and political figures, including several eastern German artists from the alternative scene.[49] The letter stated that giving the commission to Heisig "is not only an art-historical mistake, but also [demonstrates] a lack of political sensitivity."[50] For Tannert and his signatories, the problem was Heisig's seeming "cooperation with the GDR regime," which they saw as standing "in crass opposition to a democratic horizon of values."[51] Two days later, the East German artist Hartwig Ebersbach responded to these accusations with a letter signed by prominent Germans from both sides of the former wall. As they saw it,

Tannert's letter was "not about a factual discussion of work and life"; rather, it was mudslinging that served a cliché: "Heisig, that is the GDR."[52] Heisig's critics were responding, in other words, to Heisig's reputation rather than to reality, to his commitment to East Germany and his perceived role as *Staatskünstler* rather than to his art.

The term *Staatskünstler* appeared repeatedly in post-wall German discussions of prominent East German artists. According to a strict definition of the term, Heisig was indeed such an artist: his work represented the GDR in major international exhibitions, including *documenta* and the Venice Biennale. He also enjoyed significant privileges, ranging from employment to the ability to travel to and exhibit in the West. But the term *Staatskünstler*, when applied to East German artists, has several negative connotations that do not apply to Heisig, nor to most of the other artists so labeled. The first of these was the idea that these artists forfeited their artistic integrity in exchange for fame and power. In Heisig's case, however, it was just the opposite: he actually changed from an illusionistic realism in the 1950s to one inspired by Corinth, Kokoschka, Beckmann, and Dix in the early to mid-1960s. That is, he changed from an artistic style that was acceptable to orthodox political functionaries to one that was not. As this book has shown, this change in painterly style led to a number of clashes with higher-ups in the latter half of the 1960s, clashes that have been largely overlooked or misinterpreted in German scholarship. It was only with rise of Erich Honecker to power in 1971 that Heisig became a highly valued artist at the national level, the result of a change—and considerable relaxation in—cultural policy. One could even argue that, through his repeated provocations in the 1960s, Heisig helped lead the way to the modern style for which East German art became known in the 1970s and 1980s.

A second implication of the term *Staatskünstler* is that these artists actively oppressed others. In Heisig's case, the insinuation is that he, as professor at and director of the Leipzig Academy, prevented those with a more radical view of art in terms of stylistic innovation from becoming artists. But a closer examination of the record reveals that Heisig in fact worked with younger artists to make the Leipzig Academy more modern. In the 1970s, he hired Hartwig Ebersbach to create and teach a multimedia class and ran interference with political functionaries in Berlin for years before the class was ultimately shut down.[53] Similarly, as vice president of the Union of Visual Artists at the national level, he helped negotiate a compromise for the controversial Herbstsalon (Fall Salon) in Leipzig in 1984, a so-called underground exhibition of young artists who were able to display works not considered acceptable by the government.[54] All of

these facts suggest that Heisig was open to the younger generation and worked to include them and their broadening interests in the system, even if he was not interested in creating such works himself. Indeed, Ebersbach defended Heisig on just these terms during the debate around the inclusion of Heisig's work in the Reichstag in 1998.[55]

The most damning accusation about the *Staatskünstler* was that they were highly successful in the GDR, a country that was repeatedly attacked in the press in the wake of the fall of the Berlin Wall. In the heavily charged political atmosphere of Germany in the 1990s, the so-called *Staatskünstler* were seen by some western Germans as having helped legitimate the East German regime—and thus having contributed to its longevity—by the very fact that they had not left it, and thus tacitly, if not actively, supported it. This accusation recalls the exiles-*Hierbleiber* (those remaining here) debates from the Third Reich, where exiles were castigated for abandoning the German people in their time of greatest need, and *Hierbleiber* for tacitly lending their support to the regime by not leaving. Artists like Heisig were similarly castigated for staying in the GDR and attempting to change it from within.

Not all the criticism came from western Germans: There were at least three distinct groups of eastern Germans who condemned the so-called *Staatskünstler*. The first came from a younger generation of artists in the GDR whose radicalism in terms of formal innovation or direct criticism of the state had caused conflict with the government and for whom the fall of the Berlin Wall had ended the GDR before such conflicts could be worked out; or, in the case of those who had recently emigrated to the West, before they could disassociate themselves from their East German past. It was this group in particular that saw the so-called *Staatskünstler* as having sold out their artistic integrity—as evidenced by their apparent artistic conservatism—and misused their power to oppress younger, more formally innovative artists. It was also this group of younger artists who wrote the letter against Heisig's inclusion in the Reichstag in 1998. Archival evidence and interviews, however, suggest that the issue at stake here is less one of aesthetic repression than generational conflict.[56] These younger artists were rebelling against the hegemony of artists born between 1920 and 1935. This generation of artists, which included the *Staatskünstler*, held a majority of the jobs in the GDR in the 1980s, thus inadvertently blocking the upward mobility of younger generations. This blockage was the result of historical circumstances: in the wake of the Second World War, there were numerous openings in the art world that needed to be filled. By the 1980s, the generation that had taken those jobs was only just getting to

retirement age. Had the GDR survived another ten years, there would have been a significant changing of the artistic guard that presumably would have alleviated some of the tension between this generation and the ones that followed.

A second group of eastern German voices critical of the "*Staats-künstler*" came from artists who had left the GDR and made international names for themselves as "German" artists. The most notable example is Georg Baselitz, who stated in an oft-quoted interview in *Art* magazine in 1990, "There are no artists in the GDR, they all left . . . no artists, no painters. None of them ever painted a picture. . . . They are interpreters who fulfilled the program of the East German system. . . . [They are] simply assholes."[57] Both Baselitz and Gerhard Richter left the GDR as adults for the West, where they established international reputations. Until recently, their East German backgrounds—including their artistic training—have been glossed over.[58] And yet this background presumably contributed to their positive reception, lending them an aura of Otherness that also confirmed the seeming superiority of the West by their choice to live there.

The third group of eastern German voices who were critical of the "*Staatskünstler*" was composed of artists, critics, and art historians from places other than Leipzig/Halle who were attempting to reconfigure the history of East German art by downplaying the importance of the Leipzig School. This view was particularly apparent in the 2003 exhibition at the Neue Nationalgalerie in Berlin, *Kunst in der DDR, Eine Retrospektive* (Art in the GDR, a Retrospective), where the Leipzig School had only one small artificially lit room, while artists from Berlin enjoyed three of the five rooms in the exhibition that were open to natural lighting (Dresden had the other two).[59] For viewers unfamiliar with the history of East German art, the Leipzig School—which had been highly praised on both sides of the wall before 1989—would have seemed no more important than constructivism, which also had a small room in the exhibition.

With the new millennium, the *Bilderstreit* quieted.[60] In fact, the *Kunst in der DDR* exhibition of 2003 can be seen as the first in a new phase in the post-wall reception of East German art, one marked by relative acceptance, if not praise, in the press. This is the result, in part, of *Ostalgie*, or nostalgia for the East, in which East German products suddenly became trendy.[61] In part, it is also the result of tailoring exhibitions of East German art to Western interests and understanding. *Kunst in der DDR*, for example, did not attempt to present a comprehensive overview of East German art. Rather, it focused on those works that had a modern style and a universal,

if not Western, subject matter. Conservative works of socialist realism and paintings of workers, although common in the GDR, were largely excluded. The result was an exhibition that was highly praised in the press and that managed to convince many of its Western viewers—who attended in record-breaking numbers—that, indeed, there had been art in the GDR.[62]

The New Millennium

The attempt to gain recognition for East German art by casting it into a form more palatable to a Western audience can also be seen in a solo exhibition of Heisig's work that traveled to several cities in Europe in 2005–6, *Bernhard Heisig, Die Wut der Bilder* (Bernhard Heisig, the Rage of Images).[63] Presented in the catalog and official press materials as a "comprehensive overview of Heisig's work," it focused on his *Komplexbilder*, which include his history paintings, mythological and biblical works, as well as those that focus on current events.[64] These paintings made up two-thirds of those on display. The result was an exhibition that created the impression that Heisig was an artist obsessed with the traumas of war and that he could paint little else.[65]

The painting used for the catalog cover and promotional material further emphasized this reading: *Der Kriegsfreiwilliger* (The War Volunteer, 1982/84/86, fig. 6.6) focuses on a young man in a military uniform.[66] He stands with his fists in front of him and screams, eyes wide open, as if having just seen something horrific, presumably the images swirling around him. To the right is a scene from Heisig's Fortress Breslau series, a reference to where Heisig spent the final days of the war. It shows the Nazi Gauleiter Hanke, who was in charge of Breslau at the time, in a tan uniform and military hat; he holds his hands up to his ears. Before him, a screaming man in a pink shirt, his hands tied behind his back, has a noose around his neck. A tank explodes beside him. Behind the two figures, the bridges, river, and city of Breslau cover the upper right-hand quadrant of the painting. Below, the hanged man's black-clad legs suggest a swastika within a large red-and-white swirl over which skulls tumble down the canvas. At the bottom of the composition, a reclining man holds up an iron cross, recalling *The Christmas Dream of the Unteachable Soldier*. In the upper left corner of the painting, the skewered soldier from Otto Dix's *War* disappears into an egg, recalling a background image from Heisig's Christ Travels with Us series. Below it are additional scenes from Dix's war triptych.

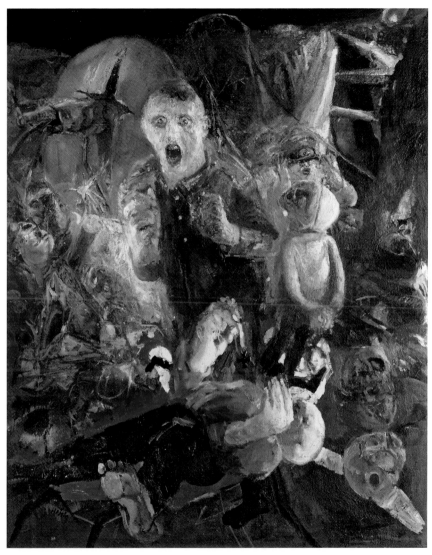

Figure 6.6. Bernhard Heisig, *Der Kriegsfreiwilliger* (The War Volunteer), 1982/84/86. Oil, 101 x 90 cm. © 2018 Artists Rights Society (ARS), New York / VG Bild-Kunst, Bonn. Galerie Brusberg Berlin Collection. Photo: copyright Galerie Brusberg Berlin.

The War Volunteer reflects upon some of the horrors that a soldier might see in the field. It also stands as a compendium of Heisigian motifs—some dating back to the late 1960s—as suggested by the original title of the work, *Begegnung mit Bildern* (Encounter with Images). This painting, like so many of Heisig's, is one in a series. It began as a portrait of his younger son, Walter, in his uniform for the East German National People's Army and standing in front of other paintings in Heisig's studio.[67] By 1982, Heisig had done several variations and had expanded into a triptych format with a variety of images from the media—such as a cameraman, singer, and soccer game—appearing in the left panel and, in the right, the Paris Commune. *The War Volunteer* is the center panel of one such triptych.

The *Wut der Bilder* catalog presented Heisig's tendency to rework images and to create multiples as evidence of trauma. This tendency in Heisig's work first emerged in the early 1960s with his series of paintings on the Paris Commune. Yet it can also be seen in his many paintings of workers, including *Brigadier II*. In East Germany, this tendency to create multiple versions and to constantly reword them was explained as a result of Heisig's unwillingness to tolerate imperfection: "Creative unrest is a foundational element in the work of the Leipzig painter and graphic artist Bernhard Heisig. . . . His constant dissatisfaction with himself proves to be a creative and destructive trait at the same time: it leads him on the one hand to paint multiple versions, and on the other, to destroy them and attempt the theme from a different angle."[68]

Not only did he continuously rework paintings in his possession, he was also known to rework them even when they were on a museum or gallery wall.[69] There are many stories of his having family members or friends keep an eye out for museum guards while he made a few changes to one of his paintings.[70] There are other stories of him working until the paintings were literally taken away from him. Heisig himself once stated that his paintings would only ever be finished when he was dead.

Whereas Heisig's tendency to repeat and repaint was explained by East German critics as an intolerance for imperfection, in the *Wut der Bilder* exhibition, it was presented as the result of trauma, a seeming illustration of Freud's essay, "Memory, Repeating and Working Through."[71] This focus was used to argue that Heisig was *the* artist of *Vergangenheitsbewältigung* (coming to terms with the past), an idea that took its cue from a comment made by historian Götz Aly in response to a politician's question during the Reichstag debate, "Do we want to explain to a guest from Israel that this picture was by a man formerly in the Waffen-SS?!"[72] Aly replied:

> We want and must have exactly that in order to explain honestly to an Israeli guest: here hangs the painting of a man who made a mistake, who stands for a generation of German youth who . . . narrowly missed "the grace of a late birth." Here hangs the painting of a man who has familiarized himself with this mistake and has spent a lifetime working on it in order to make up for it, for himself and for others. Exactly such images belong in the future German Bundestag, and in the entrance hall no less.[73]

This perspective casts Heisig as the quintessential postwar German artist, struggling with the very issues that still define German identity in the twenty-first century.

And yet this lens ignores the complexity of Heisig's work and its relationship to the Cold War context in which it was created, as well as the large swathes of his oeuvre that do not engage with conflict. Such a lens also requires a distortion of facts. In *Die Wut der Bilder*, for example, evidence of Heisig's positive relationship to East Germany tended to be overlooked, downplayed, or dismissed. This can be seen in the selection of images as well as in some of the texts in the catalog. *Brigadier II*, for example, which was one of Heisig's most famous paintings in the GDR, was not included.[74] Instead, it was dismissed in the catalog as little more than a concession to curry favor with the government. Similarly, his many images of East German cultural figures were represented by only one painting, *Vaclav Neumann*.[75] Indeed, those parts of Heisig's oeuvre that do not fit well within the rubric of trauma—still lifes, landscapes, literary illustrations, and portraiture—were almost completely excluded from the exhibition. Heisig was thus presented as a victim of history rather than an active participant. As the catalog states, "All his life, Bernhard Heisig has struggled to come to terms with the traumas of a biography that passed from war and dictatorship to a further dictatorship and the Cold War."[76]

Throughout the catalog for *Die Wut der Bilder*, Heisig appears as a great German artist *in spite of* the East German context in which he lived and worked. The overemphasis on his war paintings—interpreted primarily in terms of personal trauma—and the implication that he was almost always a modern artist suggest that neither his content nor his style was affected positively by the GDR. Similarly, Heisig's difficulties with the regime tended to be highlighted. This can be seen especially in the biographical emphasis on his conflicts with cultural functionaries at the Fifth Congress in 1964 and at the Seventh District Art Exhibition in 1965. The implication was that he was willing to fight and suffer for his artistic convictions and that those convictions were commensurate with Western beliefs about art. The conflicts Heisig had in those years in which his art was decidedly East

German in content—those over the Hotel Deutschland murals in 1965 and over *The Brigade* in 1969—are barely mentioned, if at all.[77] The story told in *Die Wut der Bilder* catalog thus suggests that Heisig was born a great artist, that he was willing to fight and suffer for his beliefs in a Western-style modern art, and that in the end he triumphed over totalitarianism.

This portrayal of Heisig in *Die Wut der Bilder* must be seen, in part, as an attempt to rescue him from the *Bilderstreit* of the 1990s and place him firmly within the canon of great German artists: Heisig as a microcosm of Germany itself and its attempts to come to terms with the Nazi past. The presentation of Heisig as a victim of history also fit well within memorial celebrations of the sixtieth anniversary of the end of World War II as well as with the recent trend in German culture to portray Germans as victims—rather than perpetrators—of the Nazi past; this can be seen in books like W. G. Sebald's *Luftkrieg und Literatur* (On the Natural History of Destruction, 1999) and films like *Der Untergang* (Downfall, 2004).[78] By presenting itself as a "comprehensive overview" of his work, however, this exhibition ultimately limited Heisig's importance as an artist and intellectual.[79] By overlooking large parts of his oeuvre and downplaying, distorting, and even excising his connections to the GDR, it drained his life and art of its complexity and critical potential.

Heisig was more than a victim of totalitarianism: he was an active participant in the Socialist project that was East Germany, an artist willing to stand up and fight for his beliefs about art. This openness to—and perhaps even desire for—confrontation placed him at the center of several controversies in the culturally volatile years of the 1960s. Praised by some and condemned by others, he worked for change in a system whose rules were in constant flux. It is this lack of a uniform policy—as opposed to a monolithically repressive one—that made being an artist in East Germany complicated, especially during the Ulbricht era. Instead of a wall, artists frequently faced a minefield, which made it difficult to predict whether their work—if it was challenging—would be praised or denigrated. Throughout the 1960s, Heisig fought for a more expansive view of art in East Germany. Without Heisig's efforts—as an artist, teacher, and cultural functionary—painting in the GDR may well not have developed beyond the stereotype of socialist realism still expected of East German art by many in the West today. Rather than leave the GDR, Heisig chose to stay and work from within to help reform the system, a task in which he ultimately succeeded in terms of redefining socialist realism.

Heisig's art and struggles offer a unique perspective on the very different development of—and biases inherent in—the Western system.

Whereas the West embraced abstraction in the early years after the war and saw in art a spiritual alternative to the corruptions of the real world, the East turned to art as an instrument of education, a way to mold people into better human beings. In 1981, Heisig described the difference between the two systems—and his preference for the East—with a metaphor: "When artists can make whatever they want . . . that is a dangerous thing, pedagogically speaking. There needs to be a field of friction. . . . It is like with a match . . . [without friction] it won't light . . . if the pressure is too strong—the commission terroristically given out—the match-head breaks. But if I fiddle around next to it, it also won't light."[80]

East Germany was a "field of friction" for art, the appreciation of which was not limited to just artists and a few specialists but rather included politicians and the general public alike. At times that friction was too great—such as with the Formalism Debates—and the metaphorical match broke. In the 1960s, however, the pressure exerted through repeated discussions and debates ultimately resulted in the art for which Heisig is praised today: complex, modern works that emphasize figuration, history, and tradition, as well as making a dialogical connection with the viewer.

When his work is placed back into the context in which it was created, Heisig emerges as a complex figure, a man who rejected the Western view of art for art's sake and chose, instead, to be actively engaged with the political, social, and cultural issues of his day. Committed to the ideals of Socialism, he chose to create an art of value—and interest—to the society in which he lived, to look beneath the surface of Cold War rhetoric for deeper truths, even when that meant facing the ire of politicians and conservative cultural functionaries as a result. Ultimately, Heisig's life and art offer a very different view of what it means to be an artist—one that focuses not on expressing the autonomy of the artist so common in the West but rather on active engagement with society in the hopes of making it a better place.

NOTES

Introduction

Epigraph: "In der DDR wird deutscher gemalt." Günter Grass, "Sich ein Bild machen," in *Zeitvergleich: Malerei und Grafik aus der DDR*, ed. Axel Hecht and Hanne Reinecke (Hamburg: Art, das Kunst Magazin, 1982), 12.

1. Artists in the collection as of 2016 include Georg Baselitz, Joseph Beuys, Hans Haacke, Anselm Kiefer, Imi Knoebel, Markus Lüpertz, Sigmar Polke, Neo Rauch, Gerhard Richter, and Günther Uecker. https://www.bundestag.de/kulturundgeschichte/kunst/kuenstler, accessed October 8, 2016.

2. Christoph Tannert, "Offener Brief," February 9, 1998, faxed to various German newspapers. "nicht nur ein kunsthistorischer Irrtum, sondern auch eine politische Instinktlosigkeit."

3. Ibid. "Kooperation mit dem DDR-Regime," "in krassen Gegensatz zum demokratischen Wertehorizon"

4. These included Jan Faktor, Jürgen Fuchs, Ralph Giordano, Katja Havemann, Freya Klier, Katja Lange-Müller, Ulrike Poppe, and Lutz Rathenow. Visual artists included Hans Hendrik Grimmling, Peter Herrmann, Cornelia Schleime and Max Uhlig.

5. Hartwig Ebersbach, "Auch der Osten hat eine Würde," letter sent to the press, February 11, 1998.

6. List of signatories given in Eckhart Gillen, "'Schwierigkeiten beim Suchen der Wahrheit': Bernhard Heisig im Konflikt zwischen 'verordnetem Antifaschismus' und der Auseinandersetzung mit seinen Kriegstrauma" (PhD diss., Ruprecht-Karls-Universität Heidelberg, 2002), 13. Compare to Karl-Siegbert Rehberg and Paul Kaiser, eds. *Bilderstreit und Gesellschaftsumbruch* (Berlin: Siebenhaar Verlag, 2013), 426.

7. Originally placed in the cafeteria, *Zeit und Leben* was moved in late 2011 to the Parliament's reference library in the Reichstag, where books about the artist and this painting would also be available. For a closer look at the development of the painting, see Rüdiger Küttner, ed., *Bernhard Heisig, Zeit und Leben* (Berlin: Galerie Berlin, 1999).

8. "Rede von Bundeskanzler Gerhard Schröder zur Ausstellungseröffnung Bernhard Heisig—*Die Wut der Bilder* am 20. März 2005," *Bundesregierung Bulletin* 26, no. 3 (April 2005), accessed December 27, 2017, https://www.bundesregierung.de/Content/DE/Bulletin/2001_2007/2005/04/26-3_Schroeder.html.

9. This view of Heisig appears in a couple of articles by West German scholars in the late 1980s, and then in Eckhart Gillen's 2004 dissertation on Heisig, which formed the core of the 2005 exhibition, of which Gillen was the curator.

10. Eckhart Gillen, ed. *Bernhard Heisig: Die Wut der Bilder* (Cologne: DuMont, 2005), 49.

11. Andrew I. Port points to the emergence of a second-wave of scholarship on East Germany in the mid-1990s dominated by a social historical approach; the third wave focuses on a cultural approach. "Introduction: The Banalities of East German Historiography," in *Becoming East German*, ed. Mary Fulbrook and Andrew I. Port (New York: Berghahn Press, 2013), 1–30.

12. Bernhard Heisig, as quoted in Karl Max Kober, "Von der Chance an einem Weltbild mitzuwirken," *Bildende Kunst* 9 (September 1972): 449.

13. See Paul Betts and Katherine Pence, eds., *Socialist Modern: East German Everyday Culture and Politics*, Social History, Popular Culture, and Politics in Germany (Ann Arbor: University of Michigan Press, 2008); and Andrew I. Port, *Conflict and Stability in the German Democratic Republic* (Cambridge: Cambridge University Press, 2007). Important older works include Julia Hell, *Post-fascist Fantasies: Psychoanalysis, History, and the Literature of East Germany* (Durham, NC: Duke University Press, 1997); Mary Fulbrook, *Anatomy of a Dictatorship: Inside the GDR 1949–1989* (Oxford: Oxford University Press, 1995); and David Bathrick, *The Powers of Speech: The Politics of Culture in the GDR* (Lincoln: University of Nebraska Press, 1995).

14. Eli Rubin, *Synthetic Socialism: Plastics & Dictatorship in the German Democratic Republic* (Chapel Hill: University of North Carolina Press, 2008), 9.

15. Dolores L. Augustine, *Red Prometheus: Engineering and Dictatorship in East Germany, 1945–1990* (Cambridge, MA: MIT Press, 2007), xv.

16. Marie Hüllenkremer, "Bernhard Heisig im Gespräch mit Helmut Schmidt," in *Kunst in der DDR*, ed. E. Gillen and R. Haarmann (Cologne: Kiepenheuer und Witsch, 1990), 382.

17. This focus on the local can also be seen in Port's book, *Conflict and Stability in the German Democratic Republic*.

18. Anglo-American scholars have shown interest in East German literature since at least the 1970s. Interest in East German film emerged largely after unification. Examples from this substantial body of literature include Sean Allan and John Sandford, eds., *DEFA, East German Cinema, 1946–1992* (New York: Berghahn Books, 1999); Marc Silberman, "Learning from the Enemy: DEFA-French Co-productions of the 1950s," *Film History* 18, no. 1 (February 2006): 21–45; and Thomas Lindenberger, "Home Sweet Home: Desperately Seeking Heimat in Early DEFA Films," from the same issue of *Film History*, 46–58. The most recent addition to the study of East Germany is material culture, of which there have been a number of edited volumes about postwar Germany as a whole, including Greg Castillo, *Cold War on the Home Front: The Soft Power of Midcentury Design* (Minneapolis: University of Minnesota Press, 2010); and David F. Crew, ed. *Consuming Germany in the Cold War* (Oxford: Berg, 2003). There have been no monographs in English that focus exclusively on East German art. There have been books that have addressed aspects of East German art in a comparative approach with West German art. These include John-Paul Stonard, *Fault Lines: Art in Germany, 1945–1955* (London: Ram Distribution, 2008); and Claudia Mesch, *Modern Art at the Berlin Wall: Demarcating Culture in the Cold War Germanys* (London: Taurus Academic Studies, 2009). Like art, East German music has received little scholarly

attention. Exceptions include Joy Calico, "*Für eine neue deutsche Nationaloper*: Opera in the Discourses of Unification and Legitimation in the German Democratic Republic," in *Music and German National Identity*, ed. Celia Applegate and Pamela Potter (Chicago: University of Chicago Press, 2002), 190–204; and Laura Silverberg, "Between Dissonance and Dissidence: Socialist Modernism in the German Democratic Republic," *Journal of Musicology* 26, no. 1 (Winter 2009): 44–84.

19. Hellmut Lehmann-Haupt, *Art under a Dictatorship* (New York: Oxford University Press, 1954), 200–215. Lehmann-Haupt was born in Berlin in 1903. He moved to the United States in 1929. After World War II he worked for several years in the American military, first as a civil arts liaison administration officer (1946–48) and then as an art intelligence coordination officer (1948). "Hellmut Lehmann-Haupt Papers in the Museum of Modern Art Archive," accessed March 19, 2011, http://www.moma.org/learn/resources/archives/EAD/LehmanHauptb.html.

20. Lehmann-Haupt could not have foreseen the significant changes that would take place in the wake of Stalin's death in March 1953 and the People's Uprising that June.

21. "The Artistic Situation in East Germany," *Burlington Magazine* 98 (1956): 257–58.

22. According to Saunders, the United States was responding to the Soviet Union's use of culture in the "battle for men's minds." Frances Stonor Saunders, *Who Paid the Piper? The CIA and the Cultural Cold War* (London: Granta Books, 1999), 17. See also Serge Guilbaut, *How New York Stole the Idea of Modern Art: Abstract Expressionism, Freedom, and the Cold War* (Chicago: University of Chicago Press, 1983); and Greg Barnhisel, "Perspectives USA and the Cultural Cold War: Modernism in Service of the State," *Modernism/Modernity* 14, no. 4 (November 2007): 729–54.

23. For a study of how modern art was imposed on West Germany, see Jost Hermand, "Modernism Restored: West German Painting in the 1950s," *New German Critique*, no. 32 (1984): 23–41.

24. The Grove Art Online Dictionary describes socialist realism as follows: "Apart from ideology . . . the most obvious attributes of Socialist Realism are its monumental scale, heroic optimism, and eclectic realism as well as its dependence on the personality of the cult of the leader." David Elliott, "Socialist Realism," in *Oxford Art Online: Grove Art Online* (Oxford University Press, 2003), accessed April 2, 2007, http://www.groveart.com/. Earlier in the article, however, Elliott states, "Socialist Realism was seen as a method of creation rather than a style." It is this latter definition that best fits East German art. In fact, many of Heisig's paintings contain none of the "obvious attributes" of socialist realism.

25. David Elliott, *Tradition and Renewal: Contemporary Art in the German Democratic Republic* (Oxford: Museum of Modern Art, 1984). It was also in these years that West Germany had its first major exhibition of contemporary East German art. *Zeitvergleich, Painting and Graphics from the GDR* opened in 1983 and traveled to several cities in West Germany. It was followed in 1984 by *Durchblick*, an exhibition of works from the Ludwig Institute of GDR art located in Oberhausen, West Germany.

26. Elliott, *Tradition and Renewal*, 7.

27. Ibid., 8.

28. According to Nisbet, the Busch Reisinger Museum began borrowing work from the GDR in the 1980s for various exhibitions. This interaction ultimately resulted in an exhibition of East German art. Peter Nisbet, *Twelve Artists from the German Democratic Republic* (Cambridge, MA: Harvard University Press, 1989), 7. This exhibition had five artists in common with the 1984 exhibition in Oxford: Bernhard Heisig, Willi Sitte, Sighard

Gille, Carlfriedrich Claus, and Walter Libuda. Unlike the earlier exhibition, it did not include women or artists who worked in a realist style inspired by Neue Sachlichkeit.

29. Ibid.

30. There are a handful of texts translated from the German, including Eckhart Gillen, ed., *German Art from Beckmann to Richter: Images of a Divided Country* (New Haven, CT: Yale University Press, 1997). I am focusing here on scholarship by Anglo-American academics.

31. Marion Deshmukh, ed., *Cultures in Conflict: Visual Arts in Eastern Germany since 1990* (Washington, DC: American Institute for Contemporary German Studies, 1998), 14. The German authors are Matthias Flügge, Eckhart Gillen, and Jost Hermand. In comparison to Flügge and Gillen, Hermand moved to the United States in 1958, where he became a German professor at the University of Wisconsin–Madison at the age of twenty-eight. Thereafter, he had numerous year-long visiting appointments in West Germany.

32. For more about how the catalog dealt with East German art, see my review of this exhibition: April Eisman, review of the 2009 LACMA exhibition catalog, *Art of Two Germanys / Cold War Cultures*, ed. Stephanie Barron and Sabine Eckmann, *German History* 27, no. 4 (2009): 628–30.

33. Joachim Joachimides, "A Gash of Fire across the World," in *German Art in the 20th Century* (London: Prestel Verlag, 1985), 11.

34. David Elliott, "Absent Guests," in *Divided Heritage: Themes and Problems in German Modernism*, ed. Irit Rogoff (Cambridge: Cambridge University Press, 1991), 25. This elision of East German art can also be seen in the United States: in 1987, for example, the Museum of Modern Art's inclusively titled exhibition, *Berlinart, 1961–87*, contained no works from the eastern side of the wall. The assumption that West Germany was the only Germany stems, at least in part, from the Hallstein Doctrine, a Cold War policy from 1955 that stipulated West Germany would not have diplomatic relations with any country that had diplomatic ties to East Germany. In its wake, West Germany became the only Germany in the Anglo-American West. Although this doctrine passed out of favor in West Germany in the early 1970s with the *Ostpolitik* (east politics) of Willy Brandt, its view of West Germany as the only Germany clearly continued in the minds of many British and American curators in the 1980s. As Olu Oguibe has stated, "The contemporary art 'world' is one of the last bastions of backwardness in the West today." Olu Oguibe, *Culture Game* (Minneapolis: University of Minnesota Press, 2004), xii.

35. Benjamin H. D. Buchloh, "How German Was It?," *ArtForum* (Summer 2009): 294–99. Buchloh was born in Cologne in 1941.

36. For more on East German artists' awareness of and ability to visit the West, see April A. Eisman, "East German Art and the Permeability of the Berlin Wall," *German Studies Review* 38, no. 3 (2015): 597–616.

37. Paul Kaiser was socialized in East Germany but has embraced the totalitarian approach to East German studies that reemerged in Western scholarship after the fall of the Berlin Wall.

38. Paul Kaiser, "Symbolic Revolts in the 'Workers' and Peasants' State': Countercultural Art Programs in the GDR and the Return of Modern Art," in *Art of Two Germanys / Cold War Cultures*, 171 and 172.

39. Stephanie Barron, "Blurred Boundaries: The Art of Two Germanys between Myth and History," in *Art of Two Germanys / Cold War Cultures*, 25.

40. Transcript (April 20, 1995) for Lutz Dammbeck's documentary film, *Dürers Erbe* (1995), as quoted in Gillen, "'Schwierigkeiten," 9. This dissertation is a rich source of Heisig quotes from interviews Gillen conducted in 2000 and from interviews conducted by Dammbeck in 1997. My interpretation of Heisig's relationship to East Germany, however, differs significantly from Gillen's.

41. In East Germany, visual artists and writers were considered part of the intelligentsia. They were expected to help create a better world through their work.

42. Bathrick, *Powers of Speech*, 3.

43. This view comes most directly through the inclusion of speakers, writers, and in the case of the LACMA exhibition, a co-curator from Germany. It also appears in the biases expressed by American authors of German descent, such as Buchloh. Although the inclusion of (West) German voices is almost unavoidable in the absence of American scholars on the topic, the volatility of East German art's reception after unification has rarely been addressed. A notable exception is Hans Belting, *The Germans and Their Art, a Troublesome Relationship*, trans. Scott Kleager (New Haven, CT: Yale University Press, 1988).

44. Klaus Baschleben, "Streit um Reichstagskunst: Heisig rein oder raus?," *Leipziger Volkszeitung*, February 11, 1998.

45. See Hannah Arendt, *The Origins of Totalitarianism* (New York: Harcourt, Brace, 1951); and *Eichmann in Jerusalem: A Report on the Banality of Evil* (New York: Viking Press, 1963).

46. Corey Ross, *The East German Dictatorship: Problems and Perspectives in the Interpretation of the GDR* (New York: Oxford University Press, 2002), 21.

47. Important figures in the totalitarian approach of the 1990s include Dan Diner, Ernst Nolte, and Hans Magnus Enzensberger. This approach has since fallen out of favor among GDR scholars, who see it as an example of liberal capitalist triumphalism that contributes little to the understanding of East Germany. Mary Fulbrook's *Anatomy of a Dictatorship* (1995) is an early example of this shift away from the totalitarian model in the wake of unification. Other notable early examples are what Eli Rubin terms the *Alltagshistoriker* (Alf Lüdtke, Dorothee Wierling, Alexander von Plato, Lutz Niethammer) and those centered around the Zentrum für Zeithistorische Forschung in Potsdam (Konrad Jarausch, Martin Sabrow, Thomas Lindenberger). Rubin, *Synthetic Socialism*, 5. See also Port, "Introduction." For more on how East Germans were treated after unification, see Kristen Ghodsee, *Red Hangover: Legacies of Twentieth-Century Communism* (Durham, NC: Duke University Press, 2017), 58–64, 92–97.

48. This tendency can also be seen as part of a general bias in humanist disciplines toward more recent scholarship. In the case of East German studies, it is compounded by the fact that unification led to much greater access to archival files.

49. Eastern German scholars who embrace Western views of East Germany do not face the same hindrances. For a look at how East Germans were affected by unification, see Wolfgang Dümcke and Fritz Vilmar, eds., *Kolonialisierung der DDR: Kritische Analysen und Alternativen des Einigungsprozesses* (Münster: Agenda Verlag, 1995).

50. Konrad H. Jarausch, *The Rush to German Unity* (New York: Oxford University Press, 1994), 80. See also Stephen Brockmann, *Literature and German Reunification* (Cambridge: Cambridge University Press, 1999), 54.

51. Bathrick, *Powers of Speech*, 1; and Jarausch, *Rush to German Unity*, 67.

52. Jarausch, *Rush to German Unity*, 54.

53. Daphne Berdahl, *Where the World Ended: Re-unification and Identity in the German Borderland* (Berkeley: University of California Press, 1999), 162.

54. Ibid., 121.

55. Ibid., 163.

56. Ibid.

57. The SPD governor of Brandenburg, Matthias Platzeck, told *Spiegel* magazine with regard to the twentieth anniversary of unification: "I don't know what there is to celebrate. . . . We didn't want an accession; we wanted a cooperation of equals with a new constitution and a new anthem. We wanted symbols of a real, collective new beginning. But others got their way." C. G. H., "Reunification Controversy: Was East Germany Really 'Annexed'?," *Der Spiegel*, August 31, 2010, accessed December 27, 2017, http://www.spiegel.de/international/ germany/ 0,1518,714826,00.html.

58. In *Red Hangover*, Ghodsee refers to it as "the colonization of East Germany through the process of privatization" (93). Bathrick uses the term "annexation" in *The Powers of Speech*: "the accelerating push for annexation with the Federal Republic" (1).

59. *Weissensee*, written by Annette Hess (b. 1967, Hannover), began on ARD in 2010 and released its final season in 2018. *Deutschland 83*, a coproduction of RTL and AMC's Sundance TV written by the western German American duo Jörg and Anna Winger, first appeared in 2015; it is expected to be followed by *Deutschland 86* and *Deutschland 89*.

60. Heisig received the National Prize (Second Class) in 1972 and the National Prize (First Class) in 1978. HGB-Archiv: Personalakte Heisig.

61. For more on the impact of unification on literature, see Brockmann, *Literature and German Unification*, 1999.

62. Heisig and Brüne married in 1991, forty years after they first began dating.

63. The last major museum exhibition of Heisig's work was in 2005, *Bernhard Heisig: Die Wut der Bilder*. There have been a number of smaller, gallery exhibitions since then, most notably at the Galerie Berlin in 2015 for what would have been Heisig's ninetieth birthday.

64. Michael Baxandall, *Patterns of Intention: On the Historical Explanation of Pictures* (New Haven, CT: Yale University Press, 1985).

65. Heisig is not the only artist to rework paintings. The nineteenth-century English painter J. M. W. Turner, for example, would send unfinished paintings to the Royal Academy and then completely rework them in the days leading up to the opening. See conclusion for more about Heisig's tendency to rework paintings.

66. Compare with the biography in the 2005 catalog, Gillen, *Bernhard Heisig: Die Wut der Bilder*, which is the most detailed to date; it divides Heisig's life into five sections based largely on his relationship to the Leipzig Academy: (1) his early years in Leipzig, when he was a student and later a freelance artist, 1948–53; (2) his "first career," beginning when he was hired to teach at the Leipzig Academy and ending with his first term as director, 1954–63; (3) a period of conflict and punishment, beginning with his controversial speech at the Fifth Congress—for which he supposedly lost his job as director—and ending with his leaving the Leipzig Academy altogether, 1964–68; (4) his "second career" as a freelance artist, 1969–75; and (5) his years as director of the Leipzig Academy (for the second time), 1976–89, although technically Heisig retired two years before the wall fell. Gillen, *Die Wut der Bilder*, 307–29.

67. In terms of dates, this categorization is similar to that used by other scholars of the GDR such as Wolfgang Emmerich and Genia Schulz, but it does not privilege the

later periods as they do. Emmerich, for example, saw these three periods as premodern, modern, and postmodern, and gave preference to the latter two. Hell, *Post-fascist Fantasies*, 11–14. As I discuss in the conclusion of this book, I believe the shift to a "German" subject matter in this third period of his work marks a substantial change in Heisig's work based on disillusionment with the GDR in the wake of the forced expatriation of the East German singer-songwriter Wolf Biermann, on the one hand, and the opening up of the West German art market to the GDR, on the other. The latter created a new opportunity for Heisig to create work for a united Germany—if only at the level of *Kulturnation*—at a time when his hopes for such a unification under Socialism had been put to a conclusive end. For a discussion of the concept of *Kulturnation* with regard to German literature on both sides of the wall in the 1980s, see Brockmann, *Literature and German Reunification*.

68. This thematic approach is the result of difficulties in establishing a chronological overview of his work. To date there have been only two significant attempts to look at Heisig's work chronologically. In 1988, Bernfried Lichtnau finished a dissertation at Greifswald University in East Germany on Heisig's history paintings, which he organized thematically and then chronologically within each group. He also looked at several portraits, landscapes, and still lifes. Bernfried Lichtnau, "Der Beitrag Bernhard Heisigs zur Weiterentwicklung der Historienmalerei in der bildenden Kunst der Deutschen Demokratischen Republik: Bestimmung der Funktions- und Gestaltungsdifferenzierung historisch-thematischer Kompositionen" (PhD diss., Greifswald University, 1988). Five years later, in 1993, the eastern German curator Dietulf Sander completed his dissertation at Leipzig University. It is essentially a *Werkverzeichnis* (*catalogue raisonné*) of Heisig's prints: "Bernhard Heisig—das druckgraphische Werk, Kommentiertes Verzeichnis der Lithographien, Radierungen und Monotypien, 1950–1990." Begun under Karl Max Kober's guidance, Sander's dissertation organized thousands of prints dating from the early 1950s to the early 1990s into ten volumes; these offer the only overview of Heisig's style and subject matter until now. Unfortunately, both dissertations are available in only a handful of university libraries in Germany, thus making two of the most significant studies of Heisig's work to date two of the least known by nonspecialists.

69. Literary scholars have noticed a similar "convergence" between the work of authors on both sides of the wall in the 1980s. See Rob Burns, ed., *German Cultural Studies: An Introduction* (Oxford: Oxford University Press, 1995). In the visual arts, this is the result of changes that took place on both sides: in the East, a shift toward modern artistic styles; in the West, a return to figuration. See also Brockmann, *Literature and German Reunification*.

70. My thanks to Vincent Klotzsche at the Archive of the Leipzig Academy for his diligence in finding relevant information for me. Some of these documents were subsequently cited in the *Bernhard Heisig: Die Wut der Bilder* catalog.

71. In the summer of 2005, I also looked at the Lea Grundig files in the AdK-Archiv and spoke to Christa Cremer about the files of her father, Fritz Cremer, neither of which included documents directly related to Heisig.

72. All three were professional painters in East Germany. Walter took his mother's maiden name, Eisler, in part, to differentiate himself from his father and older brother.

73. These include Gunter Meißner, Rita Jorek, and Anneliese Hübscher.

74. Piotr Piotrowski, "The Geography of Central/East European Art," in *Borders in Art: Revisiting "Kunstgeographie*," ed. Katarzyna Murawska-Muthesius (Warsaw: Institute of Art, 2000): 43–50.

75. Terry Smith, *What Is Contemporary Art?* (Chicago: University of Chicago Press, 2009).

76. Piotr Piotrowski, "Toward a Horizontal History of the European Avant-Garde," in *European Avant-Garde and Modernism Studies*, ed. Sascha Bru and Peter Nicholls (Berlin: De Gruyter, 2009), 57.

77. Like many organizations in East Germany, the VBK changed its name from the Verband Bildender Künstler Deutschlands (VBKD) to the Verband bildender Künstler der DDR (VBK-DDR) in the 1970s.

Chapter One

1. Walter Heisig (1882–1941) and Hildegard Rossa (1895–1978).

2. Freya Mülhaupt, "Biographische Dokumentation," in *Bernhard Heisig: Retrospektive*, ed. Jorn Merkert and Peter Pachnicke (Munich: Prestel Verlag, 1989), 94. "Aber ich habe nicht das gemacht, was man allgemein Kinderzeichnung nennt. Ich zeichnete mit einer gewissen Perfektion."

3. Bernhard Heisig, interview with the author, June 13, 2005. "Technisch hat er mir gar nichts beigebracht. . . . Er hat mir nie eine Korrektur gegeben."

4. A questionnaire Heisig filled out on May 28, 1948, lists "Sowjetische Kriegsgefangenschaft" (Soviet war imprisonment) from May to October 1945. SächsStAL: SAfgKBL 324/1/108.

5. Heisig, as quoted in Gillen, "Schwierigkeiten," 202.

6. Gillen, "Schwierigkeiten," 65.

7. Heisig in 2000, as quoted in Gillen, "Schwierigkeiten," 65. "Alle sprachen deutsch, damit ich sie verstehe. Das hat mich ziemlich beeindruckt. Ich dachte darüber nach, was mit Polen geworden wäre, wenn es unter deutscher Besetzung geblieben wäre."

8. Previously known as the Leipziger Akademie für graphische Künste und Buchgewerbe, the Leipzig Academy was renamed the Staatliche Hochschule für Grafik und Buchkunst (HGB) when it reopened in 1947. Schiller Walter, ed., *Zweihundert Jahre Hochschule für Grafik und Buchkunst Leipzig* (Leipzig: Hochschule für Grafik und Buchkunst, 1964), 28.

9. A letter from Heisig to the Leipzig Academy dated April 26, 1948. SächsStAL: SAfgKBL 324/1/0111.

10. Martin Damus, *Malerei der DDR, Funktionen der Bildenden Kunst im Realen Sozialismus* (Reinbek bei Hamburg: Rowohlt, 1991), 40–42.

11. Günter Feist and Eckhart Gillen, eds., *Kunstkombinat DDR, Daten und Zitate zur Kunst und Kunstpolitik der DDR 1945–1990* (Berlin: Museumspädagogischen Dienst, 1990), 8.

12. Ibid., 9.

13. Ibid., 10.

14. Damus, *Malerei der DDR*, 44. "Für viele Künstler war es das Erlebnis von Freiheit, einfach ungezwungen malen zu können, Schönheit und Harmonie im Bild zu verwirklichen."

15. Ullrich Kuhirt and Herbert Heerklotz, *Weg zur sozialistischen Künstler-organisation: Dokumentation* (Berlin: VBK, 1983), 184. For an alternate opening date for Halle and Dresden, see Feist and Gillen, *Kunstkombinat DDR*, 10. The visual arts

department in Weimar was closed in 1951, leaving just four main art academies in East Germany.

16. From 1947 to 1949, the journal's title was set in all lowercase letters.

17. This debate, which took place in both East and West Germany, can also be seen as a resumption of the expressionism debate of the 1930s among Georg Lukács, Ernst Bloch, and Bertolt Brecht on what art's relationship to society should be. Theodor Adorno et al., *Aesthetics and Politics: The Key Texts of the Classic Debate within German Marxism* (London: Verso Books, 1977). Eugene Lunn, *Marxism and Modernism, an Historical Study of Lukacs, Brecht, Benjamin, and Adorno* (Berkeley: University of California Press, 1982). It also finds an echo in the Faustus debate, which took place in East Germany in 1952–53. This debate focused on the negative—and thus, for some, inappropriate—portrayal of the protagonist in Hanns Eisler's libretto *Dr. Faustus* (1952). Stephen Brockmann, *The Writers' State: Constructing East German Literature, 1945–59* (Rochester, NY: Camden House, 2015), 176–77. Werner Mittenzwei, *Die Intellektuellen: Literatur und Politik in Ostdeutschland 1945–2000* (Berlin: Aufbau Verlag, 2003), 97–103.

18. Oskar Nerlinger, "Politik und Kunst," *bildende kunst 10* (1948): 23–25.

19. Alexander Dymschitz, "Über die formalistische Richtung in der deutschen Malerei, Bermerkungen eines Außenstehenden," *Tägliche Rundschau*, November 24, 1948, 11.

20. Massloff replaced Walter Tiemann, who had been director of the Leipzig Academy from 1921 to 1943, and again from mid-1945 until February 1946 during the American occupation. Once SMAD took charge of Leipzig, it appointed Massloff to be the new director. Henry Schumann, "Leitbild Leipzig, Beiträge zur Geschichte der Malerei in Leipzig von 1945 bis Ende der achtziger Jahre," in *Kunstdokumentation SBZ/ DDR 1945–1990*, ed. Günter Feist, Eckhart Gillen, and Beatrice Vierneisel (Cologne: DuMont, 1996), 482–83.

21. In 2005, Heisig explained that he initially did not get along with Massloff but later came to value him for having "die Grundlage für die so-genannte Leipziger Schule gelegt" (laid the foundation for the so-called Leipzig School). Heisig, interview with the author, June 13, 2005.

22. Gillen, "'Schwierigkeiten," 67. "Da bin ich abgelehnt worden, weil ich nicht modern genug war, also das verrückte Zeug, das konnte ich nicht, keine Phantasie und so."

23. Bernhard Heisig, interview with the author, June 13, 2005.

24. Gillen, "Schwierigkeiten," 68.

25. Meeting minutes from July 1, 1949, list Heisig as one of nine students invited to take the entrance exam. "Protokoll über Kollegium-Sitzung am 1. Juli 1949," SächsStAL: SAfgKBL 334/1/0441. Meeting minutes from July 18 list Heisig (misspelled Heißig) as one of the students accepted. "Protokoll über Kollegium-Sitzung am 18.7.1949," SächsStAL: SAfgKBL 334/1/0052. Meeting minutes from August 25 list Heisig as one of seventeen students who passed the entrance exam and were therefore eligible to begin studying at the Leipzig Academy that fall. "Immatrikulations-Kommission für die Zulassungarbeiten zum Wintersemester 1949/50," August 25, 1949, SächsStAL: SAfgKBL 334/1/0438. A certificate from 1994 in his personnel file at the HGB indicates he was a student from October 17, 1949, until August 31, 1951. HGB-Archiv: Personalakte Heisig.

26. Sander, "Bernhard Heisig." The Statue of Liberty appears to be giving the finger, perhaps a reflection on capitalism's indifference to racial inequality.

27. "Protokoll: Fraktions-über Kollegiums-Sitzung am 7.8.1950," August 11, 1950, HGB-Archiv: 21.

28. N. Orlow, "Wege und Irrwege der modernen Kunst," *Tägliche Rundschau*, January 20, 1951, and January 23, 1951.

29. Orlow, "Wege und Irrwege der modernen Kunst," January 20, 1951.

30. Orlow, "Wege und Irrwege der modernen Kunst," January 23, 1951. "Was aber soll man von Leuten sagen, die viele Jahre nach Käthe Kollwitz das große Vorbild der Arbeiter und Bauern der Sowjetunion sowie das Vorbild des erfolgreichen Aufbaus der Deutschen Demokratischen Republik unter der Führung der Arbeiterklasse vor Augen haben und die Schöpfer des neuen Lebens als 'unglückliche' Menschen darstellen! Ist es denn so schwer zu begreifen, daß eine solche Einstellung zur Arbeiterklasse und zum werktätigen Volk in der DDR falsch ist und nicht der sittlichen Erneuerung des deutschen Volkes dienen kann?"

31. My thanks to Ulrike Goeschen for the Orlow/Magritz reference: Anne Hartmann and Wolfgang Eggeling, *Sowjetische Präsenz im kulturellen Leben der SBZ und frühen DDR 1945–1953* (Berlin: Akademie Verlag, 1998), 218. Peter Pachnicke, "Aufgaben, Struktur und Traditionslinien der Hochschule für Grafik und Buchkunst," in *Hochschule für Grafik und Buchkunst Leipzig, 1945–1989*, ed. Arno Rink and Dieter Gleisberg (Leipzig: Seemann Verlag, 1989), 19.

32. The Fifth Conference [Tagung] of the SED's Central Committee was held March 15–17, 1951.

33. Walter Ulbricht, "Aufgaben der Kunst," *Neues Deutschland*, November 1, 1951. "Wir wollen in unseren Kunstschulen keine abstrakten Bilder mehr sehen. . . . Die Grau-in-Grau-Malerei, die ein Ausdruck des kapitalistischen Niederganges ist, steht in schroffstem Widerspruch zum neuen Leben in der Deutschen Demokratischen Republik."

34. Inge Stuhr, *Max Schwimmer: Eine Biographie* (Leipzig: Lehmstedt, 2010), 158. The article in the *Leipziger Volkszeitung* was published on April 8, 1951.

35. Stuhr, *Max Schwimmer*, 159.

36. E. Hermann, "Mit Phantasie und Anmut: Ausstellungen in Leipzig anläßlich der Messe," *Berliner Zeitung*, March 15, 1951. "Schwimmer [liefert] einen wesentlichen Beitrag zur lebendigen Fortführung der durch Menzel und Slevogt gefestigten Tradition deutscher Zeichenkunst. Schwimmer—einer der bedeutendsten deutschen Illustratoren der Gegenwart ist ein naives Talent voll . . . künstlerischem Charme."

37. Stuhr, *Max Schwimmer*, 165. "Es [sei] nicht nur Zeitmangel, wenn er nicht zur Produktion käme." According to Heisig, Massloff was "a different type" of person than Schwimmer, "more fundamental." He was also "a painter who no longer painted. He had an eye injury from the KZ [concentration camp]. He couldn't really see anymore." Heisig, interview with the author, June 13, 2005.

38. Untitled report, June 25, 1951, HGB-Archiv: 6. This one-page report summarizes the findings of a commission that looked into the discussions taking place at the Leipzig Academy at the time. There are no identifying marks to indicate who wrote the report or for which organization.

39. Bernhard Heisig to Max Schwimmer, July 24, 1951, Leipziger Stadtbibliothek: Schwimmer Nachlass. "Nun handelt es sich nur noch um den Versuch eine Ecke zu finden, wo man noch etwas Luft holen kann."

40. Gillen, "Schwierigkeiten," 70. These trade fairs, which took place twice per year (spring and fall), made Leipzig a particularly lucrative place for artists to live. Heisig had joined the Union of Visual Artists the previous year, in 1950. "Kurzbiographie Prof. Bernhard Heisig," May 28, 1976, BStU-Leipzig: 000001.

41. Bernhard Heisig, interview with the author, 2005.

42. Conservative socialist realist paintings like those at the Third German Art Exhibition in 1953 marked the emergence of the term "Leipzig School," which is one of the reasons artists like Heisig, Tübke, and Mattheuer later rejected it as a label for their work.

43. Tino Heim, "Der kurze Aufstieg und lange Fall der ersten 'Leipziger Schule'—Die Dritte Deutsche Kunstausstellung 1953," in *60/40/20, Kunst in Leipzig Seit 1949*, ed. Karl-Siegbert Rehberg and Hans-Werner Schmidt (Leipzig: Seemann Henschel, 2009), 54–58.

44. *Bildende Kunst* began publication in 1953 and was organized by the Union of Visual Artists; it is not to be confused with *bildende kunst* (all lowercase), which ran from 1947 to 1949 in the Soviet Zone of Occupation. Under Herbert Sandberg's guidance, *Bildende Kunst* ran a series of articles debating Picasso's value for East German artists in 1955 and 1956. The first was Heinz Lüdecke, "Phänomen und Problem Picasso," *Bildende Kunst* 5 (1955): 539–43.

45. Fred Runowsky, "Picasso regt zum mitdenken an," *Bildende Kunst* 2 (1956): 108. "Der 'Kunstverbraucher' . . . will ein Bild, bei dem er selbst mitdenken kann, er will Bilder, die ihn zum Denken und auch zum Träumen anregen. Und das letztere tun die Bilder Picassos zweifellos."

46. Massloff welcomed Heisig, Meyer-Foreyt, and Wagner at the January 19, 1954, meeting of the Leipzig Academy council. "Protokoll der Kollegiumssitzung am Dienstag, dem 19.1.1954," January 23, 1954, SächsStAL: SAfgKBL 336/1/0384.

47. With one exception: Heisig was not on the jury for the 1956 exhibition.

48. "Vorschläge für historische Themen auf dem Gebiete der bildenden Kunst," Dresden, June 26, 1952, SächsStAL: RdB 2265.

49. Ibid. "Es kommt weniger darauf an, den Kampf auf den Barikaden darzustellen, als vielmehr die Volkserhebung zu symbolisieren, bei der die Arbeiter die Hauptrolle spielen gemeinsam mit einem Teil der Studentenschaft, während sich das Kleinbürgertum abwartend verhält."

50. This quote from Heisig was in response to a discussion about his Paris Commune paintings from the late 1950s / early 1960s. Gillen, "Schwierigkeiten," 120. "Das hatte auch etwas mit unserer Situation in der DDR zu tun. Man hat praktisch geistig immer auf den Koffern gesessen. Wir glaubten alle, da muß noch was kommen, das kann nicht alles gewesen sein."

51. Tübke studied art at the Leipzig Academy from 1948 to 1950 and became a lecturer there in September 1955. SächsStAL: SAfgKBL 336/1/0348.

52. Eduard Beaucamp, Annika Michalski, and Frank Zöllner, *Tübke Stiftung Leipzig: Bestandskatalog der Zeichnungen und Aquarelle* (Leipzig: Plöttner, 2009), 20–24.

53. Ibid. Tübke was held from January 14 to September 13, 1946. For more details about Tübke's incarceration, see Annika Michalski, "Die Selbstdarstellungen des Leipziger Malers Werner Tübke: Rollensuche zwischen künstlerischer Tradition und gesellschafts-politischer Stellungnahme, 1940–2004" (PhD diss., Leipzig University, 2012).

54. In this same year, Tübke also created *Festliche Szene VI* (Festive Scene VI), which has similarities to Heisig's *1848 in Leipzig*. Both illustrate a crowd of well-dressed men, women, and children, although Tübke's image has more movement and seems to be indoors.

55. Tübke created two drawings in 1956 titled *Weisser Terror in Ungarn* (White Terror in Hungary) that reflect upon the protests that took place in Hungary between October 23 and November 10, 1956. Annika Michalski and Frank Zöllner, *Tübke Stiftung Leipzig: Bestandskatalog der Gemälde* (Leipzig: Plöttner, 2008), 32–35.

56. References to Picasso also appear in an untitled mural Heisig created in 1955 for the Sportforum in Leipzig, albeit drawing from the Picasso's classical side. In the

black-and-white photo that survives, the linear figures in Heisig's mural recall the rotund, classical nudes found in a number of Picasso's etchings from the early 1930s such as *Three Nudes and a Bowl of Anemones* (1933). The mural also includes several peace doves clearly inspired by the print of a dove that Picasso donated to the International Peace Conference in Paris in 1949.

57. Heisig, interview with the author, June 13, 2005. "Ich könnte mich damit wenig anfangen. Ich könnte meine Stoffe, die ich malen wollte, nicht damit verwenden." See also Bernhard Heisig, "Pablo Picasso," a speech given at the Sprengel Museum in 1986, as reproduced in *Bernhard Heisig "Gestern und in unserer Zeit" oder "Das Elend der Macht,"* ed. Dieter Brusberg (Munich: Hirmer, 2014), 282–87.

58. Not coincidentally, it was in these same years—1954–57—that Herbert Sandberg was editor in chief of *Bildende Kunst*, which resulted in a greater openness to modern art and to debates about art more generally, such as the one about Picasso mentioned earlier.

59. Bernhard Heisig, "Zur Kunstausstellung in Leipzig 1954," *Bildende Kunst* 5/6 (1954): 81.

60. Bernhard Heisig, "Junge Künstler in Leipzig," *Bildende Kunst* 3 (1956): 128.

61. Heisig, "Zur Kunstausstellung in Leipzig 1954," 82.

62. Bernhard Heisig, "Zur Leipziger Bezirkskunstausstellung 1955," *Bildende Kunst* 6 (1955): 476.

63. Heisig, "Junge Künstler," 130. "Der historisch getreu erfaßte Vorgang, zeichnerisch richtig auf die Fläche gebracht, ergibt nicht notwendigerweise eine künstlerische Aussage."

64. Ibid.: "keine Kunstwerke mit gutem Inhalt und schlechter Form oder umgekehrt."

65. Ibid. "Allein, diese Künstler greifen weit über die begrenzten Bezüge dieses Begriffs hinaus. Sie interpretieren keine Historie, sondern deuten sie neu im Sinne einer leidenschaftlichen Auflehnung, und ihre Malerei ist zu ihrer Zeit, wie ihre Ideen, revolutionär."

66. Ibid., 128. "Über die Grenzen des üblichen kollegialen Kontaktes hinaus existieren zwischen den Künstlern wenig Berührungspunkte, und Gruppen mit gemeinsamen künstlerischen Absichten sind nicht zu finden."

67. Ibid. The Union of Visual Artists began as part of the Kulturbund in 1950 but became an independent organization in 1952.

68. Membership enabled artists to have a tax number and to work as freelance artists.

69. Heisig, "Zur Kunstausstellung in Leipzig 1954," 82: "unlebendig, schematisiert, hölzern."

70. Heisig "Junge Künstler," 131. "Dagegen könnte eine Anzahl kleiner, sachlich und weniger verpflichtend inszenierter Ausstellungen gerade die künstlerische Jugend ermuntern, offener und experimentierfreudiger zu werden. Vielleicht würde das helfen, wieder so etwas wie eine künstlerische Atmosphäre zu schaffen, in der statt eines Exerzierens von Regeln das Abenteuer der Kunst lebendig wäre."

71. Ibid.

72. The artist Ursula Mattheuer-Neustadt (b. 1926), who first met Heisig in 1949, wrote an article about him in 2005 in which she stated that when they met, even though he was only slightly older than they, he was much more advanced as an artist than she and her husband, Wolfgang Mattheuer (1927–2004). She credited Heisig's early artistic abilities to his having grown up as the son of an artist, to having already studied art some before the war, and to his personality, with "seine Neigung zur grossen Geste" (his proclivity to

grand gestures). Ursula Mattheuer-Neustadt, "56 Jahre: Zum 80. Geburtstag von Bernhard Heisig," *Marginalien* (February 2005): 6–7.

73. Heisig was not the only artist publishing articles about art in East Germany at this time. His friend and colleague Willi Sitte, for example, was also doing so. Indeed, Heisig may have been emboldened by the regular discussions taking place among a group of artists, including Mattheuer, Metzkes, and Tübke, that Sitte organized in these years. Gisela Schirmer, *Willi Sitte: Farben und Folgen, Eine Autobiographie mit Skizzen und Zeichnungen des Künstlers* (Leipzig: Faber and Faber, 2003), 70–73.

74. Multiple documents list 1956 as the year when Heisig became chair of the VBK-L. The earliest document in the archival files with him in this position dates from December 19, 1957. "Brief an die Parteigruppe der SED des ZV des VBKD," December 19, 1957, HGB-Archiv: 23.

75. Heinrich Witz and Werner Tübke, both of Heisig's generation, followed in 1959 and 1962, respectively.

76. *Atelier-Ausstellung Leipzig, Dimitroffmuseum*, exhibition catalog, 1956.

77. Bernhard Heisig, "Atelier-Ausstellung in Leipzig," *Bildende Kunst* 3 (1957): 168: "von der gewissen Nivellierung im offiziellen Ausstellungsbetrieb loszukommen" "gegenseitige Toleranz" "fruchtbringenden Auseindersetzung."

78. Ibid.: "zur Aktivierung unseres Kunstlebens." This account of the *Studio Exhibition* differs from the one presented in Gillen's dissertation, which quotes a 1997 interview in which Heisig stated that this exhibition was initially made in opposition to the Union of Visual Artists (*gegen den Verband*), but that Walter Münze, as chair of the Leipzig branch of the Union of Visual Artists, played a trick on them and made it a *Verbandsausstellung* (official exhibition). Gillen, "Schwierigkeiten," 84. Such a statement suggests that Heisig was a dissident artist, a useful positioning of him in the politicized atmosphere of Germany in the 1990s, a time when artists with positive connections to East Germany were heavily criticized in the press, but it leaves important questions unanswered: Why would Heisig do something "in opposition to" the Union of Visual Artists in the very year he became chair of the Leipzig branch, and why would he later write about the exhibition in *Bildende Kunst*, an official art publication? Presumably, Heisig was referring to the strategies artists often employed in East Germany when working in the gray area around official policies, but he used language that emphasized conflict—either by conscious choice or coaxing—so desired in post-GDR German scholarship.

79. *Walter Münze, Skizze aus China* (Leipzig: Verband bildende Künstler, 1956).

80. HGB-Archiv: Personalakte Heisig.

81. Heisig joined this board in 1957. In 1959, it became the Staatliche Bezirksauftragskommission (State District Commissions Committee). SächsStAL: RdB 2953.

82. An examination of photographs suggests that Heisig began wearing his characteristic mustache-less beard in 1964.

83. Heisig invited Prüstel to be in the exhibition. They had met in the early postwar years when both lived in Zeitz. Gillen, "Schwierigkeiten," 67. In an article he published about the exhibition in *Bildende Kunst* in March 1957, Heisig drew attention to Prüstel, stating that "among the abstract artists was the strong power of Heinz Prüstel with [his] severe and ruthless (rücksichtslos durchgehaltenen) compositions." Heisig, "Atelier-Ausstellung," 168.

84. Hermann Weber, *Kleine Geschichte der DDR* (Cologne: Verlag Wissenschaft und Politik, 1980), 87–94.

85. Ibid. For examples of this speech's impact in literature, see Brockmann, *Writers' State*, ch. 7.

86. Weber, *Kleine Geschichte der DDR*, 87–91.

87. According to Johanna Granville, Ulbricht survived the Hungarian crisis for a variety of reasons, including the Soviet Union's need for a strong leader in East Germany, which was a crucial location in the Cold War. Granville, "The Last of the Mohicans, How Walter Ulbricht Endured the Hungarian Crisis of 1956," *German Politics and Society* 22 (Winter 2004): 88–121.

88. Walter Ulbricht, "Was wir wollen und was wir nicht wollen," *Neues Deutschland*, December 30, 1956. "Die wichtigste Lehre aus den ungarischen Ereignissen ist: Es gibt keinen dritten Weg." See also Weber, *Kleine Geschichte der DDR*, 92.

89. Harich was a philosophy professor at Humboldt University in Berlin. He also worked at the liberal Aufbau Verlag, which was run by Walter Janka. Both were highly respected intellectuals in East Germany and critical of the regime in the wake of Khrushchev's 1956 speech. There were in fact allegations that the two had sought to organize a putsch.

90. Part of Kurella's influence and interest in Leipzig stemmed from his time as director of the Institute for Literature in Leipzig (1954–57). Kurt Hager, who became secretary of the Central Commission in 1963, replaced Kurella in taking responsibility for the GDR's cultural policies. Kurt Hager, *Erinnerungen* (Leipzig: Faber & Faber, 1996), 258.

91. Feist and Gillen, *Kunstkombinat DDR*, 35.

92. Karl-Heinz Schleinitz, "Hintergründe einer Ausstellung, über eine Konferenz mit Genossen bildenden Künstlern des Bezirkes Halle (I. Teil)," *Neues Deutschland*, January 7, 1958. "Es gibt keinen 'dritten' Weg. . . . Es gibt nur ein Für oder Gegen den Sozialismus!"

93. Damus, *Malerei der DDR*, 158.

94. Feist and Gillen, *Kunstkombinat DDR*, 12.

95. Bernhard Heisig, speech at the Fourth Congress of the VBK, 1959, AdK-Archiv: Kurella Nachlass 330, 138.

96. Its eleven meetings, which took place primarily in Berlin, were in June 1950, 1952, 1955, December 1959, March 1964, April 1970, May 1974, November 1978, 1983, 1988, and April 1990. Kuhirt and Heerklotz, *Weg zur sozialistischen Künstlerorganisation*, 184–96. These meetings took place in a different city each time, and speeches were usually published afterward as conference proceedings.

97. With these comments, Heisig demonstrated his knowledge of artistic development in the West, tracing a path from the Western tendency to heroicize misunderstood artistic loners like Vincent van Gogh, to the focus on creating art for the future as written about by Wassily Kandinsky in *Concerning the Spiritual in Art,* to Clement Greenberg's more recent dismissal of the artistic preferences of the masses as kitsch. Wassily Kandinsky, *Concerning the Spiritual in Art*, trans. M. T. H. Sadler (New York: Dover, 1977). Clement Greenberg, "Avant-Garde and Kitsch," *Partisan Review* (Fall 1939): 34–49. David Shapiro and Cecile Shapiro, "Abstract Expressionism: The Politics of Apolitical Painting," in *Pollock and After, the Critical Debate*, ed. Francis Franscina (New York: Harper & Row, 1985), 135–51.

98. Heisig, speech at the Fourth Congress, 137. This report was clearly typed from a sound recording of the speech by someone who knew little about art: in the report, "Impressionismus" (impressionism) appears as "Imperionismus," and "Cezanne" as "Gezäune." "von dieser Position aus die Gesetzmässigkeiten der Kunst nur im ontologischen Bereich gesucht werden. Aus dem Imperionismus [*sic*, Impressionismus] entwickelte sich der Expressionismus, aus Gezäune [*sic*, Cezanne] der Kubismus usw. Die gesellschaftliche

Komponente waren auf der Grundlage geistigen Einzelgängertums ein Abstraktum. Nun führte der Weg konsequent und gründlich über viele reizvolle Abschattierungen und interessante Spielarten in den künstlerischen Selbstmord, wonach der meisterlich und nach allen Regeln der Kunst vorgenommen Zertrümmerung der Erscheinungsbilder ein Künstlertyp übrig bleibt, der ohne gesellschaftliche Aufgabe, schrecklich allein gelassen und gezwungen von der eisernen Logik einer Rolle, den Menschen nicht mehr darstellen kann."

99. Ibid., 138. "Wir sind an dem Punkt, wo wir klarstellen müssen, was für uns Kunst ist, genauer gesagt, was für uns aus dem gesellschaftlichen Erfahrungsbereich Kunst werden kann."

100. Ibid., 139. "verstehen wir, dass die beglückende Ordnung, die die grossen Meisterwerke der Künste durchleuchtet und lebendig erhält, primär das Resultat ihrer ideologischen Bezogenheit ist und nicht das Ergebnis von Regeln und Gesetzen in abstrakto. Die Fläche . . . ist nicht ein Abstraktum. Sie ist nicht an sich da, sondern stellt für den Maler eine Art Analogie zur Wirklichkeit dar."

101. Ibid., 140.

102. Ibid. Heisig includes himself here as a way of softening the criticism. It is unclear to what extent it is merely a rhetorical device versus an actual admission.

103. Ibid.

104. Ibid, 141: "nur eine entschlossene Abwehr von überholten Dogmen und Gesetzmässigkeiten weiterhilft."

105. Ibid., 143. "Wir sollten versuchen, diese Probleme sachlich vorurteilslos, vor allem aber gemeinsam anzugehen, in dem Bewußtsein, dass das, was wir in der Gesellschaft als bildende Künstler darstellen wollen, sich in der Proportion zu dem befinden wird, was wir zu bieten haben."

106. "Begründung zum Vorschlag für die Auszeichnung mit der 'Medaille für ausgezeichnete Leistungen' anläßlich des 1. Mai 1960," April 19, 1960, SächsStAL: VBK-L 155.

107. According to Martin Damus, the Bitterfeld Way had three main aims: (1) to raise the artistic-aesthetic level of the workers, (2) to integrate art into the workers' lives, and (3) to integrate art criticism with this new art. Damus, *Malerei der DDR*, 176.

108. Mittenzwei, *Die Intellektuellen*, 168.

109. Heisig, speech at the Fourth Congress, 138.

110. The diploma in graphics is dated May 11, 1959, and is signed by Koenig (director) and Mayer-Foreyt (graphics professor). HGB-Archiv: Personalakte Heisig. A discussion among *Direktion* (board members) at the Leipzig Academy mentioned Heisig as one of the faculty members affected and that a test would be given before the January deadline. "Protokoll über die erweiterte Direktionssitzung am 9. Dezember 1958," HGB-Archiv: 20.

111. In a meeting on January 26, 1960, the HGB leadership decided to promote Heisig to the position of *Professor* beginning with the 1961–62 academic year. "Protokoll über die Leitungssitzung von 26.1.60," HGB-Archiv: 11. Again on March 8, 1960, the HGB Senate recommended Heisig be promoted to professor in 1961–62. "Protokoll über die Senatssitzung am 8. März 1960," HGB-Archiv: 20.

112. Albert Kapr to the Ministry for Culture, November 5, 1960, HGB-Archiv: Personalakte Heisig. "Die pädagogische Arbeit von Herrn Heisig an der Hochschule ist äußerst erfolgreich und fruchtbar. Neben einer Fachklasse in der Fachrichtung freie Grafik (Bildgrafik) leitet er zusätzlich eine Klasse des Grundstudiums. . . . Seiner unermüdlichen Arbeit ist es zu danken, daß das Zeichnen heute zur besonderen Stärke der Leipziger Hochschule gehört."

113. Kapr to the Ministry for Culture, November 5, 1960: "gehört er zu den talentiertesten jüngeren Künstlern der Republik." On December 22, 1960, Kapr sent a follow-up letter to the Ministry of Culture mentioning the November 5 letter and requesting confirmation that Heisig would be made professor. HGB-Archiv: 3.

114. According to a written confirmation (Bescheinigung) from 1994, Heisig assumed the position of head of academic affairs on January 1, 1961. On June 27, 1961, Hans Bentzien sent a letter to Heisig confirming his promotion to associate professor as of August 1, 1961. Both documents are in Heisig's Personalakte at the HGB-Archiv.

115. Hans Mayer-Foreyt (1916–81) believed that he had enough to do between his responsibilities as a teacher and head of the foundations department at the Leipzig Academy and his desire to paint works for upcoming exhibitions. He also stated that he thought he was not the right person for the job. "Parteileitungssitzung von 14.4.61," HGB-Archiv: 11.

116. Ibid. In a letter to the Ministry for Culture on April 20, 1961, about various issues regarding his stepping down, Kapr mentioned that Heisig was the school's choice for his replacement as director. HGB-Archiv: 2. In a letter to the Ministry of Culture from May 24, 1961, Jochen Nusser confirmed Heisig as the school's choice. HGB-Archiv. On July 15, 1961, Kapr released an announcement stating that Heisig had been appointed to the position of director from 1961 to 1963, beginning on September 1, 1961. HGB-Archiv. On August 10, the Ministry of Culture sent a letter to Heisig confirming his promotion to director of the Leipzig Academy. HGB-Archiv: Personalakte Heisig.

117. On June 29, 1961, Kapr sent a letter to the Ministry of Culture urging it to confirm Heisig's promotion to professor before he became director to avoid possible criticism from outside observers. HGB-Archiv: 2.

118. "Protokoll der Parteileitungssitzung vom 13.10.61," HGB-Archiv: 11.

119. Ibid. "Wir wussten, dass es nicht einfach würde mit ihm zu arbeiten." König was interim director between Massloff and Kapr.

120. Bernhard Heisig to the Staatsanwalt des Kreisgerichtes Bischofswerde, September 20, 1961, HGB-Archiv: 6.

121. Ibid.: "tatsächlich eine sehr schlechte gebrauchsgrafische Arbeit."

122. Undated letter from Bernhard Heisig to the Ministry of Culture in Berlin that included a copy of the student's pardon. HGB-Archiv: 2.

123. That the building of the Berlin Wall was an important context for this discussion appears in the minutes for the October 17 meeting of the Leipzig Academy's Party Leadership (Parteileitung), both through a direct mention of it early on and in König's statement near the end that "die politische Situation ist jetzt bes. kompliziert aber sie ist verschiedentlich schon kompliziert gewesen, z.B. während der Ungarnereignisse und wir haben sie gemeistert in dem wir politisch richtig gehandelt haben" (the political situation is particularly complicated at the moment, but they have already been complicated in different ways, for example during the Hungarian event [the uprising of 1956], and we mastered them by handling ourselves in a correct political fashion). "Protokoll der Parteileitungssitzung vom 17.10.61," HGB-Archiv: 11.

124. Ibid. "Wenn der Gen. Heisig eine solche Linie wie in dem Brief weiter verfolgt, kommt er in Konflikt mit der Partei, dann müssen wir ein Parteiverfahren gegen ihn einlegen."

125. Ibid. "Vorausgesetzt, dass er unter Volltrunkenheit gehandelt habe, versuchte ich ihm zu helfen, dass sein Leben nicht völlig verpfuscht wird durch die dumme Angelegenheit, wenn es eine ist."

126. Ibid., 5. "Man kann nicht von den Studenten Disziplin verlangen, wenn man selbst nicht bereit ist diese zu halten."

127. Between December 21, 1961, and March 1962, there at least four letters requesting a car for the Leipzig Academy. HGB-Archiv: 2, 3, 11. In a letter dated November 1, 1961, Heisig thanked a woman at the Haus der Wissenschaftler (House of Scholars) for allowing several members of the Leipzig Academy to eat there. HGB-Archiv: 3. "Einschätzung ideologische Situation," SED-PO, June 20, 1963, SächsStAL: SED-L 356/198.

128. "Begründung zur Auszeichnung des 1. Mai," April 26, 1963, HGB-Archiv: 13. This award was always given out on May Day.

129. G. Thälmann (interim secretary of the Partei Organisation) and E. König (head of societal studies, *Gesellschaftswissenschaft*) to the Ministry of Culture in Berlin, October 15, 1962, Bundesarchiv DR1/606.

130. Ibid.: "Seine Klasse ist mit die stärkste an der Hochschule."

131. Ibid. "Er übt diese Funktion mit großer Einsatzbereitschaft aus. . . . Er ist bestrebt, echte Begabungen zu fördern und Spitzenleistungen für die ganze Hochschule zu erzielen."

Chapter Two

1. Bernhard Heisig, interview with the author, 2005. Mittenzwei, *Die Intellektuellen*, 169–72.

2. Ibid., 170.

3. For more about border crossings in the pre-Wall period, see Patrick Major, "Going West: The Open Border and the Problem with *Republikflucht*," in *The Workers' and Peasants' State: Communism and Society in East Germany under Ulbricht, 1945–1971*, ed. Patrick Major and Jonathan Osmond (Manchester: Manchester University Press: 2002), 190–208; and Patrick Major, *Behind the Berlin Wall: East Germany and the Frontiers of Power* (Oxford: Oxford University Press, 2010).

4. Since 1989, a myth has arisen in Heisig scholarship that he lost his position as director of the Leipzig Academy because of a controversial speech he gave at the Fifth Congress of the Union of Visual Artists on March 24, 1964. Archival files suggest otherwise: Heisig submitted a resignation letter to the Ministry for Culture in Berlin on February 19, 1964. This letter was dismissed in the 2005 Heisig catalog, *Die Wut der Bilder*, which suggested it had been misdated. Two additional letters in the same archival file confirm the early date. A second letter from Heisig, dated March 9, 1964, nominates Gerhard Kurt-Müller to replace him as director. A letter from Gerd Thielemann on March 12, 1964, accepts Kurt-Müller as Heisig's replacement effective at the end of April / beginning of May. All three letters were written to Binder at the Ministry for Culture in Berlin and are in the HGB-Archiv: 4.

5. This division was not black and white but rather a tendency: there were conservative artists and enlightened politicians and cultural functionaries, but they were the exceptions.

6. From the caption for the painting, which was illustrated in "Unsere Kunst kämpft für das Emporwachsende, für das Neue," *Neues Deutschland*, March 3, 1953, 4. "Die jungen Künstler haben von den Meistern sowjetischer Malerei gelernt und ein Werk voll Optimismus geschaffen, das die Schönheit und das leidenschaftliche Streben unserer Jugend verkörpert."

7. This is not to say there were no artists who experimented with modern styles in their work. Werner Tübke, for example, clearly did so in *Versuch II* (Attempt II, 1956, see fig. 1.6)

and *Hiroshima* (1958). As such, the fact that Heisig did not create works in a modern style is not merely the result of his being in a more conservative environment but also of his general inclination. While Heisig was open to modern art in theory, it does not seem to have played much of a role in his painted work until the mid 1960s.

8. Sitte received the prize in 1953, for example, for *Karl Marx liest vor*. According to Gisela Schirmer, who has published two books on Sitte, he was given this award in 1953 and 1954 for more aesthetically conservative work as encouragement to follow what many politicians considered the "right path." E-mail from Schirmer to the author, September 9, 2017. Willi Sitte, "Gedanken nach einer Italienreise," *Bildende Kunst* 1 (1957): 53. "Gerade das Gebiet der Malerei muß in Zukunft die Walstatt leidenschaftlicher Auseinandersetzungen um die Lösung künstlerischer Probleme werden, die uns den Mut zu bildkünstlerischen Experimenten wiederfinden lassen."

9. Schirmer, *Willi Sitte*, 81–86.

10. Gudrun Schmidt, "Die Galerie Konkret in Berlin," in *Kunstdokumentation SBZ/ DDR, Aufsätze, Berichte, Materialien, 1945–1990*, ed. Günter Feist, Eckhart Gillen, and Beatrice Vierneisel (Cologne: Dumont, 1996), 290–97. See also Lothar Lang, *Malerei und Graphik in Ostdeutschland* (Leipzig: Faber & Faber, 2002), 56.

11. Lang, *Malerei und Graphik in Ostdeutschland*, 56: "als Keimzelle eines Protestes gegen die Kulturpolitik der SED empfunden worden." In the 1950s, Cremer had received high praise from the government for his sculpture for the Buchenwald concentration camp memorial. In the early 1960s, he was secretary of the visual arts section of the Academy of Arts in Berlin.

12. Ibid. The oldest artist was born in 1920; the youngest, Ralf Winkler (better known today as A. R. Penck), in 1939.

13. For an example of how this exhibition was viewed at the time, see D.T., "Unser Kommentar," *Neue Zeit*, October 29, 1961.

14. Siegfried Wagner, "Diskussionsbeitrag an das Büro des Politbüros für das Protokoll der 14. Tagung des Zentral Kommittee," November 27, 1961, Bundesarchiv-SAPMO: DY30/ IV/2/2026/1/298-301. The Bitterfeld Conference took place April 24–25, 1964.

15. Heinrich Witz, "Einführung" [introduction], 6. *Kunstausstellung 1961 des VBKD Bezirk Leipzig* [Sixth District Art Exhibition of the Artists Association in Leipzig], exhibition catalog (Leipzig: VBKD, 1961). "Zeugnis abzulegen von der Sieghaftigkeit des Sozialismus . . . und dem Triumph aller echten humanistischen Gedanken im neuen sozialistischen Menschenbild."

16. Ibid. "Wenn in diesen Herbsttagen in Deutschland kein Blut fließt, wenn Frieden ist, dann ist es das Ergebnis der konsequenten Politik der Friedenssicherung der UdSSR, der anderen sozialistischen Staaten und des entschlossenen Handelns unserer Regierung am 13. August 1961."

17. Ibid.: "die bildenden Künstler Leipzigs wollen aktiv mit dazu beitragen . . . für die Vollendung des Aufbaues des Sozialismus in unserer Republik."

18. In his history of art in Leipzig during the GDR, Henry Schumann states that Witz emerged as the group's primary speaker. Schumann, "Leitbild Leipzig," 498. According to Heinz Mäde, they would meet in the afternoons or evenings at the Ringcafé to discuss the situation and their plans. Mäde also pointed out that Witz had a particularly strong connection to those in power. Mäde, *Das durchweg unliterarisch erzählte Leben eines Mannes im Deutschland des 20. Jahrhunderts* (Langendorf/Untergreißlau: Heinz Mäde, 1999), 244–45, 238–39.

19. Schumann points out that the exhibition was initially "unapproved" but that Walter Münze, then chair of the VBK-L, stepped in and saved the show from closing by declaring it a VBK-L exhibition. Schumann, "Leitbild Leipzig," 498.

20. When first exhibited in 1961, this painting was titled *Gruppenporträt* (Group Portrait). Heinz Mäde saw the artists in Blume's painting as the "most important members" of the group, which also included others—like himself, who had exhibited in the 1956 *Studio Exhibition*—on the periphery. Mäde, *Das durchweg unliterarisch erzählte Leben*, 244, 238–39.

21. Although women already played a greater role in the East German art world than in the West in the mid-1950s, none were part of this core group of artists in Leipzig. Indeed, the gender politics of this painting are surprisingly traditional. For more about women artists in East Germany, see April A. Eisman, "From Economic Equality to 'Mommy Politics': Women Artists and the Challenges of Gender in East German Painting," *International Journal for History, Culture and Modernity* 2, no. 2 (2014): 175–203.

22. Anneliese Hübscher, interview with the author, July 22, 2005. "Witz war der erste, der eigentlich gesagt hat, 'wir dürfen die Verbandspolitik, die Kunstpolitik, nicht den Funktionären überlassen. . . . Wir müssen die Kulturpolitik selber in die Hand nehmen.' Das heisst, ich male jetzt Bilder, die für die Partei interessant sind, aber ich bestimme die Parteipolitik des Verbandes."

23. The identity of the figures shaking hands is discussed in Karsten Borgmann and Christa Mosch, "1959, Heinrich Witz, Der neue Anfang," in *Auftrag: Kunst, 1949–1990*, ed. Monica Flacke (Berlin: Deutsche Historisches Museum, 1995), 119–24.

24. Witz exhibited *The New Beginning* at the Fifth District Art Exhibition in Leipzig in the summer of 1959. He replaced Heisig as chair of the VBK-L in December 1959.

25. Hübscher, interview with the author, July 22, 2005.

26. Ibid. "Damals, wir hatten Massloff, der war Revolutionär. Und wir hatten einen biederen Hausmeister, der war in der Nazi Partei. Da bewegte ihn eben auch die Frage, wieso werden Männer zu Revolutionären? Wieso ist der Hausmeister ein treuer Diener, und warum hat eben Massloff . . . versucht, das System zu stürzen? Diese psychologischen Probleme haben ihn bewegt."

27. Gillen, "Schwierigkeiten," 90.

28. "Protokoll Parteilehrjahr der Dozentengruppe am 18.1.1962," HGB-Archiv: 11.

29. *Chemistry Circle* is the only painting by Klaus Weber listed in the catalog for the Sixth District Art Exhibition in Leipzig. It was also around this time that another painting by Weber, *August 13, 1961*, was purchased and placed on public display at the local SED building in Leipzig. This work, which depicts workers and soldiers on the morning after the Berlin Wall began to be built, was heavily criticized by artists in Leipzig, eventually leading to a competition to replace the work. See April A. Eisman, "Painting the Berlin Wall in Leipzig: The Politics of Art in 1960s East Germany," in *Berlin: Divided City, 1949–1989*, ed. Sabine Hake and Philip Broadbent (New York: Berghahn Books, 2010), 83–95.

30. Werner Krecek and Karl Heinz Hagen, "Ein Blick in den Spiegel unserer Zeit: Rundgang mit Walter Ulbricht durch die 6. Bezirkskunstausstellung Leipzig," *Neues Deutschland*, December 15, 1961. "Viele Arbeiter wollten es am liebsten gleich mitnehmen."

31. For an example of these criticisms, see Gerhard Pommeranz-Liedtke, "Auf dem Weg zur Volkstümlichkeit," *Neues Deutschland*, June 24, 1961.

32. "Zu gross, zu romantisch, schlecht gemalt und schlecht gezeichnet." The jury consisted of VBK members from around the country. The jury comments are from the rejection

of *Visit by Martin Andersen Nexö* from an exhibition marking the 15th anniversary of the SED in 1961 as found in Witz's notes. HGB-Archiv: Witz Nachlass.

33. Anneliese Hübscher, "Heinrich Witz: *Besuch bei Martin Andersen Nexö*," *Das Blatt* (January 1961): 7–10. "Fast alle bisher erschienenen Artikel, die sich mit den Bildern von Heinrich Witz beschäftigten, kamen sinngemäß zu der gleichen Feststellung: prinzipiell richtiges Herangehen, ernste Auseinandersetzung mit dem gewählten Thema—aber welch schlechte Malerei!"

34. Hübscher, interview with the author, July 22, 2005.

35. Mäde, *Das durchweg unliterarisch erzählte Leben*, 245. "Diese Anerkennung bekam ihm nicht. Ich merkte, wie alles, was er dachte und arbeitete oberflächlicher wurde."

36. Meeting at the Leipzig Academy (Tübke, Mayer-Foreyt, Blume, Witz, and, for some of it, Heisig), July 11, 1962, HGB-Archiv: Witz Nachlass. "Tübke fragt, ob ich das Bild ausstellen wolle. Ich erklärte, dies sei eine Frage für Narren. Natürlich wolle ich das Bild ausstellen, sonst hätte ich der Leipziger Volkszeitung nicht die Genehmigung zur Publikation gegeben."

37. Hübscher spoke of Witz's method of documenting everything. Hübscher, interview with the author, July 22, 2005. Some of these documents are now housed at the archive of the Leipzig Academy.

38. Witz to SED-L, October 3, 1962, 5, HGB-Archiv: Witz Nachlass. "Opfert Witz, mit euch anderen können wir zusammenarbeiten!" Witz believed that Eberhard Bartke (1926–90) had said this about him; Bartke was head of the Visual Arts and Museums department within the Ministry for Culture at the time.

39. Heinrich Witz to Paul Fröhlich at the SED-L, October 3, 1962, 1, HGB-Archiv: Witz Nachlass. "Ich wende mich in einer Angelegenheit an Dich, die mir ernsthafte Sorgen bereitet, die sich auch auf privates Gebiet erstrecken."

40. Ibid. "Als Ursache sehe ich die Nichtdurchführung dieses Politbürobeschlusses an."

41. In a letter from Bartke to Witz dated October 21, 1963, he stated that his painting, *Walter Ulbricht in Conversation*, did not display the appropriate level of artistic mastery necessitated by the commission. Bartke announced the end of the contract, with partial payment, rather than a reworking of the painting since he believed that Witz was not able to do better. HGB-Archiv: Witz Nachlass.

42. Schirmer, *Willi Sitte*, 78: "eine tragische Figur, denn in seinem Anpassungseifer hatte er dermaßen überzogen, daß es schließlich selbst den Funktionären zu dick aufgetragen war, und sie ihn fallen ließen."

43. I found a black-and-white photo of this painting in the Kober files at the Academy of Arts in Berlin in August 2005. The Deutsche Fotothek also has a copy. This book is the first time this painting has been reproduced in Heisig scholarship. In their dissertations, both Bernfried Lichtnau and Eckhart Gillen believed *The Christmas Dream of the Unteachable Soldier* (1964, see fig. 2.8) was this earlier painting. Lichtnau, "Der Beitrag Bernhard Heisigs zur Weiterentwicklung der Historienmalerei," 2:108. Gillen, *Die Wut der Bilder*, 126.

44. Joachim Uhlitzsch, "Vom richtigen Weg und Dem grossen Ziel, Zur Eröffnung der V. Deutschen Kunstausstellung in Dresden," *Bildende Kunst* 10 (1962): 515.

45. Helena Krajewska, "Die Dresdner 'Fünfte' aus polnischer Sicht," *Bildende Kunst* 4 (1964): 211–13 (first published in *Przeglad Artystyczny*, May 1963): "die in einer sparsamen, beinahe monochromen Skala warmer und kalter Asphalte . . . erlaubt einem nicht, gleichgültig daran vorbeizugehen . . . die zielbewußt gewählten und unterschiedlich

gestalteten . . . Akzente der menschlichen Gesichter potenzieren das Grauenhafte der Situation. Ich fand auf der Ausstellung keine Lösungen, die denen von Heisig verwandt gewesen wären."

46. Signed letter from Bernhard Heisig to Binder, February 19, 1964, HGB-Archiv: 4. The letter also states that he had already spoken to the Senate of the Leipzig Academy and they had approved his decision.

47. The Fifth German Art Exhibition opened on September 22, 1962, and closed on March 6, 1963. Heisig was invited to speak at the Congress at a meeting held on February 24, 1964. "Bericht über die 5. erw. Sekretariatssitzung des VBK-L," AdK-Archiv: VBK-ZV 58. His topic was assigned a couple of weeks later, on March 11, 1964, at another meeting. "Bericht über die 5. erw. Bezirksvorstandssitzung des VBK-L," AdK-Archiv: VBK-ZV 58.

48. Ulrike Goeschen, *Vom sozialistischen Realismus zur Kunst im Sozialismus: Die Rezeption der Moderne in Kunst und Kunstwissenschaft der DDR* (Berlin: Duncker & Humblot, 2001), 143.

49. Transcript of Hermann Raum's speech at the Fifth Congress, AdK-Archiv: VBKD 67.

50. Ibid.: "dass aus der 'Form an sich' eine Form für uns wird."

51. Ibid.: "sind unsere Künstler zu schwach für eine schöpferische Auseinandersetzung mit dem sogenannten Modernismus?"

52. Transcript of Fritz Cremer's speech at the Fifth Congress, AdK-Archiv: VBKD 67, 63.

53. Ibid. "Das, was ich sage, ist nicht viel anderes, nur ein bisschen primitiver."

54. Ibid.: "offene Gespräch über die Kunst. . . . Wir brauchen tatsächlich einen echten Meinungsstreit und keinen künstlichen."

55. Ibid.: "eine Überprüfung der Folgen aus der Periode des Personenkults auf dem Gebiet der Kunst."

56. Ibid.: "der Weiterentwicklung unserer sozialistischen Gesellschaft sehr wohl dienlich sein könnte.

57. Ibid. "Wir brauchen die Einsicht, dass sich unsere Kunst an zivilisierte Menschen, an Alphabeten und nicht an Analphabeten wendet."

58. Ibid. "Wir brauchen eine Kunst, die den zivilisierten Menschen und Alphabeten unseres Jahrhunderts mit der Frage 'Kapitalismus oder Sozialismus' provoziert und ihm das Recht und die Verantwortung gibt, selbständig über diese zwei verschiedenen gesellschaftlichen Systeme zu entscheiden. . . . Wir brauchen eine Kunst, die die Menschen zum Denken veranlasst, und wir brauchen keine Kunst, die ihnen das Denken abnimmt."

59. Ibid. "Wir brauchen keine volkstümliche Kunst. Das Volk ist nicht 'tümlich.'"

60. Ibid. "Wir brauchen die freie Entscheidung über Stoff und Form jedes einzelnen Künstlers für seine Arbeit. Wir brauchen Wahrheitssuche in der Kunst, und wir brauchen die unbedingte Eigenverantwortlichkeit des Künstlers."

61. Garaudy published the book as *D'un realisme sans rivages* in 1963. It was known in German at the time as *Realismus ohne Ufer*, although it was not officially published in German until 1981.

62. Cremer, speech at the Fifth Congress. "keine Reklame für den Sozialismus. Wir brauchen eine Kunst, die ein neues Lebensgefühl ausstrahlt."

63. Transcript of Bernhard Heisig's speech at the Fifth Congress, AdK-Archiv: VBKD 67.

64. Ibid.: "zunächst charakterisiert war von dem Bemühen ..., den Künstler möglichst gegen alle Erscheinungsformen der westlichen Ideologie abzuschirmen"; "den Künstler aus seiner Isolierung zu führen"; "ihn von dem Extrem des autonomen Künstlertums."

65. Ibid.: "faulende Frucht am sterbenden Baum des Imperialismus."

66. While perhaps surprising to Western readers, this comment about a class-indifferent character was not one for which Heisig was later criticized.

67. Heisig, speech at the Fifth Congress. "In dem Bemühen, ihn vor schädigenden Einflüssen zu bewahren, wird der Künstler manchmal behandelt wie ein Kind, das nicht auf die Straße gelassen wird, damit der große Verkehr es nicht gefährdet."

68. Ibid. "Es handelt sich hier nicht um die Einnahme von Gift, sondern es handelt sich um die geistige Auseinandersetzung mit der Kunst des 20. Jahrhunderts."

69. Ibid.: "die erfreut und beglückt, oder ärgert und provoziert, ... in jedem Fall aber interessant sein muß."

70. Ibid. "Der Künstler ist auch der Kritiker seiner Zeit."

71. Gillen, "Schwierigkeiten," 157.

72. Transcript of Walter Womacka's speech at the Fifth Congress of the VBK, AdK-Archiv: VBKD 67.

73. Ibid. "Da hat er nämlich genau das Gegenteil behauptet!"

74. Ibid.: "er ist eben zu dieser damaligen Zeit Beamter und Professor geworden." Womacka was mistaken here. Heisig was leaving his position as chair of the VBK-L in 1959, not assuming it. He did not become a professor until the 1961–62 academic year, although the decision to make him a professor was made in late January 1960, one month after his speech at the Fourth. "Protokoll über die Leitungssitzung vom 26.1.60," HGB-Archiv.

75. Womacka, speech at the Fifth Congress. "Eine solche Verhaltensweise bezeichnet man bei uns schlicht und einfach als Demagogie!"

76. Transcript of Gerhard Bondzin's speech from the Fifth Congress of the VBK, AdK-Archiv: VBKD 67: "was heute früh schon Kollege Womacka sagte, auf dem IV. Kongreß hinter einer Konzeption gestanden hat, durch seine Arbeiten versucht hat, diese Konzeption zu realisieren, und gestern einen Standpunkt eingenommen hat, der mit dieser Konzeption eigentlich nichts mehr zu tun hat."

77. Ibid. "Ich habe die Konzeption nie aufgegeben."

78. "Protokoll Aktivtagung am 23.3.64," AdK-Archiv: VBKD 70.

79. "Bericht über die Auseinandersetzung in der erweiterten Parteileitungssitzung der Bildenden Künstler zum Auftreten des Genossen Professor Bernhard Heisig auf dem Kongress des Verbandes Bildender Künstler," April 3, 1964, SächsStAL: SED-L IV/A/2/9/2/362. According to the same report, "Genosse Heisig erklärte ... dass ihm Genosse Womacka in der Zwischenzeit angerufen und einen Termin für eine persönliche Aussprache angekündigt habe, um sich bei ihm zu entschuldigen" (Comrade Heisig explained ... that Comrade Womacka had called him since then and announced a meeting for a personal talk in order to apologize to him). When I asked him about this more than forty years later, Womacka denied having made such a call. Walter Womacka, interview with the author, December 2005.

80. "Bericht über die Auseinandersetzung in der erweiterten Parteileitungssitzung der Bildenden Künstler zum Auftreten des Genossen Professor Bernhard Heisig auf dem Kongress des Verbandes Bildender Künstler."

81. "Der Ton seines Vortrages wäre sehr zynisch und ironisch gewesen." "Information über den 5. Kongreß des VBKD in Berlin durch den Vorsitzenden Günter-Albert Schulz," Rat

des Bezirkes, Abteilung Kultur, Leipzig, April 2, 1964, SächsStAL: SED-L IV/A/2/9/2/362, 3. Another report written by the SED-L on April 10, 1964, stated that Heisig's speech was "noch zynischer, provokativer und überheblicher" (even more cynical, provocative and arrogant) than Cremer's. Hans Lauter, "An die Grundorganisation des VBK-L," April 10, 1964, SächsStAL: SED-L IV/A/2/9/2/362.

82. Cremer's speech was published shortly thereafter in a West German newspaper. At the Politburo's urging, Cremer wrote to them about it, but rather than take back what he had said at the conference, he stated that the speech was not intended for Western manipulation. Like Heisig, he did not take back his core statements; his letter clarifies that his criticism was not aimed against the GDR but rather toward improving it from within. Siegfried Wagner, "An Alle Mitglieder und Kandidaten des Politbüros" (with attachment), April 8, 1964, Bundesarchiv-SAPMO: DY30/IVA2/2.024/37.

83. Ibid.

84. Lea Grundig to Kurt Hager, March 26, 1964, Bundesarchiv-SAPMO: DY30/IVA2/2.024/37: "der polit. feindlichen Ideologie durch Fritz Cremer zusammen mit Raum."

85. Ibid. "Ich würde sehr empfehlen, den seines Zynismus und seiner üblen Anspielungen wegen, besonders unangenehmen Beitrag des Gen. Bernhard Heisig zu überprüfen. Er scheint mir in seinen versteckten Angriffen besonders giftig."

86. According to Heisig, Lea Grundig did not like him initially. It was not until she saw his painting *Jüdische Ghettokämpfer* (Jewish ghetto fighters, 1964) in the mid-1960s, he states, that she softened toward him. Bernhard Heisig, interview with the author, summer 2005.

87. Typescript of Harry Blume's speech at the Fifth Congress, March 25, 1964, AdK-Archiv: VBKD. "Es haben sich bestimmte Tendenzen der Vulgarisierung des Begriffes Realismus bei den Künstlern—ich nehme mich nicht aus—, im Staatsapparat und auch bei Genossen der Partei breitgemacht."

88. Ibid. "nicht gegen die Partei Recht haben, sondern mit der Partei Recht haben!"

89. Typescript of Gerhard Kurt Müller's speech at the Fifth Congress, March 25, 1964, AdK-Archiv: VBKD 67: "der Kongreß ist ein Kongreß der offenen Aussprache und der offenen Diskussion, der Darlegung aller Probleme und Fragen, die uns bewegen. . . . ich muß sagen, daß an der Person des Kollegen Heisig schätzenswerte Eigenschaften sind, in dem er oft auch als Motor, wirkende Probleme in die Diskussion bringt."

90. "Einschätzung des 5. Kongresses des VBKD und seiner Vorbereitung, 4/11/64," Bundesarchiv-SAPMO: DY/IVA2.901/37.

91. "Bericht über die Auseinandersetzung in der erweiterten Parteileitungssitzung der Bildenden Künstler zum Auftreten des Genossen Professor Bernhard Heisig auf dem Kongress des Verbandes Bildender Künstler."

92. A committed Communist, Havemann was critical of the East German government and its tendency to try to control every facet of life. In particular, he called for more freedom and for constructive discussions of problems. Similar views were expressed Wolfgang Harich in the mid-1950s and later by Cremer, Raum, and Heisig in their speeches at the Fifth Congress. Unlike Harich, Havemann only lost his job; he was not thrown in jail. This difference in treatment suggests a significant change in the political atmosphere of the GDR between the mid-1950s and the mid-1960s.

93. "Bericht über die Auseinandersetzung in der erweiterten Parteileitungssitzung der Bildenden Künstler zum Auftreten des Genossen Professor Bernhard Heisig auf dem Kongreß des Verbandes Bildender Künstler."

94. Ibid. "Genosse Heisig hat die Tribüne des Verbandskongresses benutzt, um die Richtigkeit der Kulturpolitik der Partei infrage zu stellen und das Verhältnis der Partei gegenüber den Künstlern grob zu entstellen."

95. Ibid.: "der heuchlerischen Losung von der künstlerischen Freiheit."

96. Ibid. "Offensichtlich angespornt durch die Darlegungen des Genossen Raum und das gegen die Linie der Partei gerichtete politischästhetische Programm des Genossen Cremer begann Genosse Heisig eine Polemik gegen die Behandlung der Künstler durch die Partei."

97. Ibid.: "die Künstler würden wie kleine Kinder behandelt, die man nicht auf die Straße liesse, damit sie nicht überfahren werden. Gleichzeitig propagierte Genosse Heisig die Forderung nach einen verweiterten Realismus."

98. Ibid. "Die in der Diskussion durch Genossen Heisig selbst geäußerten Auffassungen bestätigten, daß es in der Tendenz um das Einschleusen des Modernismus unter dem Deckmantel revolutionärer Phrasen geht."

99. Ibid. "Der Kern der Kritik bestand darin, daß Genosse Heisig Zweifel gegenüber der Politik der Partei in Grundfragen äußerte und die Ergebnisse der Märzberatung des Politbüros mit Künstlern dadurch praktisch infrage stellte."

100. Ibid.: "verließ er bewußt die Positionen der Kulturpolitik unserer Partei mit dem Argument: Das Jubiläum der Hochschule sei nicht nur ein Ereignis von Republik-Bedeutung, sondern von nationaler und internationaler Bedeutung und propagierte praktisch die friedliche Koexistenz im Bereich der Ideologie und Kultur."

101. One needs to be careful about attributing these words to Heisig since it is unclear whether the report writer was actually looking at Heisig's work or merely quoting from memory; errors in these reports are not infrequent. In the document in the Kober Nachlass, there is no mention of "peaceful coexistence," although it may be a different version. It seems unlikely, however, that someone as astute as Heisig would use such a politically loaded term in an official text.

102. "Bericht über die Auseinandersetzung in der erweiterten Parteileitungssitzung der Bildenden Künstler zum Auftreten des Genossen Professor Bernhard Heisig auf dem Kongreß des Verbandes Bildender Künstler": "subjektivistische Entstellungen der Beschlüsse der Partei bei der Führung der Hochschule . . . eine gleiche prinzipienlose Verhaltensweise zeigte er in einer Reihe von anderen Diskussionen, die seine eigene künstlerische Tätigkeit und seine Lehrtätigkeit betrafen."

103. Ibid.: "gab er seine Positionen scheinbar auf." It is unclear whether the term "position" here refers to Heisig's function as director of the Leipzig Academy or his position in the confrontation. If the former, this statement may offer an additional motivation for why he resigned as director of the Leipzig Academy in February 1964.

104. Ibid. "Nunmehr benutzte er den Kongreß dazu, um seine alten, gegen die Partei gerichteten, Positionen in dogmatischer Weise erneut vorzutragen und bewies damit, dass die durch ihn jeweils geübte Selbstkritik im Grunde unehrlich und doppelzünglerisch war."

105. Ibid. "Er sei nicht gegen die Kulturpolitik der Partei, sondern gegen ihre enge dogmatische Auslegung aufgetreten."

106. Ibid.: "im Diskussionsbeitrag von Fritz Cremer nichts gefährliches gesehen hätten."

107. Ibid. "Sie . . . distanzierten sich nicht offen von den Positionen Heisigs und Cremers."

108. Whereas the visual arts in Leipzig at this moment were more conservative than in Berlin, in music, it was the opposite: Leipzig had a thriving jazz scene and musicology professors at the university had new-music listening parties. Joy H. Calico, *Arnold Schoenberg's "A Survivor from Warsaw" in Postwar Europe* (Berkeley: University of California Press, 2014), 94. For more about music in East Germany, see Laura Silverberg, "Between Dissonance and Dissidence: Socialist Modernism in the German Democratic Republic," *Journal of Musicology* 26, no. 1 (Winter 2009): 44–84.

109. "Bericht über die Auseinandersetzung in der erweiterten Parteileitungssitzung der Bildenden Künstler zum Auftreten des Genossen Professor Bernhard Heisig auf dem Kongreß des Verbandes Bildender Künstler." "Dabei richtet sich der Hauptangriff gegen die Bilder des Malers Klaus Weber, von denen der Chemiezirkel durch Genossen Walter Ulbricht angekauft wurde, und die Bilder von Genossen Heinrich Witz."

110. "Bericht vom Auftreten der Leipziger Genossen auf dem V. Kongress des Verbandes Bildender Künstler," April 2, 1964, SächsStAL: SED-L IV/A/2/9/2/362.

111. Ibid. "Leipzig hat auf dem Kongreß eine Niederlage erlitten. Woran liegt das? . . . [I]n Leipzig gäbe es eine gewisse Enge in der Kunstauffassung, besonders der Auslegung des Begriffes sozialistischer Realismus. . . . Es gilt jetzt für uns zu untersuchen, ob diese Auffassung einer falschen Einstellung der Kulturfunktionäre oder vielleicht auch die Haltung der Künstler selbst zu einer 'künstlerischen Enge' geführt hat, oder ob der Vorwurf der Enge überhaupt zutrifft."

112. Ibid. "Wir sollten uns . . . loyaler künstlerischem Suchen zur Gestaltung der Themen unserer Zeit (!) gegenüber verhalten. Wir sollten konsequenter qualitätsvolle Arbeiten fordern. Wir müssen aber auch mehr als bisher offene Gespräche in den Ateliers führen."

113. Ibid. "In diesen Fragen gibt es in der Stadt und im Bezirk Leipzig Einiges zu korrigieren."

114. Heisig, interview with the author, June 13, 2005.

115. Gillen, "Schwierigkeiten," 435. "Obwohl es mit der Absicht, die Dinge im Bereich der Kunst voranzutreiben zu helfen, konzipiert und vorgetragen war, waren die Ausführungen in wichtigen Punkten unrichtig." A written copy of Heisig's self-criticism, taken from an audio recording of the event, can be found in the AdK-Archiv: VBKD 70.

116. Gillen, "Schwierigkeiten," 436. "Die Partei hat diese Beurteilungssimplifizierung . . . selbst korrigiert."

117. Ibid., 437. "Hiermit war allerdings nicht die Übernahme der Apparaturen und des Formelwerks der westlichen Kunst gemeint, noch sollte einer von jedem gesellschaftlichen Engagement gelösten Kunstspielerei das Wort geredet werden. . . . Es ging daher . . . um das legitimierte Offenhalten von Möglichkeiten, neue Ausdrucksträger kennenzulernen, um sie zum Nutzen des sozialistischen Realismus verwenden zu können."

118. Ibid., 435: "dass der Formcharakter eines Kunstwerks noch nicht entscheidend für seinen Anregungsgehalt ist."

119. Ibid. 436: "nicht um ein Höchstmaß an sogenannter künstlerischer Freiheit ging; etwa im Sinne eines sich nur selbst verantwortlichen Künstlertyps. Es ging um ein höheres Maß an Verantwortung."

120. Ibid., 437. "Da dem Autor die Auffassung der Partei nicht genügend bekannt war, verstand er es nicht, dogmatische Erscheinungen zu lokalisieren, sondern verallgemeinerte sie."

121. For a different interpretation on this point, see Gillen, "Schwierigkeiten," 167.

122. Ibid.: "die Partei eine differenzierte Beurteilung der Kunst des Spatbürgertums längst formuliert hatte."

123. Blume's comment may in fact have been a reference to Sitte's speech on the first day of the Congress in which he stated, "Und ich möchte betonen, nicht gegen, sondern mit der Partei der Arbeiterklasse" (And I would like to emphasize, not against, but rather with the Party of the working class). Thanks to Gisela Schirmer for this insight.

124. Raum's response was much like Witz's approach to the party a few years earlier.

125. Raum's second speech at the Congress, given on the second day, is missing from the VBKD folder at the AdK Archiv.

126. "Information über die Parteiaktivtagung der bildenden Künstler zur Auswertung der 2. Bitterfelder Konferenz und des 5. Verbandskongresses am 10.6.1964 in Berlin," June 26, 1964, Bundesarchiv-SAPMO: DY 30/IV A 2/ 2024/37, 66–68. Dr. Raum "[hat] das Wesen der Kritik an ihm noch nicht begriffen. . . . Er erklärte zwar, daß er wohl etwas falsch gemacht habe wenn er jetzt von allen dafür kritisiert werde, versuchte dann jedoch des Langen und des Breiten zu erläutern, was er gemeint habe und wie falsch es verstanden worden sei."

127. Ibid.: "einen ersten Schritt ernsthaften Nachdenkens."

128. The one archival document that suggests Heisig received a "strong reprimand" is a handwritten report for the Stasi by Bertallo from 1974. According to Gillen, Bertallo was the Leipzig artist Oskar Erich Stephen. Gillen, "Schwierigkeiten," 145. Bertallo states, "Von 1964–69 wurden Heisig keine . . . Funktionen übertragen, eine 1964 [auch?] gesprochene Parteistrafe 'strenge Rüge' wurde 1969 gelöscht!" (From 1964–69, Heisig . . . was given no functions, a verbal party punishment "strong reprimand" from 1964 [also?] was erased in 1969!) BStU-Leipzig: Bernhard Heisig 000071. It seems unlikely that Heisig could have received a "strong reprimand" and kept his position as professor at the Leipzig Academy or as head of the graphics and painting department. Moreover, just a few months after his self-criticism, in October 1964, he was nominated for a medal of outstanding achievement for his work at the Leipzig Academy. "Begründung," October 1, 1964, HGB-Archiv. One needs to be careful with Stasi reports, as they are frequently filled with errors, the result of being private reports based on the personal understandings, feelings, and aspirations of the writer. More reliable sources such as Heisig's personal file at the Leipzig Academy contain no mention of this punishment. According to the East German art historian Wolfgang Hütt, however, who had himself received a "strong reprimand," "[such a] punishment was not just entered into the Party files . . . 'it accompanied my career, was part of my personal file at the university.'" Gillen, "Schwierigkeiten," 168. If Heisig had received the *strenge Rüge*, it seems likely there would be more evidence of it than a passing reference in one Stasi report. Despite the lack of evidence, however, current scholarship continues to assert that Heisig received a "strong reprimand" because of his speech at the Fifth Congress. See Karl-Siegbert Rehberg, "Expressivität zwischen Machtkalkül und produktiver Verunsicherung: Bernhard Heisig als 'Motor' und Integrationsfigur der Leipziger Malerei," in Gillen, *Die Wut der Bilder*, 294; and Gillen, "Schwierigkeiten," 168–69.

129. In 1963, the artists Roger Loewig (Berlin) and Siegfried Pohl (Leipzig) were sentenced to jail for "agitation against the state" for artwork they had shown in private exhibitions. Lang, *Malerei und Graphik in Ostdeutschland*, 55.

130. The exhibition opened on October 8, 1964.

131. Heisig was not the only East German artist to respond to the Auschwitz trials in his work. In fact, several artists in Leipzig—including Werner Tübke and Heinz Zander—also

created paintings that engaged directly with the Nazi past at this time. Some of these will be discussed in the fourth chapter.

132. Heisig was under consideration for the commission in mid-April 1964, shortly after his speech at the Fifth Congress. "Personalvorschläge zum Aufbau des Stadtzentrums Leipzig. Schreiben der Standigen Kommission Kultur, Aktiv Bildende Kunst vom 18.4.1964," SächsStAL: VBK-L 114. Heisig was also mentioned as an artist under consideration for the Hotel Deutschland murals in the minutes from a May 2, 1964, meeting of the Leipzig branch of the Union of Visual Artists. "Bericht über die 6. Bezirksverstandssitzung des VBKD Leipzig vom 2. Mai 1964 im Büro," AdK-Archiv: VBK-ZV 58. According to another set of meeting minutes, Heisig and the other artists selected for the Hotel Deutschland mural commissions met with the Culture Department of the City Council in late May 1964 to discuss the details. Häußler, "Bericht für das Sekretariat der SED-Bezirksleitung zur künstlerischen Ausgestaltung des Hotel 'Deutschland,'" February 6, 1965, 8, SächsStAL: SED-L IV/A/2/9/2/362. Significantly, all these documents were written after Heisig's speech at the Fifth Congress but before he delivered his official self-criticism in Berlin.

Chapter Three

1. The Leipzig art historian Peter Guth (1958–2006) is a rare exception. His foundational work on murals in East Germany includes a number of Heisig's architectural works. Peter Guth, *Wände der Verheissung, Zur Geschichte der architekturbezogenen Kunst in der DDR* (Leipzig: Thom Verlag, 1995).

2. Murals were an important part of the Second German Art Exhibition in Dresden in 1949, which gave twelve commissions to artist collectives to bring "die gesellschaftlichen Veränderungen in der Ostzone Deutschlands und den Charakter des Zweijahrplanes zum Ausdruck" (the societal changes in the eastern zone of Germany and the character of the Two-Year Plan to expression). Damus, *Malerei der DDR*, 66–67. As a public medium, however, they were not infrequently at the center of controversy, as in the case of Horst Strempel's mural for Friedrich Station in Berlin in 1948, which fell victim to the Formalism Debates. Although initially praised, changes in cultural policy led to its being repeatedly criticized in the press for not adhering to the dictates of socialist realism. It was painted over in February 1952. In the 1960s, *Bildende Kunst* published several articles on the Mexican muralists, focusing in particular on David Alfaro Siqueiros and José Clemente Orozco.

3. Alfred Kurella, "Gedanken über die Wandbilder im 'Hotel Deutschland' (Leipzig)," February 11, 1965, SächsStAL: SED-L IV/A/2/9/2/362.

4. Ibid. Emphasis in the original. "Am ernstesten ist die Demonstration gegen unsere Kunstauffassung. . . . Hier ist das Prinzip absichtlicher *Deformation, Verstümmelung und Verhässlichung der Wirklichkeit* und Verwendung und beliebige Durcheinandermischung einzelner *verformter Fragmente* von Stücken der Realität auf die Spitze getrieben."

5. Heinrich Mäde to the SED-L, February 15, 1965, SächsStAL: VBK-L 117: "der Schönheit, der Kraft und dem Optimismus unseres Lebens."

6. The international trade fairs took place in the spring and fall each year.

7. Paul Fröhlich, "Vorlage zur Vorbereitung und Durchführung der 800-Jahrfeier der Stadt Leipzig," May 5, 1964, SächsStAL: SED-L IV/A/2/9/1/336.

8. SED-L, "Konzeption für die Beratung des Genossen Walter Ulbricht am 20. und 21. November 1964 in Leipzig," November 13, 1964, SächsStAL: SED-L IV/A/2/9/1/336.

9. Thomas Topfstedt, "Augustusplatz—Karl-Marx-Platz—Augustusplatz: Aufbauplanung und Neugestaltung nach dem Zweiten Weltkrieg," in *Der Leipziger Augustusplatz: Funktionen und Gestaltwandel eines Großstadtplatzes*, ed. Thomas Topfstedt and Pit Lehmann (Leipzig: Leipzig University Press, 1994), 69–76.

10. Several opera houses were rebuilt after the war, including the Semper Oper in Dresden and the Komische Oper in Berlin.

11. Rat der Stadt, "Abschrift," n.d., SächStAL: SED-L IV/A/2/9/1/533 and Bundesarchiv DY 30/IV2/2.026/57, 29–33.

12. "Investmittel 1960," SächStAL: VBK-L 107. Heisig received 2,500 marks in July for sketches of the triptych. This was 10 percent of the total, the rest of which was to be paid when he delivered the final work. The three parts of the triptych at this point were titled *Arbeitergeiger Sermuß* (Worker Violinist Sermuß), *Auftritt der "Blauen Blusen"* (Performance of the "Blue Blouses"), *Festzug Richtfest* (Procession Ceremony). Heinrich Witz to Alfred Kurella, November 9, 1960, Bundesarchiv DY 30/IV 2/2.026/56.

13. The current location of these works is unknown.

14. Heinrich Witz sent letters to the district council (August 15, 1960) and to Alfred Kurella at the Politburo in Berlin (November 9, 1960) on behalf of himself and the other artists involved. Bundesarchiv DY 30/IV 2/2.026/56.

15. Gerhard Winkler, *Leipzig Hotel Deutschland* (Leipzig: Seemann Verlag, 1967). See also Wolfgang Scheibe, "Hotel 'Deutschland,'" *Deutsche Architektur* 8 (1965): 454–56. The Hotel Deutschland was renamed the Hotel "Am Ring" in the 1970s when the GDR changed from using "Germany" to using "GDR" in the names of its organizations. After unification the hotel was renamed the Hotel Merkur. It is now the Radisson Blu Hotel, Leipzig. Quotations: "das größte Objekt des Hotelbauprogrammes," "ein Reisehotel 1. Ordnung mit einem Komfort nach internationalen Standard" (454).

16. Winkler, *Leipzig Hotel Deutschland*.

17. Hans Engels created *Weimar* and *Trier* (*Trier* was later replaced by Heisig's *Berlin*); Heisig created *Schwedt*, *Rostock*, and *Halle*; and Ursula and Wolfgang Mattheuer created *Leipzig* and *Eisenach*.

18. Ständigen Kommission Kultur, "Personalvorschläge zum Aufbau des Stadtzentrums Leipzig," April 18, 1964, SächStAL: VBK-L 114. A later report shows that Heisig was also recommended as a possible alternative to Harry Blume to work with Werner Tübke on a large mural for the hotel restaurant with the theme *Die neuen sozialistischen Beziehungen der Menschen im sozialistischen Deutschland* (The New Socialist Relationship of Man in a Socialist Germany). "Schreiben der Ständigen Kommission Kultur, Arbeitsgruppe Dokumentation, vom 23.5.1964, Vorschläge für die künstlerische Ausgestaltung des 'Hotel Deutschlands' entsprechend der Beratung am 22.5.64," SächStAL: VBK-L 114. Ultimately, the only murals Heisig created for the Hotel Deutschland were those in the *Bettenhaus*.

19. On May 22, Heisig, Engels, and W. Schaefter were invited to submit sketches. Wolfgang and Ursula Mattheuer later replaced Schaefter; the archival files do not offer reasons for this change.

20. Standing Commission for Culture, "Vorschläge für die künstlerische Ausgestaltung des 'Hotel Deutschland' entsprechend der Beratung am 22.5.1964," May 23, 1964, SächStAL: VBK-L 114: "soll in einfacher sinnbildhafter Ablesbarkeit das Thema der nationalen Landschaft in Verbindung mit progressiven Traditionen der nationalen Geschichte der Vergangenheit und Gegenwart künstlerisch gestaltet werden."

21. Ibid.: "damit auch ein optisches Bild über die neue Art und Weise der künstlerisch-en Gestaltung zur Diskussion gestellt werden kann."

22. A rival to Alexandria and Rome in the ancient world and the capital of Gaul in the Middle Ages, the city of Trier was founded in 16 BCE by Augustus Caesar. Excavations and legends suggest it may have been established as an Assyrian settlement 2,000 years before that. John Dornberg, "Trier—Germany's Oldest and 'Most Splendid City,'" *German Life* 4/5 (1997), accessed April 1, 2007, http://www.germanlife.com/Archives/ 1997/9704_01. html.

23. Marga Tschirner, "Schwedt wird international," in *Leipziger Volkszeitung*, July 25, 1965: "jetzt Symbol für das Neue, das Vorwärtsdrängende unserer Republik."

24. For more on women in East Germany, see Donna Harsch, "Squaring the Circle: The Dilemmas and Evolution of Women's Policy," in Major and Osmond, *Workers' and Peasants' State*, 151–70.

25. "Der kleine Trompeter" was a song often sung in the FDJ. The East German state-owned film studio (DEFA, Deutsche Film-Aktiengesellschaft) released *Das Lied vom Trompeter* (The Song of the Trumpeter) in 1964. The film detailed the life of Fritz Weineck, a man from Halle who used his trumpet for the Communist cause in the 1920s, blowing signals and warnings to militant workers and, most famously, Ernst Thälmann in 1925.

26. Standing Commission for Culture, "Personalvorschläge für die künstlerische Ausgestaltung des 'Hotel Deutschlands' entsprechend der Beratung am 22.5.64," May 23, 1964, SächStAL: VBK-L 114.

27. Both Mäde and Meißner commented at the time on the sense of optimism that Heisig's murals convey.

28. Werner Tübke was a particular favorite of Kurella's in these years.

29. Kurella lost his position as head of the Cultural Commission in 1963, at which point he gave an official self-criticism. The significant stir his criticism of the Hotel Germany murals caused, however, suggest that he was still a powerful figure in 1965 as does his having received the prestigious Vaterländischer Verdienstorden in Gold (National Gold Medal for Distinguished Service) in early 1965. VBKD-ZV, "Mitteilungen an die Mitglieder des VBKD," August 14, 1965, SächStAL: RdB 8072.

30. Kurella, "Gedanken über die Wandbilder im 'Hotel Deutschland' (Leipzig)": "stel-len einen ernsten Einbruch des Modernismus und der Theorie des 'Realismus ohne Ufer' in unserer Kunstleben dar. . . . Wie konnte es kommen, dass die Herstellung dieser Bilder erfolgte, ohne dass die Auftraggeber und die staatlichen Kontrollinstanzen die untragbare Abweichung von der Kunstauffassung und -politik von Partei und Regierung bemerkten und verhinderten?"

31. Ibid.: "versuchten, unter der Losung 'Kunst am Bau' den ganzen Unfug formalist-ischer, antirealistischer, abstrakter, symbolischer 'Kunst' bei uns einzuschmuggeln."

32. Ibid.: "Relativ annehmbar"; "verstärkt unnötig die formalistische Vereinfachung"; "unbefriedigend gelöst."

33. Ibid.: "Völlig unqualifiziert."

34. Ibid.: "primitivsten Mitteln," "die noch unter dem Niveau von Kinderzeichnungen liegen."

35. Ibid.: "unverschämte Zumutung."

36. Ibid. "Nur mit Mühe kann man im Prinzip der Anordnung dieser Bruchstücke zum Zweck rein *formaler Effekte* oder *dekorativer* Wirkungen ("rhythmisch" verteilte, vor den Gegenständen gelöste formlose Farbflecken) erkennen. In dem Bild 'Schwedt' bringt

dieser Anti-Realismus eine (dem Künstler vielleicht unbewusste) *Technikfeindschaft* zum Ausdruck. Das *rhythmische* und *harmonische Bild* des Systems von Röhren, Kondensatoren, Krakingtürmen, Schweltürmen, das ein moderner Erdöl-Chemie-Betrieb jedem Betrachter darbietet, wird in ein Chaos absichtlich unharmonisch, zerbrochen, zerquetscht, unrhythmisch gemachter Fragmente technischer Details verwandelt!"

37. Ibid.: "ein 'Zeitbewusstsein.'"

38. Ibid.: "eine fremde *Kunstauffassung.* . . . Hier wird eine Kunst propagiert (und praktiziert) die es ablehnt, Wirklichkeit abzubilden, und fordert, dass der Künstler der Wirklichkeit grundsätzlich eine Gegen-Wirklichkeit gegenüberstellt."

39. Alfred Kurella to Günter Witt at the Ministry of Culture, October 27, 1960, Bundesarchiv-SAPMO: DY30/IV2/2.026/56: "die begabtesten jüngeren Künstler nicht nur in Leipzig, sondern in der Republik."

40. Kurella, "Gedanken über die Wandbilder im 'Hotel Deutschland' (Leipzig)." "Das Unglück ist nur, dass Heisig seiner Begabung und Anlage nach ein *Realist* ist. . . . Er muss sich also *zwingen*, Antirealismus zu machen, und muss deshalb zu *Anleihen bei Picasso und Leger* greifen. Es ist peinlich zu sehen, wie dilettantisch er sich Formelemente dieser Künstler aneignet."

41. Ibid. "Die ideologische und kunsttheoretische Auseinandersetzung mit Heisig an Hand dieser Bilder ist von *grundsätzlicher Bedeutung für unsere ganze Kunst* und muss gründlich vorbereitet und geführt werden."

42. Kimmel, "Abschrift eines Schreibens von Gen. Prof. Alfred Kurella," February 20, 1965, Bundesarchiv-SAPMO: DY30/IV2/9.06/7. This document is a cover sheet to Kurt Hager that states that Kurella's "Gedanken über die Wandbilder im 'Hotel Deutschland' (Leipzig)" is attached.

43. Heinrich Mäde to the SED-L, February 15, 1965, SächsStAL: VBK-L 117: "grundsätzlich die Lösungen der gestellten Aufgaben begrüssen."

44. Ibid.: "der Schönheit, der Kraft und dem Optimismus unseres Lebens."

45. Gerhard Winkler to Paul Fröhlich at the SED-L, February 15, 1965, SächsStAL: SED-L IV/A/2/9/2/362. "Das besonders Schwierige, aber m.M. nach Neue, besteht darin, dass hier ein Versuch unternommen wurde, das Ornament auf der Basis einer politisch inhaltlichen Thematik zu entwickeln. In Kunst und Architektur gibt es m.M. [*sic*] bisher keine solchen Beispiele."

46. Ibid.: "einen möglichen und entwicklungsfähigen Weg."

47. Ibid.: "einen Schritt nach vorn"; "eine fruchtbringende Discussion."

48. Unlike Kurella, however, it viewed Engels's *Weimar* as successful. Leipzig City Council, "Bericht des Rates der Stadt Leipzig über die Konzeption und Durchführung der künstlerischen Ausgestaltung des Hotels 'Deutschland,'" February 15, 1965, SächsStAL: SED-L IV/A/2/9/2/362. "Das Werk wird als künstlerisch nicht ausgereift und politisch nicht voll bewältigt beurteilt."

49. Ibid. "Diese Synthese ist in der Vordergrunddarstellung eines optimistischen Menschenantlitzes und der Auffassung des dynamischen Arbeitsprozesses gelungen."

50. Häußler, "Bericht für das Sekretariat der SED-Bezirksleitung zur künstlerischen Ausgestaltung des Hotels 'Deutschland,'" February 16, 1965, SächsStAL: SED-L IV/A/2/9/2/362.

51. Ibid.: "ideologischen Schwächen"; "einen Ausgangspunkt für künftigen dekorative Wandgestaltungen an Bauvorhaben in realistischer Weise mit künstlerischen Mitteln."

52. Ibid. "Die Verwischung des Inhalts und die Überbetonung des Formalen."

53. Ibid. "Die Überbetonung des Formal-Dekorativen führt zu einem weitgehen-den Auseinanderfallen von Form und Inhalt—die Verletzung einer der wesentlichsten Forderungen eines realistischen Kunstwerkes."

54. Ibid. "Herausgekommen ist eine formalistische Auffassung, die sich von vielen westlichen Kunstwerken tatsächlich kaum noch unterscheidet und keinen Weg für die real-istische Kunstgestaltung in modernen Bauobjekten für die weitere Zukunft darstellen kann." Significantly, the report then states that these works show an "eindeutiger Bruch" (un-equivocal break) and "eine Rückkehr zu schon früher in der Tendenz vorhandenen Auffassungen, bespielsweise [im] Sportforum" (return to tendencies already existent in earlier conceptions, such as the Sportforum). This is an important statement because it mentions one of Heisig's earliest murals, one he created for the Sports Forum in Leipzig; it is the only one of his murals from the 1950s of which there is a visual record. As men-tioned in chapter 1, it is a black-and-white sgraffito that emphasizes the linear and clearly draws upon Picasso's classical work and his doves of peace. At that time, 1955, there was a discussion in *Bildende Kunst* taking place about Picasso as a possible role model for East German artists.

55. Ibid.: "eine sogenannte kühne moderne."

56. Ibid.: "unserer Kulturpolitik." The report also called for fundamental changes in the state leadership activities and an improvement in the district council's supervision of such works.

57. "Information über die Lage im Bereich der bildenden Kunst und über Argumente, die in Gesprächen auftreten, in Vorbereitung auf das Gespräch des Sekretariats mit bilden-den Künstlern," June 18, 1965, SächsStAL: SED-L IV/A/2/9/2/362.

58. Werner Krecek, "Nachschrift wesentlicher Gedanken aus der Diskussion während des Gesprächs des Genossen Paul Fröhlich mit bildenden Künstlern am 21. Juni 1965," n.d., SächsStAL: SED-L IV/A/2/9/2/362. "Wir brauchen ein Fachpublikum auch für die bildende Künstler."

59. The SED-L pointed out the need for the *Leipziger Volkszeitung* to develop con-versations about art with its readers and to represent the successful cultural politics dis-played during the Leipzig's eight hundredth anniversary. SED-L, "Plan zur Führung der Wahlbewegung durch die Redaktion der *LVZ*," July 12, 1965, SächsStAL: SED-L IV/2/9/1/346. At the fourth conference for journalists in December 1964, the Central Committee of the SED gave journalists the task of contributing to the "comprehensive building of Socialism in the GDR" with their work. SED-L, "Stellungnahme der Abt. Prop.-Agit. der BL zur Vorlage des Chefredakteurs und des Redaktionskollegiums der 'Leipziger Volkszeitung,'" September 26, 1965, SächsStAL: SED-L IV/2/9/1/346.

60. *Protokoll Parteilehrjahr der Dozentengruppe am 18.1.1962*, HGB-Archiv: 11.

61. Rita Jorek, "Wir stellen zur Diskussion: Bilder auf der Etage, Ein erstes Gespräch mit Prof. Bernhard Heisig," *Leipziger Volkszeitung*, July 10, 1965.

62. Ibid.: "uns die Wandbilder zu erklären, damit auch wir ihre besonderen Schönheiten erkennen könnten."

63. Ibid. "Bernhard Heisig hatte es ihr . . . nicht einfach gemacht."

64. Ibid.: "um . . . die vom Künstler interpretierte Wirklichkeit zu begreifen."

65. Ibid.: "nicht als Illustration von Gedanken und Ideen aufgefasst, sondern als eigen-ständige künstlerische Gestaltung."

66. Ibid. "Allzuoft wird noch vergessen, dass auch das heitere Lebensgefühl, das ein Kunstwerk vermittelt, eine ideologische Funktion hat."

67. Ibid. "Künstler, Kunstwissenschaftler und Architekten uns zu schreiben, damit die Erfahrungen, die bei dieser Arbeit gewonnen wurden, für andere Gelegenheiten genutzt werden können."

68. Günter Meißner, "Schönheit und Überfülle, Diskussionsbeitrag zum Thema 'Bilder auf der Etage,'" *Leipziger Volkszeitung*, July 17, 1965. "Von vornherein verbot es sich, ein fotogetreues Panorama dieser Städte auszubreiten, denn die Wandbilder in diesen Durchgangsräumen sollten knapp und schnell erfaßbar das Wichtigste vor Augen stellen und den Raum schmücken."

69. Ibid.: "Schwung und persönliche Leidenschaft müssen erlebbar werden, die künstlerische Form selbst muß inhaltsvoller Ausdrucksträger sein und nicht bloß Mittel zum Zweck einer ideellen Aussage mit Hilfe bestimmter Motive."

70. Ibid. "Dieser Künstler, dessen Hang zum Phantastischen manchmal in die skurrile Deformierung umschlägt, will nicht wohlgefällige Pathetik offerieren, sondern Sinn und Phantasie mit beruhigender [*sic*] Intensität packen. Er drängte die Symbolvielfalt zugunsten der großen einheitlichen Wirkung zurück, zwingt alles in eine eigentümlich bewegte Formensprache, die zunächst bestürzend wirken kann, deren Sinn aber aus dem Inhalt seiner Aufgabe entspringt. So ist vieles 'verfremdet,' und was das Auge zuerst als schönes Spiel der Formen und Farben wahrnimmt—eine durchaus legitime Funktion der baugebundenen Kunst—enträtselt die Phantasie beim Betrachten."

71. Herbert Letsch, "Wir diskutieren: Bilder auf der Etage, Das Bild im Raum," *Leipziger Volkszeitung*, July 31, 1965: "einen interessanten Versuch"; "nicht hinreichend gelöst."

72. Ibid. "Der Betrachter empfindet m.E. einen Mißklang zwischen der Intimität des Raumes und der harten, sozusagen zyklopischen Symbolik der Bildgestaltung."

73. Ibid.: "längere Zeit und wiederholt zu betrachten." Here Letsch seems to be making a reference to—and subtle refutation of—Jorek's article from a few weeks earlier.

74. Wolfgang Scheibe, "Montagebauweise negiert nicht die Kunst," *Leipziger Volkszeitung*, August 7, 1965.

75. Another article in this issue focuses on the Hotel Deutschland as a whole. (The murals in the *Bettenhaus* were not the only artworks created for the building, which also included murals in the restaurant and bar as well as sculpture. Winkler, *Leipzig Hotel Deutschland*).

76. A letter from Jutta Schmidt, editor of *Bildende Kunst*, to Meißner on July 26, 1965, indicates that the article was nearing the final stages of preparation for publication already in late July. In the letter, she indicated that she shared Meißner's positive view of *Schwedt*. I thank Günter Meißner for providing me with a copy of this letter.

77. Günter Meißner, "Architekturbezogen und originell," in *Bildende Kunst* 10 (1965): 527–33. "Er ließ sich nicht von der Sinnbildfülle überrennen, sondern reduzierte sie und verschmolz sie zu einer dekorativen großen Einheit bewegter, organischer Linien, Flächen und Farben. . . . Hier dokumentiert sich ein dem Künstler eigenes Lebensgefühl, das sich nicht mit glatter Wohlgefälligkeit zufriedengibt, sondern mit beunruhigender Intensität Sinn und Phantasie packen will, in diesem Fall durchaus mit optimistischem Grundgehalt."

78. Of all the Hotel Deutschland murals in the *Bettenhaus*, this is the only one not currently visible. After reunification, the hotel's owners placed a temporary wall in front of it. This seems to have occurred before 1993 as a detailed restoration report from that year does not include it. Rainer Mahn, "Restaurierungsprotokoll," October 29, 1993, author's collection.

79. The division of the canvas into good and bad halves recalls a number of works created for a competition in Leipzig in 1966 for a painting on the theme "13. August 1961," the day the Berlin Wall began to be built. Heisig was invited to submit a work to this competition but did not. The similarities between *Berlin* and these other works, however, suggests that *Berlin* may have originated as a sketch for this competition. For more about this competition, see Eisman, "Painting the Berlin Wall in Leipzig," 83–95.

80. In a CV dated April 6, 1972, Heisig listed architectural art as one of his four artistic areas, together with painting, graphics, and illustration. AdK-Archiv: Kober Nachlass 14/3.

81. Schirmer, *Willi Sitte*, 156–57. "Heisig wollte sich großen Wandbildaufträgen widmen, die sich freiberuflich besser bewältigen ließen. Sie waren nicht nur lukrativer, sondern brachten ihm auch interessante künstlerische Erfahrungen mit Gipsintarsie und Sgraffito . . . ein."

82. When I discussed this theory with Günter Meißner in 2005, he agreed it seemed likely and was surprised he had not made the connection himself. Anneliese Hübscher also agreed that Heisig's Hotel Deutschland murals and the Paris Commune painting had the "same dynamic" (gleiche Dynamik). Hübscher, interview with the author, July 22, 2005.

83. VBK-L, "Kunstpreis der Stadt Leipzig, 1966," May 31, 1966, SächStAL: 155. "Im DDR-Maßstab wurden seine baugebundenen Arbeiten für das Interhotel Deutschland stark beachtet. Er wirft damit, wie auch in seinem gesamten Schaffen, Gestaltungsprobleme auf, die das Gespräch über die Weiterentwicklung unserer nationalen Kunst interessant und positiv anregt."

Chapter Four

1. The *Bezirke* (regional districts) in East Germany had art exhibitions every two to four years and were usually numbered sequentially. These exhibitions provided an opportunity for each district to showcase its artists and to evaluate their work in preparation for the national exhibition in Dresden, which took place every four to five years. In this chapter, I am referring to the district exhibitions in Leipzig unless explicitly stated otherwise.

2. "Information über den Stand der Vorbereitung der 7 BKA-L," August 21, 1965, SächsStAL: BT 4516. Another report listed the total number of works as 732. "Mäde Einschätzung der 7. BKA-L," n.d. [early November 1965]. Thank you to Rita Jorek for providing me with this document. The exhibition contained twelve of Heisig's works, which was far more than he had previously shown at a district exhibition.

3. This painting is often dated 1964 today, although it is clear from archival sources quoted later in this chapter that he continued to work on it until the exhibition opened in October 1965. Undated in the Seventh's catalog and in articles published in the *Leipziger Volkszeitung* at the time, it was dated 1965 by Günter Meißner in an article published in *Bildende Kunst* three months later. Gunter Meißner, "Um die Vertiefung realistischer Aussage," *Bildende Kunst* 2 (1966): 73–78. The first time 1964 was used for this painting seems to be in the 1973 retrospective catalog, *Bernhard Heisig, Gemälde, Zeichnungen, Lithographien.* There is no explanation for the change in date. In his 1988 dissertation on Heisig, Lichtnau gave both dates: "1964, auch Dat. 1965." Lichtnau, "Der Beitrag Bernhard Heisigs zur Weiterentwicklung der Historienmalerei," 2:9.

4. Günter Meißner, "Suchen nach neuen Wegen, 7. Bezirkskunstausstellung Leipzig eröffnet," *Neues Deutschland*, October 5, 1965; M.T., "Entwicklung und Leistung, Leipziger

Künstler legen Rechenschaft," *Die Union*, October 21, 1965; and "Erster Rundgang—erste Urteile, Paul Fröhlich und Erich Grützner besuchten die 7. Bezirkskunstausstellung Leipzig," *Leipziger Volkszeitung*, October 3, 1965. "vitaler Malerei" (Meißner); "explosive" (M.T.); "Sinfonie dramatischer Töne" (Meißner); "[macht] die unerhörte Kraft der Kommunarden spürbar" (Erster Rundgang).

5. Harald Olbrich, "Ästhetische Subjektivität oder Subjektivismus," *Bildende Kunst* 5 (1966): 272–73: "das vordergründige Interesse an Formproblemen . . . und sich windenden amorph-teigigen Massen [schränkt] die parteiliche Wertung der Kommune entscheidend ein."

6. Heisig created images of the Paris Commune through at least the end of the 1980s, recreating the controversial 1965 painting for his retrospective exhibition in 1989. Of particular importance beyond those discussed in this chapter is the four-panel polyptych he created in 1971–72, which is in the Museum der bildenden Künste Leipzig's permanent collection.

7. In current scholarship, by contrast, Heisig's works on the Paris Commune are seen almost exclusively as allegories of his wartime experiences, while the controversy around the 1965 painting is presented as a traumatic example of dictatorial repression. For an example, see Gillen, *Die Wut der Bilder*, 95–123. Significantly, the title of that chapter is "Bernhard Heisig scheitert als Historienmaler und findet sein Thema: Die Pariser Kommune als Schützengrabenbild" (Bernhard Heisig fails as a history painter and finds his theme: The Paris commune as trench painting).

8. "Arbeitsplan des VBK-L bis zum Verbandskongress März 1964," July 9, 1963, VBK-L 114.

9. "Protokoll über die Sektionsleitungssitzung am 9. Dezember 1964," SächsStAL: VBK-L 21.

10. "Aufruf an alle bildende Künstler des Bezirkes Leipzig," March 25, 1965, SächsStAL: VBK-L 114. "Erneut beschäftigen sich . . . Künstler, Kunstkritiker und Kulturpolitiker mit der Frage nach den künstlerischen Mitteln, welche Formulierungsmöglichkeiten der bildenden Kunst ein adäquater Ausdruck unserer Zeit sind, inwieweit individuelle Begabungen und Neigungen sich zu einer großen, objektiven Aussage über die Probleme unserer Zeit vereinen lassen, wie im echten sozialistischen und künstlerischen Meinungsstreit die Kunstentwicklung vorangetrieben werden kann."

11. Ibid.: "Wir bitten alle Kolleginnen und Kollegen, diese Ausstellung mit ihren besten Werken zu beschicken und dadurch mitzuhelfen, diese vielseitig, interessant und anziehend zu machen, mit ihren Arbeiten beizutragen zu einem echten künstlerischen Meinungsstreit und zur Weiterentwicklung des Leipziger Kunstschaffens."

12. With the exception of the blond woman at the far left-hand side of the painting, the gender of most of the figures in the work cannot be ascertained from the black-and-white reproduction. For the sake of narrative clarity, I have assigned a gender to each of the figures in my description of the work. Where possible, I have used other paintings by Heisig as a guide.

13. The six groupings are *Group of Communards with Canon*, *Communards 1871 I–III*, *Barricades I–II*, *Aufbruch I–III*, *The Last Barricade*, and *Communards with Beds in Front of Buildings*. Sander, "Bernhard Heisig."

14. Karl Max Kober, *Bernhard Heisig* (Dresden: VEB Verlag der Kunst, 1981), 31. "Als ich im Spätherbst 1977 zusammen mit Bernhard Heisig erstmals Paris besuchte, mußte ich darüber staunen, wie der Maler der Vorgänge von 1871 orten konnte. Seine Kenntnisse

reichten so weit, daß er im heutigen Paris noch die Stellung einzelner Barrikaden und die Orte verschiedener Ereignisse und Kämpfe ohne Hilfsmittel ausmachte." (When I, together with Bernhard Heisig, first visited Paris in the late fall of 1977, I was amazed at how [he] could locate the scenes from 1871. His knowledge was so deep that he could find the locations of individual barricades, events, and battles in today's Paris without help.)

15. A document dated February 17, 1959, states that Heisig received 2,000 marks from the 1958 cultural funds for an oil sketch of the Paris Commune. "Abrechnung Kulturfondsmittel bildende Kunst 1958," SächsStAL: VBK-L 107. On July 10, 1958, Heisig showed the RdB photos of a 160 x 110 cm painting of the Paris Commune. "Protokoll der Sitzung des Kuratoriums zur Förderung der bildenden Kunst am 10.07.1958," SächsStAL: RdB 2972. On December 8, 1958, Witz reported in an advisory board meeting that he had visited Heisig's studio, where Heisig had changed the painting's subject matter from the Paris Commune to *Hamburger Aufstand unter Ernst Thälmann*. Witz told him that he could not change the topic. The advisory board asked for more sketches so it could decide. "Protokoll über die Sitzung des Kuratoriums am 8.12.1958," December 9, 1958, SächsStAL: RdB 2972.

16. "Marxismus und Verbindung mit dem Leben. Walter Ulbricht in der Leipziger Kunstausstellung über Voraussetzungen künstlerischer Gestaltung des neuen Menschen," *Tribüne*, December 9, 1961. Ulbricht's exact wording varies depending on the source. According to Heinrich Witz's notes, Ulbricht visited the exhibition on December 7, 1961, and said to Heisig, "Wissen Sie, die Pariser Commune hat gekämpft" (You know, the Paris Commune fought). HGB-Archiv: Witz Nachlass.

17. Anneliese Hübscher, "Bezirksausstellung Leipzig," *Junge Kunst* 1 (1962): 20. "Heisig wählt jene Situation der Märztage von 1871, in der die Pariser Kommunarden die Macht in die Hände genommen hatten. Aber das Wissen um das grausame Ende, das die Reaktion den Kommunarden bereitete, liegt über dem ganzen Bild. Man kann sich des Eindrucks nicht erwehren, daß die auf dem Bild dargestellten Menschen auf verlorenem Posten stehen, entschlossen zwar, im Kampf ihr Leben einzusetzen, aber bereits wissend, daß sie der feindlichen Übermacht erliegen werden . . . von der Kraft, dem revolutionären Elan des Proletariats jener Tage ist nichts zu spüren."

18. Ibid.: "Bernhard Heisig [hat sich] entschlossen, die zweite Fassung dieses Themas zwischen Jury und Ausstellungeröffnung umzumalen und hat dabei versucht, die ihm in der Jury gegebenen Anregungen zu verwerten. Die zweite Fassung ist etwas aktiver, wenn er auch die Grundtendenz des Herangehens an dieses Thema noch nicht überwunden hat."

19. Ibid.: "wir sind der Überzeugung, daß der Künstler in der weiteren parteilichen Auseinandersetzung mit solchen bedeutenden Themen zu der Gestaltung zielbewußt handelnder Menschen kommen wird."

20. Krecek and Hagen, "Ein Blick in den Spiegel unserer Zeit": "wichtige Vorarbeiten für den nächsten Lösungsversuch."

21. Henry Schumann, "Die Fäden wieder knupfen," *Leipziger Volkszeitung*, December 14, 1962.

22. Joachim Uhlitzsch, "Zwei Staaten in der Kunst, Eine Betrachtung vor der V. Deutschen Kunstausstellung," *Leipziger Volkszeitung*, September 5, 1962. "In der neuen Fassung hat Heisig dem Thema einen anderen Inhalt gegeben. In einheitlicher Front stehen die Kommunarden und erwarten den Gegner. Die Züge der Depression, die dem Bild der Bezirkskunstausstellung eigentümlich waren, sind hier dem Ausdruck entschlossener Kampfbereitschaft gewichen. 'Vous êtes travailleurs aussi' (Ihr seid auch Arbeiter) steht auf

dem Transparent, das den zu erwartenden angreifenden Soldaten entgegengehalten wird. Das in tiefen, gebrochenen Farben gemalte Bild, in dem Rottöne die wichtigsten Akzente sind, ist von hohem malerischem Reiz. Das Bild könnte den Titel 'Vor dem ersten Sturm' tragen. 'Vor der letzten Niederlage' das war etwa der Titel, den man unter die vorige Fassung hätte schreiben können."

23. A report from January 25, 1963, about the Kulturfondsmittel for 1962 lists Heisig as having received payment for a Paris Commune triptych. "Verwendung der Kulturfondsmittel im Jahre 1962," January 25, 1963, SächsStAL: VBK-L 107.

24. Rita Jorek, "Von Oeser bis zum Absolventen, Über die Jubiläumsausstellungen der HGB," *Leipziger Volkszeitung*, October 15, 1964. "Bewundern kann man auch die drei Teile der 'Pariser Kommune' von Bernhard Heisig, obwohl das Thema mit dieser letzten Fassung nicht richtig bewältigt ist. Farbkompositorisch gestaltet er erregend Aufstand, Kampf und Ende der Kommunarden. Wäre es ihm gelungen, in der Masse Mensch wirklich aufrechte Menschen zu gestalten—im dritten Teil deuten sich an—dann wäre ein grossartiges Werk entstanden. Jetzt erinnern die ersten beide Teile etwas an Dix und an sinnloses Mördern im Krieg."

25. From a June 1966 interview with Tübke in *Berliner Rundfunk*, as quoted in *Weggefährten, Zeitgenossen, Bildende Kunst aus drei Jahrzehnten* (Berlin: Zentrum für Kunstausstellungen der DDR, 1979), 180.

26. Dieter Gleisberg, "Das Gleichnis des Kain," *Leipziger Volkszeitung*, October 23, 1965: "die verblendete Unmenschlichkeit des Völkermordes." Friedrich Möbius, "Erkenntnis und Gestaltung," *Bildende Kunst*, 6 (1968): 329–30. The figure grasping at his neck appears in several lithographs from 1958 titled *Algerien* (Algeria), two of which include rifles, war planes, and a massive explosion. *Wolfgang Mattheuer, das druckgrafische Werk 1948–1986* (Leipzig: Museum der bildenden Künste, 1987), 34–35. Mattheuer was responding here to the Battle of Algiers (1956–57), which marked a particularly brutal period in the Algerian War of Independence against France (1954–62).

27. See "Einschätzung der Kreisseiten der *LVZ* von 4.–9.07.1966 in Bezug auf die Behandlung der politischen Schwerpunkte (Pressekonferenz des Gen. Prof. Albert Norden, Offenes Wort und Protestbewegung gegen den schmutzigen Krieg der USA in Vietnam)," SächsStAL: SED-L IV/A/2/9/1/347. There were calls aimed specifically at artists to create works to help raise awareness of and money for the suffering of the Vietnamese people. "Kunst-Auktion für Vietnam," *Leipziger Volkszeitung*, July 24, 1966.

28. Another print with the same title focuses on just one of these figures, his right arm covered in the inverted insignia of a sergeant in the US Army. Image illustrated in *Heinz Zander, Malerei, Zeichnungen, Grafik* (Leipzig: Museum der bildende Künste, 1984), 27.

29. Verband Bildender Künstler Deutschlands, Berzirksvorstand Leipzig, Vorwort [introduction], *7. Kunstausstellung 1965 des VBKD, Bezirk Leipzig* [Seventh District Art Exhibition in Leipzig], exhibition catalog (Leipzig: VBKD, 1965).

30. Ibid. "Die Leipziger Künstler sind überzeugt, einen weiteren Beitrag zur Entwicklung des sozialistischen Realismus geleistet zu haben. Wir geben dem Wunsch Ausdruck, daß die in dieser Ausstellung gezeigten Arbeiten zu einer lebendigen geistigen Auseinandersetzung anregen und das Gespräch über die großen Aufgaben und Möglichkeiten der Kunst in unserer Zeit befruchten möge."

31. "Vielfalt des künstlerischen Ausdrucks: Gespräch mit Mitgliedern der Jury zur 7. Bezirkskunstausstellung," *Leipziger Volkszeitung*, August 1, 1965: "künstlerischen Auffassungen"; "die Künstler haben zu sich selbst gefunden."

32. Günter Meißner, "Malerei und Grafik auf der 7. Bezirkskunstausstellung," *Leipziger Volkszeitung*, October 9, 1965: "sie ist . . . eine der interessantesten."

33. Henry Schumann, "Allegorie des Unrechts," *Leipziger Volkszeitung*, October 16, 1965. "Naziblutrichter"

34. Günter Meißner, "Ein Bild der Commune," *Leipziger Volkszeitung*, October 30, 1965. "Acht Tage tobte ein erbitterter Straßenkampf, ehe die von Preußen unterstützte reaktionäre Übermacht die Pariser Commune . . . in einem Meer von Blut erstickte. Größe und Tragik dieser ersten proletarischen Revolution bleiben immer als Vermächtnis und Lehre lebendig, auch in der deutschen Arbeiterklasse. Gering aber war das Echo in der bildenden Kunst. . . . Heute, knapp hundert Jahre später, da die Träume der Pariser Kommunarden in vielen Ländern Wirklichkeit sind, steht der Besucher der 7. Bezirkskunstausstellung vor einem Bild Bernhard Heisigs, das jenem Ereignis gewidmet ist."

35. Ibid. "Heisig [malt] historisches Geschehen nicht zum Gedenken allein, sondern als aufrüttelnde Mahnung an die Zeitgenossen. Eigene Erlebnisse und Visionen flossen ein in diesen Appell gegen die Kräfte des Todes und der Unterdrückung, die heute noch drohen. Daher das Hauptaugenmerk auf die tragische Seite der Commune."

36. Ibid.: "immer suchende, nie zufriedene Haltung Bernhard Heisigs."

37. Ibid.: "aus innerster Überzeugung [wird Heisig] der Hauptfrage unseres Seins, Kampf gegen Tod und Unterdrückung, noch manches aufrüttelnde Bild widmen."

38. "Erster Rundgang." This cautiously positive review may have been the result, in part, of a desire to avoid creating more tension between artists and functionaries in the wake of the months-long debate around the Hotel Germany murals that began in January 1965.

39. Werner Krecek [Klaus-Dieter Walther], "Brief zu einem Bild," *Leipziger Volkszeitung*, November 6, 1965.

40. Ibid.: "diesen Geist nicht atmet."

41. Ibid. "Vielleicht ist es auch gar nicht möglich, das im Bild zu zeigen, wenn man nur das Ende gestaltet."

42. Ibid.: "hier [war] ein großer Anfang: der erste proletarische Staat der Welt."

43. "Genossen Hager zur Information," October 20, 1965, Bundesarchiv-SAPMO: 37. In an article published in 1999, Henry Schumann mentions that Lotte Ulbricht had also expressed dissatisfaction with the Seventh after her visit, although he does not mention the date she was there. This may have also played a role in the shift that took place in the exhibition's reception. Schumann, "Leitbild Leipzig," 515.

44. "Genossen Hager zur Information": "einer Vielfalt von künstlerischen Handschriften."

45. Ibid. "In Leipzig machten sich jedoch noch andere Tendenzen bemerkbar. . . . Im Grunde genommen zeugen ein ganzer Teil der ausgestellten Werke, besonders der Malerei, von einem Verlassen unserer weltanschaulichen Position."

46. Rita Jorek, in discussion with the author, summer 2005.

47. Rita Jorek, unpublished article for the *Leipziger Volkszeitung*, November 6, 1965, author's collection. "'Pariser Commune' . . . erschließt sich dem Betrachter oft erst nach längerem Anschauen ganz." Thank you to Rita Jorek for this document.

48. Ibid. "Man begreift es besser, je mehr man selbst über den heldenhaften Kampf der Kommunarden weiß."

49. Ibid. "Sollte es unseren Feinden gelingen, Paris in ein Grab zu verwandeln, so wird es jedenfalls niemals ein Grab unserer Ideen werden."

50. Ibid.: "der . . . einem Propheten gleicht und die Hand warnend und mahnend erhebt, als wollte er die Mordenden vor einem Irrtum bewahren."

51. Ibid. "Die Hoffnung, daß die gute Idee überzeugen müsse, daß sie es vielleicht besser noch könne als die Waffen, charakterisiert die Größe dieser Kämpfer der proletarischen Revolution, sie ist aber auch ein Grund für ihre Niederlage; denn bis zum Schluß meinten einige ihrer Führer, daß die Gerechtigkeit der Gewalt nicht bedarf."

52. Corey Ross, "'Protecting the Accomplishments of Socialism'? The (Re)Militarisation of Life in the German Democratic Republic," in Major and Osmond, *Workers' and Peasants' State*, 78–93.

53. This was Brecht's basic point of view in his play *The Days of the Commune*.

54. Jorek, unpublished article for the *Leipziger Volkszeitung*. "Das Optimistische, das vom Bild ausstrahlt, liegt nicht nur in einzelnen Gestalten der Kommunarden begründet . . . sondern auch in der Komposition. Das wird im Vergleich mit der Mitteltafel des Kriegstriptychons von Otto Dix besonders deutlich. . . . Hier wird das Gefühl des Sinnlosigkeit des Krieges hervorgehoben. . . . In dem Bild der "Pariser Commune" dagegen streben die Menschen nach oben . . . sind sie selbst das Zeichen, das in die Zukunft weist." In a review of a triptych of the Paris Commune shown at the Leipzig Academy in October 1964, Jorek criticized the lack of individuals in Heisig's painting. In her view, this is something he has clearly "corrected" in this later version. See Jorek, "Von Oeser bis zum Absolventen." Dix's war triptych, *Krieg*, belongs to the Gemäldegalerie Neue Meister in Dresden. After World War II, Dix settled in East Germany, one of the most prominent visual artists to do so. A major exhibition of his work took place at the Academy of Arts in (East) Berlin in 1957, *Otto Dix: Gemälde und Graphik von 1912–1957.*

55. Jorek, unpublished article for the *Leipziger Volkszeitung*: "reichen Assoziationsmöglichkeiten."

56. Meißner, "Um die Vertiefung realistischer Aussage," 7. "Gegenstand der Kritik und einer umfassenden Diskussion. Dabei erhob sich die prinzipielle Frage nach der historischen Wahrheit und der Berechtigung, diese unter dem Gesichtspunkt einer subjektiv betonten, beunruhigenden Zeitbezüglichkeit zu sehen."

57. Ibid. "Damit ist die Aussage noch heute von brennender Aktualität, aber zweifellos muß man den Kritikern des Bildes darin zustimmen, daß mit der Akzentverlagerung auf die Vernichtung nur ein Teil der historischen Wahrheit erfaßt ist. Aber dieser Teil ist sehr expressiv und aufrüttelnd gestaltet und nicht nur konzentriert auf die pessimistische Feststellung des physischen Unterganges."

58. Ibid. "Mir scheint, daß Momente des Heroismus, wie die geballten Fäuste der letzten Kommunarden, das dynamische Fanal des roten Transparents oder das fanfarenstoßähnliche Gelb des Hintergrundes, auf den zukünftigen Sieg der Ideen des proletarischen Befreiungskampfes hinweisen. Ekstatisch und visionär zugleich ist hier die Ausdruckskraft des Künstlers."

59. Olbrich, "Ästhetische Subjektivität oder Subjektivismus," 272–73. "Ich schätze die Bemühungen von Professor Bernhard Heisig um eine packende, emotional tieflotende und geistig vielschichtige Kunst. Ich bin beeindruckt von seinen Wandbildern im 'Interhotel Deutschland' in Leipzig. In dem dynamischen Konzept der Bilder und im hohen Grad ihrer Verallgemeinerung sehe ich den vom Künstler ganz persönlich empfundenen Abglanz der menschlichen Atmosphäre freier sozialistischer Gesellschaftlichkeit. Ich kann aber nur schwerlich einverstanden sein mit seinen jüngsten Versuchen zur 'Pariser Kommune'; denn dort schränkt das vordergründige Interesse an Formproblemen, das Angezogensein

des Künstlers von . . . sich windenden amorph-teigigen Massen die parteiliche Wertung der Kommune entscheidend ein. Die Tragik des letzten Kampfes, die unbeugsame Haltung der revolutionären Kommunarden wird zur animalisch-triebhaften Zuckung. Das Bild beschränkt sich auf eine ethische Ablehnung der konterrevolutionären Truppen, verharrt also in der Anklage und Negation."

60. Ibid.: "das Thema der Kommune kann doch nur Unsterblichkeit trotz Niederlage sein."

61. Ibid., 273 "Entsteht also nicht das Chaos der Bildfläche primär aus einem momentanen Unglauben an den Sieg der Humanität und des sozialen Fortschritts?"

62. Ibid.: "künstlerische Kritik am Neofaschismus und Imperialismus Westdeutschlands." Significantly, Olbrich suggests moving beyond simply focusing on the horrific and threatening, however, to focus on unveiling the system of oppression. Heisig's later work in the Fascist Nightmare series does exactly this.

63. Ibid.: "Tendenzen der Negation, der Beschwörung des Unheimlichen als einer kathartischen Schockwirkung."

64. Ibid., 272: "weil historische Erfahrungen des Marxismus nicht völlig zu eigenen und damit auch nicht bildwirksam wurden."

65. Ibid. "Erst im Wechselspiel beider Seiten und in der dominierenden Rolle der letzteren offenbart sich die sozialistische Parteilichkeit ihrem ganzen Umfang." It is unclear whether Olbrich is alluding here to Heisig's own words at the Fifth Congress. There, Heisig had made a similar comment, but, in contrast to Olbrich, he was criticizing the prohibition on portraying the negative side of life in East German art.

66. Ebersbach and Zander also had oil paintings in the exhibition that fit with this new style: *Selbstbildnis mit Freunden* and *Coriolan*, respectively.

67. Gabriele Kihago, "Probleme der baugebundenen Kunst—nachgewiesen an den neuen Hotels in Leipzig" (MA thesis, Pädagogischen Institute "Dr. Theodor Neubauer" [Erfurt], 1968).

68. H[enry]. S[chumann]., "Als Künstler gebraucht werden," *Leipziger Volkszeitung*, March 16, 1968. The controversial 1965 painting also appears prominently on the poster for Heisig's 1968 exhibition. Stadtgeschichtliches Museum Leipzig, Inv.-Nr. PL 68/328. This poster and Schumann's text refutes current scholarship's suggestion that Heisig destroyed this painting—and several others—between 1965 and 1967 as a form of "self-censorship." See Gillen, "Schwierigkeiten," 10, 15; and Gillen, *Die Wut der Bilder*, 95–110. Further refuting current scholarship is Heisig's main art historian in East Germany, Karl Max Kober, who wrote that the 1965 version of the *Paris Commune* "stood for years" in Heisig's studio. Karl Max Kober, *Bernhard Heisig* (Dresden: Verlag der Kunst, 1981), 35.

Chapter Five

1. Lothar Lang, "Der Maler Bernhard Heisig," *Weltbühne*, July 24, 1973, 944. Similarly, the East German art historian Renate Hartleb believed that Heisig was "predestined for portraiture." Renate Hartleb, *Bernhard Heisig* (Dresden: Verlag der Kunst, 1975), 3. Karl Max Kober also stated that "Bernhard Heisig is a painter of figures. His figural compositions form the core of his work." Kober, *Bernhard Heisig*, 69.

2. It was not difficult to survive on art alone in East Germany as the cost of living was extremely low. Artists were also supported by the Union of Visual Artists. Letters in the

archives suggest that artists could—and did—go to the Union of Visual Artists, usually at the district level, for help when struggling to make ends meet. In a worst-case scenario, artists could work a day or two in a factory; this would be enough to pay the bills for the entire month. (East German artist Sonja Eschefeld, in discussion with the author, summer 2002). This is an important distinction to make from the capitalist system: money was not a pressing concern in East Germany the way it is in the West.

3. Henry Schumann, *Ateliergespräche* (Leipzig: Seeman Verlag, 1976), 119. This book is a collection of interviews with East German artists that Schumann conducted in 1975. "gefördert durch einige Umstände, die mir damals 1968 das Lehramt verleidet hatten."

4. [Eva] Barth and [Gerhard] Butzmann, "Information für Gen. Paul Fröhlich," July 14, 1966, SächsStAL: SED-L 356. "Diplom-Klassen von Gen. Professor Bernhard Heisig . . . verkörpern in ihrer geistigen Grundhaltung ausgeprägten Skeptizismus . . . dass es einen Hang zur Gestaltung der Absonderlichen, Skurrilen oder wie es in der bildenden Kunst ausgedrückt wird, einen Hang zum 'loten in die Tiefe der Seele' gibt." Barth was from the Cultural Department (Kulturabteilung) of the SED in Leipzig; Butzmann from the Department of Schools (Schulen, Fach- und Hochschulen).

5. Ibid.

6. Heisig, as quoted in Schumann, *Ateliergespräche*, 119. "Die Umstände gaben mir damals nicht das nötige Maß an Freiheit, das ich brauchte, um Zielvorstellungen verwirklichen zu können."

7. Bernhard Heisig's Lebenslauf, April 6, 1972, AdK-Archiv: Kober Nachlass 14/3: "[Ich] löste 1968 das Lehrverhältnis auf eigenen Wunsch, da die zeitliche Belastung eine sinnvolle Fortführung meiner künstlerischen Arbeit nicht mehr ermöglichten."

8. Unlabeled report, c. 1974, BStU-Leipzig: Bernhard Heisig 000022. "Prof. H. gehört zweifellos zu den wichtigsten Künstlern unserer Republik. Einer größeren Öffentlichkeit ist er allerdings erst in den letzten Jahren bekannt geworden, d.h., seit er sein Lehramt an der Hochschule für Grafik und Buchkunst in Leipzig aufgegeben hat und sich ganz seiner künstlerischen Arbeit widmen konnte." In a document dated April 30, 1968, only "health reasons" are cited for his departure, effective August 31, 1968, HGB-Archiv: Personalakte Heisig.

Current scholarship explains Heisig's departure from the Leipzig Academy in 1968 solely in political terms: the threat of being sent to a one-year political school. (Gillen, *Die Wut der Bilder*, 321). The source given is an interview with Heisig conducted in 2000, less than two years after he had been at the center of vehement attacks in the press because of his commission for the Reichstag building. Although not mentioned, there is an archival document that mentions the party school: minutes from an October 1967 meeting of the SED-L. ("Protokoll der Leitungssitzung vom Oktober 19," October 19, 1967, SächsStAL: SED-L 356). In those minutes, Heisig appears to have responded positively to the idea of a party school but asked "for concrete suggestions on how he can reconcile his currently large stock of artistic commissions for the public with his activity as a teacher." (Er bittet . . . um konkrete Vorschläge, wie er den jetzigen großen Auftragsbestand an künstlerischen Arbeiten für die Öffentlichkeit und der Tätigkeit als Lehrer verinbaren soll.")

9. In 1969, Heisig created murals for the Gästehaus des Ministerrates der DDR, Leipzig (Guest House of the Council of Ministers Leipzig) and for the Volksschwimmhalle Mariannenpark (Peoples Swimming Pool). SächsStAL: BT/RdS 8094. Both are still visible in their original locations in Leipzig today, although the one in the Guest House is covered in

graffiti. The Leipzig photographer Margret Hoppe (b. 1981) took a photograph of the work in 2006 for a series about the post-unification disregard for East German art. Hoppe, *Die verschwundenen Bilder* (Leipzig: Spinnerei Archiv Massiv, 2007), 19. The advisory council was called into being on November 15, 1968. "Antlitz unserer Stadt," *Leipziger Volkszeitung*, December 21, 1968.

10. The first painting in the Fortress Breslau series was *Festung Breslau: Die Stadt und ihre Mörder* (Fortress Breslau: The City and Her Murderer) in 1968; the first in the Difficulties for the Search for Truth series was *Die Söhne von Ikarus* (The Sons of Icarus) in 1969; and for the Christ Travels with Us series, *Allegorie der Lüge* (Allegory of Lies) in 1968.

11. M.T., "Eine Topographie in Farben: Werke von BH bei 'Kunst der Zeit' ausgestellt," *Die Union*, March 30, 1968. See also "Der Maler Bernhard Heisig: Ausstellung bei 'Kunst der Zeit,'" *Sächsische Tageblatt*, March 27, 1968.

12. Heisig, speech at the Fourth Congress, 1959. The American art critic Clement Greenberg was an important figure in the distancing of Western art from the masses. For an early example of this position in his work, see Greenberg, "Avant-Garde and Kitsch," 34–49. For more about the differences between the East German art world and art in the West with regard to audience, see April Eisman, "Painting in East Germany: An Elite Art for the Everyday (and Everyone)," in *Experiencing Postwar Germany. Everyday Life and Cultural Practice in East and West, 1960–2000*, ed. Erica Carter, Jan Palmowski, and Katrin Schreiter (Oxford: Berghahn, 2019).

13. Cremer, speech at the Fifth Congress, 1964.

14. Bathrick, *Powers of Speech*, 1995.

15. As discussed in the conclusion, *Auftragskunst* (commissioned art) has been a point of contention in the reception of East German art in the West, especially after 1990, when it was used to discredit East German art in comparison to the art produced in the "freedom" of the West. For more on this, see Flacke, *Auftrag*; and Paul Kaiser and Karl-Siegbert Rehberg, eds., *Enge und Vielfalt: Auftragskunst und Kunstförderung in der DDR* (Hamburg: Junius, 1999).

16. "Werkvertrag," June 12, 1968, SächsStAL: VBK-L 213 and VBK-L 273. "Staatliches Auftragswesen 1968," September 10, 1968, SächsStAL: SED-L IV/B/2/9/2/607.

17. This District Art Exhibition was not numbered. "Werkvertrag," June 12, 1968, SächsStAL: VBK-L 213 and VBK-L 273. Heinz Mäde, "Arbeitsvorhaben Leipziger bildender Künstler des Jahres 1968," SächsStAL: BT/RdS 8082.

18. "Kommunique," SächsStAL: VBK-L 128.

19. "Der Künstler zu seinem Werk: Bernhard Heisig zum Gemälde *Der Brigadier—VII. DKA*," *Kunsterziehung* 2 (February 1973): 4: "die Atmosphäre einzufangen. Zum Beispiel hat mich sehr interessiert, als ich bei starker Kälte eine Rohrisolier-Brigade sah, wie sie im Schnee, mit grossen, roten Händen ihre Arbeit verrichtete. . . . Ich malte zwei, drei Fassungen des Bildes, kam bis kurz vor dem Ablieferungstermin . . . Bis ich mich entschloss, eine der Figuren, die diese Bewegung mit dem Daumen nach oben machte, im Bild ganz nach vorn zu ziehen." Commissions in East Germany were relatively open ended. Presumably the RdB approached Heisig about creating a worker portrait, and he gave them the working title of *Rohrisolierbrigade*.

20. I discovered a color photograph of this painting in the Kober Nachlass (AdK-Archiv) in the spring of 2005.

21. For more on the development of the worker portrait, see Damus, *Malerei der DDR*.

22. "Referat des Genossens Walter Ulbricht auf dem VII. Parteitag der Sozialistischen Einheitspartei Deutschland," *Neues Deutschland*, April 18, 1967: "ein[e] gewiss[e] Unsicherheit vieler Künstler, auch jüngerer, gegenüber . . . unserer Republik."

23. Gertraude Sumpf, "Das Mensch-Technik-Problem in neuen Arbeiten von Willi Neubert," *Bildende Kunst* 1 (1968): 9. "Das Bild der Menschen zu gestalten, die heute in unserem Land den Sozialismus vollenden, ist die zentrale Aufgabe unserer bildenden Kunst."

24. Saying artists needed to solve this problem is an improvement over similar discussions earlier in the decade, as evident in Heisig's speech at the Fifth Congress in 1964.

25. Waltraut Westermann and Jutta Schmidt, "Das Bild des arbeitenden Menschen," *Bildende Kunst* 1 (1968): 2–8.

26. LIW stands for Landtechnische Instandsetzungswerke (an agricultural equipment repair facility).

27. Westermann and Schmidt, "Das Bild des arbeitenden Menschen," 6, 8. "es fehlt eben noch jenes innere Verbundensein, das die einzelnen Gestalten zueinander ins Verhältnis bringt."

28. Ibid, 6. "ein ernsthafter Schritt vorwärts."

29. Letsch had written one of the critical reviews of Heisig's Hotel Deutschland murals.

30. Herbert Letsch, "Handschrift-Expressivität-Ideologie," *Leipziger Volkszeitung*, May 24, 1969. "Diese expressive Malerei erweckt vor allem die Vorstellung vom gequälten, vom geschundenen Menschen. Diese Malerei hat einen starken Zug ins Amorphe, ins Destruktive, ins Morbide. Zugleich ist das Ungeschlachte und Brutale des malerischen Duktus nicht zu übersehen. . . . Da werden in Gesichtern blutige, geradezu brutal-stofflich wirkende Rots eingesetzt, und blässliche, kranke Blaus und schwächliche Grüns korrespondieren mit ihnen. Die Wärme der Orange-Töne unterstreicht diesen amorphen und brutalen Charakter der Malerei. Dieser Einsatz der Farbe dient nicht der expressiven Steigerung einer wahren Aussage vom geistigen Leben des neuen Menschen, sondern er stimuliert die Vorstellung vom gequälten und direkt physisch geschundenen Menschen . . . Auch die Komposition lässt im Ganzen jede Festigkeit vermissen, sie ist ebenso amorph, formlos, wie die Malerei selbst. Die Züge der Handschrift, die hier vorliegt, sind malerischer Ausdruck einer subjektivistischen, einer falschen Auffassung vom Wesen des sozialistischen Menschen."

31. Irma Nitschka, "Wir suchen unser geistiges Antlitz, Leser schreiben zu Bezirksausstellung 'Architektur und bildende Kunst,'" *Neues Deutschland*, July 24, 1969. "Ich weiss Professor Heisig ist ein Künstler mit grossem Talent, aber die Bauarbeiter, die er gemalt hat, strahlen nach meiner Meinung weder die Kraft der Arbeiterklasse, ihr Schöpfertum, ihr Selbstbewusstsein, noch die echte Menschlichkeit sozialistischer Persönlichkeiten aus. Auf mich wirkten sie eher grob, unpersönlich und fremd." While this article may have been written by a reader, criticisms by officials were sometimes presented as such; thus it is possible that Irma Nitschka is a pseudonym. Werner Krecek's letter about *The Paris Commune* discussed in chapter 4, for example, was published under the pseudonym Klaus-Dieter Walter, who was alleged to be a reader.

32. The earliest paintings demonstrating such brushwork are currently dated to 1966 and include *Akt im Spiegel*, *Bildnis der Mutter*, and *Gudrun*.

33. M.T., "Eine Topographie in Farben." "Seine neuere, sehr malerische Malerei ist laut, brutal, wild—und sehr sensibel. Sie ist ungefällig und ungraziös und kennt doch die Delikatessen auf den Paletten des deutsche Spätimpressionismus oder auch bei Schwimmer. Was aber gerade bei diesem feinhäutig, durchgeschimmert war . . . schlingt sich bei Heisig durch eine eigenwillige Topographie, droht tief hinter der Bildfläche, bricht plastisch aus

ihr hervor, schwebt als feines Liniengespinst darüber. Die formale Aggression deckt sich mit der thematischen."

34. "Einschätzung der Werke der Malerei, Grafik und Plastik der Bezirksausstellung Leipzig 'Architektur und bildende Kunst,' Leipzig, May 28, 1969," SächsStAL: SED-L IV/B/2/9/2/607. "die dialektische Einheit von Inhalt und Form. Er verselbständigt die Form und löst sie auf. Die Arbeiter werden bewußt häßlich dargestellt. Das Brigadebild stellt einen Gegensatz zur sozialistischen Menschenbildgestaltung dar. Durch diese Gestaltungsweise äußert Prof. Bernhard Heisig Skeptizismus, sein Verhältnis zur Arbeiterklasse als der führenden Kraft unserer gesellschaftlichen Entwicklung."

35. In 2007, Heisig acknowledged the impact of that event on the people in Leipzig when he spoke out in favor of a new design for Leipzig University's main building, one that incorporated visual references to the church that had been demolished to make room for it nearly forty years earlier: "Diese brutale Sprengung war ein Schock. Deshalb brauchen wir heute eine würdige Form des Erinnerns." (This brutal demolition was a shock. We are in need of a worthy form of remembrance today.) Jackie Richard, "Der grosse Bernhard Heisig fleht: Erspart uns bitte den St.-Pauli-Schock," *BILD*, October 7, 2005.

36. "Einschätzung der Malerei und Grafik der Bezirksausstellung 'Architektur und bildende Kunst' im Messehaus am Markt vom 1. Mai bis 30. Juni 1969," SächsStAL: SED-L IV/B/2/9/2/607. "Prof. Heisigs Komposition schockierte manchen Betrachter durch die sehr expressive Art des Farbauftrags. . . . Wenn es jedoch gelang, den ersten und für viele fremdartigen Eindruck zu überwinden, erschlossen sich am Werk hervorragende Werte. Besonders hervorzuheben sind der Optimismus, den das ganze Bild ausstrahlt, der völlige Mangel an Konvention sowie die überzeugende innere Kraft und Stärke der Menschen." A second document with the same title in the same file has slight variations.

37. Ibid. "Die Ausstellung liess erkennen, dass die Leipziger Künstler insgesamt keine Scheu vor der Übernahme grosser Aufgaben—bis hin zum Historienbild—haben. Das gilt auch im Hinblick auf die Formate. Der Mut, bedeutsame Themen geistig und praktisch zu bewältigen, ist hervorzuheben und anzuerkennen."

38. Joachim Uhlitzsch, "Zur Einschätzung der Abteilung 1 der Bezirkskunstausstellung Architektur-bildende Kunst zum 20. Jahrestag der DDR," May 28, 1969, SächsStAL: SED-L IV/B/2/9/2/607. "Die drei problematischsten Künstler sind zur Zeit: a) Werner Tübke, b) Bernhard Heisig, c) Wolfgang Mattheuer."

39. Ibid. "Ich halte keinen dieser drei Künstler für so weit von den Forderungen der Partei abgekommen, dass er bei geduldiger Einbeziehung in das Kollektiv der fortschrittlichen Kräfte, und vor allem bei konkretisierter Aufgabenstellung, für künftige Werke nicht gewonnen werden könnte." Current scholarship frequently cites the first half of this sentence, but not the latter half, an omission that significantly alters its meaning.

40. Ibid. "Im Gegensatz zum Genossen Letsch, der in einem Artikel in der *LVZ* vom 24.6. das Brigadebild Heisigs heftig attackiert, bin ich der Auffassung, dass hier Ansatzpunkte zu einer Besinnung des Künstlers auf den gesellschaftlichen Auftrag liegen."

41. Ibid. "Ich würde Heisig nach ausführlicher Diskussion an diesem Brigadebild einen erneuten Auftrag zum gleichen Thema erteilen, mit dem konkreten Hinweis, den optimistischen Grundgehalt stärker und endgültiger herauszuarbeiten und eine formale Klärung der Figuren und des Raumes, entsprechend diesem Grundgehalt, zu unternehmen."

42. The new paintings were *Brigadier I* (1969) and *Brigadier II* (1970). In her MA thesis, Patricia Ferdinand-Ude explains that the Leipzig Museum had acquired *The Brigade* and that Heisig had managed to convince its director, Gerhard Winkler, to let

him bring the work back to his studio for further work. Patricia Ferdinand-Ude, "Das gemalte Selbstbildnis im Werk von Bernhard Heisig in der Zeit von 1958–1995" (MA thesis, Universität Leipzig, 1995), 24. Heisig told me a similar story in an interview conducted on June 13, 2005.

43. Bernhard Heisig, interview conducted by Eckhart Gillen on October 15, 2000, as quoted in Gillen, *Das Kunstkombinat DDR: Zäsuren einer Gescheiterten Kunstpolitik* (Cologne: DuMont, 2005), 140. "Das Brigadebild ist so verrissen worden, dass ich das Gemälde zurückgenommen habe. Ich wollte es ändern, es wurde aber immer schlechter und dann habe ich es in die Ecke geschmissen. Durch Flüsterpropaganda kam die Zeitschrift *FF Dabei*, die einzige, die Kunstreproduktion brachte, auf mich zu und wollte die Brigade ganzseitig abbilden, das Bild existierte aber nicht mehr. Auf die Reproduktion wollte ich aber nicht verzichten. Da habe ich die Hauptfigur . . . herausgenommen und habe sie vor dem Ballettspiegel gemalt." Ferdinand-Ude mentions that Heisig created *Brigadier II* under some pressure, thus seeming to support his account. Ferdinand-Ude, "Das gemalte Selbstbildnis," 24. Heisig stated he painted the work using himself as a model. He was also inspired by the Balla figure in *Spur der Steine*. Bernhard Heisig, interview with the author, summer 2005. *Spur der Steine* was a controversial East German film directed by Frank Beyer in 1965. Balla was played by Manfred Krug.

44. Gerhard Winkler, "Kunstwerk des Monats aus dem Museum bildende Künste Leipzig: Bernhard Heisig's *Der Brigadier*, Ölgemälde," *Leipziger Volkszeitung*, April 10, 1971. "Sie rief viel Zustimmung, aber auch scharfe Ablehnung hervor. Einige dieser Diskussionen waren der Anlass . . . zum hier besprochenen Gemälde *Der Brigadier* [*sic*]."

45. Ibid.: "entstanden in schneller Folge einige Bildfassungen, in denen sich das Grundthema des hier besprochenen Gemäldes zu kristallisieren begann."

46. Gerhard Winkler, "Kostbarkeiten aus Bildgalerien: Bernhard Heisig, *Der Brigadier*," *FF Dabei*, December 4, 1970. "ein erfahrener Bauarbeiter zwischen 30 und 40 Jahren, den so schnell nichts mehr aus der Ruhe bringt, dem man aber zutraut, dass er im geeigneten Augenblick hart werden kann. Sein Klassenbewusstsein drückt sich nicht durch äussere Attribute, sondern durch seine innere Haltung aus. Es ist nicht der Arbeiter, der im ständigen Lohnkampf stehend als sogenannter 'Arbeitnehmer' seine Rechte gegenüber dem kapitalistischen Unternehmer durchsetzen muss, sondern es ist der Arbeiter, der als Eigentümer gesellschaftlicher Produktionsmittel den Menschentyp unserer sozialistischen Gegenwart charakterisiert."

47. Winkler, "Kunstwerk des Monats." "Der individuelle Reichtum des Mannes, seine Vitalität sind . . . als koloristisches Erlebnis gestaltet."

48. In the mid-1960s, after a commission had determined that women tended to work in unskilled, lower-paid jobs, training programs were made more accessible to women, and a number of affirmative action measures were implemented to encourage women to study engineering in college. The result was a significant increase in the numbers of women doing skilled labor by the mid-1970s. Donna Harsch, "Squaring the Circle: The Dilemmas and Evolution of Women's Policy," in Major and Osmond, *Workers' and Peasants' State*, 151–70. Müller's painting is one of the first to reflect upon this change.

49. Heisig reworked the painting 1979. In addition to downplaying the background, he added a dark-red undershirt to the man's clothing (see Ferdinand-Ude, "Das gemalte Selbstbildnis," 25). The two versions, which were painted on the same canvas—one erasing the other—are often referred to interchangeably.

50. Ibid., 23.

51. Heisig was actually invited to submit work for two portraiture competitions at this time, one for Lenin and one for Georgi Dimitroff. The two competitions were usually discussed together. "Protokoll der Sitzungsleitung—Sitzung am 1. Oktober 1968," SächsStAL: VBK-L 114.

52. Kober, *Bernhard Heisig*, 70.

53. Bernhard Heisig, undated transcript [1973?], AdK-Archiv: Kober Nachlass 13/5. "Als ich mich mit dem Lenin-Thema zu beschäftigen begann, hatte ich keinen Kontakt zu dem Thema, das heißt nicht mehr und nicht weniger wie alle anderen auch. Das ist ja eine Figur, die als Stoff so abgegriffen ist und so oft gemacht worden ist, daß man eigentlich verzweifeln könnte. Es schien keinen Sinn zu haben, die Figur überhaupt anzugehen, wo denn bloß, es ist doch schon alles gemacht worden. Ich habe mir alle möglichen Filme angeguckt und anderes Material studiert, bis mir das Gespräch mit Kurella wieder einfiel. Da habe ich also den alten biblischen Stoff von Christus und dem ungläubigen Thomas genommen, und aus dem Thomas habe ich den Timofej gemacht; Ich wußte gar nicht, daß Timofej gar nicht die Übersetzung von Thomas ist.—Es ging einfach darum, eine Verhältnisweise zweier Menschen zueinander zu schildern. . . . Ich suchte einfach eine Fabel, um die Lenin-Figur irgendwie aktuell zu machen. Das war für mich ein sehr wesentlicher Punkt."

54. In all but one version of this painting, the older man looks at Lenin. The exception is the second version of the painting, an illustration of which appears in the catalog for 1970 exhibition, *Leipziger Künstler zur Lenin Initiative*. As Heisig explained it, "In the second version, I found Timofej to be too jammed [*geklemmt*] in the corner, so I made the eyes different in order to create a more direct contact because my sons said: he is not listening. I didn't want to go that far. But the second version is worse, as is often the case with second versions." AdK-Archiv: Kober Nachlass 13/5. In this second version, Timofej looks at the viewer as if asking for help.

55. Put together by the Ministry for Culture, the VBK, and the Society for German-Soviet Friendship, this exhibition took place in the Altes Museum in East Berlin from April 16 to June 14, 1970.

56. Heisig, undated transcript [1973?]. "Man kann den anderen Menschen auf ganz verschiedene Weise überzeugen, auch mit dem Witz, aber der Andere bleibt stur, der ist schon zu alt. Und das habe ich versucht zu malen, indem ich dem Lenin zwei Drittel eingeräumt und den Timofej in die Ecke geklemmt habe, so daß man die Vorstellung hat, der Lenin drückt ihn so langsam in die Ecke und sagt: so, nun mußt du es langsam glauben! Aber der andere denkt nicht daran. Offenbar war das der Grund, warum Viele sich so angesprochen fühlen, weil es ihnen offenbar ja selbst ähnlich geht und weil ihnen dabei die Tatsache vielleicht sympathisch ist, daß man jemanden langsam und ruhig und mit Witz oder mit Spaß überzeugen kann."

57. Karl Max Kober, "Bernhard Heisig—Leben und Werk," in *Bernhard Heisig: Gemälde, Zeichnungen, Lithographien* (Dresden: Gemäldegalerie Neue Meister, 1973), 35. "Es ging also nicht darum, Lenin zum vielhundertsten Male schlechthin zu konterfeien, sondern jeweils neue Sichten oder doch neue Nuancen der Sicht auf ihn zu schaffen . . . aus den Personen, den Dingen und Erscheinungen 'an sich,' Personen, Dinge und Erscheinungen 'für uns' werden zu lassen."

58. In an interview, Heisig stated that when he first exhibited *Lenin and Doubting Timofej*, he helped circumvent official criticism by saying the image had been inspired by Maxim Gorky, a Soviet writer considered beyond reproach. When asked which story

inspired the work, Heisig simply stated he could not remember. Bernhard Heisig, interview with the author, June 13, 2005.

59. This project was mentioned in the introduction to an exhibition held in the fall of 1970, *Exhibition of Leipzig Artists for the Lenin Initiative*. The Lenin telegrams were also discussed in an article in the *Leipziger Volkszeitung*: Werner Krecek and Renate Brühl, "Gesellschaftlicher Auftrag und Leninstudium, ein LVZ-Interview mit Prof. Gerhard Kurt Müller," on April 15, 1971. In conversation with Kober, Heisig mentioned the Lenin telegrams and stated that the work he created for it came between his two paintings on the topic.

60. This second work was not reproduced in the catalog.

61. Gillen, *Die Wut der Bilder*, 221.

62. I have not seen evidence that the work was commissioned by the SED. It is possible that the SED simply bought it after it was exhibited in the Eighth District Art Exhibition or the Seventh Art Exhibition of the GDR. It is listed in the 1973 retrospective catalog as belonging to the SED-L.

63. Heisig, undated transcript [1973?]. "Für mich bestand das Problem darin, einen so unattraktiven Mann zu malen, einen Mann, der mit so einem zerknautschten Anzug und mit einem fast zerschlitzten Hemd herumläuft . . . der alles andere als heroisch aussieht, dennoch aber so eine Faszination ausstrahlt. Da habe ich also sehr viele Versuche gemacht und dachte, die beste Lösung wäre die, ihn in ein Quadrat zu setzen, ihn wie einen Pfahl, wie ein Ausrufungszeichen hochzubringen; die Arme habe ich mehrfach verändert. Es hat lange gedauert, bis ich die Bewegung so hatte, daß er etwas aus dem Bild herauskommt."

64. Handwritten letter from Alfred Kurella to Bernhard Heisig, August 22, 1972, AdK-Archiv: Kurella Nachlass. "Du wirst Dich erinnern, dass ich bei meinem letzten Besuch bei Dir meiner Freude ueber einige Deiner letzten in Leipzig ausgestellten Bilder zum Ausdruck gebracht habe, besonders auch ueber das Lenin-Porträt. Du erzähltest mir damals von Deinen nicht einfachen Überlegungen hinsichtlich der Darstellung Lenins. Ich sagte dir dann, dass Du . . . ungewöhnlich genau Lenins Persönlichkeit erfasst hast, so wie ich ihn aus meinem Umgang mit ihm 1919 . . . in mir trage." With this note, Kurella apparently included a photocopy of a personal photo of Lenin that had never been published but that apparently displayed the same sense of the man as Heisig had captured in his painting. This photo is not in the archival file. The praise evident in this letter contrasts sharply with the criticism Kurella leveled against Heisig's Hotel Deutschland murals in 1965. Archival files offer little insight into their relationship: there are several friendly notes from Heisig to Kurella in 1960 and 1961, and then an exchange of letters in 1972 about the Lenin painting. AdK-Archiv: Kurella Nachlass.

65. Kober, "Bernhard Heisig—Leben und Werk," 46: "ich möchte gern, daß es den Leuten gefällt, daß sie etwas davon haben. . . . Immer bin ich wie ein Luchs hinterher zu erfahren, was die Leute zu einem Bild sagen."

66. In current scholarship, these works are often dismissed as *Randerscheinungen* (peripheral), done simply to gain political favor. Gillen, *Das Kunstkombinat DDR, Zäsuren*, 139–42. Yet these works were clearly valued in East Germany by art historians and the public alike. Moreover, Heisig valued them: a report from 1972 mentions that he was unhappy with an initial list of works to be included in his retrospective exhibition the following year because it did not include *Brigadier II*, "the big Lenin portrait," and his portrait of Dimitroff. Apparently Heisig had not included these works

in an initial list he had supplied because he had taken it for granted that they would be included ("Heisig [hat] diese Bilder für so selbstverständlich gehalten"). SächsStAL: RdS 8103.

Conclusion

Epigraph: Peter Schneider, *The Wall Jumper, a Berlin Story*, trans. Leigh Hafrey (New York: Pantheon Books, 1983), 119.

1. Erich Honecker, "Zu aktuellen Fragen bei der Verwirklichung der Beschlüsse unseres VIII. Parteitages," *Neues Deutschland*, December 18, 1971. "Wenn man von der festen Position des Sozialismus ausgeht, kann es . . . auf dem Gebiet von Kunst und Literatur keine Tabus geben. Das betrifft sowohl die Fragen der inhaltlichen Gestaltung als auch des Stils."

2. East German awards Heisig received between 1971 and 1976 as listed in a questionnaire filled out by Heisig on April 8, 1976, HGB-Archiv: Personalakte-Heisig:

National Prize (Second Class), 1972

Kunstpreis der DTSB (Deutscher Turn- und Sportbund) (Art Prize of the German Gymnastics and Sports League), 1972

Ehrennadel der Gesellschaft für DSF (Deutsch-Sowjetischen Freundschaft) in Gold (Badge of Honor of the Society for German-Soviet Friendship in Gold), 1973

Kunstpreis des FDGB (Freier Deutscher Gewerkschaftsbund) (Art Prize of the Free German Trade Union), 1973

Vaterländischer Verdienstorden in Gold (Fatherland Order of Merit in Gold), 1974

Theodor-Körner-Preis der NVA (National Volksarmee) (Theodor Körner Prize of the National People's Army), 1974

Johannes R. Becher Medaille in Gold (Johannes R. Becher Medal in Gold), 1975

Banner der Arbeit, Stufe I (Banner of Work, Level I), 1976

3. Kober, "Bernhard Heisig—Leben und Werk," 13–47.

4. This painting for the Palast der Republik is one of the two state commissions that Heisig acknowledges having created during the Cold War period, a number that refutes the frequent attempt to dismiss East German art as *Auftragskunst* (commissioned art) during the *Bilderstreit* in the 1990s. The other state commission was for West Germany: Chancellor Helmut Schmidt's official portrait. "Bernhard-Heisig-Schau in Berlin," *Kölner Stadt-Anzeiger*, October 10, 2005.

5. Intended to be a *Haus des Volkes* (house of the people), the Palast also had a snack counter (*Imbiss*), a milk bar, a coffee bar, a post office, and a book and newspaper stand, all of which made it a popular destination for Berlin residents. Martin Beerbaum and Heinz Graffunder, *Der Palast der Republik* (Leipzig: Seemann, 1979).

6. There is another painting from 1979 that is almost identical, *Dying Icarus*.

7. Mittenzwei, *Die Intellektuellen*, 274.

8. Peter Hutchinson, *Stefan Heym: The Perpetual Dissident* (Cambridge: Cambridge University Press, 1992), 169–70. In addition to Wolf and Heym, prominent authors who signed the protest letter—submitted to *Neues Deutschland* and Western outlets including Reuters—included Sarah Kirsch, Volker Braun, Franz Fühmann, Stephan Hermlin, Günter Kunert, and Heiner Müller. In response, the party gathered names of those who supported their decision, including Anna Seghers, Ludwig Renn, Konrad Wolf, Wieland Herzfelde, Willi Neuert, Willi Sitte, and Ekkehard Schall. Mittenzwei, *Die Intellektuellen*,

274–76, 283–91. Ann Stamp Miller, "Wolf Biermann: 1936–?," in *The Cultural Politics of the German Democratic Republic: The Voices of Wolf Biermann, Christa Wolf, and Heiner Müller* (Parkland, FL: Brown Walker, 2004), 84–86.

9. Jürgen Winkler, *"Kulturpolitik,"* in *Die SED: Geschichte, Organisation, Politik; ein Handbuch*, ed. Andreas Herbst (Berlin: Dietz, 1997), 400.

10. See Manfred Krug, *Abgehauen* (Berlin: Ullstein, 2003); and Hutchinson, *Stefan Heym*, 1992, among others. Prominent writers who left include Günter Kunert, Sarah Kirsch, Jurek Becker, and Erich Loest; actors include Manfred Krug, Armin Müller-Stahl, and Angelica Domröse.

11. Birgit Lahann, "Salto mortale in zwei Diktaturen, Bernhard Heisig und Johannes Heisig," in *Väter und Söhne, Zwölf biographische Porträts*, ed. Thomas Karlauf and Katharina Raabe (Berlin: Rowohlt, 1996), 411–12.

12. Fritz Cremer was one of the few prominent visual artists to sign the letter opposing Biermann's forced expatriation but later withdrew his signature. Mittenzwei, *Die Intellektuellen*, 275.

13. Caroline Molina, "Wolf Biermann's 'Prussian Icarus' 1976–1996: A Comparatist Perspective," *German Politics & Society* 14, no. 2 (Summer 1996): 106. The concert was televised by ARD and could be seen in East Germany. Mittenzwei, *Die Intellektuellen*, 274.

14. For more on the *Kulturnation*, see Brockmann, *Literature and German Reunification*, 5–10, 30–32.

15. These latter two pairs are ambiguous. The man seeming to strangle another may in fact be performing CPR, while the nude woman may be gasping in pleasure at the man's advances.

16. Early works in the Christ Travels with Us series began as a critique of the Vietnam War. A 1974 version of the painting has an American soldier with a corporal's insignia on his arm crouching on the front of an American tank, which is recognizable by the five-pointed star on its side. There is also a print from c. 1972 with an American tank in it and the words "US Army" on the cross above Christ's head. For the latter, see Sander, "Bernhard Heisig," image 448/2.

17. The tank division's "black uniform was attractive. Like everyone at this age, I of course had girls in mind." Heisig, as quoted in Gillen, "Schwierigkeiten," 192.

18. The Munich-based magazine *Tendenzen* published an article about Heisig in 1966, but it was written by the East German curator Gerhard Winkler. The first articles written by West German authors appeared in the *Frankfurter Allgemeine Zeitung* in the early 1970s, although articles about the Leipzig art scene more generally had been published as early as 1968 (Eduard Beaucamp, "Auf der Suche nach Bildern, Kunst in einer sozialistischen Stadt: Bericht aus Leipzig," *Frankfurter Allgemeine Zeitung*, April 13, 1968). The first article to focus on Heisig appears to be the one published on January 8, 1972, although without a named author, "DDR-Kunstmarkt gefordert," *Frankfurter Allgemeine Zeitung*; it was followed nearly two years later by Camilla Blechen's article, "Nie ganz zufrieden: Bernhard Heisig in Leipzig," *Frankfurter Allgemeine Zeitung*, October 1973. With the exception of an article in the *Neue Zürcher Zeitung* on September 2, 1976, and mentions in reviews of *documenta* 6 in 1977, nothing else of significance appears to have been published about Heisig in the West until 1980, at which point at least nine different articles in a number of newspapers were published.

19. This was not Heisig's first exhibition in the West. In 1966, he had exhibited prints from *The Fascist Nightmare* in Würzburg. (The Magdeburg catalog lists the Würzburg

exhibition as having taken place in 1965). Nonetheless, he did not become a recognized name in the West until these later exhibitions.

20. Early texts include Georg Bussmann, *Bernhard Heisig: Die Beharrlichkeit des Vergessens und andere Bilder*, exhibition pamphlet (Frankfurt am Main: Frankfurter Kunstverein, 1980). Volker Bauermeister, "Hannover: 'Bernhard Heisig. Bilder und Graphik,'" *Die Zeit*, December 18, 1981; Camilla Blechen, "Der Unzufriedene," *Frankfurter Allgemeine Zeitung*, February 5, 1982; Rudolf Lange, "Höllenfahrt durch Zeit und Geschichte, Bernhard Heisig bei Brusberg in Hannover," *Hannoversche Allgemeine*, December 12–13, 1981.

21. Only three of nineteen articles from the 1980s mention his landscapes, and they do so only in passing. Significantly, of the three, one dismisses them as a failure (P.H.G.), while another sees little difference between them and his war paintings: "Even nature is made into a battlefield" (Michael Nungesser, "Bernhard Heisig: Neue Bilder, Zeichnungen," *Die Kunst* 6 [1984]). P.H.G., "Unter dem Teppich sind Menschenleiber gefangen," *Berliner Morgenpost*, June 24, 1984.

22. Bussmann: "zu tiefst erschreckter Mahner." Blechen: "traumatisch berührt." Lange: "selber im innersten aufgewühlt ist." Lange: "quält ihn bis heute." Bussmann, "Bernhard Heisig," 1980. Blechen, "Der Unzufriedene," 1982. Lange, "Höllenfahrt durch Zeit und Geschichte," 1981.

23. Lange, "Höllenfahrt durch Zeit und Geschichte": "versucht von Ängsten zu befreien." C.B. [Camille Blechen], untitled, *Frankfurter Allgemeine Zeitung*, January 25, 1982: "traumatisches Erlebnis der Zerstörung seiner Heimatstadt Breslau."

24. Bussmann, "Bernhard Heisig." "Fragen, die so in dieser BRD-Gesellschaft zu selten, zu wenig genau und zu wenig beharrlich gestellt werden."

25. Lange, "Höllenfahrt durch Zeit und Geschichte": "bis heute nicht aufgehört . . ., die Gewaltverbrechen des Nationalsozialismus und des Faschismus anzuprangern."

26. Bill Niven, ed., *Germans as Victims* (New York: Palgrave Macmillan, 2006), 153.

27. Benjamin Buchloh, "Figures of Authority, Ciphers of Regression," *October* 16 (Spring 1981): 39–68.

28. Buchloh, however, did not see Heisig—or any artist from East Germany—as a viable alternative. This has less to do with the artwork itself than with Buchloh's bias against East German art, which was discussed in more detail in the introduction to this book.

29. Rühle, for example, praises Heisig's work in terms of its "authenticity" as expressions of the "entanglement" of the artist's life in what Bussmann terms the "chaos of German history." Günther Rühle, "Deutschland, Deutschland: Betrachtungen zur deutschen Kunst und Geschichte," *Frankfurter Allgemeine Zeitung*, April 14, 1979. Bussmann, "Bernhard Heisig." "Der Markt hat gewonnen." Dieter Brusberg, ed., *Bernhard Heisig: "Begegnung mit Bildern"* (Berlin: Galerie Brusberg, 1995), 80. Elsewhere, Brusberg explained his belief that modernism had been exhausted: "Denn auch die Moderne scheint erschöpft. . . . [sie] stellt keine Fragen mehr, hat kein Geheimnis, keine Träume. Und ist längst zur Satire ihrer selbst verkommen, überschreitet keine anderen Grenzen mehr als (allenfalls) die des Geschmacks. Wir wissen längst, dass der Kaiser nackt vor unsere Augen trat. Warum geben wir nicht zu und sagen es laut, dass wir heute auch den Kaiser nicht mehr sehen. Es gibt ihn nicht mehr." (For modernism too seems exhausted . . . [it] no longer poses any questions, has no secret, no dreams. . . . It has long since degenerated into a satire of itself, [it] crosses no more boundaries than (at most) those of taste. We have known for a long time that the emperor is naked before us. Why don't we admit it and say out loud that we don't see the

emperor either. He doesn't exist anymore.) Dieter Brusberg, ed., *Bernhard Heisig: "Gestern und in unserer Zeit"* (Berlin: Galerie Brusberg, 2003), 13.

30. Dieter Brusberg, 1981, from a speech reproduced in *Bernhard Heisig: "Gestern und in unserer Zeit" oder "Das Elend der Macht"; das Welttheater eines deutschen Malers in sechs Akten* (Munich: Hirmer, 2014), 302: "einer der großen deutschen Maler der Gegenwart—gewachsen aus einer verpflichtenden, spezifisch deutschen Tradition—Corinth, Kokoschka, Beckmann und Dix." Heisig was aware of abstract expressionism but would have had little exposure to originals.

31. Heisig kept these eight canvases together, creating the polyptych, *Zeiten zu Leben* (Our Times) in 1992. Eberhard Roters, "Der Maler und sein Thema," in *Bernhard Heisig: Zeiten zu Leben, Malerei*, ed. Theodor Helmert-Corvey (Bielefeld: Kerber Verlag, 1994), 17. Heisig and Peter Beckmann first met in the mid-1970s and soon became good friends. Mayen Beckmann, "Erben," in *Gestern und in dieser Zeit: Bernhard Heisig zum Achtzigsten*, ed. Heiner Köster and Marianne Köster (Leipzig: Faber & Faber, 2005), 13–15. See also Bernhard Heisig, "Über Beckmann," in Helmert-Corvey, *Bernhard Heisig*, 13–15.

32. Letter from the Ministerium für Kultur, August 11, 1989, AdK-Archiv: VBKD 41. The catalog contains more than one hundred full-page color illustrations dedicated to Heisig's paintings. Roughly 45 percent are history paintings and *Komplexbilder* (complex paintings), 34 percent are portraits, and 21 percent are still lifes and landscapes. There are also more than one hundred black-and-white pages devoted to Heisig's drawings and prints—which are generally black and white in the original—with topics representatively distributed among portraiture, history, and literary illustrations. The catalog thus captures the diversity of Heisig's artistic production in the GDR and weights each section accordingly. The works shown also represent the various phases in his oeuvre—as much as was possible considering his tendency to rework images—with canvases dating from the late 1950s to 1989. In terms of their presentation in the catalog, there is no reliable order to the images, although one could argue they are roughly chronological.

33. Jörn Merkert and Peter Pachnicke, eds., *Bernhard Heisig: Retrospektive* (Munich: Prestel, 1989), 7: "wirklichkeitsverschönernder parteikonformer Realismus ohne jede künstlerische Individualität"; "kunstmarktgesteuerte Diktatur der Abstrakten ohne allen Wirklichkeitsgehalt."

34. Ibid., 12: "dogmatische Engstirnigkeit"; "geistig[e] Auseinandersetzungen."

35. Ibid. "ein bis dahin in Inhalt und Form neues Realismus-Verständnis gegen ein historisch altgewordenes durchsetzen."

36. Ibid., 13. "Die Künstler wollte . . . ein 'dialogisches' Verhältnis zum Publikum."

37. Ibid., 14.: "Methode, die eigene Wahrheit zu erkennen und sie eigensinnig zu formulieren."

38. Ibid., 24: "dass nicht überall Unterdrückung und Angst herrschen. . . . Ungestillte Sehnsucht nach Schönheit, Harmonie, Dauer erfüllt . . . viele Landschaften, Akte, Porträts Heisigs."

39. Ibid., 26: "sich an sich selbst festhalten zu müssen, ist sehr anstrengend, besonders für den Künstler. Verlangt es doch von ihm, stets originell und neu zu sein, immer sein Ich nach vorn zu treiben. Ein schrecklicher Gedanke."

40. Ibid. ". . . 'Mach doch, was du willst,' und das ist eine gespenstische Gleichgültigkeit, die bei dem Künstler das Gefühl des Nichtgebrauchtwerdens erweckt. . . . Um gebraucht zu werden, in den geistigen Auseinandersetzungen der Gesellschaft eine unverzichtbare Rolle zu spielen, dazu bedarf es auch eines Entgegenkommens des Künstlers gegenüber

der Gesellschaft. Nicht, indem er sich ihr anpaßt, sondern indem er . . . mit dem eigenen Anliegen auf sie zugeht, sich einmischt und Stellung bezieht."

41. AdK-Archiv: Loewig Nachlass.

42. "Protest gegen offizielle 'DDR'-Maler in Kassel," *Die Welt*, June 22, 1977; "Was auf der documenta nicht gezeigt wird: Die verfemte Kunst der ungehorsame Maler aus der 'DDR.' Hinter jeder Säule lauschen Riesenohren," *Die Welt*, June 30, 1977; "Malerei, Plastik, Zeichnung, Video, Photo: Auf der sechsten documenta ist die Kunst sich selber zum Thema geworden," *Die Zeit*, July 1, 1977. For a more comprehensive look at the inclusion of East German artists in *documenta* 6, see Gisela Schirmer, *DDR und documenta: Kunst im deutsch-deutschen Widerspruch* (Berlin: Reimer, 2005).

43. Two additional factors that contributed to the negative reception of East German artists in the new Germany were (1) West German artists did not want the competition East German artists brought to the art market, and (2) after unification Berlin lost the extra funding for the arts it had had in the Cold War era when it was a *Schaufenster* (show window) between East and West, making competition between artists even greater.

44. David Childs, "Obituary: Roger Loewig," *Independent*, November 26, 1997, https://www.independent.co.uk/news/obituaries/obituary-roger-loewig-1296351.html.

45. Roger Loewig Archiv, Akademie der Künste Berlin, 766/782/785. Creszentia Troike-Loewig wrote at least two letters to Werner Schmalenbach at the Kunstsammlungen Nordrhein-Westfalen (January 25, 1990, and February 6, 1990) and one to Michel Kukutz at the Neues Forum (January 28, 1990). She also wrote to the Dresden artist Angela Hampel on March 13, 1990, to ask for help in digging up incriminating stories on Heisig.

46. Loewig to Schmalenbach, February 6, 1990.

47. Kaiser and Rehberg, *Enge und Vielfalt*, 589.

48. Nicola Kuhn, "Parteischule Nationalgalerie," *Der Tagesspiegel*, April 24, 1994. For a reprint of some of the major press articles from this debate, including Kuhn's, see Wolfgang Kahlcke, "Pressedokumentation zu einem durch die Neue Nationalgalerie ausgelösten 'deutschen Bilderstreit,'" *Jahrbuch Preußisches Kulturbesitz* 31 (1994): 365–408.

49. These included Jan Faktor, Jürgen Fuchs, Ralph Giordano, Katja Havemann, Freya Klier, Katja Lange-Müller, Ulrike Poppe, and Lutz Rathenow.

50. Tannert, "Offener Brief": "ist nicht nur ein kunsthistorischer Irrtum, sondern auch eine politische Instinktlosigkeit."

51. Ibid. "Kooperation mit dem DDR-Regime"; "in krassem Gegensatz zum demokratischen Wertehorizont."

52. Ebersbach, "Auch der Osten hat eine Würde": "es geht gar nicht um eine inhaltliche Auseinandersetzung mit Werk und Leben, sondern es werde lediglich ein Klischee bedient: Heisig, das ist der DDR."

53. Lang, *Malerei und Graphik in Ostdeutschland*, 275; Uta Grundmann, Klaus Michael, and Susanna Seufert, eds., *Revolution im geschlossenen Raum: Die andere Kultur in Leipzig 1970–1990* (Leipzig: Faber & Faber, 2002), 10–11, 43–46, 48.

54. Lang, *Malerei und Graphik in Ostdeutschland*, 210–11.

55. Ebersbach, "Auch der Osten hat eine Würde."

56. Eduard Beaucamp, Dieter Honisch, and Bernhard Schulz also pointed to a generational conflict in their articles about the *Bilderstreit* as it unfolded around the Nationalgalerie's exhibition in 1994. Christoph Tannert's criticisms are good examples of this younger generation's perspective. Articles by all four are reprinted in Kahlke, "Pressedokumentation."

57. Alex Hecht and Alfred Welti, "'Ein Meister, der Talent verschmäht': Interview mit Georg Baselitz," *Art, Das Kunstmagazin* 6 (1990): 70. "Es gab keine Künstler in der DDR, alle sind weggegangen . . . Keine Künstler, keine Maler. Keiner von denen hat je ein Bild gemalt. . . . Das sind Interpreten, die ein Programm des Systems in der DDR ausgefühlt haben . . . ganz einfach Arschlöcher."

58. Recent examples of scholars engaging with these artists' East German past include Karen Lang, "Expressionism and the Two Germanys," in Barron and Eckmann, *Art of Two Germanys / Cold War Cultures,* 84–100; and Jeanne Nugent, "Family Album and Shadow Archive: Gerhard Richter's East, West, and All German Painting" (PhD diss., University of Pennsylvania, 2005).

59. The two curators of this exhibition, Roland März and Eugen Blume, had both been active in the art scene of East Berlin.

60. There were at least two more confrontations in the German-German *Bilderstreit.* In 1999, the *Aufstieg und Fall der Moderne* (Rise and Fall of Modernity) exhibition in Weimar raised controversy for its poor hanging of East German works and the implication that these works were of lesser value than those created in the Third Reich. In 2001, a planned retrospective of Willi Sitte's work at the Germanisches Museum in Nürnberg was canceled because of concerns about his connections to the GDR. (Sitte himself canceled it.)

61. *Ostalgie* reached its peak in 2003 with the film *Goodbye Lenin.* The *Art in the GDR* exhibition, which opened in the summer of 2003, coincided with this relatively new positive interest in East Germany. The exhibition was intended as a follow-up to the Neue Nationalgalerie's controversial 1994 exhibition.

62. For more about the *Bilderstreit* and the rewriting of East German art in the new millennium more generally, see April A. Eisman, "Whose East German Art Is This? The Politics of Reception after 1989," *Imaginations, Journal of Cross-Cultural Image Studies* 8, no. 1 (May 2017), accessed December 27, 2017, http://imaginations.csj.ualberta.ca/?p=9487.

63. The English translation comes from the English-language brochure that accompanied the exhibition: *Bernhard Heisig, the Rage of Images* (Martin-Gropius-Bau Berlin, 2005). For Heisig, the title—which was chosen by the curator—referred to Max Beckmann's quote "Wut der Sinne" (rage of the senses) and thus to the gusto of his painterly style as well as his own frustration when working on something but unable to achieve the desired result: "Es . . . hängt tatsächlich mit dem Hinweis auf Beckmann zusammen. Die Wut bezieht sich im Wesentlichen auf meine Wut, wenn mir etwas nicht gelang . . . Welcher Thematik ich mich dabei bediene ist sekundär." (It has to do with the reference to Beckmann. The rage refers primarily to my rage when I can't accomplish something . . . which topic I am working on is secondary.) Letter from Heisig to the author, January 28, 2006.

64. Gillen, *Die Wut der Bilder,* 10. The press release from the Museum der bildenden Künste Leipzig stated that the exhibition contained a representative selection of Heisig's work. Similarly, the brochure for the exhibition in Berlin stated, "With more than 60 paintings, the exhibition gives a comprehensive overview of the work of the painter who was born in Breslau in 1925." Despite these claims, the 1989 exhibition, *Bernhard Heisig, Retrospektive,* remains the most comprehensive and representative overview of Heisig's work to date.

65. For more about Heisig's reception and how it has changed, see April A. Eisman, "Denying Difference in the Post-Socialist Other: Bernhard Heisig and the Changing Reception of an East German Artist," *Contemporaneity: Historical Presence in Visual Culture* 2 (2012): 45–73.

66. The multiple dates of the painting reflect his substantial reworking of the image at various points in time. This was a common occurrence in Heisig's oeuvre, especially after the mid-1970s.

67. The initial painting was inspired by a visit Walter paid him in 1977 while on a break from his mandatory service in the National People's Army. Heisig was particularly struck by the similarity of his son's uniform to his own in World War II.

68. Hartleb, *Bernhard Heisig*, 1. "Schöpferische Unruhe ist ein Grundelement im Schaffen des Leipziger Malers und Grafikers Bernhard Heisig. . . . Seine ständige Unzufriedenheit mit sich selbst erweist sich dabei als schöpferische und zerstörische Eigenschaft zugleich: sie führt ihn dazu, von dem einen Vorwurf mehrere Fassungen zu malen, von einem anderen die einzige vorhandene wieder zu vernichten und das Thema von einer ganz anderen Seite her anzupacken."

69. A 2014 catalog has photos that show Heisig at work on one of his paintings while it hangs on the walls of the Galerie Brusberg in 1981. The accompanying text, also from 1981, states, "Einige Tage nach der Eröffnung der Ausstellung kann der Maler seinen Bildern immer noch nicht untätig gegenüberstehen. Bernhard Heisig hat sein Arbeitszeug mitgebracht und sein Atelier für den Augenblick von Leipzig in die Räume der Galerie Brusberg verlegt." (A few days after the opening of the exhibition, the painter still can't stand idle near his work. Bernhard Heisig has brought his tools with him and moved his studio, for the moment, from Leipzig to the rooms of the Galerie Brusburg.) Bauermeister, "Hannover."

70. Conversations between the author and Gudrun Brüne, Johannes Heisig, and Walter Eisler, c. 2005. Stories about Heisig's reworking of paintings frequently come up in conversations with artists and gallerists who knew him.

71. Gillen, *Die Wut der Bilder*, 28. In his dissertation, Gillen also mentions Freud and trauma in this context, as well as "uncertainty" (*Verunsicherung*) as a result of the East German situation: "die ständige Verunsicherung zwischen parteilicher Kritik . . . und geforderter Selbstkritik" (the constant uncertainty between party criticism . . . and compulsory self-criticism. Gillen, "Schwierigkeiten," 233, 146.

72. Gillen, *Die Wut der Bilder*, 28. "Wollen Sie etwa einem Gast aus Israel erklären, dieses Bild wurde von einem ehemaligen Mann der Waffen-SS gemalt?!"

73. Ibid.: "genau das wollen und müssen wir um der Ehrlichkeit Willen einem israelischen Gast erklären: Hier hängt das Gemälde eines Mannes, der sich irrte, der für eine Generation deutscher Jugendlicher steht, die 'die Gnade der späten Geburt' knapp verfehlte. Hier hängt das Gemäldes eines Mannes, der sich zu diesem Irrtum bekannt und ein Leben lang daran gearbeitet hat, sich und anderen darüber Rechenschaft abzulegen. Genau solche Bilder gehören in den künftigen Deutschen Bundestag, und zwar in die Eingangshalle."

74. *Brigadier II* belongs to the Museum der bildenden Künste Leipzig, which is where the exhibition opened, thus making its absence all the more striking.

75. Born in Prague in 1920, Neumann was conductor of the Leipzig Gewandhaus Orchestra from 1964 to 1968.

76. Gillen, *Die Wut der Bilder*, 49.

77. One of these focused on Heisig's murals at the Hotel Germany in Leipzig; the other, on his painting *The Brigade*. Detailed discussions of these controversies can be found in chapters 3 and 5 of this book.

78. See Niven, *Germans as Victims*, 7–8. Niven dates the beginning of this turn at 1998, stating that the lack of interest in German suffering apparent in the Red-Green coalition

under Gerhard Schröder suggested such a topic could be discussed without fear of high-level political instrumentalization.

79. Indeed, some newspapers even called it the most comprehensive exhibition of Heisig's work to date, clearly overlooking the larger and more representative 1989 exhibition, *Bernhard Heisig, Retrospektive*. For examples of this see Ingeborg Ruthe, "Malen am offenen Nerven," *Berliner Zeitung*, October 22, 2005; and Tobias D. Höhn, "K20: Die Wut der Bilder," *Westdeutsche Zeitung*, March 22, 2005, accessed March 18, 2007, http://www.wz-newsline.de/ sro.php?redid=78676.

80. Hüllenkremer, "Bernhard Heisig im Gespräch mit Helmut Schmidt," 382. "Wenn die Künstler machen können, was sie wollen. . . . Das ist eine gefährliche Sache, pädagogisch gesehen. Es muß eine Reibungsfläche entstehen. . . . Das ist wie beim Streichholz, sonst brennt es nicht. Und wenn der Druck zu stark ist, der Auftrag terroristisch erteilt wird, bricht der Streichholzkopf ab. Aber wenn ich daneben fummle, brennt es auch nicht.

BIBLIOGRAPHY

Archives

AdK-Archiv. Archiv der Akademie der Künste, Berlin [The Archives of the Academy of Arts, Berlin].

Archiv of the Berlin Ensemble [Archive of the Berlin Ensemble].

Brecht Archiv, Berlin [Brecht Archive, Berlin].

BStU-Leipzig. Bundesbeauftragte für die Unterlagen des Staatssicherheitsdienstes der ehemaligen DDR Leipzig—Außenstelle Leipzig [Federal Commissioner for the Records of the State Security Service of the former German Democratic Republic, Leipzig branch].

Bundesarchiv, Dienststelle Berlin [The German Federal Archives, Berlin branch].

Deutsche Dienststelle, Berlin [Wehrmacht Inquiries Office, Berlin].

HGB-Archiv. Archiv der Hochschule für Grafik und Buchkunst, Leipzig [Archive of the Academy of Fine Arts, Leipzig].

SächsStAL. Sächsisches Staatsarchiv Leipzig [Saxon State Archives Leipzig].

Leipziger Stadtbibliothek [Leipzig City Library].

Published Sources

Adorno, Theodor, Frederic Jameson, Walter Benjamin, Ernst Bloch, and Bertolt Brecht. *Aesthetics and Politics: The Key Texts of the Classic Debate within German Marxism.* London: Verso Books, 1977.

Allan, Seán, and John Sandford, eds. *DEFA, East German Cinema, 1946–1992.* New York: Berghahn Books, 1999.

"Antlitz unserer Stadt." *Leipziger Volkszeitung,* December 21, 1968.

Arendt, Hannah. *Eichmann in Jerusalem: A Report on the Banality of Evil.* New York: Viking Press, 1963.

———. *The Origins of Totalitarianism.* New York: Harcourt, Brace, 1951.

"The Artistic Situation in East Germany." *Burlington Magazine* 98 (1956): 257–58.

Atelier-Ausstellung Leipzig, Dimitroffmuseum. Exhibition catalog. Leipzig, 1956.

Augustine, Dolores L. *Red Prometheus: Engineering and Dictatorship in East Germany, 1945–1990.* Cambridge, MA: MIT Press, 2007.

Barnhisel, Greg. "Perspectives USA and the Cultural Cold War: Modernism in Service of the State." *Modernism/Modernity* 14, no. 4 (November 2007): 729–54.

Barron, Stephanie. "Blurred Boundaries: The Art of Two Germanys between Myth and History." In *Art of Two Germanys/Cold War Cultures,* edited by Stephanie Barron and Sabine Eckmann, 12–33. Cambridge, MA: MIT Press, 2007.

Barron, Stephanie, and Sabine Eckmann, eds. *Art of Two Germanys / Cold War Cultures.* New York: Abrams, 2009.

Baschleben, Klaus. "Streit um Reichstagskunst: Heisig rein oder raus?" *Leipziger Volkszeitung,* February 11, 1998.

Bathrick, David. *The Powers of Speech, the Politics of Culture in the GDR.* Lincoln: University of Nebraska Press, 1995.

Bauermeister, Volker. "Hannover: 'Bernhard Heisig. Bilder und Graphik.'" *Die Zeit,* December 18, 1981.

Baxandall, Michael. *Patterns of Intention: On the Historical Explanation of Pictures.* New Haven, CT: Yale University Press, 1985.

Beaucamp, Eduard. "Auf der Suche nach Bildern, Kunst in einer sozialistsichen Stadt: Bericht aus Leipzig." *Frankfurter Allgemeine Zeitung,* April 13, 1968.

Beaucamp, Eduard, Annika Michalski, and Frank Zöllner. *Tübke Stiftung Leipzig: Bestandskatalog der Zeichnungen und Aquarelle.* Leipzig: Plöttner, 2009.

Beckmann, Mayen. "Erben." In *Gestern und in dieser Zeit: Bernhard Heisig zum Achtzigsten,* edited by Heiner Köster and Marianne Köster, 13–15. Leipzig: Faber & Faber, 2005.

Beerbaum, Martin, and Heinz Graffunder. *Der Palast der Republik.* Leipzig: Seemann Verlag, 1979.

Belting, Hans. *The Germans and Their Art, a Troublesome Relationship.* Translated by Scott Kleager. New Haven, CT: Yale University Press, 1988.

Berdahl, Daphne. *Where the World Ended: Re-unification and Identity in the German Borderland.* Berkeley: University of California Press, 1999.

Bernhard Heisig: Gemälde, Zeichnungen, Lithographien. Dresden: Gemäldegalerie Neue Meister, 1973.

Bernhard Heisig, the Rage of Images. Exhibition brochure. Berlin: Martin-Gropius-Bau, 2005.

"Bernhard-Heisig-Schau in Berlin." *Kölner Stadt-Anzeiger,* October 10, 2005.

Betts, Paul, and Katherine Pence, eds. *Socialist Modern: East German Everyday Culture and Politics.* Social History, Popular Culture, and Politics in Germany. Ann Arbor: University of Michigan Press, 2008.

Blechen, Camilla. "Nie ganz zufrieden: Bernhard Heisig in Leipzig." *Frankfurter Allgemeine Zeitung,* October 1973.

———. Untitled. *Frankfurter Allgemeine Zeitung,* January 25, 1982.

———. "Der Unzufriedene." *Frankfurter Allgemeine Zeitung*, February 5, 1982.

Blume, Eugen, and Roland März, eds. *Kunst in der DDR, eine Retrospektive der Nationalgalerie*. Berlin: Verlag Berlin, 2003.

Borgmann, Karsten, and Christa Mosch. "1959, Heinrich Witz, der Neue Anfang," in *Auftrag: Kunst, 1949–1990*, ed. Monika Flacke, 119–24. Munich: Deutsches Historisches Museum, 1995.

Brockmann, Stephen. *Literature and German Reunification*. Cambridge: Cambridge University Press, 1999.

———. *The Writers' State: Constructing East German Literature, 1945–59*. Rochester, NY: Camden House, 2015.

Brusberg, Dieter, ed. *Bernhard Heisig: "Begegnung mit Bildern."* Berlin: Galerie Brusberg, 1995.

———. *Bernhard Heisig: "Gestern und in unserer Zeit."* Berlin: Galerie Brusberg, 2003.

———. *Bernhard Heisig: "Gestern und in unserer Zeit" oder "Das Elend der Macht"; das Welttheater eines deutschen Malers in sechs Akten*. Munich: Hirmer, 2014.

Buchloh, Benjamin H. D. "Figures of Authority, Ciphers of Regression: Notes on the Return of Representation in European Painting." *October* 16 (Spring 1981): 39–68.

———. "How German Was It?" *ArtForum* (Summer 2009): 294–99.

Burns, Rob, ed. *German Cultural Studies: An Introduction*. Oxford: Oxford University Press, 1995.

Bussmann, Georg. *Bernhard Heisig: Die Beharrlichkeit des Vergessens und andere Bilder*. Exhibition pamphlet. Frankfurt am Main: Frankfurter Kunstverein, 1980.

Calico, Joy H. *Arnold Schoenberg's "A Survivor from Warsaw" in Postwar Europe*. Berkeley: University of California Press, 2014.

———. "*Für eine neue deutsche Nationaloper*: Opera in the Discourses of Unification and Legitimation in the German Democratic Republic." In *Music and German National Identity*, edited by Celia Applegate and Pamela Potter, 190–204. Chicago: University of Chicago Press, 2002.

Castillo, Greg. *Cold War on the Home Front: The Soft Power of Midcentury Design*. Minneapolis: University of Minnesota Press, 2010.

Childs, David. "Obituary: Roger Loewig." *Independent*, November 26, 1997. https://www.independent.co.uk/news/obituaries/obituary-roger-loewig-1296351.html.

Crew, David F., ed. *Consuming Germany in the Cold War*. Oxford: Berg, 2003.

Damus, Martin. *Malerei der DDR, Funktionen der Bildenden Kunst im Realen Sozialismus*. Reinbek bei Hamburg: Rowohlt, 1991.

"DDR-Kunstmarkt gefordert." *Frankfurter Allgemeine Zeitung*, January 8, 1972.

"Der Maler Bernhard Heisig: Ausstellung bei 'Kunst der Zeit.'" *Sächsische Tageblatt*, March 27, 1968.

Deshmukh, Marion, ed. *Cultures in Conflict: Visual Arts in Eastern Germany since 1990*. Washington, DC: American Institute for Contemporary German Studies, 1998.

Dornberg, John. "Trier—Germany's Oldest and 'Most Splendid City.'" *German Life* 4/5 (1997). http://www.germanlife.com/Archives/1997/9704_01.html.

Dümcke, Wolfgang, and Fritz Vilmar, eds. *Kolonialisierung der DDR: Kritische Analysen und Alternativen des Einigungsprozesses*. Münster: Agenda Verlag, 1995.

Dymschitz, Alexander. "Über die formalistische Richtung in der deutschen Malerei." *Tägliche Rundschau*, November 24, 1948.

Eisman, April A. "Denying Difference in the Post-Socialist Other: Bernhard Heisig and the Changing Reception of an East German Artist." *Contemporaneity: Historical Presence in Visual Culture* 2 (2012): 45–73.

———. "East German Art and the Permeability of the Berlin Wall." *German Studies Review* 38, no. 3 (2015): 597–616.

———. "From Economic Equality to 'Mommy Politics': Women Artists and the Challenges of Gender in East German Painting." *International Journal for History, Culture and Modernity* 2, no. 2 (2014): 175–203.

———. "Painting in East Germany: An Elite Art for the Everyday (and Everyone)." In *Experiencing Postwar Germany. Everyday Life and Cultural Practice in East and West, 1960–2000*, edited by Erica Carter, Jan Palmowski, and Katrin Schreiter. Oxford: Berghahn, 2019.

———. "Painting the Berlin Wall in Leipzig: The Politics of Art in 1960s East Germany." In *Berlin: Divided City, 1949–1989*, edited by Sabine Hake and Philip Broadbent, 83–89. New York: Berghahn Books, 2010.

———. Review of the 2009 LACMA exhibition catalog, *Art of Two Germanys / Cold War Cultures*. *German History* 27, no. 4 (2009): 628–30.

———. "Whose East German Art Is This? The Politics of Reception after 1989." *Imaginations: Journal of Cross-Cultural Visual Studies* 8, no. 1 (May 2017). http://imaginations.csj.ualberta.ca/?p=9487.

Elliott, David. "Absent Guests." In *Divided Heritage: Themes and Problems in German Modernism*, edited by Irit Rogoff, 24–49. Cambridge: Cambridge University Press, 1991.

———. "Socialist Realism." *Oxford Art Online: Grove Art Online*. Oxford University Press, 2003.

———. *Tradition and Renewal: Contemporary Art in the German Democratic Republic*. Oxford: Museum of Modern Art, 1984.

Emmerich, Wolfgang. *Kleine Literaturgeschichte der DDR, Erweiterte Neuausgabe*. Berlin: Aufbau, 2000.

"Erster Rundgang—erste Urteile, Paul Fröhlich und Erich Grützner besuchten die 7. Bezirkskunstausstellung Leipzig." *Leipziger Volkszeitung*, October 3, 1965.

Feist, Günter, and Eckhart Gillen, eds. *Kunstkombinat DDR, Daten und Zitate zur Kunst und Kunstpolitik der DDR 1945–1990*. Berlin: Museumspädagogischen Dienst, 1990.

Feist, Günter, Eckhart Gillen, and Beatrice Vierneisel, eds. *Kunstdokumentation SBZ/DDR, Aufsätze, Berichte, Materialien, 1945–90*. Cologne: DuMont, 1996.

Ferdinand-Ude, Patricia. "Das gemalte Selbstbildnis im Werk von Bernhard Heisig in der Zeit von 1958–1995." MA thesis, Leipzig University, 1995.

Flacke, Monica, ed. *Auftrag: Kunst, 1949–1990*. Munich: Deutsches Historisches Museum, 1995.

Fulbrook, Mary. *Anatomy of a Dictatorship: Inside the GDR 1949–1989*. Oxford: Oxford University Press, 1995.

Fulbrook, Mary, and Andrew I. Port. *Becoming East German: Socialist Structures and Sensibilities after Hitler*. New York: Berghahn, 2013.

G., P. H. "Unter dem Teppich sind Menschenleiber gefangen." *Berliner Morgenpost*, June 24, 1984.

Ghodsee, Kristen. *Red Hangover: Legacies of Twentieth-Century Communism*. Durham, NC: Duke University Press, 2017.

Gillen, Eckhart, ed. *Bernhard Heisig: Die Wut der Bilder*. Cologne: DuMont, 2005.

———, ed. *German Art from Beckmann to Richter: Images of a Divided Country*. New Haven, CT: Yale University Press, 1997.

———. *Das Kunstkombinat DDR: Zäsuren einer Gescheiterten Kunstpolitik*. Cologne: DuMont, 2005.

———. "'Schwierigkeiten beim Suchen der Wahrheit': Bernhard Heisig im Konflikt zwischen 'verordnetem Antifaschismus' und der Auseinandersetzung mit seinem Kriegstrauma." PhD diss., Ruprecht-Karls-Universität Heidelberg, 2003.

Gillen, Eckhart, and R. Haarmann, eds. *Kunst in der DDR*. Cologne: Kiepenheuer und Witsch, 1990.

Gleisberg, Dieter. "Das Gleichnis des Kain." *Leipziger Volkszeitung*, October 23, 1965.

Goeschen, Ulrike. *Vom Sozialistischen Realismus zur Kunst im Sozialismus: Die Rezeption der Moderne Kunst und Kunstwissenschaft der DDR*. Berlin: Duncker & Humblot, 2001.

Granville, Johanna. "The Last of the Mohicans: How Walter Ulbricht Endured the Hungarian Crisis of 1956." *German Politics and Society* 22 (Winter 2004): 88–121.

Grass, Günter. "Sich ein Bild machen." In *Zeitvergleich: Malerei und Grafik aus der DDR*, edited by Axel Hecht and Hanne Reinecke, 10–13. Hamburg: Art, das Kunst Magazin, 1982.

Greenberg, Clement. "Avant-Garde and Kitsch." *Partisan Review* (Fall 1939): 34–49.

———. "Modernist Painting." *Forum Lectures*. Washington, DC: Voice of America, 1960.

Grundman, Ute, Klaus Michael, and Susanna Seufert, eds. *Revolution im geschlossenen Raum: Die andere Kultur in Leipzig, 1970–1990*. Leipzig: Faber & Faber, 2002.

Guilbaut, Serge. *How New York Stole the Idea of Modern Art: Abstract Expressionism, Freedom, and the Cold War*. Chicago: University of Chicago Press, 1983.

Guth, Peter. *Wände der Verheissung, Zur Geschichte der architekturbezogenen Kunst in der DDR*. Leipzig: Thom Verlag, 1995.

H., C. G. "Reunification Controversy: Was East Germany Really 'Annexed'?" *Der Spiegel*, August 31, 2010. http://www.spiegel.de/international/germany/0,1518,714826,00.html.

Hager, Kurt. *Erinnerungen*. Leipzig: Faber & Faber, 1996.

Harsch, Donna. "Squaring the Circle: The Dilemmas and Evolution of Women's Policy." In *The Workers' and Peasants' State: Communism and Society in East Germany under Ulbricht, 1945–1971*, edited by Patrick Major and Jonathan Osmond, 151–70. Manchester: Manchester University Press: 2002.

Hartleb, Renate. *Bernhard Heisig*. Dresden: Verlag der Kunst, 1975.

Hartmann, Anne, and Wolfgang Eggeling. *Sowjetische Präsenz im kulturellen Leben der SBZ und frühen DDR 1945–1953*. Berlin: Akademie Verlag, 1998.

Hecht, Axel, and Hanne Reinecke, eds. *Zeitvergleich: Malerei und Grafik aus der DDR*. Hamburg: Gruner & Jahr, 1982.

Hecht, Axel, and Alfred Welti. "'Ein Meister, der Talent verschmäht': Interview mit Georg Baselitz." *Art, das Kunstmagazin* 6 (1990): 54–72.

Heim, Tino. "Der kurze Aufstieg und lange Fall der ersten 'Leipziger Schule'—Die Dritte Deutsche Kunstausstellung 1953." In *60/40/20, Kunst in Leipzig Seit 1949*, edited by Karl-Siegbert Rehberg and Hans-Werner Schmidt, 54–58. Leipzig: Seemann Henschel, 2009.

Heinz Zander, Malerei, Zeichnungen, Grafik. Leipzig: Museum der bildenden Künste, 1984.

Heisig, Bernhard. "Atelier-Ausstellung in Leipzig." *Bildende Kunst* 3 (1957): 168.

———. "Junge Künstler in Leipzig." *Bildende Kunst* 3 (1956): 127–31.

———. "Der Künstler zu seinem Werk: Bernhard Heisig zum Gemälde *Der Brigadier*—VII. DKA." *Kunsterziehung* 20 (February 1973): 4–5.

———. "Leipziger Bezirkskunstausstellung 1956." *Bildende Kunst* 1 (1957): 66–67.

———. "Pablo Picasso." 1986. In *Bernhard Heisig "Gestern und in unserer Zeit" oder "Das Elend der Macht,"* edited by Dieter Brusberg, 282–87. Munich: Hirmer Verlag, 2014.

———. "Über Beckmann." In *Bernhard Heisig: Zeiten zu Leben, Malerei*, edited by Theodor Helmert-Corvey, 13–15. Bielefeld: Kerber Verlag, 1994.

———. "Zur Kunstausstellung in Leipzig 1954." *Bildende Kunst* 5/6 (1954): 81–83.

———. "Zur Leipziger Bezirkskunstausstellung 1955." *Bildende Kunst* 6 (1955): 476–77.

Hell, Julia. *Post-fascist Fantasies: Psychoanalysis, History, and the Literature of East Germany*. Durham, NC: Duke University Press, 1997.

Helmert-Corvey, Theodor, ed. *Bernhard Heisig, Zeiten zu Leben, Malerei*. Bielefeld: Kerber Verlag, 1994.

Hermand, Jost. "Modernism Restored: West German Painting in the 1950s." *New German Critique*, no. 32 (1984): 23–41.

Hermann, E. "Mit Phantasie und Anmut: Ausstellungen in Leipzig anläßlich der Messe." *Berliner Zeitung*, March 15, 1951.

Hofer, Karl. "Art and Politics." *Bildende Kunst* 10 (1948): 20–22.

Höhn, Tobias D. "K20: Die Wut der Bilder." *Westdeutsche Zeitung*, March 22, 2005. http://www.wz-newsline.de/sro.php?redid=78676.

Honecker, Erich. "Zu aktuellen Fragen bei der Verwirklichung der Beschlüsse unseres VIII. Parteitages." *Neues Deutschland*, December 18, 1971.

Hoppe, Margret. *Die verschwundenen Bilder*. Leipzig: Spinnerei Archiv Massiv, 2007.

Hübscher, Anneliese. "Bezirksausstellung Leipzig." *Junge Kunst* 1 (1962): 17–34.

———. "Heinrich Witz: *Besuch bei Martin Andersen Nexö*." *Das Blatt* (January 1961): 7–10.

Hüllenkremer, Marie. "Bernhard Heisig im Gespräch mit Helmut Schmidt." In *Kunst in der DDR*, edited by Eckhart Gillen and R. Haarmann, 382. Cologne: Kiepenheuer und Witsch, 1990.

Hutchinson, Peter. *Stefan Heym: The Perpetual Dissident*. Cambridge: Cambridge University Press, 1992.

Jarausch, Konrad H. *The Rush to German Unity*. New York: Oxford University Press, 1994.

Joachimides, Joachim. "A Gash of Fire across the World." In *German Art in the 20th Century*, 11. London: Prestel Verlag, 1985.

Jorek, Rita. "Von Oeser bis zum Absolventen, Über die Jubiläumsausstellungen der HGB." *Leipziger Volkszeitung*, October 15, 1964.

———. "Wir stellen zur Diskussion: Bilder auf der Etage, Ein erstes Gespräch mit Prof. Bernhard Heisig." *Leipziger Volkszeitung*, July 10, 1965.

Kahlke, Wolfgang. "Pressedokumentation zu einem durch die Neue Nationalgalerie augelösten 'deutschen Bilderstreit.'" *Jahrbuch Preußisches Kulturbesitz* 31 (1994): 365–408.

Kaiser, Paul. "Symbolic Revolts in the 'Workers' and Peasants' State': Countercultural Art Programs in the GDR and the Return of Modern Art." In *Art of Two Germanys / Cold War Cultures*, edited by Stephanie Barron and Sabine Eckmann, 170–85. New York: Abrams, 2009.

Kaiser, Paul, and Karl-Siegbert Rehbert, eds. *Enge und Vielfalt: Auftragskunst und Kunstförderung in der DDR, Analysen und Meinungen*. Hamburg: Junius, 1999.

Kandinsky, Wassily. *Concerning the Spiritual in Art*. Translated by M. T. H. Sadler. New York: Dover, 1977.

Kihago, Gabriele. "Probleme der baugebundenen Kunst—nachgewiesen an den neuen Hotels in Leipzig." MA thesis, Pädagogischen Institut "Dr. Theodor Neubauer" (Erfurt), 1968.

Kober, Karl Max. *Bernhard Heisig.* Dresden: Verlag der Kunst, 1981.

———. "Bernhard Heisig—Leben und Werk." In *Bernhard Heisig: Gemälde, Zeichnungen, Lithographien,* 13–47. Dresden: Gemäldegalerie Neue Meister, 1973.

———. "Von der Chance an einem Weltbild mitzuwirken." *Bildende Kunst* 9 (September 1972): 444–49.

Köster, Heiner, and Marianne Köster, eds. *Gestern und in dieser Zeit, Bernhard Heisig zum Achtzigsten.* Leipzig: Faber & Faber, 2005.

Krajewska, Helena. "Die Dresdner 'Fünfte' aus polnischer Sicht." *Bildende Kunst* 4 (1964): 211–13.

Krecek, Werner [Klaus-Dieter Walter]. "Brief zu einem Bild." *Leipziger Volkszeitung,* November 6, 1965.

Krecek, Werner, and Renate Brühl. "Gesellschaftlicher Auftrag und Leninstudium, ein LVZ-Interview mit Prof. Gerhard Kurt Müller." *Leipziger Volkszeitung,* April 15, 1971.

Krecek, Werner, and Karl Heinz Hagen. "Ein Blick in den Spiegel unserer Zeit: Rundgang mit Walter Ulbricht durch die 6. Bezirkskunstausstellung Leipzig." *Neues Deutschland,* December 15, 1961.

Krug, Manfred. *Abgehauen.* Berlin: Ullstein, 2003.

Kuhirt, Ullrich. *Kunst der DDR, 1960–80.* Leipzig: Seeman Verlag, 1983.

Kuhirt, Ullrich, and Herbert Heerklotz. *Weg zur sozialistischen Künstlerorganisation: Dokumentation.* Berlin: VBK-DDR, 1983.

Kuhn, Nicola. "Parteischule Nationalgalerie." *Der Tagesspiegel,* April 24, 1994.

Kuhn, Tom, and Steve Giles. *Brecht on Art and Politics.* London: Methuen, 2003.

"Kunst-Auktion für Vietnam." *Leipziger Volkszeitung,* July 24, 1966.

Küttner, Rüdiger, ed. *Bernhard Heisig, Zeit und Leben.* Berlin: Galerie Berlin, 1999.

Lahann, Birgit. "Salto mortale in zwei Diktaturen, Bernhard Heisig und Johannes Heisig." In *Väter und Söhne: Zwölf biographische Porträts,* edited by Thomas Karlauf and Katharina Raabe, 395–420. Berlin: Rowohlt, 1996.

Lang, Karen. "Expressionism and the Two Germanys." In *Art of Two Germanys / Cold War Cultures,* edited by Stephanie Barron and Sabine Eckmann, 84–100. Cambridge, MA: MIT Press, 2007.

Lang, Lothar. "Der Maler Bernhard Heisig." *Weltbühne,* July 24, 1973.

———. *Malerei und Graphik in Ostdeutschland.* Leipzig: Faber & Faber, 2002.

Lange, Rudolf. "Höllenfahrt durch Zeit und Geschichte, Bernhard Heisig bei Brusberg in Hannover." *Hannoversche Allgemeine,* December 12–13, 1981.

Lehmann-Haupt, Hellmut. *Art under a Dictatorship.* New York: Oxford University Press, 1954.

Letsch, Herbert. "Handschrift-Expressivität-Ideologie." *Leipziger Volkszeitung,* May 24, 1969.

———. "Wir diskutieren: Bilder auf der Etage, Das Bild im Raum." *Leipziger Volkszeitung*, July 31, 1965.

Lichtnau, Bernfried. "Der Beitrag Bernhard Heisigs zur Weiterentwicklung der Historienmalerei in der bildenden Kunst der Deutschen Demokratischen Republik: Bestimmung der Funktions- und Gestaltungsdifferenzierung histo-risch-thematischer Kompositionen." 10 vols. PhD diss., Ernst-Moritz-Arndt-Universität Greifswald, 1988.

Lindenberger, Thomas. "Home Sweet Home: Desperately Seeking Heimat in Early DEFA Films." *Film History* 18, no. 1 (2006): 46–58.

Lindner, Bernd. *Verstellter, offener Blick, Eine Rezeptionsgeschichte Bildender Kunst im Osten Deutschlands, 1945–1995*. Köln: Böhlau, 1998.

Lüdecke, Heinz. "Phänomen und Problem Picasso." *Bildende Kunst* 5 (1955): 539–43.

Lunn, Eugene. *Marxism and Modernism, an Historical Study of Lukacs, Brecht, Benjamin, and Adorno*. Berkeley: University of California Press, 1982.

Mäde, Heinz. *Das durchweg unliterarisch erzählte Leben eines Mannes im Deutschland des 20. Jahrhunderts*. Langendorf/Untergreisslau: Saale-Druck Naumberg, 1999.

Major, Patrick. *Behind the Berlin Wall: East Germany and the Frontiers of Power*. Oxford: Oxford University Press, 2010.

———. "Going West: The Open Border and the Problem with *Republikflucht*." In *The Workers' and Peasants' State: Communism and Society in East Germany under Ulbricht, 1945–1971*, edited by Patrick Major and Jonathan Osmond, 190–208. Manchester: Manchester University Press: 2002.

Major, Patrick, and Jonathan Osmond, eds. *The Workers' and Peasants' State: Communism and Society in East Germany under Ulbricht, 1945–1971*. Manchester: Manchester University Press: 2002.

"Malerei, Plastik, Zeichnung, Video, Photo: Auf der sechsten documenta ist die Kunst sich selber zum Thema geworden." *Die Zeit*, July 1, 1977.

Mattheuer-Neustadt, Ursula. "56 Jahre: Zum 80. Geburtstag von Bernhard Heisig." *Marginalien* 178 (2005): 3–19.

Meißner, Günter. "Architekturbezogen und originell." *Bildende Kunst* 10 (1965) 527–33.

———. "Ein Bild der Commune." *Leipziger Volkszeitung*, October 30, 1965.

———. "Malerei und Grafik auf der 7. Bezirkskunstausstellung." *Leipziger Volkszeitung*, October 9, 1965.

———. "Schönheit und Überfülle, Diskussionsbeitrag zum Thema 'Bilder auf der Etage.'" *Leipziger Volkszeitung*, July 17, 1965.

———. "Suche nach neuen Wegen: 7. Bezirkskunstausstellung Leipzig eröffnet." *Neues Deutschland*, October 5, 1965.

———. "Um die Vertiefung realistischer Aussage." *Bildende Kunst* 2 (1966): 73–78.

Merkert, Jörn, and Peter Pachnicke, eds. *Bernhard Heisig: Retrospektive*. Munich: Prestel, 1989.

Mesch, Claudia. *Modern Art at the Berlin Wall: Demarcating Culture in the Cold War Germanys*. London: Taurus Academic Studies, 2009.

Michalski, Annika. "Die Selbstdarstellungen des Leipziger Malers Werner Tübke: Rollensuche zwischen künstlerischer Tradition und gesellschaftspolitischer Stellungnahme, 1940–2004." PhD diss., Leipzig University, 2012.

Michalski, Annika, and Frank Zoellner. *Tübke Stiftung Leipzig: Bestandskatalog der Gemälde*. Leipzig: Plöttner, 2008.

Miller, Ann Stamp. *The Cultural Politics of the German Democratic Republic: The Voices of Wolf Biermann, Christa Wolf, and Heiner Müller*. Parkland, FL: Brown Walker, 2004.

———. "Wolf Biermann: 1936–?" In *The Cultural Politics of the German Democratic Republic: The Voices of Wolf Biermann, Christa Wolf, and Heiner Müller*, 84–86. Parkland, FL: Brown Walker, 2004.

Ministerium für Kultur der DDR. *Bernhard Heisig: Gemälde, Zeichnungen, Lithographien*. Dresden: Gemäldegalerie Neue Meister, 1973.

Mittenzwei, Werner. *Die Intellektuellen: Literatur und Politik in Ostdeutschland 1945 bis 2000*. Berlin: Aufbau Verlag, 2003.

Möbius, Friedrich. "Erkenntnis und Gestaltung." *Bildende Kunst* 6 (1968): 329–30.

Molina, Caroline. "Wolf Biermann's 'Prussian Icarus' 1976–1996: A Comparatist Perspective." *German Politics & Society* 14, no. 2 (Summer 1996): 101–23.

Mülhaupt, Freya. "Biographische Dokumentation." In *Bernhard Heisig: Retrospektive*, edited by Jorn Merkert and Peter Pachnicke, 94–107. Munich: Prestel Verlag, 1989.

Museum der bildenden Künste Leipzig. *Heinz Zander, Malerei, Zeichnungen, Grafik*. Leipzig: Museum der bildenden Künste, 1984.

———. *Wolfgang Mattheuer, das druckgrafische Werk 1948–1986*. Leipzig: Museum der bildenden Künste, 1987.

Nerlinger, Oskar. "Politik und Kunst." *bildende kunst* 10 (1948): 23–25.

Nisbet, Peter, ed. *Twelve Artists from the German Democratic Republic*. Cambridge, MA: Harvard University Press, 1989.

Nitschka, Irma. "Wir suchen unser geistiges Antlitz, Leser schreiben zu Bezirksausstellung 'Architektur und bildende Kunst.'" *Neues Deutschland*, July 24, 1969.

Niven, Bill, ed. *German as Victims*. New York: Palgrave Macmillan, 2006.

Nugent, Jeanne. "Family Album and Shadow Archive: Gerhard Richter's East, West and all German Painting, 1949–1966." PhD diss., University of Pennsylvania, 2005.

Nungesser, Michael. "Bernhard Heisig: Neue Bilder, Zeichnungen." *Die Kunst* 6 (1984).

Oguibe, Olu. *The Culture Game*. Minneapolis: University of Minnesota Press, 2004.

Olbrich, Harald. "Ästhetische Subjektivität oder Subjektivismus." *Bildende Kunst* 5 (1966): 272–73.

Orlow, N. "Wege und Irrwege der modernen Kunst." *Tägliche Rundschau*, January 20, 1951, and January 23, 1951.

Pachnicke, Peter. "Aufgaben, Struktur und Traditionslinien der Hochschule für Grafik und Buchkunst." In *Hochschule für Grafik und Buchkunst Leipzig, 1945–1989*, edited by Arno Rink and Dieter Gleisberg, 16–25. Leipzig: Seemann Verlag, 1989.

Piotrowski, Piotr. "The Geography of Central/East European Art." In *Borders in Art: Revisiting "Kunstgeographie,"* edited by Katarzyna Murawska-Muthesius, 43–50. Warsaw: Institute of Art, 2000.

———. Toward a Horizontal History of the European Avant-Garde." In *European Avant-Garde and Modernism Studies*, edited by Sascha Bru and Peter Nicholls, 49–58. Berlin: De Gruyter, 2009.

Pommeranz-Liedtke, Gerhard. "Auf dem Weg zur Volkstümlichkeit." *Neues Deutschland*, June 24, 1961.

Port, Andrew I. *Conflict and Stability in the German Democratic Republic*. Cambridge: Cambridge University Press, 2007.

———. "Introduction: The Banalities of East German Historiography." In *Becoming East German*, edited by Mary Fulbrook and Andrew I. Port, 1–30. New York: Berghahn Press, 2013.

"Protest gegen offizielle 'DDR'-Maler in Kassel." *Die Welt*, June 22, 1977.

Raum, Hermann. *Bildende Kunst in der DDR*. Berlin: Edition Ost AG, 2000.

"Rede von Bundeskanzler Gerhard Schröder zur Ausstellungseröffnung Bernhard Heisig—*Die Wut der Bilder* am 20. März 2005." *Bundesregierung Bulletin* 26, no. 3 (April 2005). https://www.bundesregierung.de/Content/DE/ Bulletin/2001_2007/2005/04/26-3_Schroeder.html.

"Referat des Genossen Walter Ulbricht auf dem VII. Parteitag der Sozialistischen Einheitspartei Deutschland." *Neues Deutschland*, April 18, 1967.

Rehberg, Karl-Siegbert. "Expressivität zwischen Machtkalkül und produktiver Verunsicherung: Bernhard Heisig als 'Motor' und Integrationsfigur der Leipziger Malerei." In *Bernhard Heisig: Die Wut der Bilder*, edited by Eckart Gillen, 282–306. Cologne: DuMont, 2005.

Rehberg, Karl-Siegbert, and Paul Kaiser, eds. *Bilderstreit und Gesellschaftsumbruch*. Berlin: Siebenhaar Verlag, 2013.

Richard, Jackie. "Der grosse Bernhard Heisig fleht: Erspart uns bitte den St.-Pauli-Schock." *BILD*, October 7, 2005. https://www.detektei-wischer.de/ erkl_licht. htm.

Rink, Arno, and Dieter Gleisberg. *Hochschule für Grafik und Buchkunst Leipzig, 1945–1989*. Leipzig: Seemann Verlag, 1989.

Ross, Corey. *The East German Dictatorship: Problems and Perspectives in the Interpretation of the GDR*. New York: Oxford University Press, 2002.

———. "'Protecting the Accomplishments of Socialism'? The (Re)Militarisation of Life in the German Democratic Republic." In *The Workers' and Peasants' State, Communism and Society in East Germany under Ulbricht 1945–71*, edited

by Patrick Major and Jonathan Osmond, 78–93. Manchester: Manchester University Press, 2002.

Roters, Eberhard. "Der Maler und sein Thema." In *Bernhard Heisig: Zeiten zu Leben, Malerei*, edited by Theodor Helmert-Corvey, 17–24. Bielefeld: Kerber, 1994.

Rubin, Eli. *Synthetic Socialism: Plastics & Dictatorship in the German Democratic Republic*. Chapel Hill: University of North Carolina Press, 2008.

Rühle, Günther. "Deutschland, Deutschland: Betrachtungen zur deutschen Kunst und Geschichte." *Frankfurter Allgemeine Zeitung*, April 14, 1979.

Runowsky, Fred. "Picasso regt zum mitdenken an." *Bildende Kunst* 2 (1956): 108.

Ruthe, Ingeborg. "Malen am offenen Nerven." *Berliner Zeitung*, October 22, 2005.

Sander, Dietulf. *Bernhard Heisig als Buchillustrator*. Leipzig: Faber & Faber, 2007.

———. "Bernhard Heisig—das druckgraphische Werk, Kommentiertes Verzeichnis der Lithographien, Radierungen und Monotypien, 1950–1990." PhD diss., Leipzig University, 1993.

———, ed. *Bernhard Heisig: Der faschistische Alptraum*. Leipzig: Reclam, 1989.

Saunders, Frances Stonor. *Who Paid the Piper? The CIA and the Cultural Cold War*. London: Granta Books, 1999.

Scheibe, Wolfgang. "Hotel 'Deutschland.'" *Deutsche Architektur* 8 (1965): 454–56.

———. "Montagebauweise negiert nicht die Kunst." *Leipziger Volkszeitung*, August 7, 1965.

Schirmer, Gisela. *DDR und documenta: Kunst im deutsch-deutschen Widerspruch*. Berlin: Reimer, 2005.

———. *Willi Sitte: Farben und Folgen, Eine Autobiographie mit Skizzen und Zeichnungen des Künstlers*. Leipzig: Faber & Faber, 2003.

Schleinitz, Karl-Heinz. "Hintergründe einer Ausstellung, über eine Konferenz mit Genossen bildenden Künstlern des Bezirkes Halle (I. Teil)." *Neues Deutschland*, January 7, 1958.

Schmidt, Gudrun. "Die Galerie Konkret in Berlin." In *Kunstdokumentation SBZ/ DDR, Aufsätze, Berichte, Materialien, 1945–90*, edited by Günter Feist, Eckhart Gillen, and Beatrice Vierneisel, 290–97. Cologne: DuMont, 1996.

Schneider, Peter. *The Wall Jumper, a Berlin Story*. Translated by Leigh Hafrey. New York: Pantheon Books, 1983.

Schumann, Henry. "Allegorie des Unrechts." *Leipziger Volkszeitung*, October 16, 1965.

———. "Als Künstler gebraucht werden." *Leipziger Volkszeitung*, March 16, 1968.

———. *Ateliergespräche*. Leipzig: Seeman Verlag, 1976.

———. "Die Fäden wieder knupfen." *Leipziger Volkszeitung*, December 14, 1962.

———. "Leitbild Leipzig: Beiträge zur Geschichte der Malerei in Leipzig von 1945 bis Ende der achtziger Jahre." In *Kunstdokumentation SBZ/DDR, Aufsätze, Berichte, Materialien, 1945–90*, edited by Günter Feist, Eckhart Gillen, and Beatrice Vierneisel, 480–555. Cologne: DuMont, 1996.

Shapiro, David, and Cecile Shapiro. "Abstract Expressionism: The Politics of Apolitical Painting." In *Pollock and After, the Critical Debate*, edited by Francis Franscina, 135–51. New York: Harper & Row, 1985.

7. Kunstausstellung 1965 des VBKD, Bezirk Leipzig. [Seventh District Art Exhibition in Leipzig]. Exhibition catalog. Leipzig: VBKD, 1965.

Silberman, Marc. "Learning from the Enemy: DEFA-French Co-productions of the 1950s." *Film History* 18, no. 1 (February 2006): 21–45.

Silverberg, Laura. "Between Dissonance and Dissidence: Socialist Modernism in the German Democratic Republic." *Journal of Musicology* 26, no. 1 (Winter 2009): 44–84.

Sitte, Willi. "Gedanken nach einer Italienreise." *Bildende Kunst 1* (1957): 53.

Smith, Terry. *What Is Contemporary Art?* Chicago: University of Chicago Press, 2009.

Stonard, John-Paul. *Fault Lines: Art in Germany, 1945–1955.* London: Ram Distribution, 2008.

Stuhr, Inge. *Max Schwimmer: Eine Biographie.* Leipzig: Lehmstedt, 2010.

Sumpf, Gertraude. "Das Mensch-Technik-Problem in neuen Arbeiten von Willi Neubert." *Bildende Kunst* 1 (1968): 9–12.

T., D. "Unser Kommentar." *Neue Zeit*, October 29, 1961.

T., M. "Eine Topographie in Farben: Werke von BH bei 'Kunst der Zeit' ausgestellt." *Die Union*, March 30, 1968.

———. "Entwicklung und Leistung, Leipziger Künstler legen Rechenschaft." *Die Union*, October 21, 1965.

Topfstedt, Thomas. "Augustusplatz—Karl-Marx-Platz—Augustusplatz: Aufbauplanung und Neugestaltung nach dem Zweiten Weltkrieg." In *Der Leipziger Augustusplatz: Funktionen und Gestaltwandel eines Großstadtplatzes*, edited by Thomas Topfstedt and Pit Lehmann, 69–76. Leipzig: Leipzig University Press, 1994.

Topfstedt, Thomas, and Pit Lehmann, eds. *Der Leipziger Augustusplatz: Funktionen und Gestaltwandel eines Großstadtplatzes.* Leipzig: Leipziger Universitätsverlag, 1994.

Tschirner, Marga. "Schwedt wird international." *Leipziger Volkszeitung*, July 25, 1965.

Uhlitzsch, Joachim. "Vom richtigen Weg und Dem grossen Ziel, Zur Eröffnung der V. Deutschen Kunstausstellung in Dresden." *Bildende Kunst* 10 (1962): 509–15.

———. "Zwei Staaten in der Kunst, Eine Betrachtung vor der V. Deutschen Kunstausstellung." *Leipziger Volkszeitung*, September 5, 1962.

Ulbricht, Walter. "Aufgaben der Kunst." *Neues Deutschland*, November 1, 1951.

———. "Was wir wollen und was wir nicht wollen." *Neues Deutschland*, December 30, 1956.

"Unsere Kunst kämpft für das Emporwachsende, für das Neue." *Neues Deutschland*, March 3, 1953.

Verband Bildender Künstler Deutschlands, Berzirksvorstand Leipzig. Vorwort [Introduction]. *7. Kunstausstellung 1965 des VBKD, Bezirk Leipzig*. [Seventh District Art Exhibition in Leipzig]. Exhibition catalog. Leipzig: VBKD, 1965.

"Vielfalt des künstlerischen Ausdrucks: Gespräch mit Mitgliedern der Jury zur 7. Bezirkskunstausstellung." *Leipziger Volkszeitung*, August 1, 1965.

Vierter Kongress des Verbandes Bildender Künstler Deutschlands. Leipzig: Verband Bildender Künstler Deutschlands, 1959.

Walter, Schiller, ed. *Zweihundert Jahre Hochschule für Grafik und Buchkunst Leipzig: 1764–1964*. Leipzig: Hochschule für Grafik und Buchkunst, 1964.

Walter Münze, Skizze aus China. Leipzig: Verband bildende Künstler, 1956.

"Was auf der documenta nicht gezeigt wird: Die verfemte Kunst der ungehorsame Maler aus der 'DDR.' Hinter jeder Säule lauschen Riesenohren." *Die Welt*, June 30, 1977.

Weber, Hermann. *Kleine Geschichte der DDR*. Cologne: Verlag Wissenschaft und Politik, 1980.

Weggefährten, Zeitgenossen, Bildende Kunst aus drei Jahrzehnten. Berlin: Zentrum für Kunstausstellungen der DDR, 1979.

Westermann, Waltraut, and Jutta Schmidt. "Das Bild des arbeitenden Menschen." *Bildende Kunst* 1 (1968): 2–8.

Winkler, Gerhard. "Kostbarkeiten aus Bildgalerien: Bernhard Heisig, 'Der Brigadier.'" *FF Dabei*, December 4, 1970.

———. "Kunstwerk des Monats aus dem Museum bildende Künste Leipzig: Bernhard Heisig's *Der Brigadier*, Ölgemälde." *Leipziger Volkszeitung*, April 10, 1971.

———. *Leipzig Hotel Deutschland*. Leipzig: Seemann Verlag, 1967.

Winkler, Jürgen. "*Kulturpolitik*." In *Die SED: Geschichte, Organisation, Politik; ein Handbuch*, edited by Andreas Herbst, 389–404. Berlin: Dietz, 1997.

Witz, Heinrich. "Einführung" [Introduction]. In *6. Kunstausstellung 1961 des VBKD Bezirk Leipzig* [Sixth District Art Exhibition of the Artists Association in Leipzig]. Exhibition catalog. Leipzig: VBKD, 1961.

INDEX

Note: Page numbers in italics indicate illustrations.